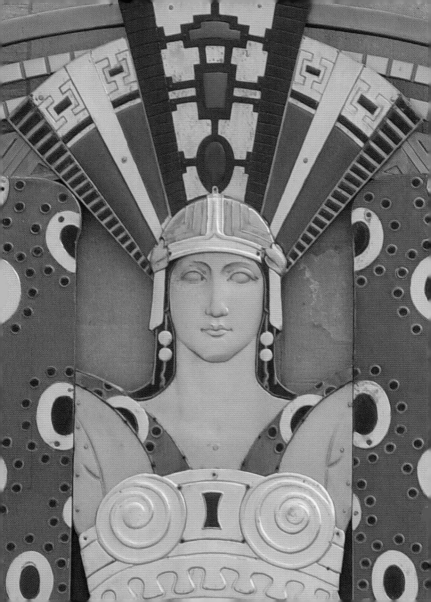

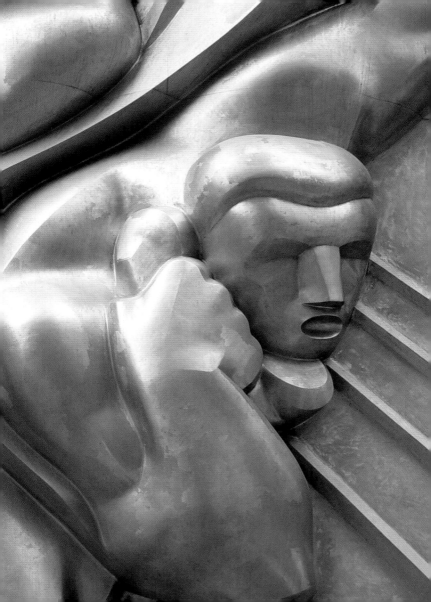

THE ART OF ROCKEFELLER CENTER

CHRISTINE ROUSSEL

W. W. NORTON & COMPANY · NEW YORK · LONDON

The Art of Rockefeller Center
Christine Roussel

Copyright 2006 by Christine Roussel
Foreword copyright 2006 by Laurance S. Rockefeller.

Manufacturing by Mondadori Printing, Verona
Book design and composition by Robert L. Wiser, Silver Spring, MD

LIBRARY OF CONGRESS CATALOGING-IN-PUBLICATION DATA

Roussel, Christine.
 The art of Rockefeller Center / Christine Roussel.—1st ed.
 p. cm.
 Includes bibliographical references and index.
 ISBN 0-393-06082-9 (hardcover)
 1. Art, American—New York (State)—New York—20th century.
2. Art deco—New York (State)—New York. 3. Rockefeller Center—
Art collections. 4. Art—Private collections—New York (State)—New
York. 5. Rockefeller, John D. (John Davison), 1874–1960—Art patron-
age. I. Rockefeller Center. II. Title.
 N6535.N5R67 2006
 709'.04'0120747471—dc22 2005015177

W. W. Norton & Company, 500 Fifth Avenue, New York, NY 10110
www.wwnorton.com
W. W. Norton & Company Ltd., Castle House, 75/76 Wells Street,
London, W1T 3QT

1 2 3 4 5 6 7 8 9 0

PHOTO CREDITS

Associated Press Archives: 93, 96–99, 101, 105

Louise Meiere Dunn: 35, 40

Roger Leo: 197, 206

Rockefeller Center Archive Center: 6, 8, 10, 13, 15, 18, 22, 27, 30, 32,
39, 52, 53, 56, 58, 59 top, 61, 62, 65, 66, 69–71, 74, 77 top, 78, 85, 94,
102, 106, 108, 112, 114–16, 119–21, 123, 124, 127, 131, 134–41, 151, 152, 159–
61, 161, 168, 173, 175, 183, 186, 187, 190, 191, 196, 200, 201, 205, 206, 209,
213, 215, 217–20, 222, 224, 232–37, 239–41, 250, 255, 258, 260–63, 266,
272, 282, 284–89, 291, 293

Christine Roussel: 1, 2, 5, 16, 24, 28, 33, 34, 37, 38, 41–46, 49–51, 55, 57,
59 bottom, 63, 64, 67, 75, 76, 77 bottom, 81, 82, 84, 87, 88, 90, 107, 111,
122, 128–30, 132, 155, 156, 158, 162, 163, 165, 169, 171, 172, 176, 179, 180, 184,
189, 192–95, 202, 210–12, 221, 227, 228, 231, 252, 253, 256, 259, 264, 267,
268, 274–76, 280, 290, 294, 295, 297, 298, 320

Dianne Roussel: 19–21, 23, 73, 143–49, 166, 182, 188, 225, 242–44, 247–
49, 254, 271, 279, 283

Marc Roussel: 198

DISPLAY PHOTOGRAPHS

*Page 1: Detail of the central figure from Drama, Hildreth Meiere's
metal, enameled openwork rondel on the south façade of Radio
City Music Hall.*

*Page 2: Detail from Isamu Noguchi's News, a reporter on the phone
getting the news. The diagonal lines symbolize the wire service and
the electronic transmission of news.*

*Page 5: Detail from Michio Ihara's Sculptures of Light and Movement
in the lobby of the International Building.*

*Page 6: The plaster maquette used to create Lee Lawrie's plaque,
The Purpose of the International Building, in 1935.*

*Page 320: Detail of the face of Atlas by Lee Lawrie and Rene
Chambellan.*

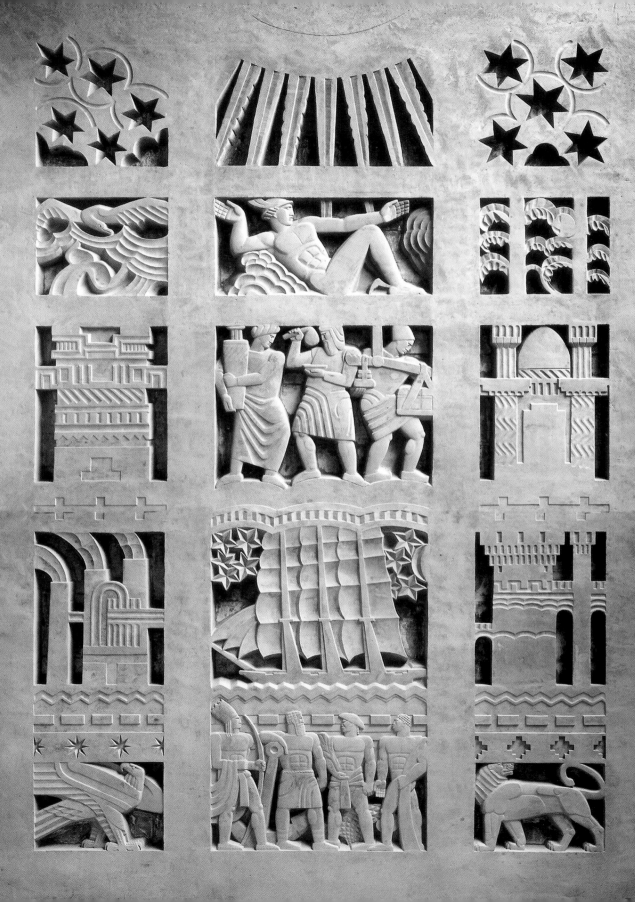

CONTENTS

FOREWORD by Laurance S. Rockefeller 9

INTRODUCTION 11
The Art Program 12

1270 AVENUE OF THE AMERICAS 17
Robert Garrison 18
Robert Kuschner 22

RADIO CITY MUSIC HALL 25
Donald Deskey 26
Donald Deskey and Edward Durrell Stone 34
Hildreth Meiere and Oscar Bruno Bach 35
Rene Chambellan 42
Edward Trumbull 47
Ezra Winter 48
Ruth Reeves 54
Marguerita Mergentime 58
Louis Bouche 60
Witold Gordon 64
William Zorach 67
Gwen Lux 68
Robert Laurent 71
Yasuo Kuniyoshi 72
Edward Buk Ulreich 75
Henry Billings 76
Henry Varnum Poor 79
Stuart Davis 80

30 ROCKEFELLER PLAZA 86
Lee Lawrie 85
Leon V. Solon 91
Edward Trumbull 92
Three Muralists 94
Diego Rivera 96
The Wailing Wall 103
José María Sert 104
Sir Frank Brangwyn 118
Leo Friedlander 126

1250 AVENUE OF THE AMERICAS 133
Barry Faulkner 133
Gaston Lachaise 150

BRITISH EMPIRE BUILDING 159
Carl Paul Jennewein 160
Carl Paul Jennewein and the Piccirilli Brothers 164
Lee Lawrie 167
Rene Chambellan 170

LA MAISON FRANÇAISE 173
Alfred Janniot 174
Rene Chambellan 181
Lee Lawrie 182
Cartier Silversmiths 183

THE CHANNEL GARDENS AND PROMENADE 185
Rene Chambellan 188
Valerie Clarebout 196

THE LOWER PLAZA 199
Paul Manship 203

PALAZZO D'ITALIA 213
Attilio Piccirilli and the Piccirilli Brothers 214
Giacomo Manzu 218
Leo Lentelli 226

THE INTERNATIONAL BUILDING 229
Lee Lawrie 241
Gaston Lachaise 251
Michio Ihara 255

THE INTERNATIONAL BUILDING NORTH 257
Attilio Piccirilli 257
Leo Lentelli 266

ONE ROCKEFELLER PLAZA 269
Carl Paul Jennewein 270
Carl Milles 272
Lee Lawrie 277
Attilio Piccirilli 278

THE ASSOCIATED PRESS BUILDING 281
Isamu Noguchi 281

10 ROCKEFELLER PLAZA 291
Dean Cornwell 291

Map of Rockefeller Center 300

Acknowledgments 301

Endnotes 302

Artists and Specifications of Their Works 304

Index 314

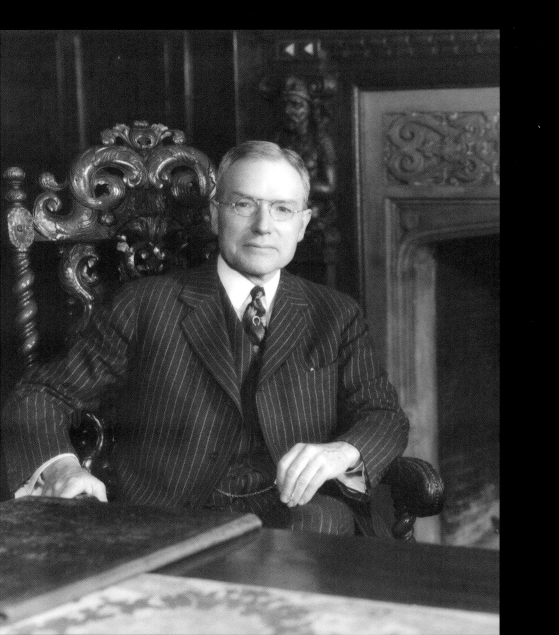

FOREWORD

For over seventy years Rockefeller Center has been emblematic of my family. My father's unique vision, strong values, and faith in the future of America are the key themes reflected in its stone façades and enduring art.

Since its beginnings in the midst of the Great Depression, resources were made available for a program of art-in-architecture. Enhancing the environment and recognizing the profound effect of creativity in an urban setting were primary factors in the original plans for the Center.

Christine Roussel's book, *The Art of Rockefeller Center*, explores the creative processes, the artists, and the people behind the scenes through her historical research, archival photographs, and beautiful new color photography. Her comprehensive view of Rockefeller Center's public art has grasped the vision and beauty that sustain the Center as a unique urban environment in the heart of New York City.

LAURANCE S. ROCKEFELLER
FEBRUARY 2003

John D. Rockefeller Jr. in his newly decorated office at the Standard Oil Building at 26 Broadway, ca. 1924. The office symbolically established "JD Jr." as the reigning head of the Rockefeller enterprises.

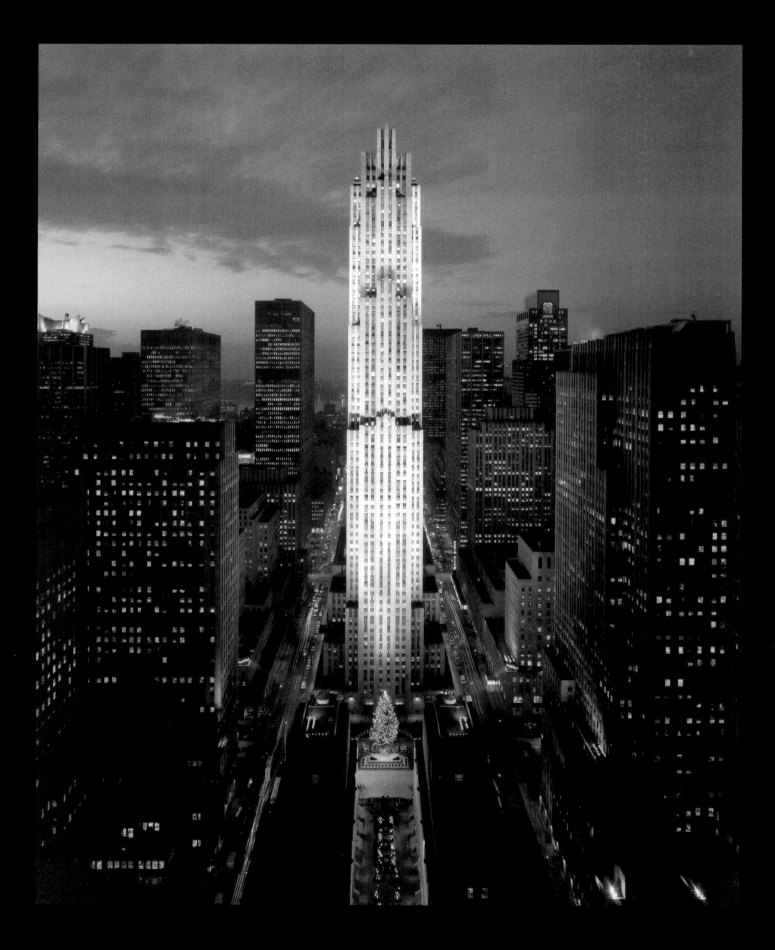

INTRODUCTION

Rockefeller Center stands in the very heart of New York City as a testament to the vision and values of a single family. John D. Rockefeller Jr.'s new urban setting, created in the depths of the Great Depression, has flourished. For over seventy-five years it has set the standard for urban planning and public art throughout the world. In 1988, fifty-eight years after its inception, Rockefeller Center was declared a National Historic Landmark. There is ample testimony concerning John D. Rockefeller Jr.'s perfectionism, sense of duty, and responsibility, as well as his financial acumen, which resulted in the Center.

The genesis of the Center is found in 1928, when a group of investors, including John D. Rockefeller Jr., envisioned developing three blocks in Midtown Manhattan as a commercial property, with a new opera house set on a vast public square. The opera house was to be its nucleus and cultural center and would act as a magnet for commerce. The next year, after the stock market crashed, Rockefeller found himself the lone investor with a ninety-nine-year lease for the site from Columbia University. He was personally responsible for the rundown property, which housed dilapidated tenements and illegal speakeasies. His son, Nelson, said, "He faced a loss of $3,000,000 a year on the lease alone, to say nothing of the taxes. It was a dilemma all right, but out of that dilemma the present Rockefeller Center was born."[1]

John D. Rockefeller Jr. assessed the situation and made the momentous decision to continue the project, altering the concepts to fit his single vision. It was the largest private building project ever undertaken in modern times, and a unique opportunity. No area of such immense size, in the center of a great city, had ever been available for development by a single person. It was an extraordinary action to take in the midst of a great economic depression.

Rockefeller hired architects, engineers, and builders to revise the plans and create a modern self-contained urban center. The opera house was removed from the project, and the commercial aspects of the original project were expanded. Prospective tenants were enticed with tempting leases, innovative rent agreements, and buildings whose decoration would symbolize their commercial interests. Landscape designers were hired to create series of lush gardens, verdant rooftops, and landscaped setbacks. "JD Jr." (as he was called) formed an art advisory group to organize and oversee the buildings' decoration. He hoped that a rich array of architectural embellishments would make the "project a mecca for lovers of art."[2] The art advisory group informally included Rockefeller's wife, Abby Aldrich, and their son Nelson. The group selected sites, sought artists, and set the standards for the work. In 1930, the architects and John D. Rockefeller Jr. literally started to demolish the past, razing whole blocks of tenements, and then to transform the area with an architectural plan that epitomized the future.

To this day, visitors to Rockefeller Center are impressed with the cohesiveness of the art and architecture. The Center is a timeless architectural entity, dominating the heart of New York City. It is a forceful statement creating a cherished memory for the visitor and, to many New Yorkers, a comforting symbol of stability and civility.

The brilliantly lit skyscraper, 30 Rockefeller Plaza, soars into the night. Its dramatic lighting was created by Broadway's famed theatrical lighting designer Abe Feder, ca. 1985.

THE ART PROGRAM

After two years of painstaking planning, construction of Rockefeller Center began on May 17, 1930, when the first dilapidated brownstone was razed. Nine years later, on November 1, 1939, John D. Rockefeller Jr. drove the final rivet—a silver one—into a steel beam of 10 Rockefeller Plaza.

When the project was conceived, one-seventh of the ground area of Rockefeller Center was to be reserved for public enjoyment; it was not to be commercially developed. There were to be street-level open spaces, acres of garden rooftops, and artistically landscaped setbacks, turning the buildings into magnificent "Hanging Gardens of Babylon."[1] Not only were areas selected to be lushly landscaped, but the magnitude of architectural ornamentation was to be unprecedented. Murals, sculptures, bas-reliefs, mosaics, and fountains were to embellish the buildings and the grounds.

In 1931, Rockefeller set aside one million dollars for the art program. This was an audacious and visionary undertaking in the midst of the Great Depression. Hartley Burr Alexander, a professor of philosophy at Scripps College at the University of Southern California in Claremont, was commissioned to develop philosophical "themes and addendum which outlines the subject of decoration."[2] for the program. Art themes on commercial buildings in America abounded during the 1920s. These themes were frequently self-aggrandizing, indicative of the owners' successes and prospects. At Rockefeller Center, the public art program was established to reflect pride in country, mankind's successes, and social and spiritual values that were particularly meaningful to the Rockefellers.

Dr. Alexander's work resulted in the impressive themes "New Frontiers" and "The March of Civilization." These primary themes were further refined into four subthemes: "Man's Progress toward Civilization of Today," "Man's Development in Mind and Spirit," "Man's Progress along Physical and Scientific Lines," and "Man's Progress in Industry and the Character of the Nation." His work was so comprehensive that certain specific subjects he suggested, such as "wisdom, sound, light and gifts of the earth," were developed into major sculptures by Lee Lawrie and Gaston Lachaise.[3]

Rockefeller went further to ensure that only art with good provenance would embellish his enterprise. He commissioned "a distinguished art committee"[4] to recommend artists and review their work. This committee included the directors of the Boston Museum of Fine Arts, the Philadelphia Museum of Art, the Fogg Art Museum at Harvard University, and the Metropolitan Museum of Art, as well as the dean of the Yale University School of Fine Arts. These experts visited some of the artists' studios and, on occasion, criticized their work quite extensively. It is apparent from letters and agendas that they usually convened at the outset of a project and then let the architects and engineers take over.

Rockefeller hired three architectural firms—Reinhard & Hofmeister; Corbett, Harrison & Mac Murray; and Hood & Fouilhoux—to plan the Center. Under the direction of this extraordinarily large group architect Edward Durrell Stone was selected to design Radio City Music Hall. Stone went on to design the Museum of Modern Art. Three members of the architectural team stand out as having been particularly influential: Hood is credited with being the most powerful architect on the project. He provided the overall grand style and Beaux-Arts design to the

Sketch of one of the proposed plans for Rockefeller Center by John Wenrich, 1935.

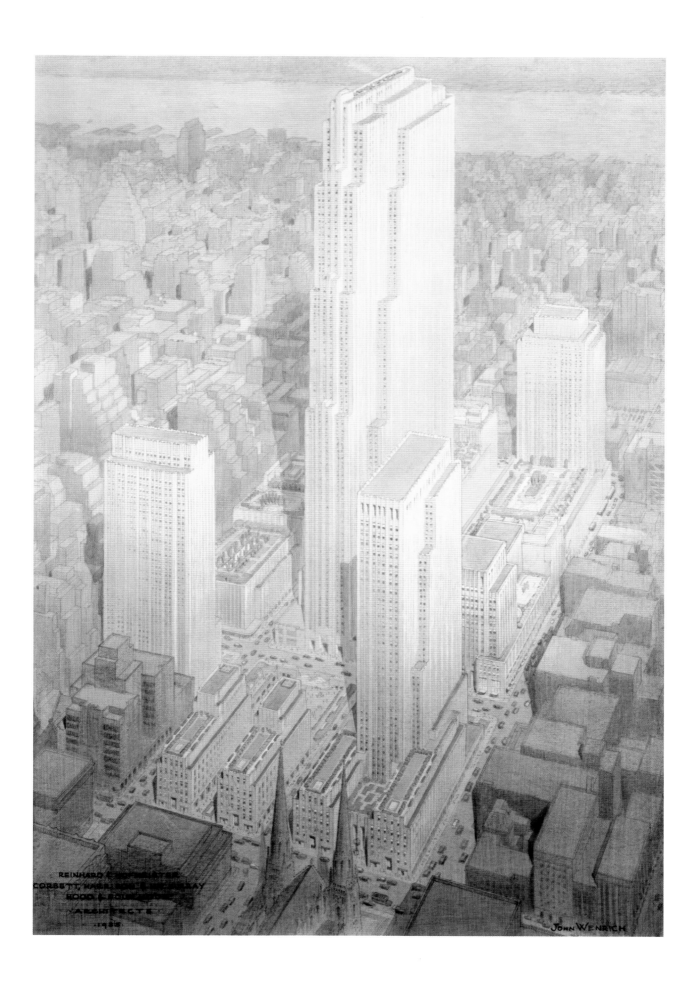

John WENRICH

project and imparted sophisticated inspiration to the design team. He insisted on grace and symmetry; the use of setbacks, gardens, and plazas; and on building with limestone rather than the less expensive brick. The two other prominent architects, Wallace Harrison and Andrew Reinhard, functioned in a variety of ways during construction. They provided balance and common sense to the architectural team, interpreting the grand, idealized concepts of Hood and turning them into realities. Harrison, in particular, worked closely with John R. Todd, the tough-minded engineer ultimately responsible for construction.

John R. Todd, of the engineering firm Todd & Brown, played an extraordinary and varied role. Given the title of project manager and sweeping authority by the Rockefellers, Todd was absolutely indispensable to the project. He held an iron grip on subcontractors and a tight rein on money. He intervened in every facet of construction, including the art program. In this single aspect, he helped determine artistic themes, selected fabricators and foundries, set fees, and controlled the finishing of a number of the works. He was forceful, opinionated, and clearly the undisputed man in charge.

The famed industrial and furniture designer Donald Deskey was commissioned to orchestrate the interior of Radio City Music Hall. He not only designed furnishings but also chose fourteen other artists to provide additional sculptures, murals, textiles, and decorations. He was paid directly and then subcontracted work to the others. In this manner, the bottom line and all responsibilities were clearly passed to him. Simultaneously, Eugene Schoen, an interior designer, was selected to plan and oversee the interior of the Center Theater (since demolished). He and Deskey worked closely with a variety of avant-garde American artists familiar with the "Moderne" vernacular to create the furnishings and establish stylish and contemporary interiors.

Edward Trumbull, a well-known American muralist, had just completed frescos for the Chrysler Building and was sought by the architects to coordinate the aesthetic effect of materials that were to be used on the interior of the buildings. He was appointed color director for all the interiors with the exception of Radio City Music Hall, which was Deskey's domain. This included art, walls, floors, furnishings, and architectural details. In spite of his renown as a painter-muralist, Trumbull did not personally create any major artwork for the Center. However, several small designs for the wood-paneled interiors of the elevators at Radio City Music Hall are attributed to him.

Leon V. Solon, a designer and ceramist, was retained as colorist for exterior work. Although he created a unique color range and distinctive style, and was restricted to coloring other artists' work on the limestone façades, his impact was significant. Coloring the stone carvings aesthetically amalgamated and unified the exteriors of the Center and served as a prelude to its interiors.

These designers, working in close collaboration with the Rockefellers, their architects, and engineers, were the essential on-site talents whose ingenious concepts structured and implemented the art program and aesthetics of the Center. Ornamentation was clearly a priority. By the time Rockefeller Center was completed, nearly forty individual artists had created more than one hundred works of art to embellish it. Over the nine years of construction, some seventy-five-thousand other technicians, craftsmen, and laborers implemented the art program and constructed the fourteen buildings that the architects, engineers, specialists, and artists designed and decorated.

Opposite, top: Raymond Hood, Wallace Harrison, and Andrew Reinhard pose by an early model of Rockefeller Center.

Opposite, bottom: Steelworkers poised on a steel beam eight hundred feet above street level during construction of the RCA Building in 1932.

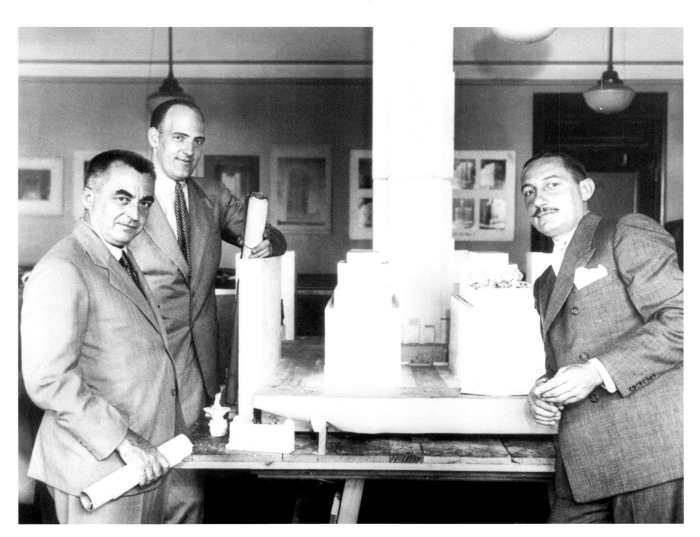

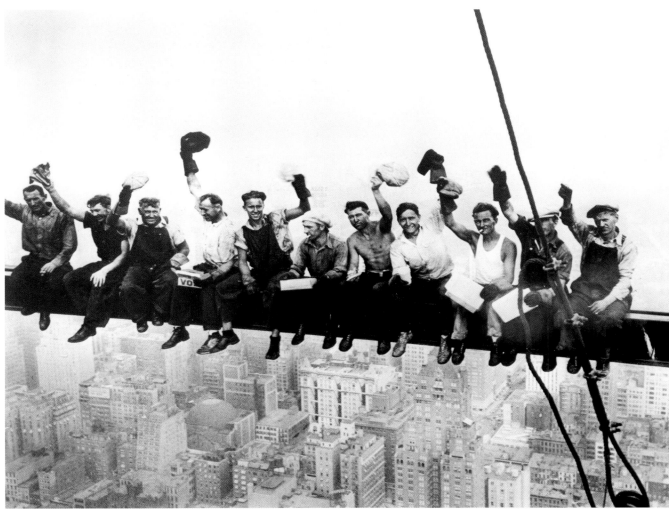

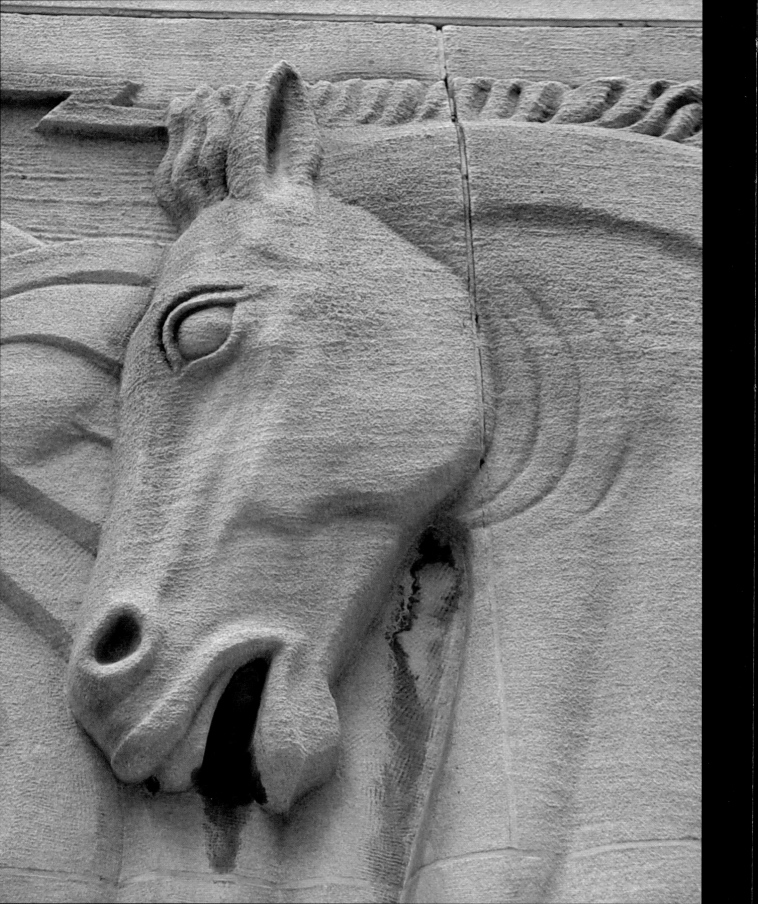

1270 AVENUE OF THE AMERICAS

Opening the building at 1270 Avenue of the Americas in October 1932, in the midst of the Great Depression, was both a financial phenomenon and a symbol of hope for many people. Today, it stands very much in the background of architectural and commercial importance in the Center. At the time of its construction, this building quietly articulated the aesthetic concept "Moderne Art." *Moderne* and *Modernistic* were the terms applied to contemporary art in the United States in the 1920s and 1930s. The more frequently used term today is "Art Deco." That expression was coined sometime during the 1960s, and is most likely derived from the French *L'art decoratif*.

The architects for the Center were influenced by the nineteenth-century European Beaux-Arts view of architecture, with its imposing plazas, vistas, and symmetrical placement of buildings off a central axis. They proposed design concepts that included grand open spaces, fountains, gardens, and artwork within a complex of imposing, well-balanced, and well-oriented buildings. The buildings were to be luminous, innovative architectural designs that totally integrated the ornamentation on the majestic modern slab exteriors with luxurious and well-appointed interiors. The architectural embellishments and artwork were to embody themes that were noble, reflective of civic virtue, and inspiring. These concepts were to reflect the Rockefeller vision of an idealized civilization. Man's scientific achievements were glorified and integrated into the aesthetic, especially electricity and radio, two relatively new developments that were fast becoming part of every modern home. This technological expansion was due, in great part, to government-sponsored programs, which in the early 1930s were to bring electricity to the most rural parts of America. These scientific and industrial advances also impacted aesthetics, resulting in a distinctly new, sleek style: "American Modernism." The Rockefellers were among the primary vanguards of the new aesthetic with its invigorating spirit. 1270 Avenue of the Americas was the first building in the Center to embody this contemporary concept.

As work continued on the Center, a sense of prestige and self-confidence developed with each newly completed building. The art program began modestly at 1270 Avenue of the Americas and blossomed into an incomparable aesthetic statement. A decade later, Modernism would come into its own and dominate the art of the 1939 World's Fair in New York.

When John D. Rockefeller Jr. originally envisioned his new complex it had included an opera house that, owing to the Great Depression, proved unfeasible. During inauguration ceremonies of Rockefeller Center on November 1, 1939, Nelson Rockefeller reflected on this event and the family's attitude toward technology and modernism when he said: "The opera was 'out' as a nucleus for development, and the question was left—was there anything that could take its place? The answer was—radio. Opera was the old art; radio the new—the latest thing in this contemporary world of ours, the newest miracle of this scientific era, young and expanding."[1] This attitude is unmistakable in the artwork on 1270 Avenue of the Americas.

Detail of the head of the mythological horse, Pegasus, *from Robert Garrison's stone bas-relief* Present *embellishing the entrance to 1250 Avenue.*

ROBERT GARRISON
MORNING, PRESENT, EVENING

Robert Garrison was the first artist to be commissioned by the Rockefellers to create art for the Center. Garrison was well known to the family as he had served as consulting artist during the building of Riverside Church, which they had largely funded. He was reliable and his work was fastidious and refined. Garrison's commission was to design and sculpt three huge stone allegorical bas-reliefs to be installed on the façade of 1270 Avenue of the Americas. These bas-reliefs were to symbolize the advent of modern communication, as the first three tenants in this building were radio stations.

Radio was unique. For the first time in history there were no physical barriers or frontiers that could not be breached by radio waves. The Rockefellers understood the power and the potential of this new tool; it was an increasingly important factor in communication. The world was destined to be its audience and the Rockefellers wished to immortalize it.

The three limestone bas-reliefs decorate the façade over the main entrance and the storefronts along the avenue. During the 1930s and 1940s they would have been at eye level for passengers riding the Sixth Avenue elevated train.

Robert Garrison skillfully combined the requisite themes of scientific achievement, corporate success, and patriotic pride in his allegorical renderings. With his academic training and artistic style, a blend of naturalism and idealism, he was the safe choice and the perfect artist to set the stage for John D. Rockefeller Jr.'s and the architect's

Robert Garrison working on the full-size clay model of Present *for the façade of 1270 Avenue of the Americas, ca. 1931.*

unified vision of "radio." Radio was a perfect fit for the forward-looking themes established by Hartley Burr Alexander. Artistic commissions were to reflect some aspect of the sweeping concept, "New Frontiers." Without exception, this far-reaching theme and its subcategories were incorporated in all artwork produced for the Center. Communication by radio was just the beginning.

Stylistically the panels Garrison carved in the new Art Deco manner also have a classical reference. The result is simple and elegant. Forms are austere, compact, and smooth. Surface rhythms unify, ornamental motifs are restrained. No part of his work is happenstance. It is crisp and fresh and reflects self-assurance and coolness. These panels went beyond ornamentation on a building; they were the inauguration of the Rockefeller Center art program. Eventually, the Center was to become the quintessential example of the Art Deco style of art-in-architecture in America.

The central panel's time line and title is *Present*. It is flanked by two panels: *Morning* on the south and *Evening* on the north. Both figures in these panels hasten toward the central panel, signifying the continuity of time. Collectively, the three signify radio as a continually active force.

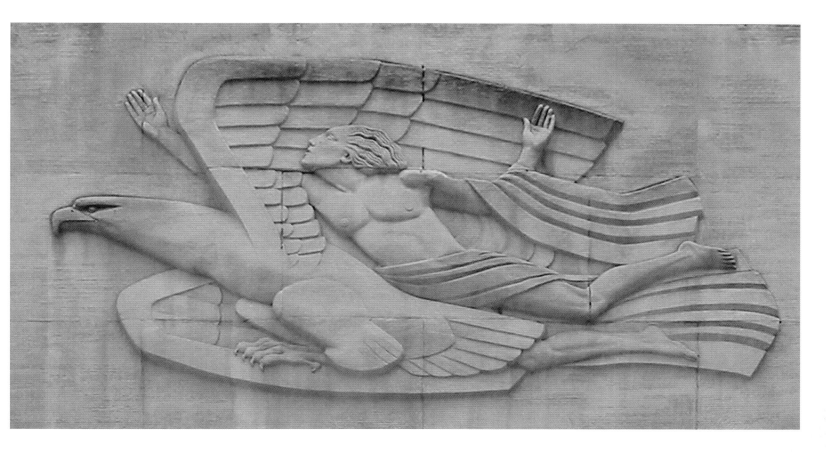

The south panel depicts a muscular youth, Morning, soaring through space with his hands outstretched to greet the day. His face is raised toward the heavens. His robe and hair flow outward as he ascends the sky. He is borne by a great eagle, America's iconic bird and a symbol of national pride. In both ancient and modern times the eagle has been associated with power and used as an emblem of swiftness. Here is no exception, as the protagonist journeys on its mighty wings to announce the break of day. In ancient Rome the eagle was symbolic of Helios, the rising sun. In Psalms 103:5, it is associated with resurrection: "Who satisfieth thy mouth with good things; so *that* thy youth is renew like the eagles." The eagle is the symbol for St. John the Evangelist. As the eagle's wings carry the gospel to the world, they also convey the radio signal.

Robert Garrison's carved limestone bas-relief Morning *on the façade of 1270 Avenue of the Americas.*

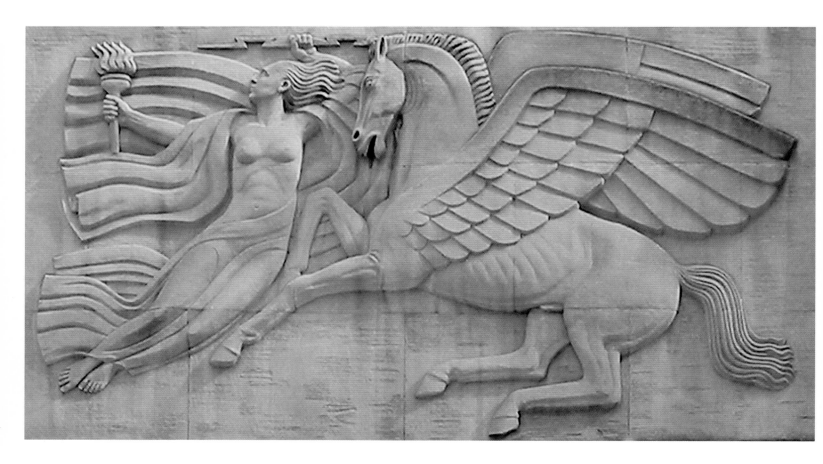

Robert Garrison's carved limestone bas-relief Present on the façade of 1270 Avenue of the Americas.

The center panel is an allegorical treatment of time and communication. The floating figure is the muse of radio and represents midday, when most activities take place. She glides before the mighty winged steed, Pegasus, who greets her and appears to prance in unison with her. She is a modern woman, a woman of purpose and bold action who has conquered nature and advanced science, using them to benefit mankind. The torch she bears in her right hand is symbolic of knowledge and our heritage from the past. The lightning bolt in her left hand signifies the rapidity of radio communication and the widespread application of electricity.

In Greek mythology, the winged horse Pegasus was tamed by the goddess of wisdom, Athena. She then presented him to the Muses. The Muses were nine lesser goddesses who personified the genius and inspiration of painters, musicians, poets, writers, and other artists. Pegasus was capable of swiftly flying through the heavens bearing messages and revelations to the Muses. He also became a symbol of inspiration when his hoofprint made Hippocrene, the fountain of the Muses, flow. In this panel, Pegasus and the Muse symbolically communicate to the world with the energy of electricity and by the means of radio.

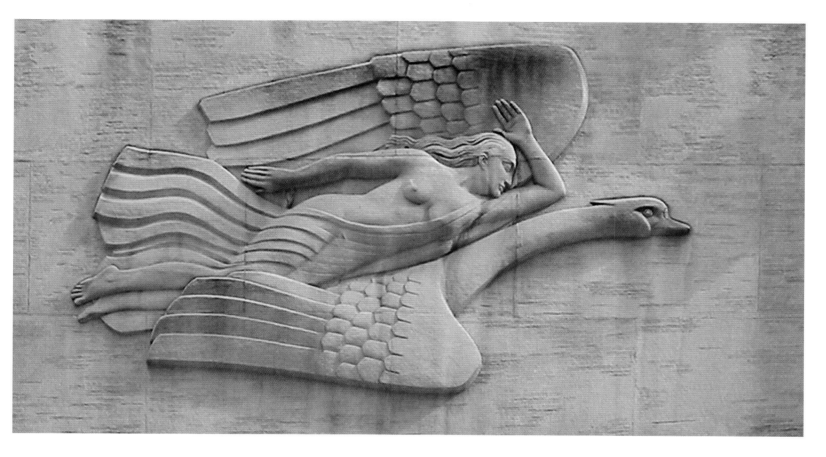

The north panel portrays evening, the third aspect of time and a continuation of the theme—radio's boundless, round-the-clock broadcasting. The partially draped female figure representing evening reclines on the wings of a heron. She appears at rest, as her left hand gently shields her face and her right arm is casually placed at her side. Her robes flow away from her body, mimicking the wings of her mount. She faces downward, with her eyes closed as if she is asleep and dreaming. In contrast, the great bird that carries her has a long, strong neck, great enveloping wings, and eyes wide opened and fixed ahead on an unwavering path. This juxtaposition of figures subtly conveys radio's continual night-flight through space.

The idea of widespread communication being available round-the-clock was an innovative concept in 1930. Prior to then, nighttime had been for repose and sleep, not an occasion to have voices from the air invade your home. Garrison depicted this ground-breaking idea of broadcasting at night in a powerful but gentle mode. The implication was that nighttime radio won't be disturbing. It will be soothing and a good and positive influence.

The flowing design, low-relief carving, and bare stone provide traditional elegance to the monotone panels. Placing them over the main entrance was to proclaim the activities of the tenants and represents the earliest art-in-architecture statement of the Rockefellers' commercial interests. Robert Garrison's work heralded the Art Deco style of the Center. The panels are a testament to the technical skill and professionalism he brought to the work, skillfully portraying the requisite theme, "radio," and stylistically setting the stage for Rockefeller Center's unique art-in-architecture program.

Robert Garrison's carved limestone bas-relief Evening *on the façade of 1270 Avenue of the Americas.*

ROBERT KUSHNER · SENTINELS

In 1990, the Rockefeller Corporation began an extensive renovation of the lobby at 1270 Avenue of the Americas. The concept of embellishing architecture with art was revived. Without knowledgeable in-house staff to research artists, the Corporation sought the assistance of the Art Advisory Service of the Museum of Modern Art. It requested the service to select an artist to decorate the lobby. The search resulted in commissioning Robert Kushner to create three bronze sculptures for the walls of the lobby.

Working with the architectural firm of Hellmuth, Obata & Kassabaum (HOK), Robert Kushner designed three winged spirits that he termed *sentinels*. They were to watch over the lobby entrances. Each figure is created in monumental scale, weighing between three hundred and four hundred pounds and measuring twelve to sixteen feet long.

The figures were made at Tallix Morris Singer Foundry. The artist referred to his works as "negative cutouts,"[2] which is a reference to the methodology of creating the castings. The process is relatively simple. First, the artist creates a small-scale rendering of his idea. Then, a full-size, detailed drawing of each subject is made. This design is transferred onto a flat, open mold consisting of a hardened mixture of sand and binders. The design is hand-carved into the mold with a pneumatic stylus that is fitted with grinding wheels of various shapes and dimensions. Once the pattern is completed in the mold, bronze ingots are heated to 1,850 degrees Fahrenheit, and the molten bronze is slowly poured into the molds until it overflows the edges, feathering out into foil-like metal leaves. Kushner chose to leave some of these overruns as a gesture to the process that created the figures.

The use of winged sentinels was, for Robert Kushner, a tribute to angels or guardians found in most religions. His openwork angels are happy, joyous figures that appear to be drawn or sketched near the glittering gilded ceiling. In contrast to the ceiling, the figures are colored with a soft blue-green patina. In this three-part work Robert Kushner echoed the past without copying it, paying tribute to artists at the Center who came before him.

Opposite: Robert Kushner's three sentinels, cast in bronze and installed near the ceiling in the lobby of 1270 Avenue of the Americas.

Robert Kushner in 1991, working at the foundry on one of the molds for Sentinels for the lobby of 1270 Avenue of the Americas.

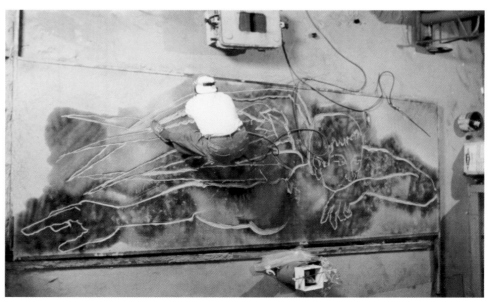

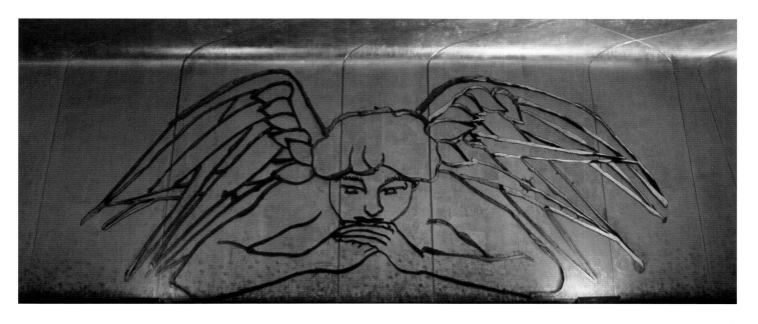

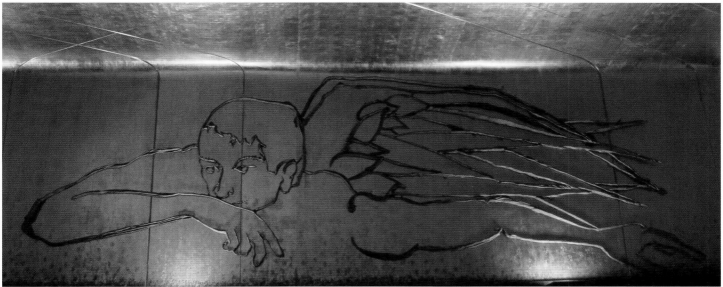

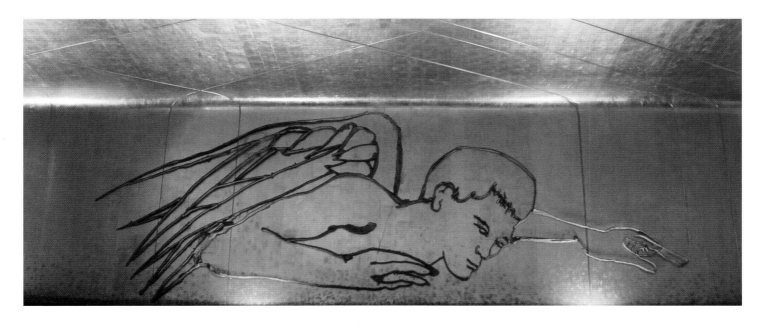

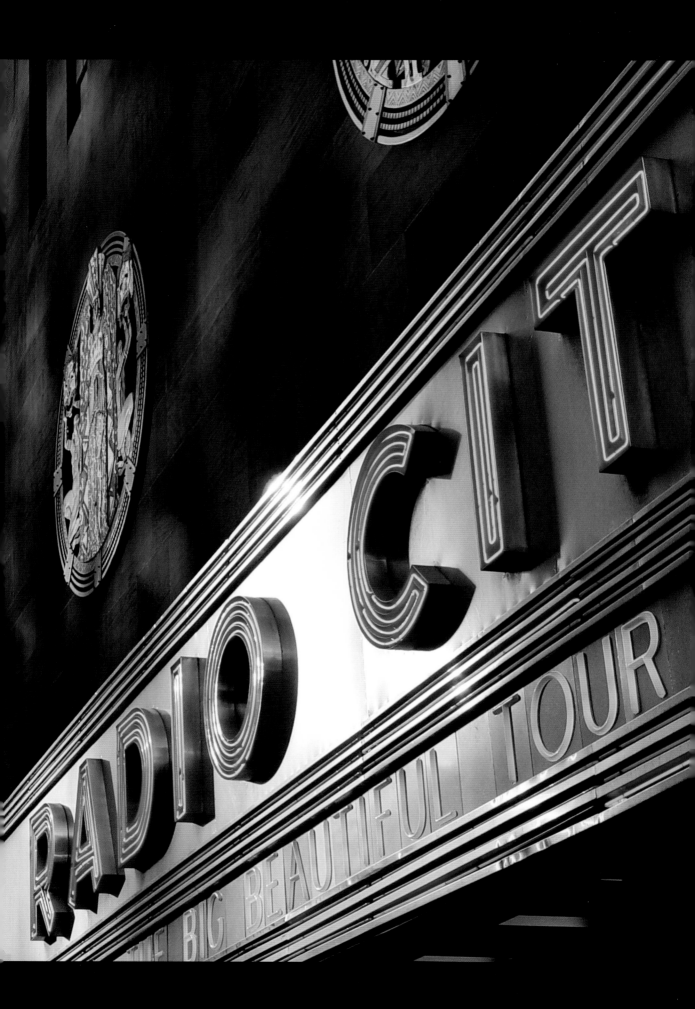

RADIO CITY MUSIC HALL

Opening in December 1932, Radio City Music Hall was the largest and most opulent theater in the world. It was originally called the International Music Hall. The name was soon changed as that label did not reflect the scope of its programs and, more importantly, blurred the Rockefellers' vision of modernism and technological progress.

Radio was the catchword of the day, and the Rockefellers were investing in the possibilities it offered in the entertainment world. Even with the economy plummeting, no expense, effort, or concept would be too much for this avant-garde high-tech pleasure palace. It was to be the shining star of their efforts and the magnet that would attract the masses to the Center.

Radio City Music Hall was planned by a consortium of three architectural firms. They hired Edward Durrell Stone to design the exterior. The interior designer Donald Deskey was hired to provide the overall aesthetic design to their plan, and to commission and coordinate additional artists and designers. He came to the project with an impressive knowledge of European Modernist theories and had been actively promoting the new style and adapting it to America interior design. Under his aegis, a multitude of artists were engaged to work on the exterior architectural embellishments and the interior decoration and furnishings for the Music Hall. He orchestrated the sophisticated style of the theater, planning and providing unity to the designs and color schemes and making the public areas shimmer and gleam with every conceivable type of custom-created luxurious ornamentation. The building remains the most comprehensive design achievement in the Center created by one man. It is also the most flamboyant. No area was left untouched by Deskey's colorful flare, his impressive management skills, and boundless energy. In September 1932, during the early design and planning stage of the theater, Deskey summed up his "uncompromisingly contemporary" program: "The International Music Hall [the original name] will be a distinct departure from the dry, formal, academic treatment of the past. It will substitute for the gaudy, gilt-ridden interior of most theaters a tasteful modern atmosphere. It will neither admit of dry imitation of traditional periods nor its flouncy [*sic*] adaptation."[1] All the artwork, fixtures, and furniture including wallpaper, rugs, stage curtain, hardware, lighting, seats, elevator cabs, and doors were integrated in his sophisticated program. In a bold move, Deskey did not limit his vision to interior design per se, but sought the work of contemporary artists. Working with Robert Edmond Jones, the art director of the theater, Deskey developed a program that he hoped would bring twelve thousand people a day into direct contact with art objects and, "where for the first time in the history of American art, be placed where the average man and woman, who has in the past found it meticulously guarded, can see it normally and in the most congenial of settings."[2]

In 1932, the Music Hall's interior epitomized modern luxury on an unthinkable and immense scale—it seated six thousand people. At first, it struggled to succeed. After changes were brought to its theatrical format, it became the single biggest tourist destination in New York City. It has remained the top venue for theatrical performances in America. In 1978, the interior was declared a New York City Landmark. A total renovation of the Music Hall and its extraordinary art and furnishings was completed in the autumn of 1999.

Radio City Music Hall's famed marquee ablaze with neon lights announcing "the big beautiful tour", one of the many spectaculars that grace the stage of the showplace of the nation.

DONALD DESKEY · INTERIOR COORDINATOR AND FURNISHINGS DESIGNER

In 1930, Donald Deskey, the industrial and interior designer, received the commission to provide an aesthetic identity to Radio City Music Hall's interiors. He was to design its furnishings and embellishments. Todd & Brown, the engineering firm in charge of building the Music Hall, had sponsored a contest for this contract. Putting his entire savings at risk, Deskey produced a three-dimensional model for the contest. Owing to his self-confidence and inherent taste, combined with an inimitable style and unparalleled modern concepts, he won. Over the next two years he created a master plan that included an immense variety of disciplines, and then launched passionately into implementing his concepts.

Deskey was fully in charge of the interior decorative work, creating a harmonious integration of styles and materials through his designs. Deskey worked on the interior with the legendary, flamboyant master of theater, Samuel "Roxy" Rothafel, who concerned himself with the stagecraft and entertainment. Although both of these men were driving forces in the construction of the theater, it was Deskey who orchestrated the aesthetic vision of the Music Hall. His imagination, style, and erudition are inseparable from the Music Hall.

Deskey had studied in France and was familiar with Modernism in Europe, especially in Paris. He was an advocate of the sleek new style and all the sparkling innovative materials that accompanied it. His style at the Music Hall would be clearly characterized by this movement, but with an important difference. By the 1930s, Modernism, due in large part to the Great Depression, was only in its infancy in the United States. The country was still finding its aesthetic in provincial furnishings, conservative art, and historically safe interior design, not the orgy of colors, jazzy patterns, sleek lines, ornamental excesses, and bold use of innovative materials bursting onto the interior design market in Europe. High-profile efforts in the 1920s failed to alter America's toned-down taste in interior design: In 1928, the department store Lord & Taylor showcased hundreds of works by modern European decorative artists and designers, including Picasso, Braque, and Ruhlmann. In the 1920s the Metropolitan Museum of Art sponsored a number of design exhibitions; its 1929 "Selected Collection of Modern Decorative and Industrial Art" featured rooms by Eliel Saarinen, Eugene Schoen, and Joseph Urban. But the country would not adopt or fully accept the new movement as anything other than a passing mode.

In 1930, Deskey was among a minority of American designers challenging the past. He was determined to express a new aesthetic and reflect new scientific and industrial advances in society—the automobile, the skyscraper, kitchen appliances, the radio, synthetics, motion pictures, and the ever widening use of electricity. He seized the creativity inspiring these innovations, combined it with his already developed European aesthetic, and generated the design style called American Modernism. He vigorously applied it to the designs of Radio City Music Hall. It was farsighted and courageous of the Rockefellers to hire Deskey. He was, for the time and place, an interior design extremist.

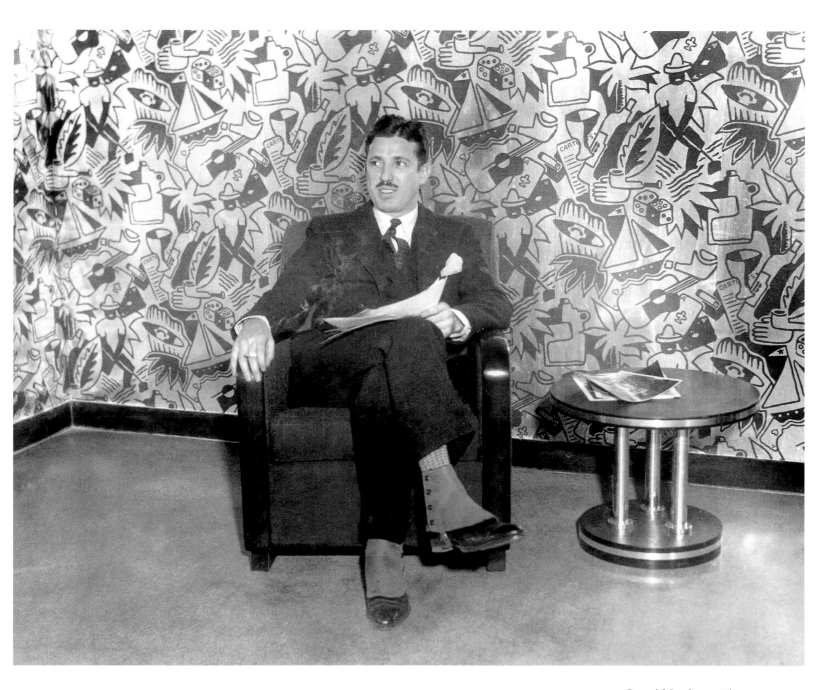

Donald Deskey, with furnishings of his design, seated in front of his aluminum-foil wall covering Nicotine, *ca. 1932, at Radio City Music Hall.*

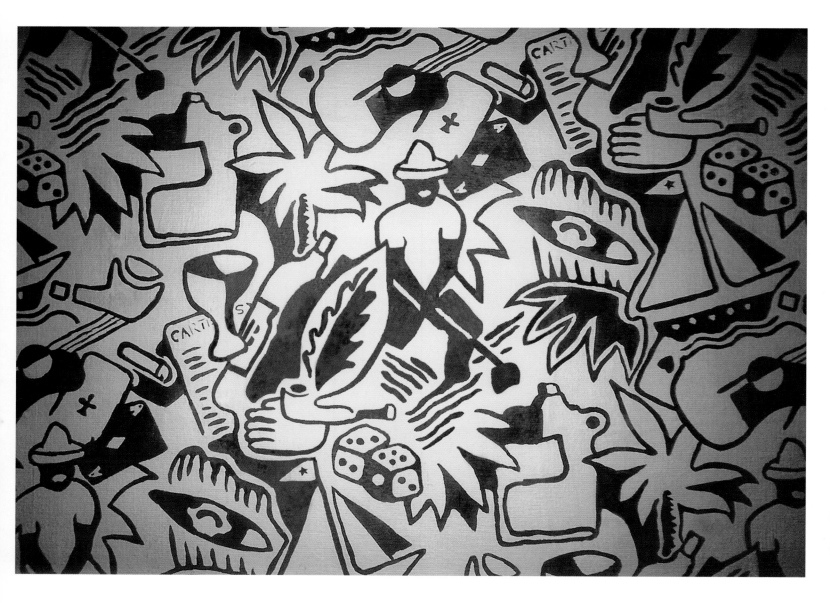

Detail of the aluminum-foil wall covering designed by Donald Deskey for a men's lounge in Radio City Music Hall.

In a brilliantly theatrical manner, it was American Art Deco, in its entire dazzling splendor, that Deskey was to define and embrace in the Music Hall. Modern chic and stylish ostentation were united in the specially designed spaces and furnishings he created. He sought industrial materials such as linoleum, Formica, cork, Bakelite and Vibrolite (modern plastics), Transite (a high-density fiberboard), Weldtex (high-pressure wood laminate), and tubular steel, as well as brushed, polished, chromed, or satin-finished metals, especially extruded aluminum, which in the 1930s was a new alloy. He combined these unusual materials in everyday objects such as lamps, chairs, and tables. His furnishings were further enriched by the use of exotic woods, gilding, glass, leather, and animal skins in splendid juxtaposition. His knowledge of art was extensive. He borrowed from the Cubists, incorporating the innovative use of

slashing lines, sharp planes, textures, and jagged patterns in his furnishings. His avant-garde aesthetic was a reflection of his personality—he was debonair and elegant. He was creating an interior essay in a streamlined vernacular.

Deskey sought fabric designers who worked in the latest style to provide elegant and exotic designs for the extensive upholstery, drapery, and carpeting required for the theater. He sought muralists capable of working in the Modernist manner to decorate the mammoth walls. He hired sculptors to create heroic works to preside over the more intimate corners. He found ceramists to create lamps and vases, and cabinetmakers to fashion the elevator cabs. He commissioned sparkling Monel Metal plaques for the brushed-steel auditorium doors and grand cascading crystal chandeliers for the main lobby. The scope of work was enormous and artistically varied. It combined the "ultra" with the ingenious as he galvanized a new era of American design sophistication. There are no incidental details; nothing was left to happenstance. No area or object was left untouched by his vision.

Deskey's seemingly unlimited energy and the extraordinary range of his talent provide a distinctive harmonious unity and style to the Music Hall. The overall result is an orchestrated architectonic character and eclectic verve in the fixtures, furnishings, and general appearance of the building. Deskey, as the dominant hand, had created the ultimate shining Art Deco star of Rockefeller Center.

As well as the monumental task of orchestrating the entire design concepts and designing furnishings for Radio City, Deskey personally designed several public rooms. The men's lounge on the second mezzanine is altogether Deskey. He designed every aspect of the décor, creating chairs, tables, lighting fixtures, even wallpaper to achieve a powerful design statement. About this time, the R. J. Reynolds Tobacco Company was looking for products that could make use of the newly invented aluminum foil. They approached Deskey, who was also a well-known industrial designer. Taking the challenge, he created wallpaper using aluminum foil as a background with a tobacco-brown, eye-catching design on its surface. It reflects the Jazz Age mentality with its cheerful ambiance and vigorous, stylized, repeating block-print patterns. Titled *Nicotine*, the wallpaper is installed in the second-mezzanine smoking room, reserved for men only. It reverberates with masculine ideals and images of the day: tobacco leaves, liquor bottles, guitars, sailboats, dice, pipes, wine glasses, and field hands. Deskey's designs for the sleek, highly functional furniture and fittings further reflect the masculine ideal in a modish world. His lamps were a combination of modern and traditional materials such as chrome-plated metal, Bakelite, and glass. The furniture was built of industrial materials including chrome-plated tubular steel, extruded aluminum, Formica, and Bakelite, combined with the time-honored materials wood, leather, glass, and so on. Deskey constantly juxtaposed the organic with the synthetic. With the development of American Modernism, the use of industrial metal in furniture became widespread. Aluminum, chromed-plated steel, Monel Metal (a nickel-copper alloy, which was highly corrosion resistant), and chromed nickel-steel were the most commonly used.

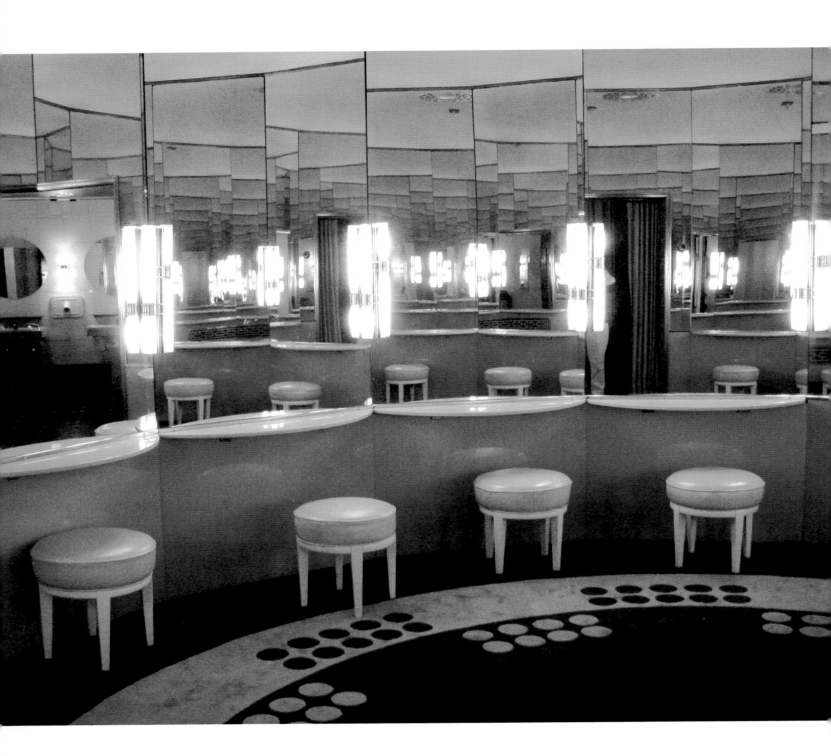

Deskey saw that even mundane areas, such as ladies' powder rooms, were carefully orchestrated design statements. In the first mezzanine's circular powder room, the Mirror Room, light bounces across the curved walls hung with sixteen angled mirrors, and reflects the muted parchment colors of the ceiling and sleek, dainty furnishings. He used long, frosted sidelights set into the mirrors as decorative devices. The combination of low-key color, frosted lights, low stools, and demilune wall-mounted shelves evokes a sense of beauty and fashion. In contrast to the deep, sober colors of the men's areas, he chose a soft, light palette, creating a genteel, elegant ambiance for the ladies. It is stylish and chic.

Deskey designed more than thirty public spaces throughout the theater, each with distinct themes. In most, he incorporated the work of a variety of artists to individualize these spaces. He could work with small intimate spaces or huge areas that would hold thousands of people, yet each space was considered in relationship to the whole. In the vast *Grand Lounge*, his powerful use of diamond-shaped lighting fixtures that crisscross the low ceiling, and the diamond-shaped three-dimensional design of the carpet, complement his well-placed comfortable furnishings, gunmetal mirrored columns, and the black, pyroxylin-coated fabric walls. Almost whimsically, he added Louis Bouche's *Phantasmagoria of the Theater*, lighthearted vignettes, to enliven the dark walls.

Deskey designed an enormous wool carpet, titled *Singing Women*, for the main auditorium. The continuous design is an abstract, stylized theme of women's heads in profile. The colors of the simple repeat pattern alternate. The off-white and purple-blue of the faces contrast with wavy purple-blue and off-white lines that indicate both hair and the sound of singing. The striking geometric design is set against a deep burnt orange background.

In addition to the public areas, Deskey personally designed a private apartment for Roxy Rothafel. Located at the top of the Music Hall and reachable by a small private elevator, it is an Art Deco environment and masterpiece in every aspect. The apartment still contains all the original furnishings down to the pots and pans in the kitchen, and can be viewed by taking a tour of Radio City Music Hall.

*The Mirror Room in
Radio City Music Hall,
a circular ladies' lounge
conceived by Donald
Deskey, with furnishings
and carpet of his design.*

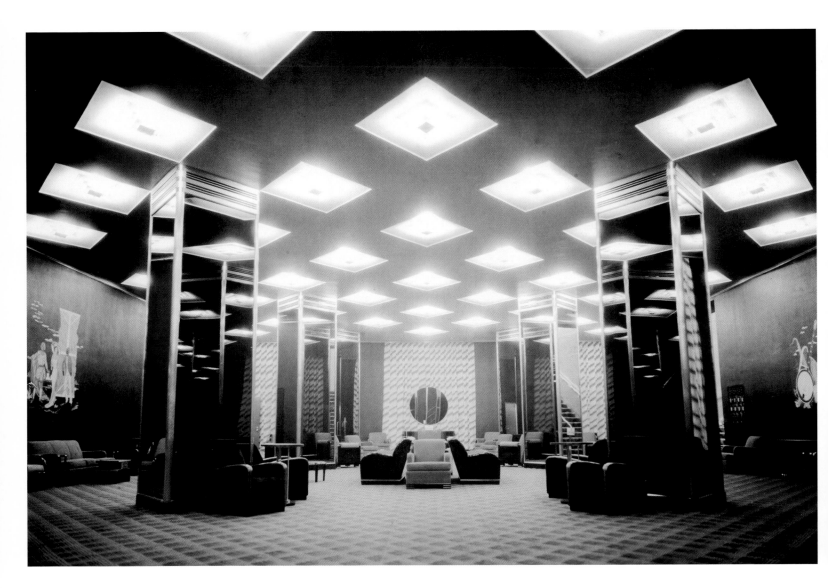

*The Grand Lounge
at Radio City Music Hall
with furnishings, carpet,
and lighting designed
by Donald Deskey
and murals painted by
Withold Gorden, ca. 1932.*

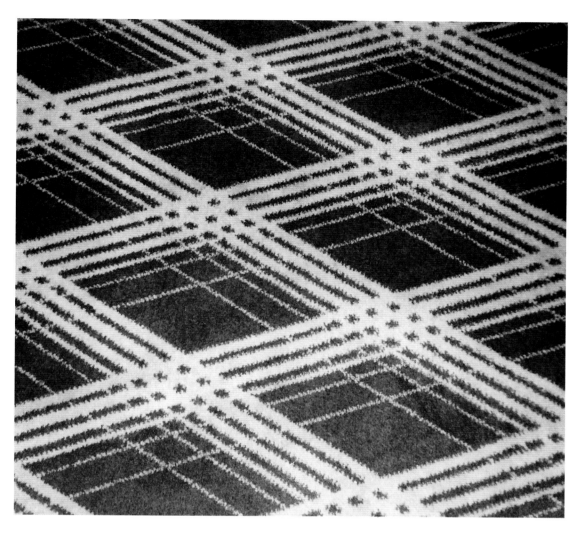

Detail of the carpet designed by Donald Deskey for Radio City Music Hall's Grand Lounge.

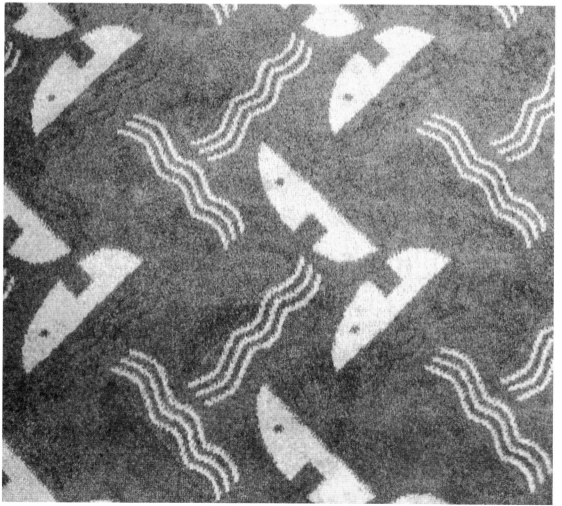

Detail of the carpet Singing Heads designed by Donald Deskey for Radio City Music Hall's auditorium.

DONALD DESKEY and EDWARD DURRELL STONE
THE TICKET LOBBY

The ticket lobby, the first area a visitor enters, is indirectly lit by a series of circular gilded lights set into a low, dark-glazed, copper-leafed ceiling. The profusion of lights is an extravagant gesture. It effectively changes the atmosphere from hectic New York streets to glittering "show business" and creates an aura of anticipation. This design statement may have been worked out between Donald Deskey and the building's main architect, Edward Durrell Stone. At the very least, Deskey appears to have been influenced by the young architect, as Stone employed repeating circular themes throughout his career. The restricted lobby area is enhanced by this sumptuous use of light and pattern. With its low ceiling and sloping entrance, it is a prelude to the spectacular soaring Grand Foyer and sweeping 180-degree arches of the enormous auditorium.

The gilded ceiling lights of the entrance lobby to Radio City Music Hall, designed by Donald Deskey.

HILDRETH MEIERE AND OSCAR BRUNO BACH
DANCE, DRAMA, SONG

By the time Radio City Music Hall was conceived, Hildreth Meiere was a successful and well-regarded figure in the world of art-in-architecture. In 1924, she had designed the tile and marble mosaics for the rotunda floor of the Nebraska State Capitol. Her mosaic design contained fabulous mythological creatures and classical settings. She had developed her ideas with the philosopher Hartley Burr Alexander, who later became the primary advisor to Rockefeller Center for artistic themes. Prior to Deskey being hired, Edward Trumbull commissioned Hildreth Meiere. Trumbull was aware of her work on the Nebraska State Capitol and the National Academy of Sciences in Washington, D.C. He sought her to provide an innovative work of a scale and pattern that would be an eye-catching attraction. It was to be installed high above the street, on the façade of the building, publicizing the theater. Her pieces and Rene Chambellan's six bronze plaques are the only works commissioned for the exterior of Radio City Music Hall.

For the site, Hildreth Meiere designed three huge, circular plaques, and Oscar Bruno Bach fabricated them. They are mounted on the Fiftieth Street façade, sixty feet above the Music Hall's marquee. Trumbull had chosen Hildreth Meiere to enrich this specific site because her designs were uniquely suitable for large public spaces. In her dramatic style, she used vibrant patterns and bold primary colors that allowed the striking images to be read at great distances. Both Trumbull and Meiere selected Bach, a German-born designer and craftsman, because of his outstanding ability to work with unusual combinations of metals and enduring enamels; the plaques had to tolerate the harsh climate extremes and pollution of New York. Meiere's sure knowledge of pattern and color dynamics matched Bach's mastery of materials and technique.

Hildreth Meiere, the designer of the metal and enamel plaques Dance, Drama, *and* Song.

The medallions are made of various cut, cast, and hammered metals brilliantly colored with vitreous enamel. To have her concepts successfully rendered in this huge format, Meiere personally worked with Bach, selecting a range of metals, including copper, Monel Metal, stainless steel, and aluminum. Closely adhering to Meiere's watercolor designs, Bach colored the metal elements with the specified bright enamels and gold plating, or if a metal surface was indicated, hammered or finished the surfaces by polishing or directional brushing. This gave different areas an array of reflective qualities that would play off one another and contribute to the effectiveness of the design. The polychromy of the different metals and the vitreous enamels produces rich patterns of texture and tone. Set against the severely simple façade of the building, the flat planes, firm outlines, brilliant colors, flashy metals, and strong patterns make the rondels eminently readable from the street below.

Meiere's work represented the first time metal and enamel decoration were used artistically on such a large architectural scale. This application was only possible owing to the skill Bach brought to the project. He had a reputation for outstanding metal and enamel work in both America and Europe. When he was eighteen years old, he received a commission from the British government to design and create a gem-encrusted metal Bible cover for Pope Leo XIII. Before 1913, he was crafting metalwork for some of America's most prestigious builders and architects, such as Cass Gilbert at the Woolworth Building in Lower Manhattan. By the time he worked on Radio City Music Hall, he was well established and known to the Rockefellers because he had just worked on Riverside Church, as well as Temple Emanu-El on Fifth Avenue, during the preceding five-year period, 1925–30. All Bach's work is extant in these buildings. The specific techniques he brought to the Music Hall project had previously only been used for commercial signage such as "Standard Oil of New Jersey," the source of the Rockefeller wealth. He had invented an anticorrosion process for ferrous metals and patented it under the name, "The Bachite Process." As a testament to Bach, the Meiere plaques have withstood the elements, remaining vibrant and unique exterior Art Deco designs. It was only sixty-six years later, in 1998, that they required restoration.

Meiere's works not only epitomize and introduce the overall Art Deco style of the Music Hall, but also indicate the building's use. The twenty-foot-diameter medallions represent the three forms of theater: song, drama, and dance.

Meiere understood the use of dramatic, vibrant colors, and diverse materials to promote texture and sheen. By forgoing depth and modeling, she endowed the rondels with an ultramodern, flat, linear clarity. The Bach touch is apparent in the solidly crafted metal and boldly hued enamel work. The resulting panels were a successful collaboration of designer and craftsman. The result is a brilliant use of an unexceptional site.

The medallion *Dance* is located nearest to The Avenue of the Americas. The central figure, a nude female dancer, leaps before a muscular Trojan. She coquettishly raises her hands above her head while playing gilded cymbals. Her hair flies upward in rippling waves of red and brown. The exuberant maiden dances in golden slippers and wears glittering copper bracelets on her arms. She flirts and gestures with youthful abandonment. The powerfully built Trojan attempts to capture her with a blue and gold drape that swirls in a circular form, emphasizing the spherical composition of the medallion. His body is adorned with a glittering, multipatterned garment and a shimmering feathered helmet, gilded necklace, and golden girdle.

There is an exuberant energy that sets *Dance* into motion. Bands of black, white, and incised copper strips bound together by riveted broad bands of copper encircle the figures. This border delineates the medallion. Crispness, colorful geometric designs, and tight composition are characteristic of the three medallions.

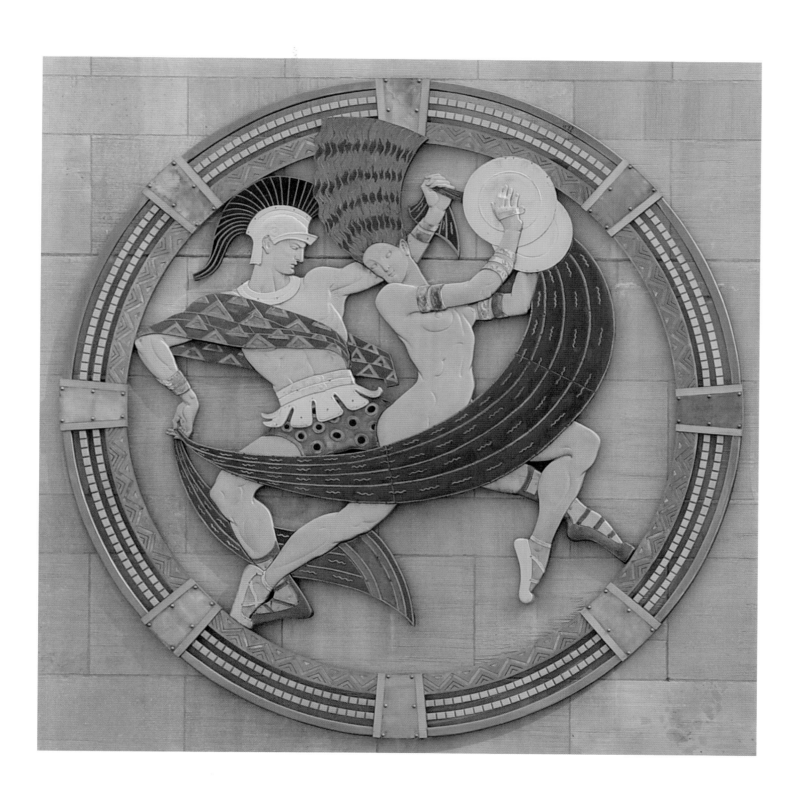

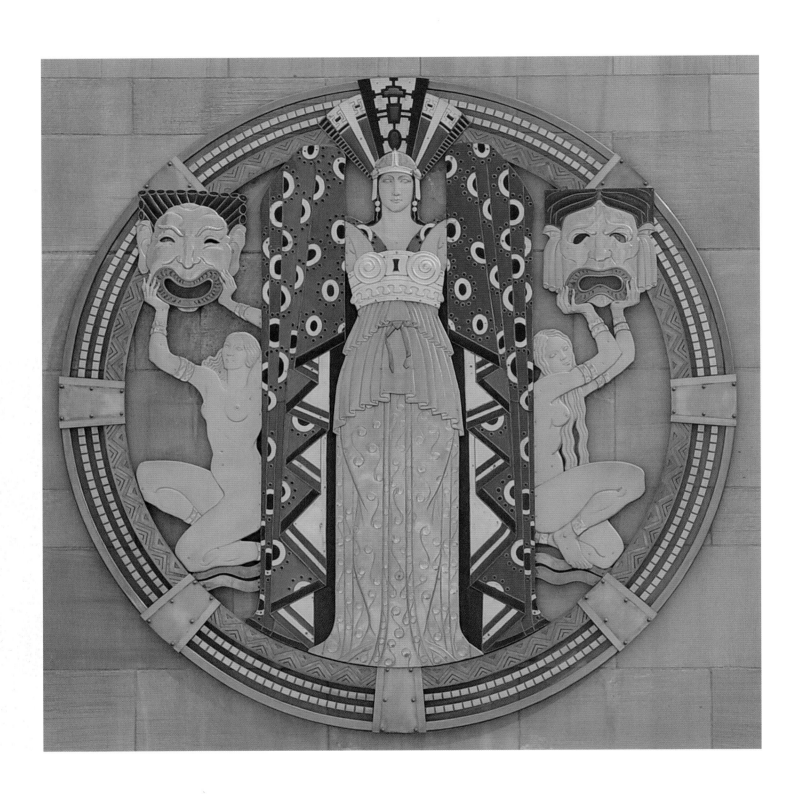

The central medallion, *Drama*, is dominated by an Athena-like figure. She is flanked by two female attendants. They raise the masks of tragedy and comedy above their heads for the world to view. The masks are brushed silver with blue hair and copper mouths. The flanking silver figures are kneeling and dressed only in copper bracelets. They are restrained, delicate, and subordinate, just visible from behind the cloak of the central figure. The main figure wears a glittering silver chiton (or tunic) with a copper breastplate and a multicolored copper helmet rising onto the medallion's border. The strong form of her body is visible through the chiton. She holds her colorful cloak aloft, letting it cascade downward to surround her shimmering form in a brilliantly patterned Art Deco textile design, which spectacularly focuses attention to her idyllic figure. The three figures' complementary actions reinforce the majesty and monumentality of the medallions. Meiere's treatment of the central figure's exotic drapery and the kneeling figures' lustrous bodies illustrates the relationship of texture, color, and the vigorous interplay of light and shade. Their emphatic gestures and the decorative embellishment—the zigzags, whorls, and enamel-embroidery—eloquently express the richness of *Drama*. This plaque is a flamboyant and harmonious mixture of jazzy patterns, primary colors, and opulent, sleek design. It is encircled with the same black, white, and copper banding as *Dance* and *Song*, amalgamating the narrative and the decorative aspects of the plaques.

Oscar Bach in his work-shop, ca. 1931, fabricating the metal and enamel rondel Drama, *designed by Hildreth Meiere.*

Opposite: Drama, *Hildreth Meiere's metal, enameled openwork rondel on the south façade of Radio City Music Hall.*

The third medallion, *Song*, depicts a nude female figure singing and prancing before a figure of a youth seated on a bench. The young man is playing golden pipes. He is looking downward, seemingly lost in his melody. He wears a brown- and copper-trimmed toga, draped over his shoulder. One end of the toga flows away as if carried by the gentle breeze of song. The other end falls in soft folds behind the stylized bench. The female figure has a long flowing scarf draped over her arms. As she frolics westward, the brightly colored green, blue, and golden scarf flows and swirls around her. Her copper hair is held by a golden band of leaves. On her arms she wears four copper bracelets and her ankles bear two small, glittering copper bands. Three sparkling silver birds flutter above the animated dancer. As she capers, she extends her arms upward with the palms open, as if releasing the birds, or song, into the air in an exultant gesture. The interplay of the flowing drapery and the smooth volumes of the dancing figure lend the plaque a wonderful *joie de vivre* and a rhythmic sense of abandonment. It is an eloquent expression of song. In juxtaposition, the tranquility and subordination of the seated figure provide harmony and solidity to the plaque.

Each of the plaques is based on flat planes, open spaces, and geometric forms playing off one another, emanating energy and kinetic force. The impact is heightened by the overall textures, reflected light, and vibrant use of color.

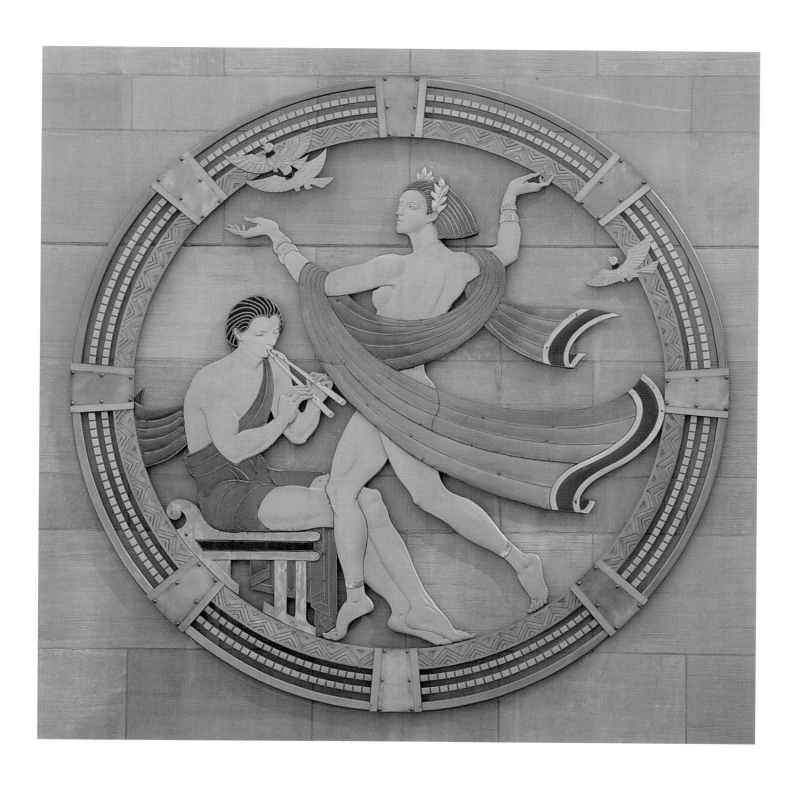

RENE CHAMBELLAN · EXTERIOR PLAQUES, AUDITORIUM AND ELEVATOR DOOR PLAQUES

Rene Chambellan was one of the most prolific and technically skilled artists to work at Rockefeller Center. He created twenty-two works for the Center, including the stainless-steel and Monel Metal doors to the auditorium and six metal plaques over the Music Hall's main entrance. He sculpted four limestone panels on the sixth-floor façades of the French and English buildings, as well as the six fountain figures at the Channel Gardens. Chambellan not only was a well-regarded sculptor, but also was considered an "artist's artist," a skilled technician and model maker who was frequently commissioned to render the designs of other artists and architects. He was a major exponent of Art Deco and fully conversant with the architecture of the 1930s. His strong style and clear, clean, hard, two-dimensional lines and innate rhythm are characteristically present in all the work he produced. An architectural sculptor, he is credited with many of the ornamental details in the Center, such as the railings, moldings, mail chutes, and balustrades.

Commissioned by Donald Deskey, Rene Chambellan designed and created the models for six metal plaques representing vaudeville acts from various international ethnic theaters. These are found on the loggia wall above the main entrance doors on the Avenue of the Americas. The six include scenes typical of Russian, African-American, German, American, French, and Jewish stages. The plaques depict, from north to south, five Russian minstrels and a gypsy dancer; two black banjo players with a tap dancer; a seated German accordionist with a saxophonist playing for a smug-looking cat; five American dancers (the Rockettes) precision kicking; a French cellist with a female violinist playing for a dog in a clown costume doing tricks; and a seated Jewish drummer playing for a dancer in tophat, tails, and a cane.

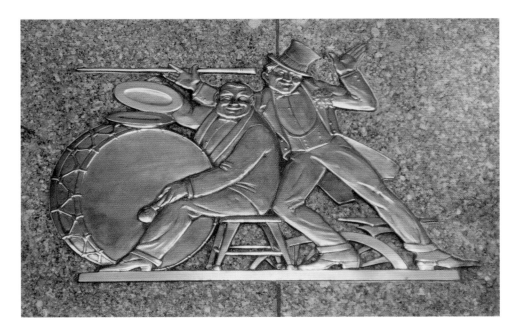

The Jewish Theater, one of the six bronze plaques from Rene Chambellan's Acts from Vaudeville, *located over the main entrance to Radio City Music Hall.*

Entrance to Radio City Music Hall, with Rene Chambellan's six open-work bronze plaques titled Acts from Vaudeville.

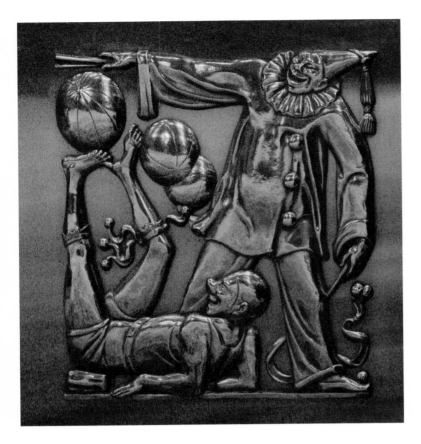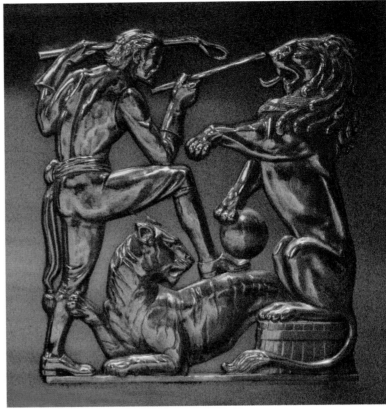

Two of Rene Chambellan's sixty-six bronze plaques that decorate the stainless-steel auditorium doors at Radio City Music Hall.

Chambellan designed the stainless-steel and Monel Metal doors of the Music Hall in 1930. They open into the vast auditorium. On the massive, brushed-stainless-steel doors are sixty-six low-relief plaques cast in highly polished golden metal, representing scenes from vaudeville, stage, and old-time theater. In dramatic fashion, the gleaming metal figures reverberate off the stainless-steel doors. Flying acrobats, fat ballooning clowns, vibrant dancers, jazzy musicians, brave lion tamers, snake charmers, and sassy fire-eaters capture the essence of theater acts from around the world. These scenes open the doors to the soaring arches of the auditorium and the adventure of the theater. Oscar Bach was selected to oversee the casting and finishing of Chambellan's figures for the steel doors and six vaudeville plaques. The highly talented artist and proficient technician continued the collaboration with cast steel panels for the elevator doors in the lobby. These are classical representations of musicians—flutist, cymbalist, violinist, and so on.

Rene Chambellan's work was highly professional and widely sought after by artists and architects for both its refinement and accuracy. During the construction of the theater, the architects commissioned him to create a huge plaster model of the interior from architectural drawings. It was so spacious that a dozen people could stand in it at one time. It took Chambellan four months to build and he was paid $15,000. Originally the model was conceived as a tool for the architects, who used it to simplify the problems of building a high-tech theater. Ultimately, it provided Roxy an opportunity for further study and refinement of the auditorium, sound transmission, and lighting effects, and it was used by Deskey to test various color schemes. Chambellan's work is technological perfection and distinctly luxurious. Working with Donald Deskey, he created a massive amount of sumptuous ornamentation for Radio City Music Hall.

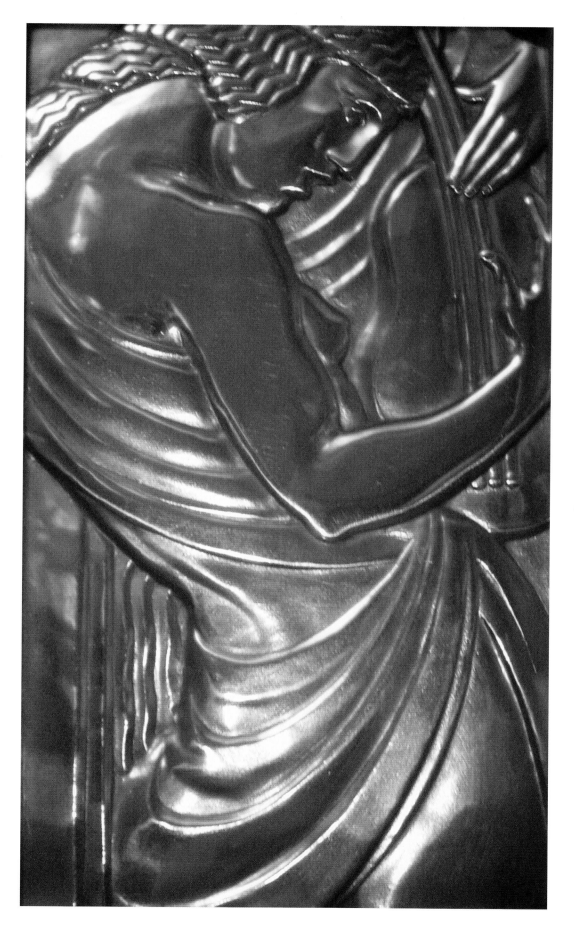

One of the series
of steel plaques titled
Musicians *by Rene Cham-*
bellan, that decorate
the elevator doors
at Radio City Music Hall.

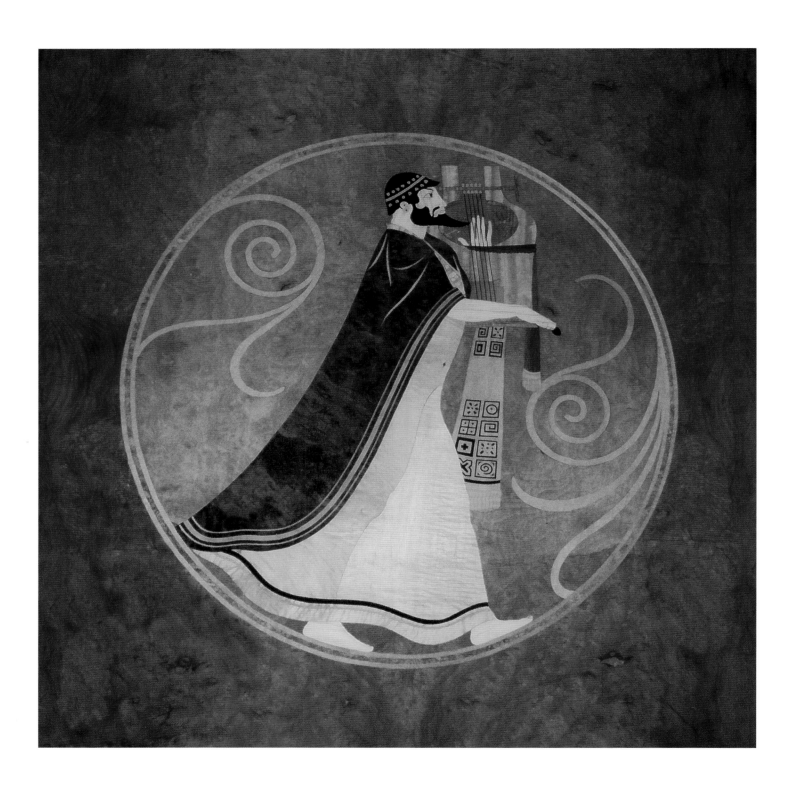

EDWARD TRUMBULL · ELEVATOR RONDELS

The circular designs found on the wood-paneled interiors of the elevator cabs are attributed to Edward Trumbull. They are the only specific designs he is credited with creating anywhere in Rockefeller Center. In spite of being a well-known and recognized muralist, he was primarily employed at the Center as a consultant for proposing and harmonizing colors, textures, and materials, as well as coordinator for the work of other artists. Since the Music Hall was clearly Deskey's domain, Trumbull would have been commissioned by him for any work he produced for the theater. There is no clear record of Trumbull creating these panels—only hearsay—and without documentation attribution is not possible. Setting aside the issue of provenance, the elevator cab panels are stunning and an effective use of mundane spaces. The rondels are delicate inlays of exotic woods, steel, Bakelite, and aluminum set in the centers of the elevator cab walls. Each elevator has three roundels; the themes are wine, women, and song. They are classical animated scenes of prancing satyrs, lively musicians, and dancing maidens, escaping the woes of life. Subtly, they add to the adventure of the theater.

One of Edward Trumbull's decorative designs for the interior wood panels of the elevator cabs at Radio City Music Hall.

EZRA WINTER · THE FOUNTAIN OF YOUTH

The sweeping mural *The Fountain of Youth* lines the walls of the grand staircase and dominates the Grand Foyer. Spectacularly placed, it instantly draws attention up toward the ornate mezzanine, the soaring gilded ceiling of the lobby, and the dazzling twenty-nine-foot-high crystal chandeliers designed and built by Edward Caldwell, Inc. It is one of the largest murals ever produced for a public space, rising to the height of a three-story building. The mural was specifically site-designed using all the surrounding elements to the its advantage—the sweep of the stairs, the curve of the wall, the height of the ceiling. Ascending the staircase, the viewer draws nearer to the procession and then draws away and views the scene at a distance from various mezzanine openings.

The mural is based on a legend from the Oregon Indians. Ezra Winter was inspired by their myth about "the author of life" and used it as an analogy for the ambitions and vanities of all mankind. An old man is depicted following the path of the ages, in search of the fountain of youth. Bent with age and resting on his cane, he stares across a deep chasm toward the mountain and the fountain of youth gleaming in golden light. It is beyond his reach, as evil spirits have caused an earthquake, breaking the mountain away from the rest of the world. The old man realizes the uselessness of his quest for immortality, as it is impossible to cross the immense chasm. In a great procession, like a rainbow in the sky, his life passes before him. The old man, with his head lifted, wistfully stares up at the dreamlike vision. It is formed by a parade of figures representing the ambitions and vanities of his life. The procession begins with the flower of youth; passes then into the fruits of labor and the desire for power, wealth, and glory; and ends in the clouds of old age marching into oblivion.

The Grand Foyer of Radio City Music Hall, with Ezra Winter's oil-paint-on-canvas mural, titled The Fountain of Youth, *and one of the three 29-foot-long crystal chandeliers designed by Edward Caldwell, Inc.*

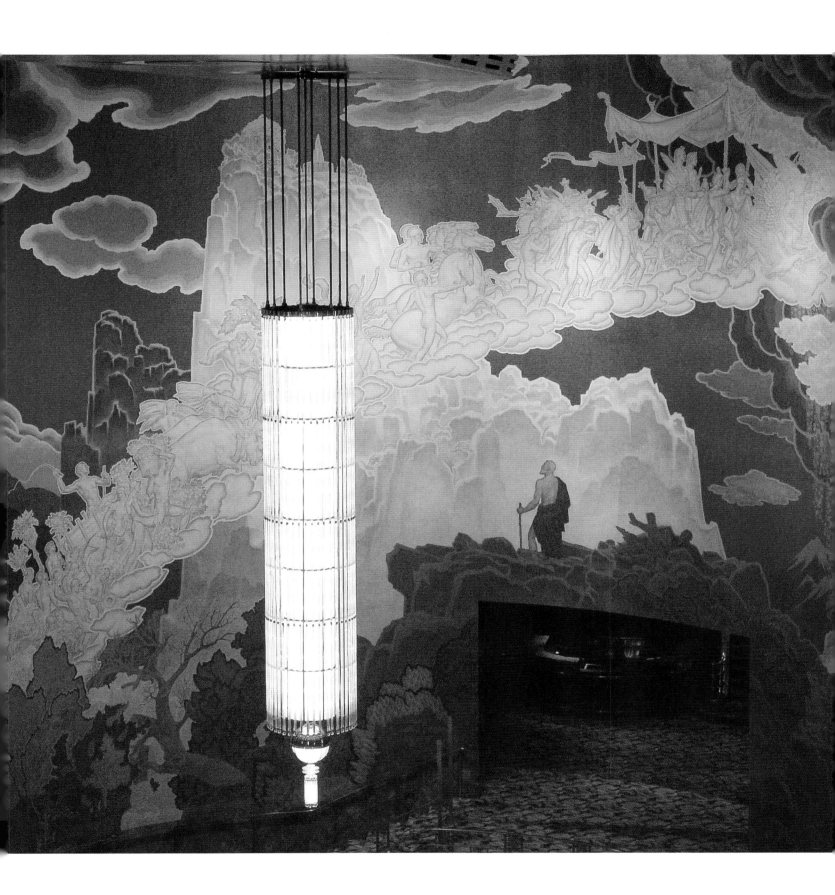

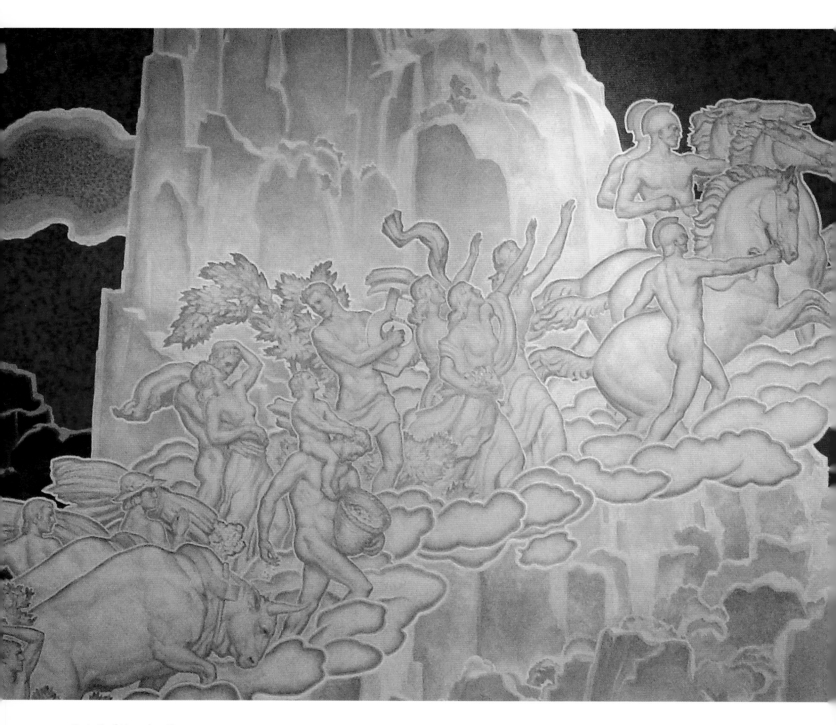

*Detail of the ghostly pro-
cession from Ezra Winter's
Fountain of Youth, at
Radio City Music Hall.*

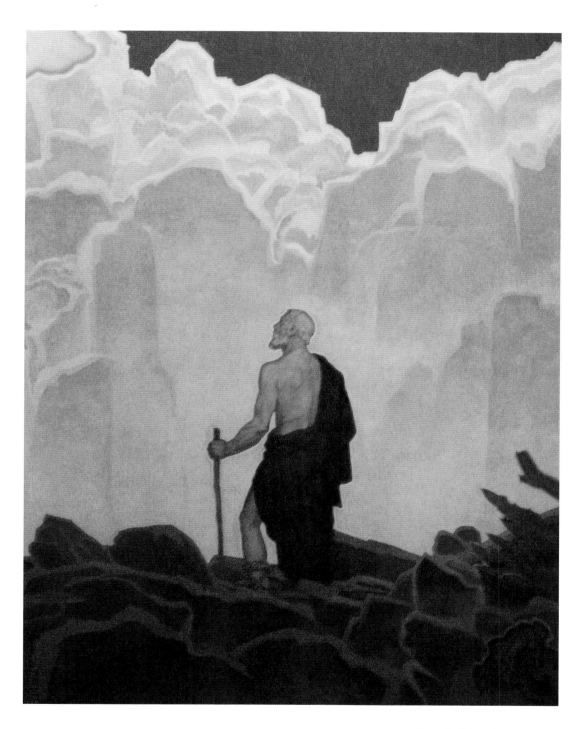

*Detail of the old man
from Ezra Winter's*
Fountain of Youth *mural
in the Grand Foyer at
Radio City Music Hall.*

In April of 1932, when Ezra Winter had just completed the preliminary sketches for the mural, he wrote, "I have followed the theme suggested by Dr. Alexander which is very similar to the story of Ponce de Leon."[3] He further stated that he planned to "represent the theme, not as an Indian picture, but applying to the human race as a whole."[4] The legend called "Author of Life" from the Oregon Indians begins, "In the beginning of time, when the world was new, a high mountain was built by the birds and on it, beside the fountain of eternal youth dwelt the Author of Life. Evil spirits, enraged at so much beauty and tranquility, caused an earthquake which opened a deep chasm forever separating the mountain from the earth."[5]

The mural was so enormous that the canvases were taken to an indoor tennis court for painting. It took six months to complete. The mural was the one art interior design in the Music Hall not directly commissioned by Deskey—it had been commissioned by the Rockefellers as a result of a competition—it was Edward Trumbull's responsibility. He followed the artist's progress step by step, suggesting changes to the figures and coloration. In October 1932, seven months after the initial sketches were approved, it was adhered to the concave north wall above the sloping marble and bronze staircase leading to the first mezzanine. After installation, the mural was given a coating of protective varnish followed by an application of wax.

The mural's predominating color is the dark henna used for the background. Set against this background are golden tones, green foliage, and pale hues. Ghostly shades of white are used for the phantoms populating the old man's vision. The gilded ceiling (perhaps coincidently) acts as a sun for the huge mural, contrasting with, and intensifying, the deep tones of the background and heightening the impact of the ethereal procession. The romance of the myth is epitomized in the bent figure of the old man gazing at the spirit-infested rainbow of his life. The artist painted massive representations of vegetation and foliage along the bottom foreground, to bring nature to eye level with the viewer and to ground the mural to its site.

Ezra Winter's mural set the overall color scheme for the Grand Foyer and the mezzanine. The enormous cascading crystal and gilded chandeliers by Edward Caldwell, Inc., add elegance and starlike sparkle to the scene, as does the gilded ceiling. Later in the interior design program, the stairs were carpeted with the highly stylized and patterned rug designed by Ruth Reeves.

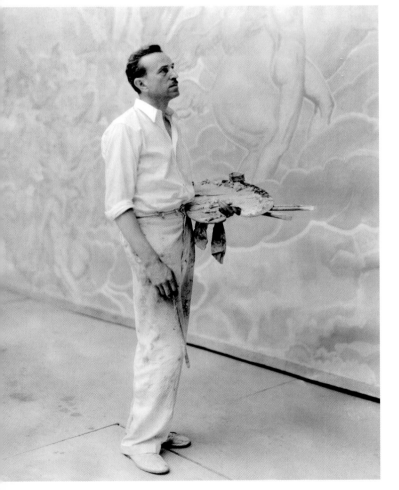

The artist Ezra Winter working on his mural The Fountain of Youth, *ca. 1932.*

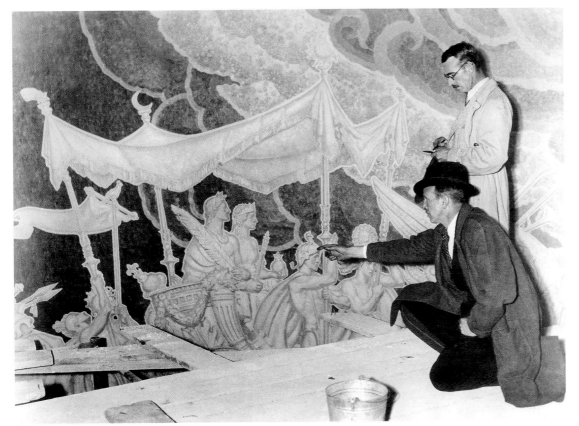

Above: Ezra Winter's temporary studio in a tennis court, the only place big enough to hold the vast canvas for The Fountain of Youth, *ca. 1932.*

The painter Ezra Winter and Edward Trumbull (foreground) discussing the progress of The Fountain of Youth *mural, ca. 1931.*

RUTH REEVES
TEXTILES and CARPET DESIGNS

Ruth Reeves was well known to Donald Deskey for her work in textile and fabric design. In 1928, she and Deskey, with other decorative artists, had organized a gallery to promote their work, the American Designers Gallery. Owing to the Depression, it had a short life, closing within the year. Another artist's group, the American Union of Decorative Artists and Craftsmen (AUDAC), was formed in 1930. Its purpose was to exhibit and attempt to sell designs of the Modernists. Both Reeves and Deskey were members, but it, too, quickly fell by the wayside. In 1931, Deskey sought Reeves out to help embellish the Music Hall. She was commissioned to design Deco-inspired textiles. She created designs for a wall covering of immense proportions for the auditorium, and a vast carpet for the floors of the Grand Foyer, staircase, and three mezzanines. These textiles provided a blaze of color, vibrant texture, and pattern to the spaces. The huge carpet had to be custom woven. The materials not only were decorative but also helped control sound.

The carpet in the Grand Foyer was designed to reflect the primary business of Radio City Music Hall—music. In an almost mosaic-like configuration—each musical motif being set into and defined in a rectangular block—Reeves interwove strong abstract interpretations of the musical instruments found in the theater. The huge size of the carpet and the strong patterns and bold bright colors are almost visually overwhelming. The rhythmic patterns, with a colorful mélange of geometrically shaped banjos, guitars, accordions, piano keys, saxophones, and harps, float against ample clouds of bright orange and yellow in a deep blue sky. The interlocking and overlapping shapes and undulating lines and sinuous curves and dots contribute an organic facet to the design. The result is an immense, jazzy carpet that is opulent and urbane. It is perfect for a vast public pleasure palace.

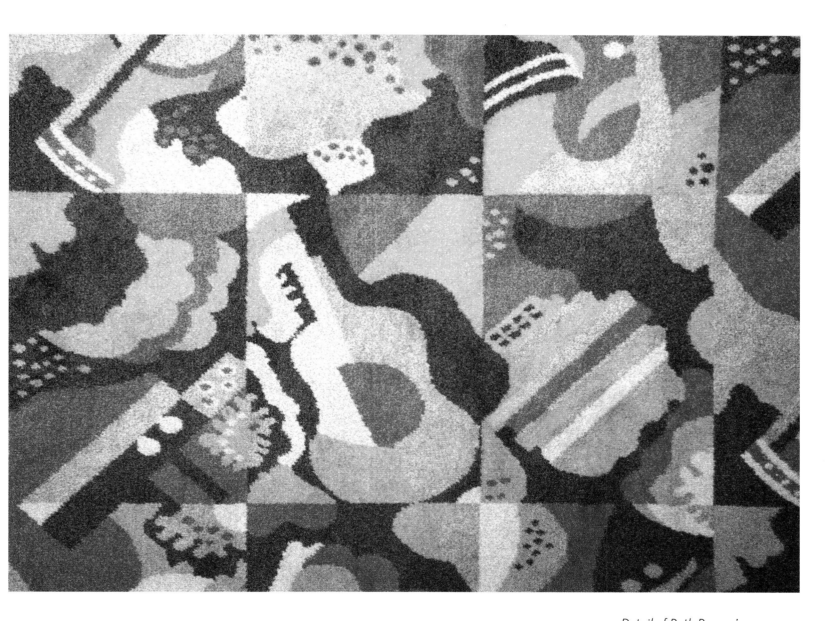

Detail of Ruth Reeves's carpet Musical Instruments *for the Grand Foyer, staircase, and mezzanines. This carpet was re-created from the original during the 1998 restoration of Radio City Music Hall.*

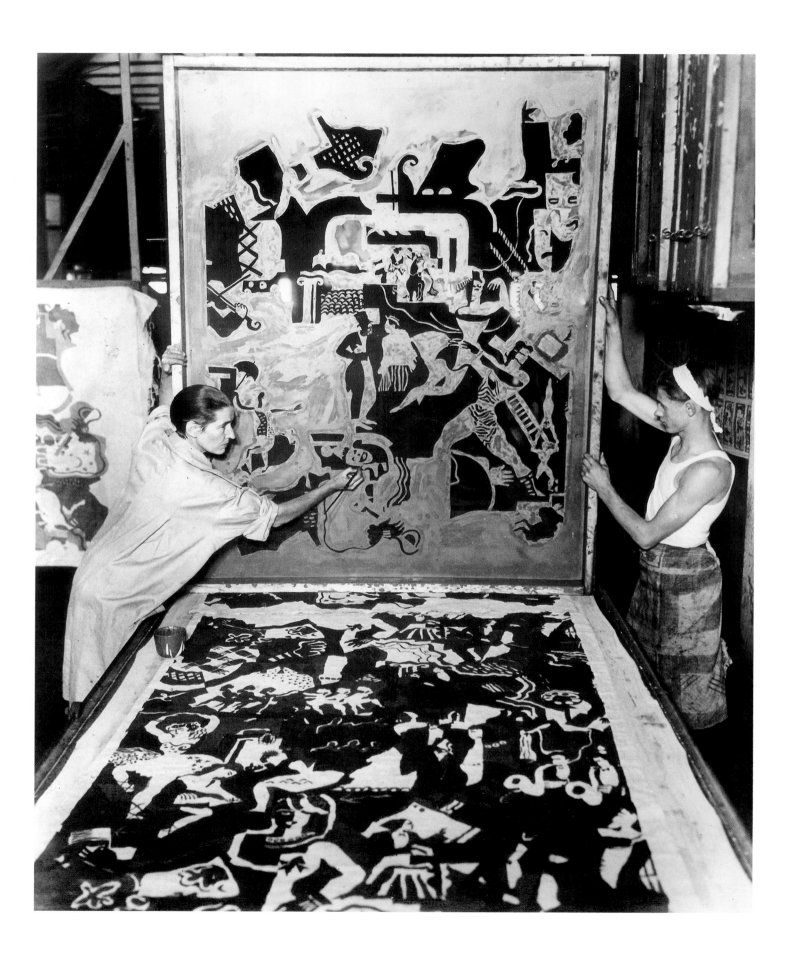

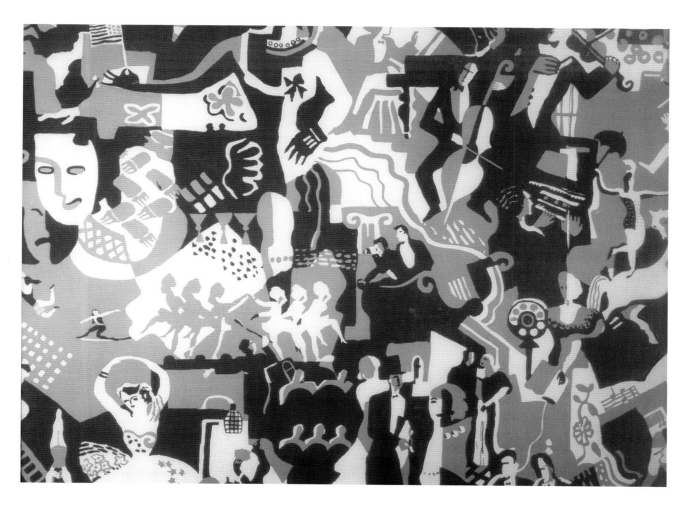

The linen wall covering Reeves designed for the auditorium is titled *History of the Theatre*. An intricate and bold pattern of the myriad events that take place on stage, the flamboyantly colored wall covering is red, pale pink, white, and salmon, contrasting with, and visually bouncing off, the deep-red plush seats of the theater. The theme is all theater; dancers, musicians, even horseback riders can be found woven into the complex abstract and fragmented design. Reeves actually produced the first screens and prints in her workshop. Donald Deskey designed the complementary carpet for the auditorium. His rug and Reeves's mural were installed in 1932.

Reeves was a pioneer in textile Modernism. Her designs enhanced and fortified the avant-garde spirit that Deskey brought to the Music Hall.

Detail of Ruth Reeves's linen wall covering for the auditorium. This wall covering was re-created from the original during the 1998 restoration of Radio City Music Hall.

Opposite: Ruth Reeves and her assistant silk-screening a panel for the linen wall covering in the auditorium at Radio City Music Hall, ca. 1931.

MARGUERITA MERGENTIME
TEXTILE AND FABRIC DESIGNS

Marguerita Mergentime was another textile designer sought and commissioned by Donald Deskey to create pieces for the Music Hall. She produced both a rug pattern and a wall fabric motif for two separate areas. Not being a strict "Modernist," her work retains traditional forms and natural organic motifs. It synthesizes different eras and yet is distinctly a reflection of American Modernism. She used a floral motif in a repeat pattern for the wall fabric in the ladies' lounge on the third mezzanine. The design of lilies, leaves, and other forms found in nature is barely perceptible. It is a muted, subtle pattern rendered in the palest of hues. In a photogravure article titled "The Latest Trend of Modern Art as Shown in the Interiors of Radio City," the *New York Times* of Sunday, December 18, 1932, described her fabric design for the "Powder Room" as follows: "Covered by Silk Damask Designed by Marguerita Mergentime in Tones of Silver and Leaf Green." The fabric that is hung today is a replica.

Marguerita Mergentime's rug design is found in the elevator area on the Grand Lounge level. It too is all about theater. On a geometric background pattern of blue and light brown hues are superimposed black line drawings of musicians, ballerinas, dancers, clowns, acrobats, prancing horses, and dancing dogs. The animated figures are reminiscent of Reeves's wall design in the auditorium.

Marguerita Mergentime, a textile and carpet designer, in her studio surrounded by sketches and designs for Radio City Music Hall, ca. 1931.

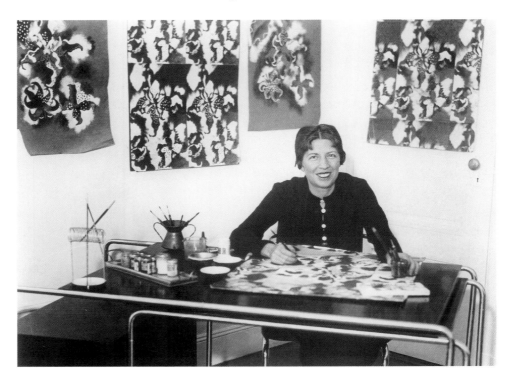

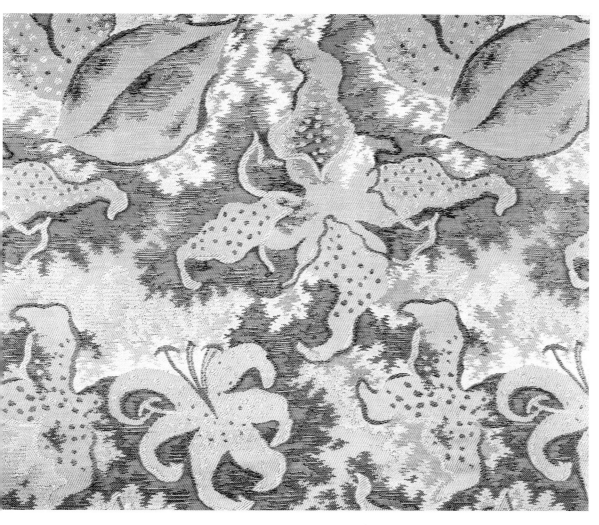

Detail of Marguerita Mergentime's floral-patterned damask wall covering in a ladies' powder room. The fabric was re-created from the original during the 1998 restoration of Radio City Music Hall.

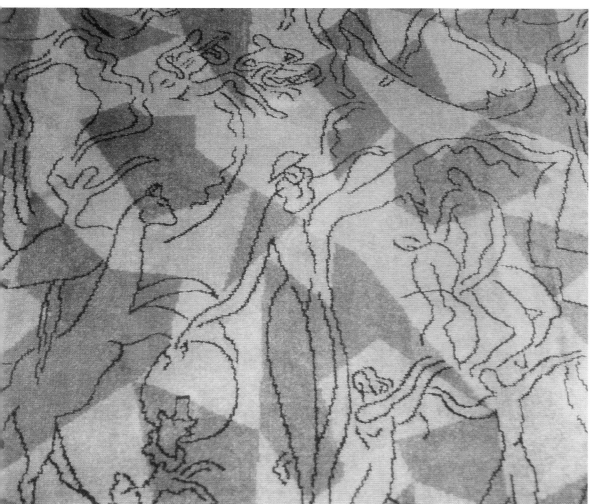

Detail of Marguerita Mergentime's carpet covering the floor near the elevators on the Grand Lounge level in Radio City Music Hall. This carpet is a 1998 re-creation of her 1931 design.

LOUIS BOUCHE
THE PHANTASMAGORIA of the THEATER

Louis Bouche was born in New York. The Bouche family had emigrated from France to New York because of Louis's father's craft and the potential of work in the United States. His father was an architectural decorator who came to work with the socially prominent American architect Sanford White. Louis grew up in this creative and sophisticated atmosphere and from an early age was encouraged to follow in his father's artistic footsteps. After his father's death the family returned to France, where Louis studied painting. He soon returned to New York City, where, in 1922 at age twenty-six, he was asked to manage the picture gallery Belle Maisons. Belle Maisons was a very fashionable decorating department at Wanamakers, a leading New York department and furniture store. This prominent position was offered because of his internationalism, sophistication, and extensive contacts in the art and design world. An important aspect of his job was to find muralists who could decorate the walls of wealthy clients' homes. In the 1920s murals were emblematic of wealth and refinement. He left his job at Belle Maisons after concluding that actually painting the murals could provide a lucrative income, as well as being more interesting and creative than his position as a gallery manager.

Bouche soon became one of the best-known and sought-after interior muralists of the 1930s. He was handsome, debonair, continental, and stylish. *Esquire Magazine* dubbed him the "Boulevardier of Art" (the man about town of art). His reputation rapidly grew as socially prominent families singled him out to paint lighthearted, fashionable murals with classical themes for their homes. He was versatile, ambitious, and hard working. He furthered this profitable mural-painting career by producing large works for commercial settings, such as the Pennsylvania Railroad, the Departments of Justice and the Interior in Washington, D.C., and the Eisenhower Foundation in Abilene, Kansas. He also produced smaller works on canvas. As an easel painter, he depicted mostly cheerful, realistic genre scenes and some portraits. He taught at the Art Students League for twenty-five years. As a director of the New York School of Interior Decoration, he had an influential role in conservative decorative art of the time.

Louis Bouche posing before one of his vignettes from Phantasmagoria of the Theater, *ca. 1932, painted for the Grand Lounge in Radio City Music Hall. The lounge was designed by Donald Deskey.*

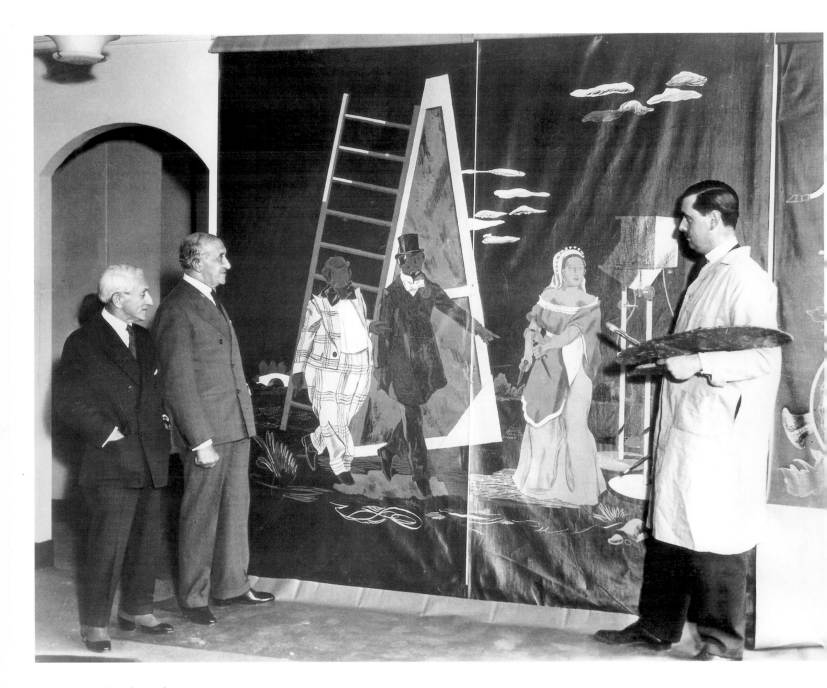

Louis Bouche with
the comedy team Weber
and Fields as he finishes
their portraits in one
of the scenes from
Phantasmagoria of the
Theater, ca. 1931.

In 1931, Deskey commissioned Bouche to paint five vignettes representing various theatrical scenes. Bouche chose five eras in which to focus his narrative. He was historically liberal, mingling various epochs in single scenes. He combined views of the early Italian stage with characters from the contemporary stage. He portrayed early Greek tragedy with modern drama. He used the vaudeville comedy team of Weber and Fields as an inspiration for one vignette.

The murals are located in the Grand Lounge in Deskey's eclectic setting. Collectively, they are pompously titled *The Phantasmagoria of the Theater*. In typical Bouche style, the color sense is subtle and delicate and his illustration academic. Set on specially prepared, pyroxylin-coated black walls, they are skillfully rendered. The result is not earth-shattering, or even particularly eye-catching; the murals are merely charming and appropriately ornamental for a theatrical lounge of the 1930s.

Detail of the portraits of Weber and Fields from Louis Bouche's Phantasmagoria of the Theater, *located in the Grand Lounge of Radio City Music Hall.*

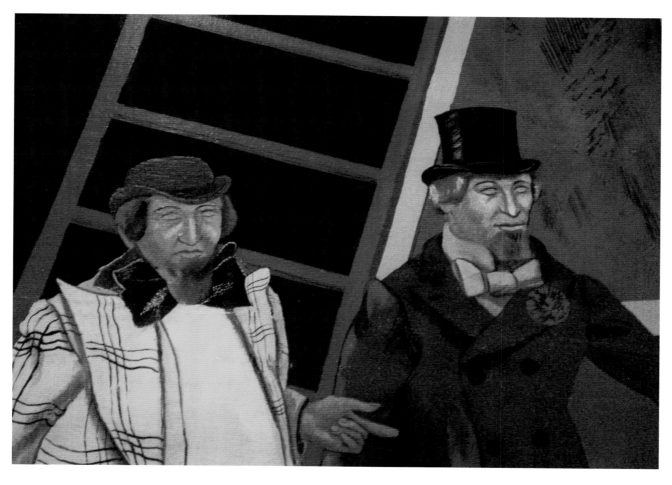

WITOLD GORDON
HISTORY of COSMETICS and CONTINENTS

Donald Deskey commissioned Witold Gordon to produce two works for Radio City Music Hall. His themes reflected the use of the space he was asked to decorate. His mural titled *History of Cosmetics* is in the ladies' powder room off the Grand Lounge. This theme is distinctly feminine and in the 1930s was considered suitable for an area reserved for ladies only. The lounge itself is more spacious than any lounge Deskey created for men. It contains many mirrors, pastel-shaded fabrics, white lacquered dados, sycamore furniture, and a chaise lounge for women having fainting spells. This carefully constructed feminine composition reflects the 1930s view of ladies' requirements.

The mural is a series of vignettes portraying ladies of all eras applying cosmetics, bathing, dressing, and beautifying themselves. The slim, fashionable figures are set against a pale colored wall. The stylish clothes are colored in pinks, pale blues and greens, and light transparent tones that lend an air of doll-like femininity to the room.

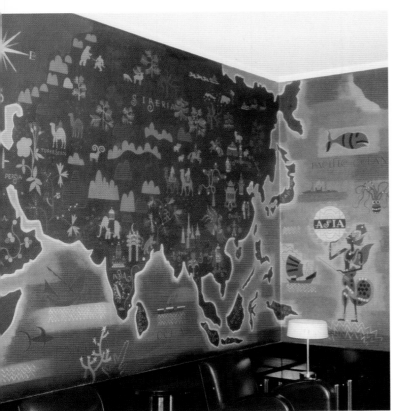

Today, it appears so insipid that it is almost amusing. Deskey designed the furnishings to accompany the feminine color scheme.

In the men's lounge on the first mezzanine, Gordon created a second mural depicting the continents of America, Europe, Asia, and Africa. Working directly on the wall, he illustrated the entire space with a common American view of the world in 1930s. The lounge is frequently referred to as the "Map Room."

The imagery is exaggerated and stereotypical. The use of disproportionate and enlarged images, the characterization of races, and the stylized symbols for the oceans and Wonders of the World impart a cartoon quality to the work. The maps of four continents and their populations are rendered in dark brown, warm yellows, reds, and gold, against a predominant burnt orange tone for the oceans. Deskey, always orchestrating the spaces, determined this to be a suitable masculine subject and the colors appropriate for an area reserved for men only. Deskey designed the sleek black leather and chrome furnishings and dark floor to emphasize and set off the color and forms of the mural.

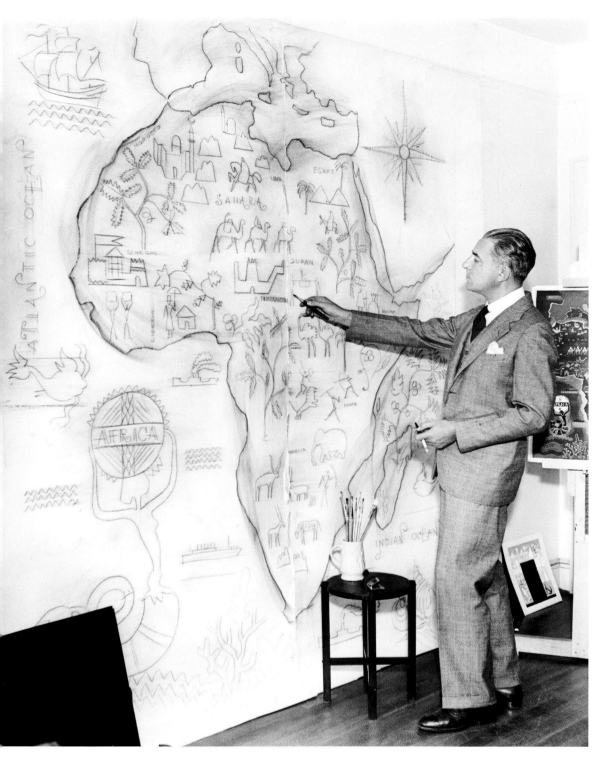

Witold Gordon drawing the full-size outline for his mural Continents, ca. 1931. Note the finished colored drawing on an easel to his left and an additional drawing resting against the wall.

Opposite, top: Detail from one scene of Witold Gordon's History of Cosmetics located in the ladies' lounge off the Grand Lounge in Radio City Music Hall.

Opposite, bottom: One wall of Witold Gordon's Continents, located in a men's lounge at Radio City Music Hall. This room is also referred to as the "Map Room."

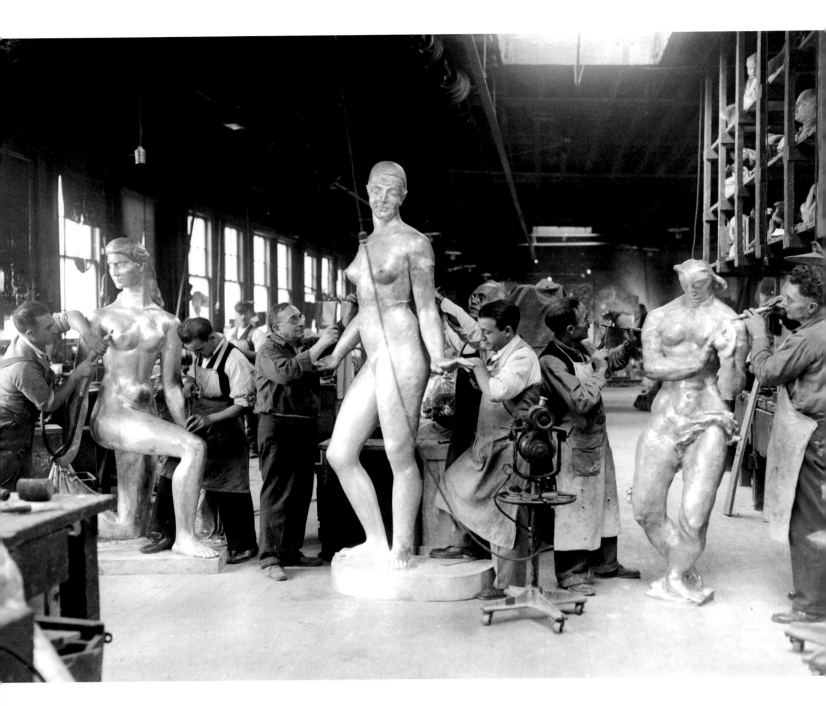

Technicians at Roman Bronze Works finishing the sculptures of (left to right) William Zorach, Robert Laurent, and Gwen Lux, ca. 1931.

WILLIAM ZORACH · SPIRIT OF THE DANCE

Donald Deskey commissioned three heroic-sized sculptures for Radio City Music Hall. They are the work of William Zorach, Robert Laurent, and Gwen Lux. All three sculptures were cast at Roman Bronze Works at the same time. Deskey had dictated the choice of the casting metal to be the newly alloyed metal aluminum. The use of aluminum as an artist's material was another indicator of Modernism. It was seen as a metal that would not corrode or require patination or future maintenance, and it was lightweight and relatively inexpensive.

William Zorach created the largest of the three figures. The over-life-size statue *Spirit of the Dance* is placed in the main lounge. It portrays a nude maiden kneeling on one knee with the other leg bent in front of her. A drape falls softly around her torso to the floor. Her head is slightly tilted, her eyes are alert; she has completed her dance and is taking a bow. Rounded shapes and simplified forms characterize Zorach's work. The calm, almost chaste atmosphere suggests a feat completed. It is a romantic figure in harmony with her surroundings. Shortly after *Spirit of the Dance* was installed, it was ordered removed from view by the famed Roxy Rothafel because he felt it was "lascivious." Then Zorach publicly exhibited a full-size clay model of the figure that received acclaim and approval by the public—it wasn't so wanton after all. The decision to remove it was reversed and the sculpture returned to the lounge, where it has remained. This is the sole aluminum cast but not a unique cast of the figure. Zorach authorized both a one-third-scale edition of six bronze casts as well as a full-size edition of six bronze casts. They can be found in private collections and museums.

Bottom left: William Zorach at Roman Bronze Works, ca. 1931, chasing the surface of his cast aluminum sculpture Spirit of the Dance.

Bottom right: Detail of the cast aluminum head of Spirit of the Dance *by William Zorach.*

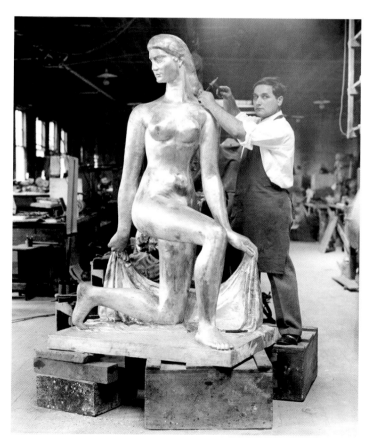

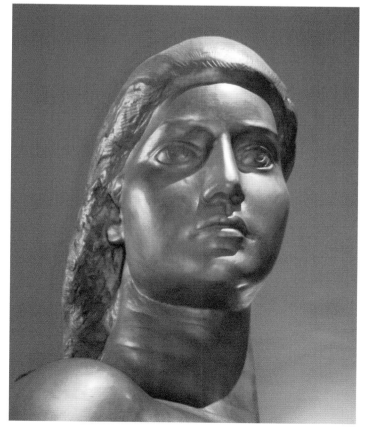

GWEN LUX · EVE

At the top of the Fiftieth Street staircase is the heroic-size figure of Eve, sculpted by Gwen Lux. In this piece, Eve is not portrayed as the time-honored lovely maiden in the Garden of Eden being seduced by the snake and taking the forbidden apple. Instead, Lux sculpted her from an evolutionary view, as the first female human, still evolving from the ape. She is roughly modeled and out of proportion. She has not yet progressed to an attractive human form. Her rudimentary drape adheres to her body as would a snake. She seems bewildered and uncertain of her fate. The object she fondles is the seed of life rather than the apple, the symbol of original sin. This piece was also deemed lascivious and removed from public view along with Laurent's and Zorach's nudes.

This work was cast in aluminum, chosen by Donald Deskey for its modern qualities. Like Donald Deskey, Gwen Lux was a pioneer in the use of modern machine-age materials. She experimented with the latest products as well as time-honored materials and was a versatile artist with a far-ranging ability.

Gwen Lux at Roman Bronze Works, ca. 1931, chasing the surface of her cast aluminum sculpture Eve.

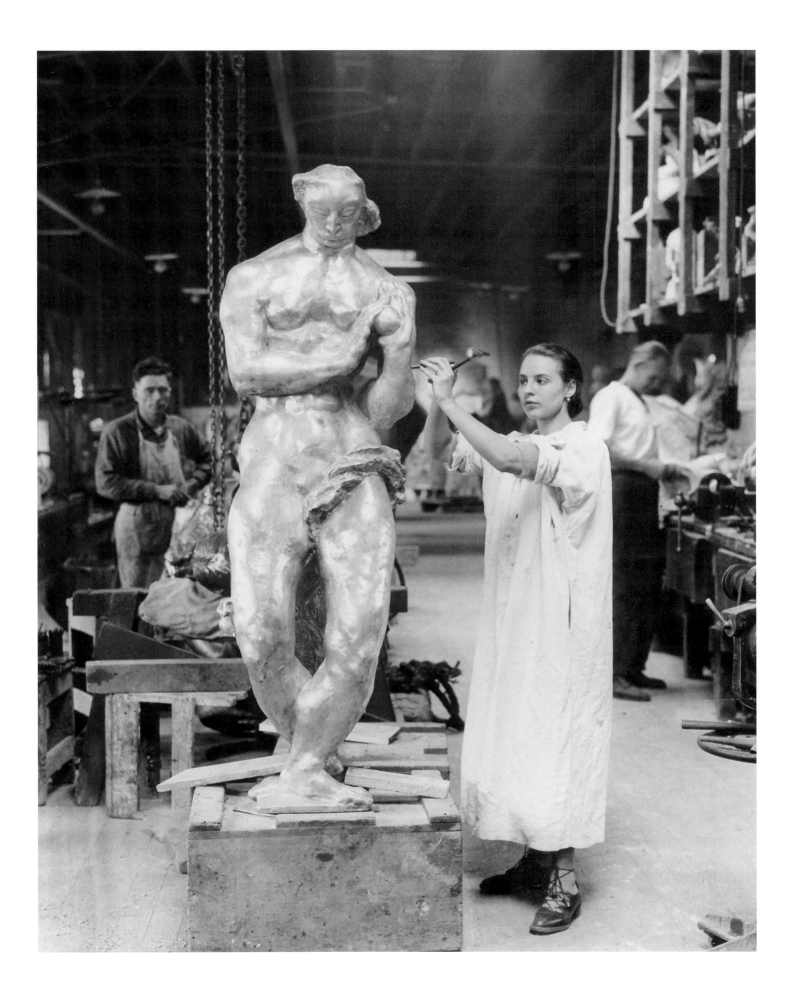

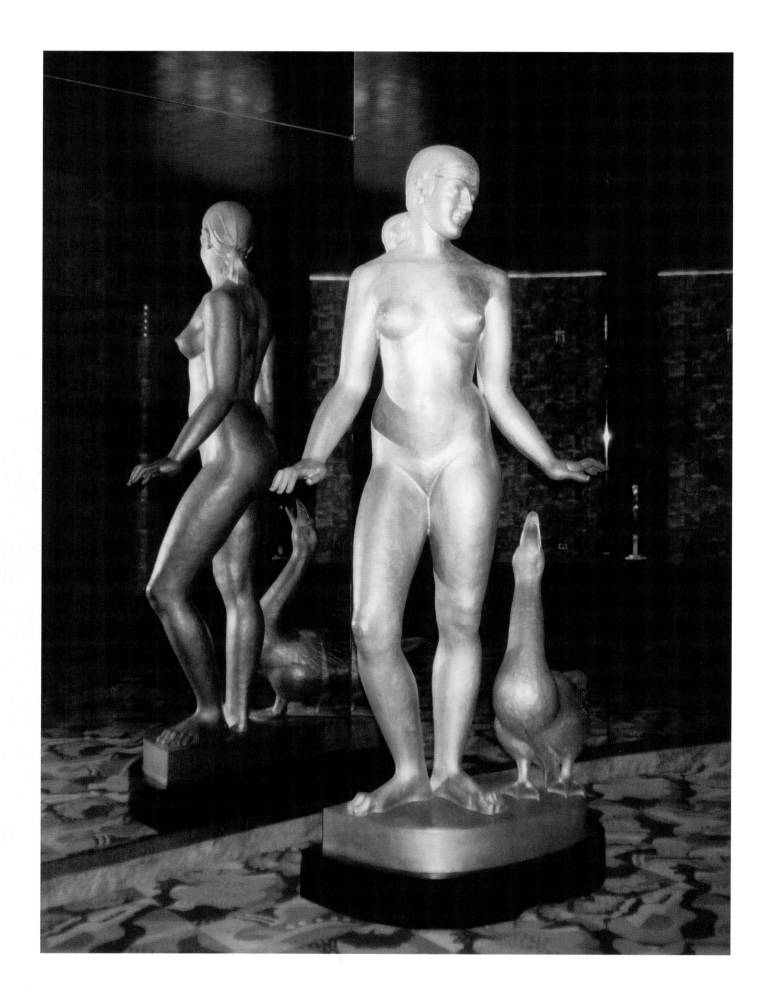

ROBERT LAURENT · GIRL AND GOOSE

On the first mezzanine is the cast aluminum statue *Girl and Goose*, by the sculptor Robert Laurent. This third heroic-size figure cast designed for the interior of Radio City Music Hall was another controversial nude. Owing to its state of undress, the statue was deemed unsuitable for public display, just like *Spirit of the Dance*. It was removed for a period of time and eventually reinstalled along with the Zorach and Lux pieces. Today, we view these serene figures and cannot imagine what the fuss was all about. It is a simple figure of a girl with a goose, the form is graceful and elegant. The piece is set against a tinted mirrored wall, which reflects the back of the pale gray aluminum sculpture in warm tones of golden brown. Laurent caught a moment of light-heartedness and gentleness between the girl and the goose. This is clearly evident in the placement of the girl's hands and the raised head of the goose. She appears composed and seems to be tenderly quieting the squawking bird. The subject matter is quite unique for a theater setting as it has nothing to do with stage business. By placing this piece and the works of Gwen Lux and William Zorach around the public spaces, Deskey hoped to provide the audience with an enriching cultural experience in an easy going ambiance.

Robert Laurent took his figure from the tradition of classical art and direct carving. His work in stone and wood provided him with a natural approach to the subject.

It is interesting to note that the three sculptors—Laurent, Lux, and Zorach—simultaneously worked on their pieces in a studio at the Roman Bronze Works, and yet produced such individualistic sculptures.

Robert Laurent at Roman Bronze Works, ca. 1931, finishing his cast aluminum figure, Girl and Goose.

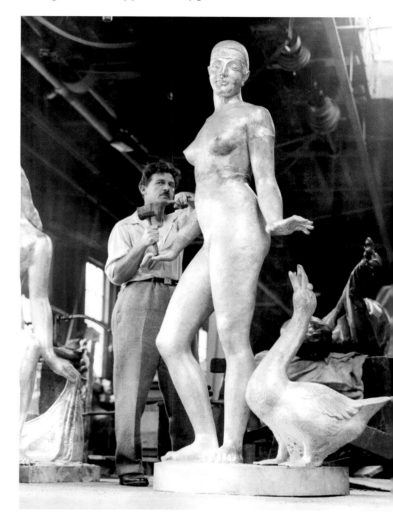

Opposite: Robert Laurent's cast aluminum figure Girl and Goose, *reflected in a tinted, curved mirror on the first mezzanine at Radio City Music Hall.*

YASUO KUNIYOSHI · EXOTIC FLOWERS

Donald Deskey attempted to commission the American painter Georgia O'Keeffe to do a mural of flowers. She was well known for her large, close-up paintings of flowers in which she reduced the subjects to an arresting concord of colors and organic shapes dominating the canvas. She had actually signed the agreement with Deskey when her husband, Alfred Stieglitz, the photographer, interfered. He claimed the pay for such a large mural was inadequate and would affect her other commissions. After a series of antagonistic events between the couple and Deskey, O'Keeffe suffered a nervous breakdown. Deskey then awarded the commission to Yasuo Kuniyoshi. Working with the same theme of nature filling the space, he created one of the most delightful small rooms in the Music Hall. Combining the aesthetics of East and West, Kuniyoshi painted a luxuriant, magical garden to decorate the walls. His painting totally covers the room, creating a scene without boundaries. Using the smooth, curving walls he evoked his world of fantasy with delicately rendered, larger-than-life botanical designs. They lithely sweep up from the floor, across the walls, and toward the rounded ceiling, creating an atmosphere of pleasure and beauty. Sinuous tendrils and gargantuan forms of plant life painted in subtropical tones create a dreamlike splendor. Soft tones are used to relax the viewer, creating a surreal world of dreams and fantasy. The motifs of lilies, palms, and other exotic plants executed in greens and white are set against an array of pale pink and blue hues. Kuniyoshi cleverly incorporated his designs into the architecture with leaves growing atop doors, flowers surrounding mirrors, and clouds enveloping the ceiling fixture. The motifs are organic, but the atmosphere and style are clearly Art Deco. This is enhanced by Donald Deskey's stylish modern furnishings and fixtures. The original work has suffered as a result of two restorations, one in the 1980s and the second in the late '90s. Even with those heavy-handed restorations, the room retains the atmosphere of a secret garden paradise where only ladies are permitted to enter.

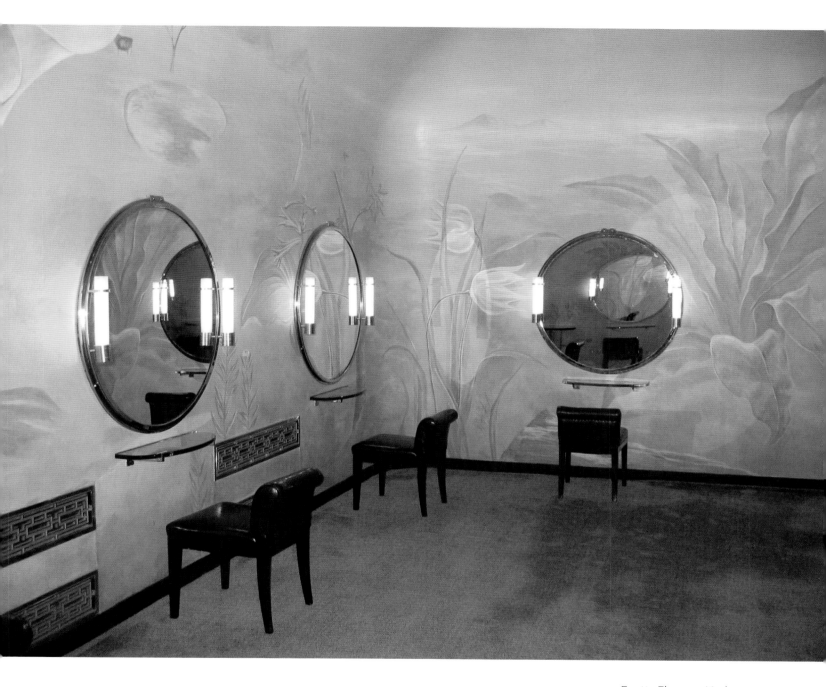

Exotic Flowers, *Yasho Kuniyoshi's oil-paint-on-primed-plaster mural covering the curved walls and ceiling of the ladies' powder room on the second-mezzanine. The mural was extensively repainted during the 1998 restoration of Radio City Music Hall.*

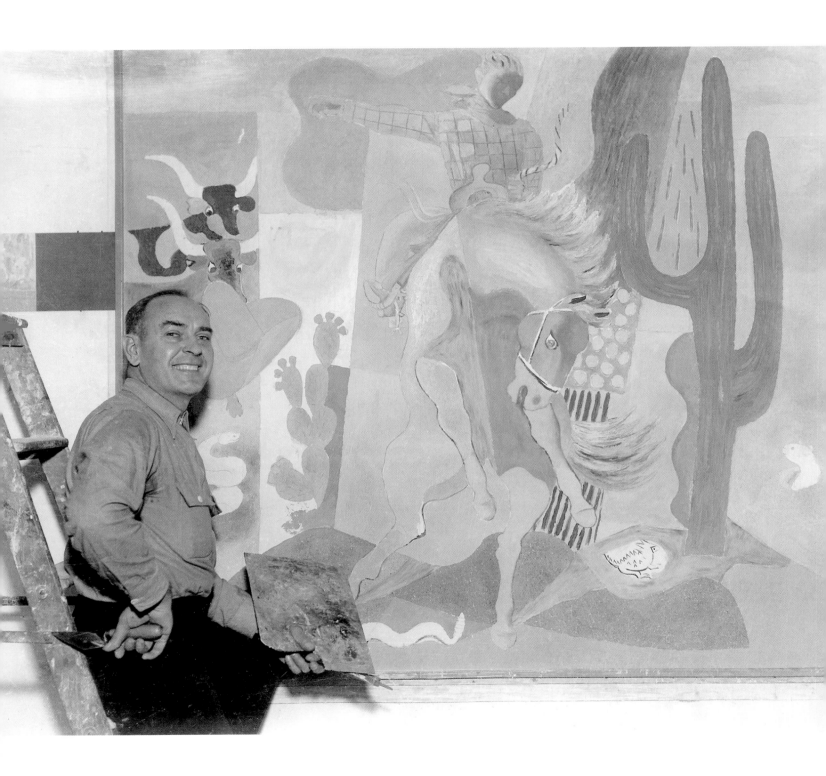

Edward Buk Ulreich painting his mural Wild West, using oil paint mixed with sand on leather, for the men's lounge on the third mezzanine at Radio City Music Hall, ca. 1931.

EDWARD BUK ULREICH · WILD WEST

In the 1930s, Edward Buk Ulreich was a well-known designer and muralist. He had painted murals for the Chicago Temple Building and designed marble mosaics for the 1933–34 Century of Progress Exposition in Chicago. Deskey commissioned the Austrian-born painter to create a mural titled *Wild West* for the men's lounge on the third mezzanine.

An example of separate elements and blocks of color fragmenting the canvas, the mural creates a playful sense of action, thrust, and speed. Ulreich's earthy palette reflects the West. The whimsical composition depicts a stereotypical western scene of a cowboy breaking a bronco surrounded by symbols of the desert—succulent cacti, snakes, a gopher, and longhorns. As the horse rears in fright, the cowboy pulls the reins and his Stetson goes flying. Curious longhorns regard the scene from the background and a gopher looks out of his burrow. Meant to be symbolic of the vanishing American frontier, Ulreich enhanced the western motif by painting the mural on leather, with sand mixed into the paint to provide rough texture. The boldly painted scene is set off by the warmth and richness of the leather, adding an original and unusual tactile sense to the work.

The mural has remained in brilliant condition, testifying to a high degree of Ulreich's technical knowledge and ability. Deskey completed the ensemble, designing the eclectic furnishings, combining tables of glass and steel, industrial-design lamps, deep-toned red leather chairs, and leather-paneled walls.

Bottom left: Detail of the horse's head from Ulreich's mural Wild West.

Bottom right: Donald Deskey's leather and industrial-style metal furnishings for the men's lounge on the third mezzanine at Radio City Music Hall.

HENRY BILLINGS · CROUCHING PANTHER

Donald Deskey commissioned Henry Billings, a painter and illustrator, to provide a mural for the ladies' powder room on the third mezzanine. The mural depicts a sleek panther crouching in the foreground. He appears to be stalking, with his body tense, his hind legs ready for action, and his tail held high. He is clearly a metaphor for power. The panther's head is turned away from the viewer, which draws attention to the mural's background. The mood is made mysterious by the solitude and isolation of the setting. The vast sky is empty and the landscape almost barren. In the distance is a broken column, a ruined arch, and a dead tree, traditional symbols for past civilizations. Evoking a surreal world of dreams, the mural is an elegant abstraction in an imaginative setting. Billings used modern spatial concepts along with strong colors, clean lines, and bold, surreal forms. Abstraction and simplification were the basis of all of his work.

Detail of the wall fabric in the ladies' powder room on the third mezzanine of Radio City Music Hall.

The colors in Billings's mural—pale blue, gray, brick red, creamy white, greens, and browns—are repeated in the wall fabric, a bold geometric design of blocks, rectangles, diagonal stripes, step shapes, and sawtooth forms. A shadow effect is achieved by overlapping the same form in differing hues. Deskey's designs and control of the palette for the mural, walls, and furnishings serve to unify the room and create a total spatial experience. He designed the wall lighting, the sleek tubular steel tables, built-in divan, and curvy leather seating to complete the sophisticated Art Deco ambiance. The result is an extremely robust setting that deliberately shifts away from the vapid and commonplace concepts usually associated with ladies in the 1930s. Even in the seemingly most humdrum areas, Deskey's style and alliances with other artists produced brilliant surroundings.

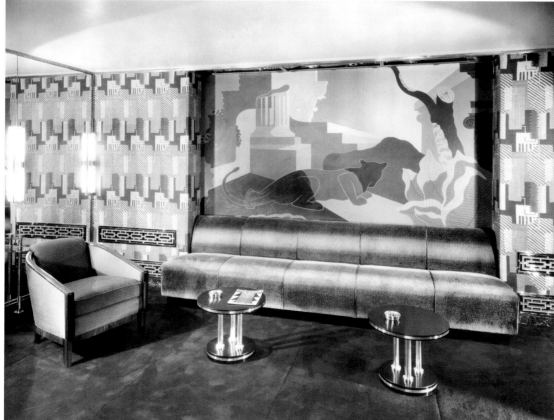

Henry Billing's mural
Crouching Panther
installed in the ladies'
powder room on the
third mezzanine of Radio
City Music Hall.

HENRY VARNUM POOR · CERAMICS

Henry Varnum Poor had originally studied painting prior to becoming interested in pottery. In 1920, he had a one-man show of his paintings at the Kevorkian Galleries in New York. It was a failure and he began to seek other creative venues to earn a living. Within a year of experimentation with glazes and pottery, he had a collection of ceramic vases on sale at the Belle Maisons Gallery in Wanamaker's Department Store, probably through an association with Louis Bouche. Most significantly, he had found his medium. He went on to create a tile-mural for the Hotel Sheldon in New York and, in 1931, he was commissioned by Donald Deskey to produce a series of pottery and lamp bases for the Music Hall.

Poor's lamps and vases reflected his background as a painter, as he frequently used the object as a canvas, decorating the surfaces with human and animal forms. Stylistically his technique derives from the works of the Fauves, a group of artists that found its voice in 1905 in Paris. Poor was influenced by their use of rich linear patterns, slashing lines and bold outlines that were originally inspired by African, Polynesian, and South and Central American art. He used graffito decoration on many of his ceramic surfaces, scratching the design or figures into the clay. However, the only lamp base created by Poor existing in the Music Hall is a simple rounded shape without any distinctive design or pattern.

With his usual flare, Deskey once again demonstrated his eclectic verve and innate style with the seemingly illogical combination of Poor's handcrafted ceramics and his streamlined furniture. The Music Hall commission facilitated Poor to leave his mark as an American Modernist ceramist.

Ceramist Henry Varnum Poor in his studio, ca. 1931. His lamp bases and vases were used by Donald Deskey throughout the Music Hall. Only one example of a lamp base remains in a men's lounge.

STUART DAVIS
MEN without WOMEN or UNTITLED

Stuart Davis painted a stunning mural for Radio City Music Hall in 1932. Although it contains no human figures, its original title was *Men without Women*. Reportedly, a Rockefeller Center "committee" named the painting, probably based on a short story by Ernest Hemingway. Davis did not think the title appropriate, and in 1975, when the mural was gifted to the Museum of Modern Art, it was retitled simply *Mural*, then, *Untitled*. In 1999, after an extensive renovation of the Music Hall, the museum lent it back to the Music Hall. The mural is installed in its original location on the west wall in the main men's lounge, with a low stainless-steel fence ensuring its safety. In an early statement issued by Rockefeller Center concerning the Music Hall artists, Stuart Davis's mural is depicted as "extremely abstract and is acknowledged by many critics as being the most daring and powerful of the 'left wing' American moderns. The daring color combinations and bold special relationships characteristic of Mr. Davis' work will attain added strength through the color scheme of the room. The dark brown of the cork walls is calculated to soften the effect of the black terrazzo floor which will further have a tone cast upon it from the copper-leafed ceiling."[6]

Stuart Davis's oil-on-canvas mural Men without Women or Untitled. *The Rockefellers had gifted the work to the Museum of Modern Art, but it was reinstalled, on loan from MOMA, following the 1998 restoration of Radio City Music Hall.*

Today, the symbols Davis used are outmoded images of masculine recreation and leisure time; nevertheless the mural remains spontaneous and stimulating. The images suggest what men enjoyed in the 1930s for exercise and sports. A roadster, a pipe, a gasoline pump, a package of cigarettes, cigars, a tobacco pouch, playing cards, a horse, a sailboat, matches, and barber poles are strewn across the surface in a stylized, jazzy Cubist manner. It was Davis's first painting in such a large format. He was paid $800. At first, Davis and Deskey planned the mural in cut-out linoleum, another modern material. This limited media had dictated the color scheme and the blocklike shapes of the mural. After abandoning the idea of linoleum, Davis completed the mural in traditional oil paint on canvas following approval of his sketch.

To complete the lounge, Donald Deskey designed a black stone floor, patterned fabric upholstery for the furniture, and chrome and steel tables and used dark henna-colored paint and deep-stained paneling on the walls. These furnishings and color scheme combined with Stuart Davis's theme to create a striking and uniquely masculine milieu.

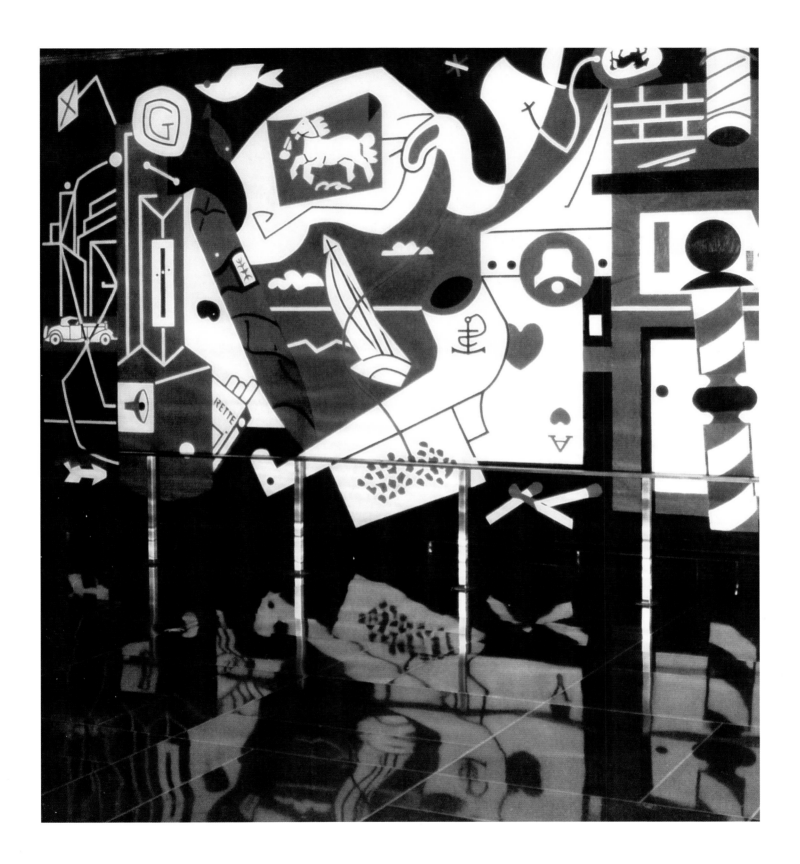

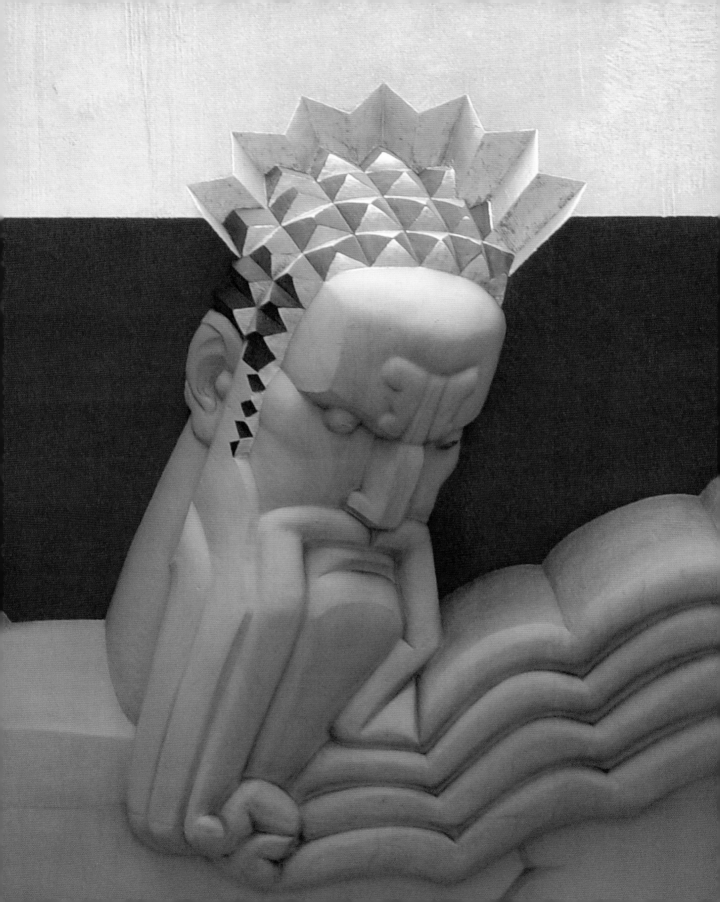

30 ROCKEFELLER PLAZA

In May of 1933, four buildings at Rockefeller Center opened, including the seventy-story skyscraper at 30 Rockefeller Plaza. From the very beginning of design and construction, "30 Rock" was considered the flagship building and referred to as "Building No. 1." Its placement followed Beaux-Arts design principles and the design concepts of the lead architect, Raymond Hood.

30 Rockefeller Plaza is the heart of the Center and the culmination of the Channel Gardens. Dwarfing surrounding skyscrapers, it is located on the central axis of the Center and set behind the Lower Plaza, where it can be viewed from Fifth Avenue. The gently sloping Promenade is the main approach from Fifth Avenue. It is flanked by the French and British buildings. With this third structure of the Center, the architects and builders had fine-tuned their comprehensive building program. They had commissioned the best-available talents in the fields of architectural ornamentation and art.

The art program was in its third year and had been refined, becoming compelling and comprehensive. Edward Trumbull, the famed muralist, was hired to be the color director and guide the architects through the complex task of color schemes for "the marble, elevator doors, painting and materials, such as draperies, carpets, etc. Where requested by the Architects you are to supervise and carry out the color schemes selected by you and render whatever color sketches the Architects may deem necessary."[1] Given this much consideration and attention, the art program was destined to be significant. It would acknowledge and interpret America's spiritual, societal, and intellectual development in terms of time: its current status, its progress, and its future potential.

The art committee, with the help of George Vincent, Professor M. I. Pupin, and the professor-philosopher Hartley Burr Alexander, developed a number of philosophical subthemes for the New Frontiers art program. The unifying theme New Frontiers measured the relationship of human to the development of science, labor, education, travel, communications, humanitarianism, finance, and spirituality. All subthemes would reflect some aspect of these dynamics. In broad terms, New Frontiers described the aesthetic arrangement envisioned for Rockefeller Center.

Modernist themes resounded throughout 30 Rockefeller Plaza. Ornamentation was carefully orchestrated to reflect that aesthetic. Sumptuous details and quality materials were exuberantly applied throughout; bronze grills, gilded moldings, alabaster light fixtures, exotic wood elevator cabs, marble and granite walls and floors, brass mailboxes, and sculpted bronze elevator doors were commissioned and executed by the same artists working on major installations. The Rockefellers and their architects were determined to transform the once-shabby tenement area into a stunning and harmonious center for commerce and culture as they emerged into a new economic period. They were in the forefront with a bold urban style, a striking, streamlined approach, and 30 Rockefeller Plaza was the centerpiece, showcasing masterworks from the reigning Art Moderne period. To this day, 30 Rockefeller Plaza remains the art and architectural focus of the Center and continues to house the Rockefeller family offices.

Detail of the figure of Wisdom by Lee Lawrie above the main entrance to 30 Rockefeller Plaza.

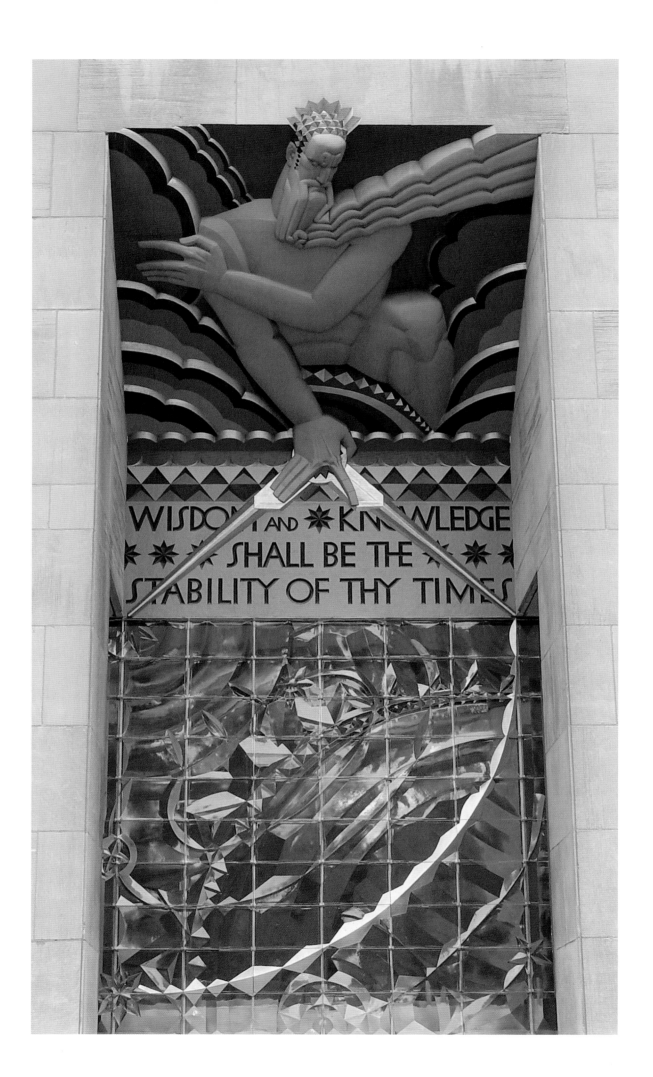

LEE LAWRIE
WISDOM with SOUND and LIGHT

By the 1930s Lee Lawrie had established himself as a major architectural sculptor and Modernist. At 30 Rockefeller Plaza he reached his artistic apogee and designed one of the most dramatic and technically difficult works in the Center, a massive multimedia piece created from a single slab of carved, polychromed limestone and 240 cast glass blocks. This powerhouse of form, color, and light explodes from the building's façade.

Originally, the central sculptural panel was titled *Wisdom—a Voice from the Clouds*. Over the years it has simply become *Wisdom*. It is both a complex allegory and a multifarious three-section glass and stone screen, dominating and rising thirty-seven feet above the central doorway. The symbols, images, and narratives Lawrie used transform the entrance to a powerful, mystical vision.

First, Lawrie developed his ideas for the screen in plaster. Slowly, he simplified and created a multimedia sculpture that would work both spatially and aesthetically. Once satisfied with the maquette, the work of stone carving and glass casting began, and finally, the sculpture was installed on the building's façade.

Opposite: Panels of carved, gilded, and polychromed limestone and cast glass blocks forming the central design of Lee Lawrie's Wisdom, *the complex and multipart work that dominates the entrance to 30 Rockefeller Plaza.*

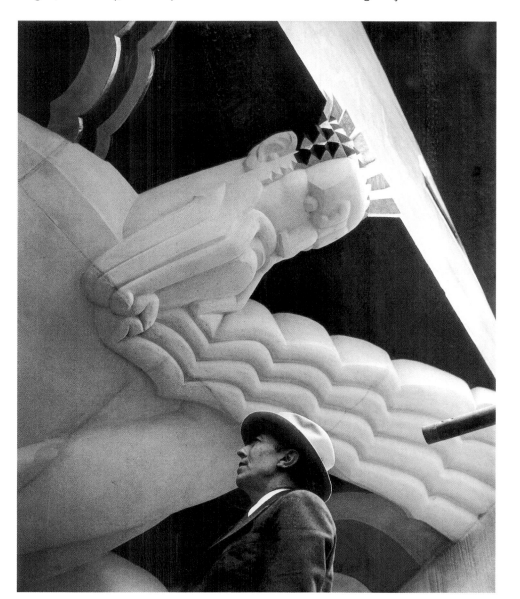

Lee Lawrie examining Wisdom *at the time of its installation, ca. 1934, at the main entrance to 30 Rockefeller Plaza. The figure had not yet been gilded and painted.*

The imposing central figure of the bearded sage Wisdom looms over the main entrance to 30 Rockefeller Plaza. With one hand he thrusts aside the clouds of ignorance, while drawing the cosmic forces and cycles of the universe with his huge compass. These forces spread in huge ellipses over the glass screen below. Through the inscription behind his compass he proclaims, "Wisdom and Knowledge Shall Be The Stability Of Thy Times" (Isaiah 33:6).

Lawrie was deeply involved with the selection of the inscription. He mulled over nine pages of text, containing over fifty passages from the Bible, prior to settling on the text from Isaiah. Also concerned with the appearance of the carved inscription, he chose to "have the words not too easily read and to make as solid a block of ornament below the figure as possible."[2]

In his sculpture, the genius Wisdom is in control of all of man's activities—first masterminding them and then appraising his accomplishments. Lawrie created this colossal figure as the embodiment of power and knowledge, endowing it with a rich three-dimensionality and enduring monumentality. The figure is carved onto one huge piece of limestone. Lawrie established focus on the central figure and generated an awesome and dazzling effect by installing the seven-ton limestone lintel at an acute angle. This brought the top of Wisdom's gilded crown level with the façade of the building and thrust the powerful figure toward the viewer. The massive body with its exaggerated musculature imparts drama to the building's entrance, and his written word conveys an admonition to man that he *will* be measured by a higher power. An effect such as this can only be achieved by brilliant use of space, a virile style, and technical competence.

Appropriately, it is here in the heart of Rockefeller Center, in Building No. 1, that the architects chose to place the bearded sage to preside over mankind, interpret the laws of the universe, and mark the cycles of two of the cosmic forces: sound and light. It was within these two fields that twentieth-century man had ventured farthest in the technological and material world. The Rockefellers knew the future would concentrate on *"the new electric arts of sound and light."*[3]

On the left stone lintel is the figural representation of sound and on the right stone lintel is light, two of the cosmic forces of the universe that disseminate wisdom.

Detail of the carved, gilded and polychromed limestone element in Wisdom, *by Lee Lawrie, at 30 Rockefeller Plaza.*

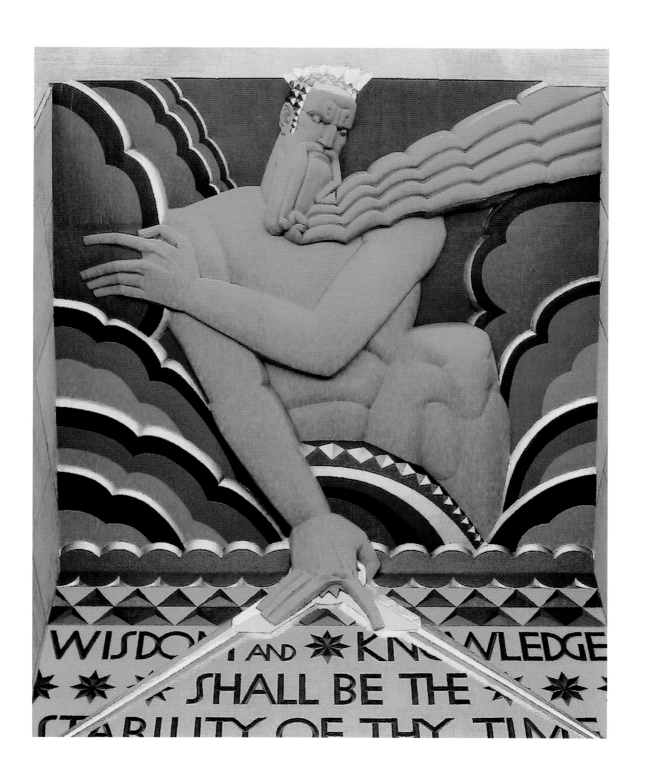

The figure Sound is depicted crouched, leaning forward, his hands cupped around his mouth, shouting. Symbolic circles of noise penetrate the air toward pedestrians below. The bas-relief *Sound* alludes to the dissemination of wisdom through the voices of radio and the telephone.

The figure Light floats in a cloud, holding her arms high above her head. Rays radiate and shimmer all around her. The bas-relief *Light* alludes to the newly developing motion-picture industry and the fledgling television studios that conveyed knowledge through pictures. The compass Wisdom holds in his right hand marks the cycles of these cosmic forces. Below, the swirling forms of movement and luminosity in the glass lintels extend the cosmic forces into glittering panels. The religious iconography of the work, the concept of spiritual light, was molded into one of the glass panels in the form of a large, thin swastika (borrowed from the ancient symbol for life or eternity).

The glass screen was multipurpose. It was to provide natural light in the grand lobby and add artistic complexity to the overall design of the building. The 240 glass blocks were hand-cast at Corning Glass Works from plaster models the artist had created. The blocks were originally mounted using vinylite (a clear synthetic sealant) in the seams and on the interior, and reinforced by steel rods. As massive as they appear, they are fragile and unique; no two are alike and no others exist in the world. At night the lobby is lit and the glass screen radiates light onto the plaza below.

Above the glass, the carved limestone is gilded and painted with a specified range of colors, including subdued blues, deep maroon, beige, and muted orange. Leon V.

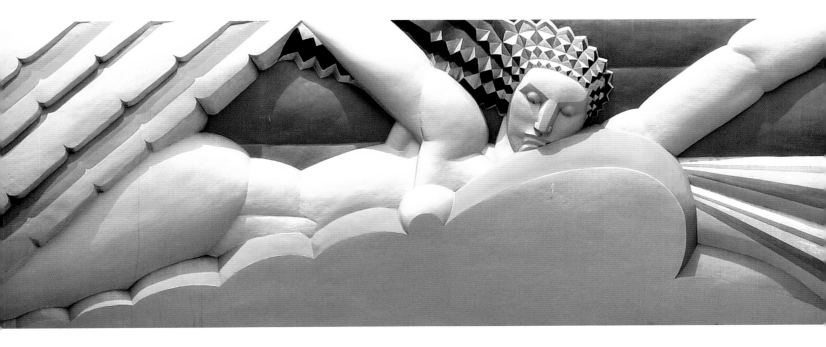

Solon, a talented colorist, developed the gilding and color scheme for the stone work. The architects had requested him to research and provide a durable protective coating for the polychrome stone carvings. Through a chance remark, Solon heard that prior to World War I, the Germans had developed a paint to be applied to concrete gun mounts near the sea and that after twenty years of exposure to salt and wind, the camouflage paint was still intact. Solon imported some of the pigment, Keim Mineralfarben. He found that, owing to its chemical components, it both penetrated the limestone and formed a hard surface coat, in effect creating colored limestone. With this information in hand, he proceeded to design a color scheme for *Wisdom*. It was the first sculpture of polychrome-painted limestone in the Center. The gilding was with 25-carat, XX-deep, genuine gold leaf. The effect was stunning. It further dramatized the sculpture and focused attention on the main entrance of 30 Rockefeller Center. Since 1933, this gilding and color scheme has remained unvarying.

The complex planning of the imposing façade of Building No. #1 stressed the importance of the art program and the significance of the Rockefeller's philosophical beliefs. The immensity and value of the technological achievements of the first part of the twentieth century were very clear to the Rockefellers and the desire to acknowledge and glorify these accomplishments was a matter of both personal and national pride. At this time, the city, and the nation, needed a tangible morale boost and a lucid vision of the possibilities of the future. The government, through the Works Progress Administration (WPA) program, was providing it to a desperate nation. In the private sector, the Rockefeller family was providing it to a depressed city.

Lee Lawrie's gilded and polychromed limestone carvings Sound *(opposite) and* Light *(above) flank each other at 30 Rockefeller Plaza. These figurative bas-reliefs reference the new radio and television industries of the 1930s.*

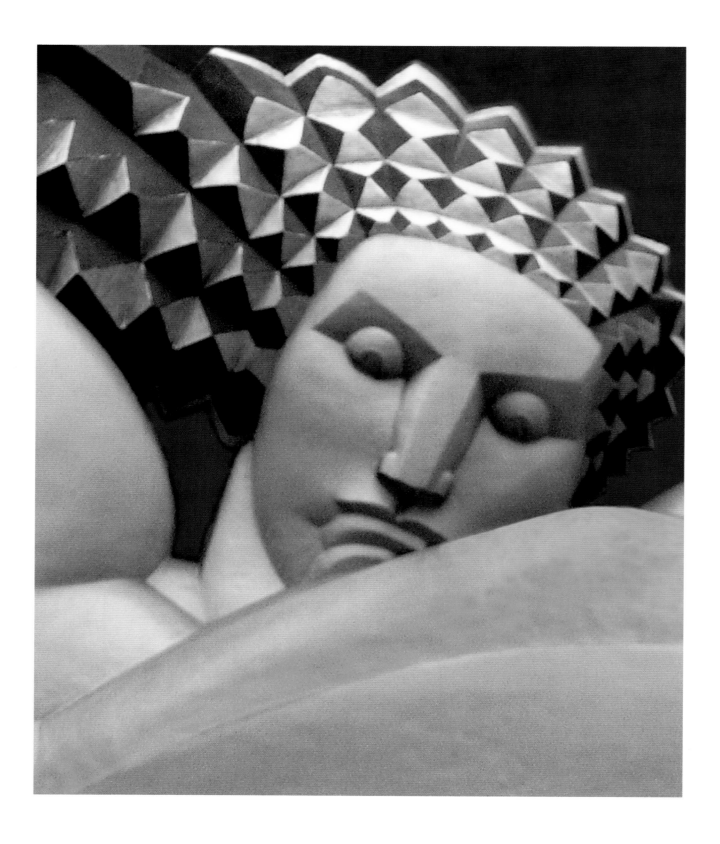

LEON V. SOLON · COLORIST

Working from both his apartment in New York City and his home in Friendship, Maine, Leon V. Solon was to revolutionize the exterior artwork of Rockefeller Center. At the time, he was a well-recognized ceramist and industrial designer, having shown his work internationally. He was most active in Rockefeller Center for a five-year period between 1934 and 1939. His first color work was on Lee Lawrie's sculpture *Wisdom* with *Sound* and *Light*. The work had been contracted directly with Lawrie, who was aware of Solon's work and skill as a colorist. This was enthusiastically received and led to the architects employing him as the expert for color on sculpture. By November 1935, Solon had submitted eighty-seven color schemes for selection. By this time, his contracts were directly with Rockefeller Center, Inc. The contracts were building-specific and awarded him a price for each rendering and an additional fee for supervision of the painters.[4] In May 1936 he created renderings for the French, British, Italian, and International buildings. He was to work with the Rambusch Decorating Company, which had submitted a bid of more than $7,000 to adhere to his color schemes and paint the stone sculptures on these buildings.[5] His research on the German paint system Keim Mineralfarben provided a coating that could withstand the harsh climates of New York City and urban grime by actually integrating with the limestone.

As well as designing color schemes, he supervised all the on-site exterior paint work. Since that time, the colors on the exterior carved limestone have remained unadulterated throughout the Center. Solon's belief in polychrome decoration was that "it is not merely the revival of an art which has fallen into disuse, but the revival of a practice in the arts of architecture and sculpture which was dominant in all countries from the earliest eras up to the sixteenth century. All Greek, Egyptian, Hindu, Chinese, Assyrian and Mayan buildings and sculptures were colored." He goes on to state, "Phidias, one of the most famous of the Greek sculptors, said that an essential was imparted to his sculpture by the artist who treated the surface with color and gold. He stated that he considered the artist's work more important than his own."[6]

In the 1930s, glazed tiles, polychromed terra-cotta, multicolored brickwork, and a variety of metals were being commonly used to provide abstract designs, contrasting patterns, and a variety of decoration to buildings of the period. The Rockefeller Center architects had determined that their buildings would be built of limestone, not brick and terra-cotta, thereby restricting built-in color embellishment. Consequently, Solon advocated the use of gilding and paint in Rockefeller Center to provide color to the otherwise gray façades. He believed, "Perhaps, a hundred years from now, one of the things for which people will gratefully remember Rockefeller Center long after they have forgotten it was once the world's largest and most interesting building promotion will be its re-pioneering in the use of color, its throwing off of the chains of a dead and colorless tradition."[7]

The head of Light *in the sculpture by Lee Lawrie at 30 Rockefeller Plaza. The colorist Leon V. Solon's adroit uses of color give the carving a potent energy.*

EDWARD TRUMBULL · COLORIST

The Grand Lobby of 30 Rockefeller Plaza before Diego Rivera worked on his west-wall fresco and prior to installment of José María Sert's mural Time on *the ceiling, ca. 1933. Note the two information booths that were replaced with a single long black-granite counter. Edward Trumbull was hired to coordinate all the materials and colors used in this lobby and all public interior spaces.*

In 1931, Edward Trumbull was a well-known painter, designer, and muralist who had just completed a stunning mural for the main lobby of the recently built Chrysler Building. Lee Lawrie, well aware of Trumbull work, introduced Trumbull to the engineers at Todd & Brown. As managers of Metropolitan Square Corporation (the original company formed to create Rockefeller Center), they hired Trumbull to be an advisor for color work. Initially, they did not specify any area or project but simply established a rate of pay ($100 per day); that he was to work under the general supervision of the architects; and that "all drawings, paintings, models or work of any kind done by you under this arrangement shall be the property of the Metropolitan Square Corporation."[8]

With his reputation flourishing and two dazzling works in nearby prominent buildings, Trumbull was a natural to be commissioned as the aesthetic advisor for Rockefeller Center. Initially, it was a rather open-ended role. He was asked to provide the architects with detailed color renderings of "whatever they deemed necessary."[9] Oddly, he did not create a mural for the Center himself. Perhaps, it was felt this might duplicate or compete with his recent creations in the nearby Chrysler, Chanin, and Metropolitan Life buildings. Evidently, in March of 1932, as a result of their expanding art program, Todd & Brown reestablished the agreement between Trumbull and Rockefeller Center and laid out his specific duties. He was "to take charge under the supervision of the Architects of all color schemes of work on Rockefeller Center. This includes choosing the colors for marble, elevator doors, painting and materials, such as draperies, carpets, etc. Where requested by the Architects you are to supervise the carrying out of the color schemes selected by you and render whatever color sketches the Architects may deem necessary."[10]

Trumbull had enormous influence on the aesthetics of the main lobby at 30 Rockefeller Plaza. He helped the architects select both José María Sert and Sir Frank Brangwyn to paint huge murals. In spite of their world-class stature, he orchestrated their work. He specified the style in which the artists were to paint. He limited and dictated their color palettes. He provided them with specially ordered and prepared canvases. In a letter to Webster Todd, in January 1933, he wrote, "The scheme of drawings on toned canvas was my idea, and I know your father [John Todd, the engineer in charge of the building of the Center] and everyone concerned, hope that it will be an outstanding success."[11]

During the painting process, difficulties arose concerning Brangwyn's health and his ability to complete the murals and institute some changes the architects desired. Since Trumbull knew Brangwyn well—as a young man he had studied mural painting in his atelier—the architects sent him to England to meet with the aging artist, inspect the murals and determine the artist's progress, and gently discuss some of the problems such as schedule. Trumbull had limited success overcoming the delays. Brangwyn stubbornly refused to alter his working method and delays continued to be inevitable, mostly due to the artist's age and failing health. Eventually the murals were completed and shipped to New York.

After installation of all of Sert's and Brangwyn's murals, Trumbull personally blended their canvases, applied the "toning" application, and supervised the application of the protective coatings.

Trumbull had nothing to do with the fresco by Diego Rivera, as this choice was very much Nelson and Abby Rockefeller's. He did not have a role in the selection or creation of the fresco or in its subsequent destruction.

In spite of his enormous influence at the time, and probably because he personally created no significant artwork, Edward Trumbull very soon became a forgotten figure in the development of the art in Rockefeller Center.

THREE MURALISTS

José María Sert, Sir Frank Brangwyn, and Diego Rivera, all accomplished muralists, were commissioned to decorate the main lobby of 30 Rockefeller Center. Sert and Brangwyn had been on the original list of potential muralists along with Picasso and Matisse. Both Picasso and Matisse proved either too expensive or not readily available to meet the building schedule. Rivera, promoted by Nelson and Abby Rockefeller, was selected as the third painter.

A public relations release dated September 30, 1932, and titled "Re Painting in Great Hall of No.1 Building Rockefeller Center" begins as follows: "They should not be 'illustrations.' The philosophical or spiritual quality should dominate. We want a vision suggested." It continues: "Our theme is 'NEW FRONTIERS.' To understand what we mean by 'New Frontiers' look back over the development of the United States as a nation. The beckoning of geographical frontiers had a vital effect on the growth and shaping of American civilization. As long as there were new geographical frontiers, people always could find a transient escape from old problems, economic, political and even spiritual, by 'moving on.'" The release goes on: "Today our frontiers are of a different kind. There are no new physical territories to explore and settle. Man cannot pass up his pressing and vital problems by 'moving on.' The development of civilization is no longer lateral, it is inward and upward." The release outlined the themes that were assigned to the artists. Brangwyn was to depict the ethical development of man and express man's relationship to society and his fellow

Diego Rivera's sketch for his fresco Man at the Crossroads, *ca. 1932, at 30 Rockefeller Plaza. Rivera deviated substantially from the sketch when he created the fresco.*

man. Sert was to represent man's development of technological power and mastery of the material universe. Rivera's theme was to express societal concepts depicting "man at a crossroads looking with uncertainty but with hope and high vision towards a new and better future."[12] The murals were to embody these lofty concepts as spiritual revelations. They were expected to interact with one another and yet remain distinct works by three major painters. In spite of this seemingly simple plan, the task was enormously difficult, burdened with delays, embarrassment, politics, and anger.

Rivera was to paint the central mural that faced the main entrance, Sert was to paint four murals on the north walls and Brangwyn four murals on the south walls. This plan was radically altered by actions that took place during the next two years.

Sert and Brangwyn were assigned specific spaces in the lobby for each work. They were provided detailed instructions. Themes were set by the art committee. The materials, limited color palette, and method of painting—chiaroscuro—were determined by Trumbull. Canvases were ordered from E.H. and A.C. Friedrichs Company of New York, and the ground color prepared and painted on their surfaces. Trumbull had specified the weight of the canvas and applied a specifically colored primer coat on which the artists were to create their murals. The huge prepared canvases were shipped to Europe in special containers to both artists. Along with the primed canvases were Trumbull's very specific instructions to work in compatible black, white, and gray palettes.

In contrast, Rivera was sponsored by Nelson and Abby Rockefeller. Despite his blatant anticapitalistic views, Abby Rockefeller had collected and championed Rivera's work and had even been the primary benefactor for his one-man exhibition at the Museum of Modern Art in December 1931, "Frozen Assets," a dismal view of the Great Depression. For the Rockefeller fresco, Rivera was given freer rein than either Sert or Brangwyn. He accepted the commission in October of 1932 after assurances that he would be allowed to paint with his choice and range of colors. He was assigned the premier location in the lobby—the largest wall, which faced the front entrance. Rivera was creating a fresco, so his work would take place on site, directly on the plaster wall at 30 Rockefeller Plaza, not on a canvas. He liked publicity and welcomed visitors to his scaffold. Significantly, this proved to be a disadvantage, as his progress on the mural would be scrutinized daily and noticed by the press.

Prior to receiving their commissions, all three muralists had submitted a short description and sketches (or photos of them) for approval.

Upon receiving their contracts, canvases, and first payments, Sert and Brangwyn went to their respective studios in France and England to paint murals with the requisite exalted themes. After Rivera finished a mural for Chrysler in Detroit, he moved to New York to begin his fresco.

DIEGO RIVERA · MAN at the CROSSROADS

In April of 1933, Diego Rivera accompanied by his equally famous wife, the painter Frieda Kahlo, arrived in New York and immediately set about exuberantly prepping and painting directly on the west wall of the main lobby of 30 Rockefeller Plaza. His fresco was to cover the entire wall and wrap around the corners to the flanking walls of the first elevator bank, for cover a total of 1,071 square feet. He was permitted to use color on the front aspect only (the west wall). The flanking frescos were to merge laterally and their colors blend with the chiaroscuro of Brangwyn's and Sert's murals.

Rivera's typical palette was colorful and voluptuous. His technique was bold. He was audacious and fearless in the themes he ordinarily painted, the exceptionally harsh realities and inequities of life, such as war, disease, famine, and revolution. He was one of the most politically dedicated painters, continually espousing Marxism. Rivera's assigned theme was "man at the crossroads looks uncertainly but hopefully towards the future". This general topic was to include the subthemes "human intelligence controlling the powers of nature" and "the era of science." In his written statement, Rivera proposed to depict human intelligence in possession of the forces of nature on one side of the mural and the workers of the world inheriting the earth on the other side.

Opposite: Diego Rivera working on the cartoon for a section of the west-wall fresco Man at the Crossroads *in April of 1933, at 30 Rockefeller Plaza.*

Diego Rivera and his wife Frieda Kahlo on the scaffold in front of his fresco Man at the Crossroads *in April of 1933, at 30 Rockefeller Plaza.*

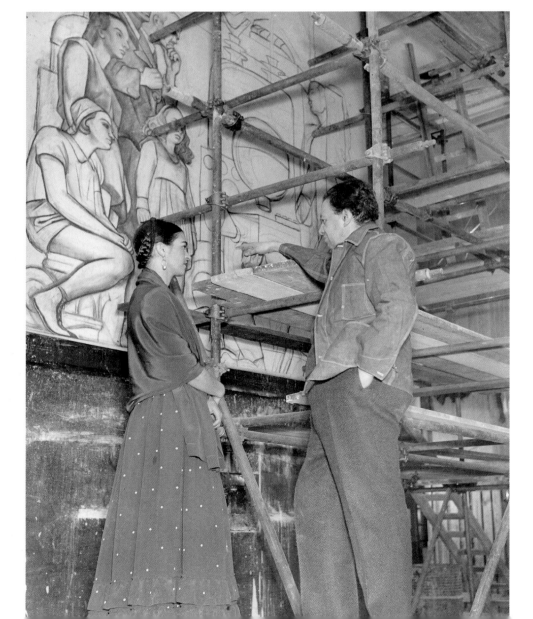

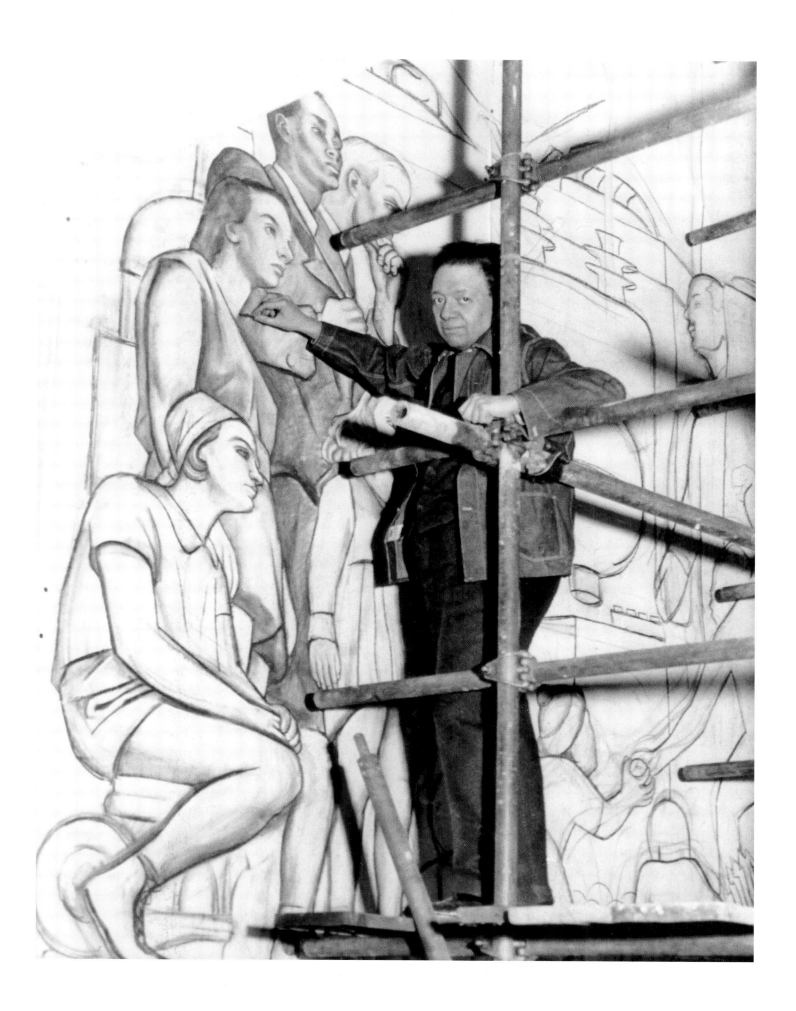

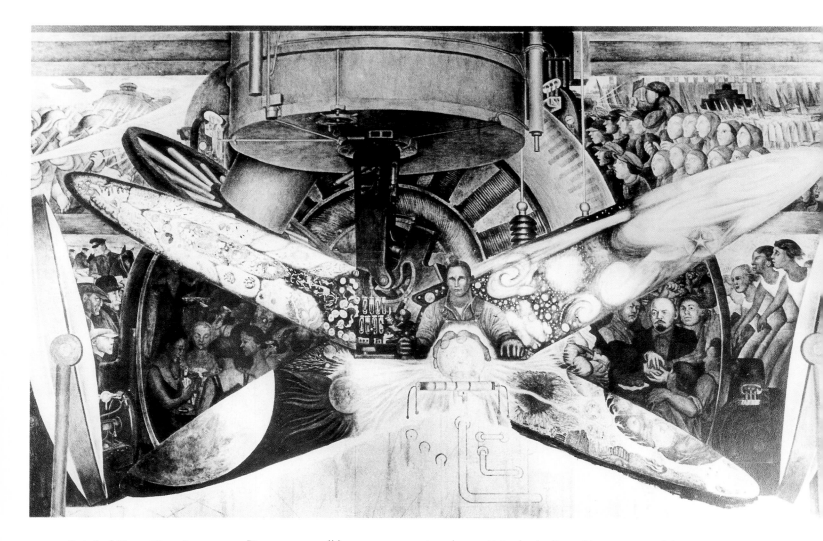

Detail of Diego Rivera's central panel Man at the Crossroads *in April of 1933, at 30 Rockefeller Plaza. The main motif contains two ellipses. The controversial portrait of Lenin is visible in the right quadrant.*

Rivera was well known as an outspoken artist who believed in a communist paradise but opted to work in a capitalist's world. In Rivera's own words, "Art should be propaganda. Art which is not propaganda is not art at all."[13] He reinforced this concept when he stated, "Art must be nothing but art, but there is not a single activity, including pray and love, that is not essentially political."[14] Throughout his life, these views formed the themes and passion found in his paintings. Subsequently, to many people it was not a surprise that the vibrant, monumental-sized fresco he was producing for the Rockefellers included Lenin. Just prior to coming to Rockefeller Center he had painted murals titled *Detroit Industry* that had been commissioned by Edsel B. Ford. These murals had caused considerable hullabaloo and should have raised a warning flag to the Rockefellers, especially Rivera's portrayal of the Holy Family in the panel titled *Vaccination*. It was deemed blatantly sexual and blasphemous and received a good deal of negative press. Furthermore, the murals were judged as an extravagant and shameful expense at a time

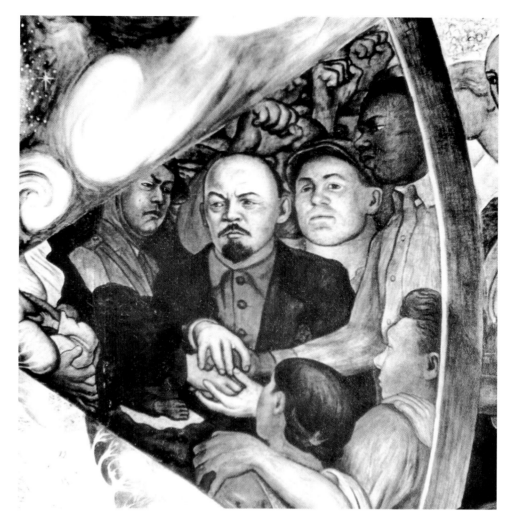

The controversial portrait of Lenin *from* Man at the Crossroads *by Diego Rivera, in April of 1933 at 30 Rockefeller Plaza.*

when automobile workers in Detroit were being laid off. Hence, when the Rockefellers commissioned Rivera, they knowingly hired the complete and complex man—a great artist, a radical, and a provocateur. To this day, questions remain about his descriptions and sketches for the fresco. Were they ever really "approved" or, for that matter, ever really looked at until the problems arose? Or, had Rivera simply been ushered in by Abby and Nelson?

The story goes that Lenin's face had not been apparent to the architects either in Rivera's sketches or in the written description of the proposed work. Naturally, when it became evident, the architects and Nelson Rockefeller were alarmed and approached Rivera about changes. Nelson wrote a diplomatic letter to Rivera both praising his work and asking to have the face of Lenin removed, since he thought it, "appearing in this mural, might very easily seriously offend a great many people. If it were in a private house it would be one thing, but this is in a public building and the situation is therefore quite different."[15]

The partially completed fresco *Man at the Cross-roads* covered up during the Lenin controversy, in May of 1933, at 30 Rockefeller Plaza. Diego Rivera was paid in full and dismissed. After one year, the fresco was destroyed.

Rivera wrote a reply suggesting he insert some great American leader such as Lincoln as a balance to Lenin. In essence, Rivera was obstinate and flatly refused Rockefeller's request to remove the head of Lenin. Rivera wrote, "I understand quite thoroughly the point of view concerning the business affairs of a commercial public building, although I am sure that the class of person who is capable of being offended by the portrait of a deceased great man, would feel offended, given such a mentality, by the entire concept of my painting. Therefore, rather than mutilate the conception, I should prefer the physical destruction of the concept in its entirety, but preserving, at least, its integrity."[16]

A few days later, on May 9, 1933, Rivera was dismissed from the incomplete project and given a check for the entire amount due ($21,000). That same day the fresco was covered with brown paper. On a quiet Saturday night, February 9, 1934, the controversial fresco was smashed. Obviously this was a decision the Rockefellers had agonized over, as they waited nine months to the day, for any signs of accommodation, before ordering this drastic action.

A public debate ensued; the art community was outraged and public protests were held outside 30 Rockefeller Plaza. The Rockefellers responded by issuing a terse statement: "The Rivera mural has been removed from the walls of the RCA Building and the space re-plastered. The removal involved the destruction of the mural."[17] Not intimidated, Rivera flaunted his dismissal and, sounding a triumphal note to the press, stated that Lenin's message had reached the exploited masses because the richest man in America had destroyed his image and it was front-page news.

Rivera's final response to the Rockefellers came the following year when he re-created a version of the *Man at the Crossroads* fresco in Mexico, from memory, notes, and photos furtively taken by an assistant. In many ways it thematically duplicates the Rockefeller fresco, including the face of Lenin, but it varies in many ways too. For one thing, he added a revenge portrait, an unflattering depiction of John D. Rockefeller Jr. as well as portraits of Trotsky and Marx. It also includes many modifications that advanced or altered the original theme. The title itself, *Man Controller of the Universe*, differs and indicates a great deal about the changes. This fresco is even more cynical and raw in its depiction of the inequities of life than his original one. It is said that Rivera wanted it to haunt the Rockefellers forever. *Man, Controller of the Universe* can be viewed at the Palacio de Bellas Artes in Mexico City.

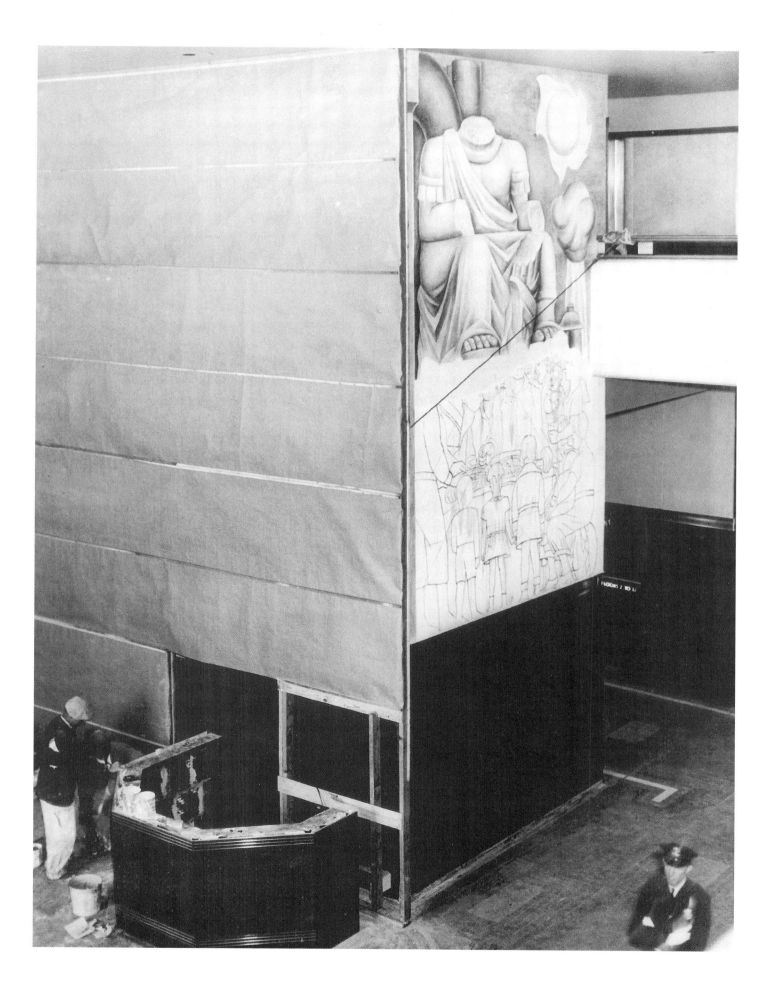

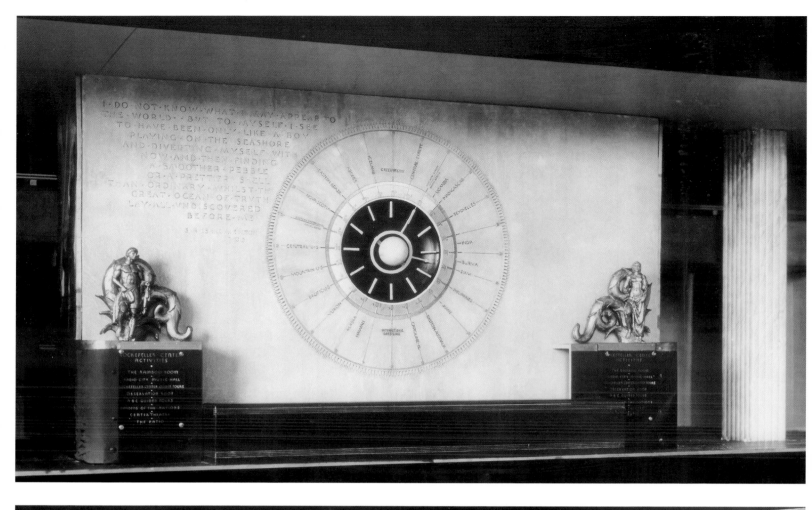

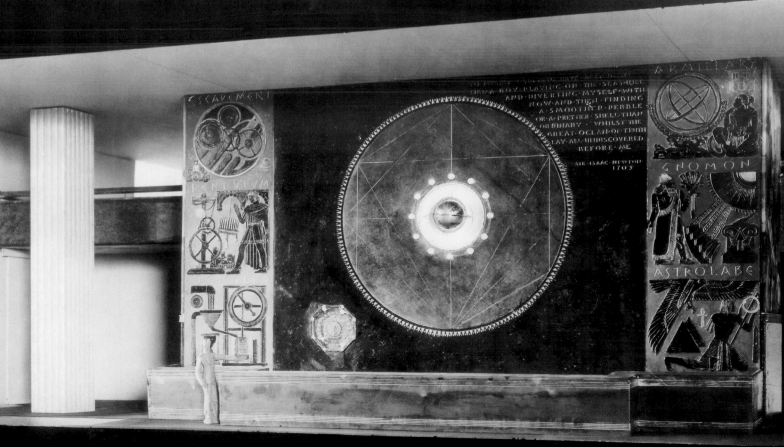

THE WAILING WALL

Immediately following the destruction of Rivera's fresco, the Rockefellers assigned the architects the task of discreetly finding a suitable artistic replacement for this prominent area. Within a short time, memos were circulating about "the wailing wall," as the architects termed the empty space. Five options were developed in an October 1, 1935, memo from John Todd to Henry Schley, who had been hired to act as a liaison between the managers and the architects. Schley's role was to coordinate and settle differences, a task that had become necessary as more buildings were being planned and constructed. Todd outlined his choices as follows: "*Possibilities for River Space* (1) Clock, bronze figures from the fountain, etc. with the side murals on the ends. (2) Milles' idea of a black marble background, with glass figures in bas relief and free standing. The ends in marble or murals. (3) Bas relief treatment in plaster—possibly with a clock in the center and possibly with murals on the ends. (4) Treatment with the right colored mirrors and possibly some of this new Pittsburgh plate glass effect; with or without a clock; with or without murals on the ends. (5) All murals."[18] The Milles proposal appears to have had the most potential, as subcontractors were contacted and detail costs were worked out. A mere two weeks later (October 18, 1935), another memo that circulated presented five concepts, which were slightly more focused than the first proposals. The concepts were given in order of preference: The first was a complete mural wrapping the three sides—by Sert. The second item was a map of the Center. The third idea was the clock scheme. The fourth proposal was the mirror scheme. And, the last was the Carl Milles's black marble and glass decoration with a changed subject matter.

Over the next months many of these options and more were discussed, sketched, modeled, or projected on to the wall. The 1,090 square feet of the wailing wall was on the agenda for the weekly architects' meetings until nearly a year later, September 1936, when the architects suddenly decided to "go to Sert unless something better shows up."[19] By the end of December 1936, José María Sert received the commission for this prominent space—he was delighted.

Opposite, top: A proposal for the west wall, termed "the wailing wall" by the architects, ca. 1934. This proposal used Manship's two figures, Youth and Maiden, *that had been removed from the Lower Plaza where they had flanked* Prometheus.

Opposite, bottom: Another proposal for "the wailing wall," ca. 1934. This proposal employed a huge clock flanked by historic instruments that indicate time and place, such as an astrolabe, and also introduced the concept of a long single information counter.

JOSÉ MARÍA SERT · AMERICAN PROGRESS

When José María Sert received the commission for the main lobby space, he immediately set about creating a mural that would surpass the Rivera fresco. Sert and Rivera were acquainted with each other, and had had several opportunities to review the other's work in Rockefeller Center. By the time the Rivera fresco was destroyed, Sert had already completed his series of grandiloquent murals for the four walls of the elevator banks, and was visibly elated to receive this particular commission. It was widely known that he disliked Rivera and his politics, and resented his reputation in the art world. This was a triumphal moment in Sert's life.

Sert was a Spanish Catalan painter who spent his creative life in Paris. He was politically conservative, arrogant, and had achieved international acclaim in the society set. His mural work at the Cathedral of Vic established his importance in Spain. His previous work at Rockefeller Center and work for the noted architect William A. Delano, as well as murals for the Waldorf-Astoria, had brought him considerable fame in America. Now, he was about to produce his most grandiose and undoubtedly sumptuous mural in America.

Not desiring any additional artistic bombshells like the Rivera fiasco, the architects commissioned Rene Chambellan to create a model (1:10 scale) of the lobby space. This bulky model was shipped to Sert in Paris. Using the model for form and size, he produced a meticulously detailed oil sketch, and shipped the model containing his proposed mural sketch back to New York. Fortunately, this oil sketch is extant in a private collection. It is a valuable record of the process and insight to the final work. The result of all this meticulously planned and carefully orchestrated effort is his stunning mural *American Progress*.

José María Sert joining Diego Rivera on the scaffold in 1933 and examining his sketch for the fresco at 30 Rockefeller Plaza.

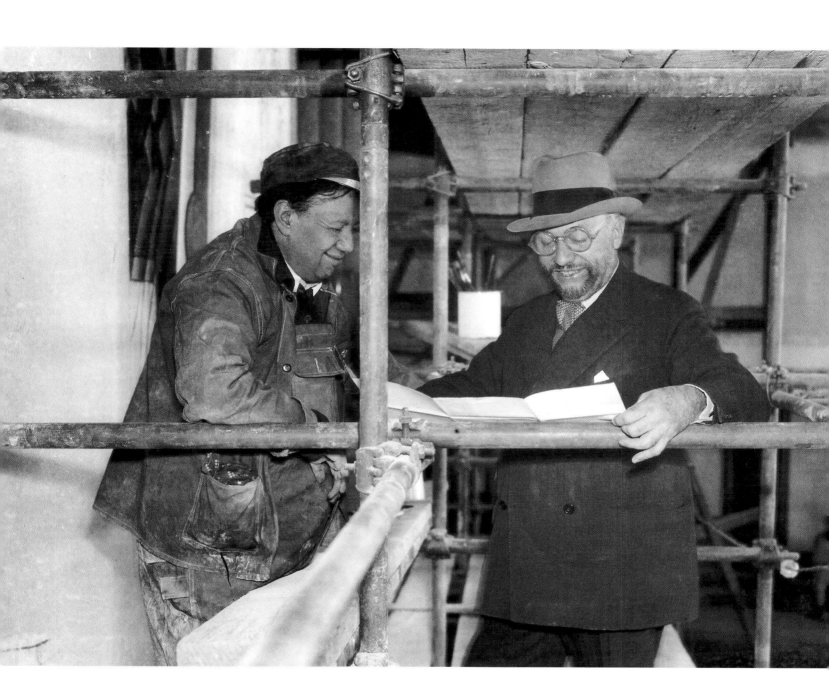

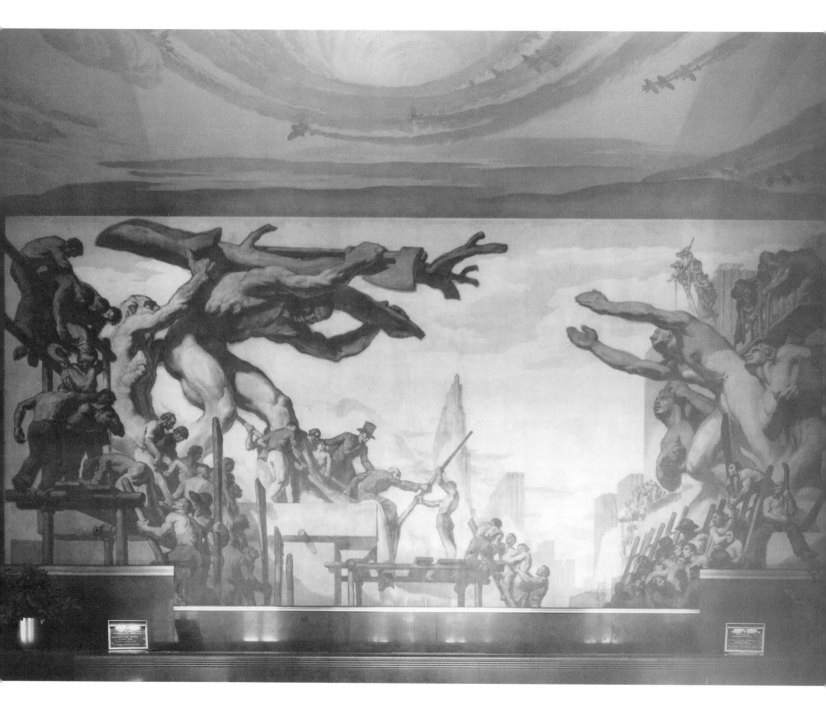

José María Sert's Ameri-can Progress *installed on the west wall of the Grand Lobby of 30 Rockefeller Plaza in December 1937.*

American Progress radiates power. It is a vast allegorical scene of men constructing contemporary America. Over sixteen feet high and forty-one feet long, it is the focal point of the Grand Lobby, set behind the Information Desk and above the black Champlain marble walls.

With a virtuoso use of images and symbolism, Sert depicts the development of America during the past three hundred years through the harmonious unity of brain and brawn. The theme, American progress, is reconfirmed with the presence of two great Americans: Abraham Lincoln (standing on the left center) as the man of action and Ralph Waldo Emerson (seated below Lincoln) as the great philosopher and thinker.

The mural portrays the harmonious relationship between idealists and labor. On the right, small figures are raising heroic statues of three Muses: Poetry, Music, and Dance. Representing creative energy and man's dreams, their arms are outstretched to receive the results of Labor's effort. On the left, looking toward the soil for strength, men of action are raising colossal statues representing Labor. In the background, Sert painted the rising towers of Rockefeller Center, his idea of the fusion of labor and ideals. *American Progress* does not wrap the flanking walls. Sert was commissioned to paint two additional murals for these areas.

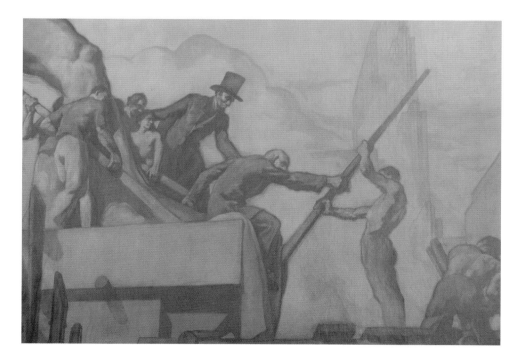

The figures of Lincoln and Emerson in José María Sert's American Progress *mural in the Grand Lobby of 30 Rockefeller Plaza.*

On the north flanking wall, Sert created *Spirit of Dance*. The mural presents an idealistic scene, symbolic of joy and release from the problems of everyday life. The central figures are tied together, suggesting that all men are connected and face the problems of everyday life together. Six other figures are on a scaffold, reaching out toward the larger figures to help release them from their bonds. The central figures dance as their restraints fall away. An expression of elation and freedom can be found in the face of the figure being dramatically lifted by her joyous partner. Sert's mural was conceived to have wide-reaching symbolism. Throughout the world, dancing provides mankind the power to move freely and forget the tribulations of daily life.

On the south flanking wall, Sert's mural represents "man's triumph in communication." Here he pays homage to modern communication through the advent of radio, telephone, and telegraph. As in his mural *Spirit of Dance*, Sert employs a scaffold, ropes, and two sizes of figures to symbolize his message. The large, godlike figures are placed in the foreground. One god is speaking into a globe representing the world, while the other heroic figure listens to him from the other side of earth—symbolizing that the new electronic communication has no bounds. The six smaller figures represent mankind, who through his cooperative and creative efforts has tied the gods and the world of communication together. They depict mankind working in harmony and communicating from above and below, while hoisting the harnessed world of communication. Four small figures lean off the scaffold struggling to hoist the ropes that encircle the globe. One is in the background leaning forward and giving encouragement to their efforts. The sixth figure is standing on one god while reaching upward. He is struggling to aid the others to elevate the world of communication. He is not standing at the feet of the god, but on a leg, symbolizing mankind's triumph. Rockefeller Center, symbolic of the modern age of communication, is seen being built, rising in the distance.

By the time the building was completed, José María Sert had been commissioned to paint a total of twelve heroic-size murals. He painted all the murals in his studio in Paris and transported them to the Center for installation. To apply the paint, he not only used paintbrushes but also employed a variety of techniques including dragging rags and finger painting, to achieve his characteristically complex and sumptuous images.

Edward Trumbull had specified the materials and a subdued and muted color range: black, white, and gray. Sert took the color limitations further, restricting his palette to "stony" colors as if his figures were sculptures. Despite these rather limited tones, he achieved an astonishing range of hues, creating the illusion of depth, space, and motion and achieving a complex spatial unity. This neutral coloration and vastness of the canvases also serve to architecturally integrate the murals with the building. The result bedazzles. It is dramatic and imposing.

*José María Sert's
murals* Spirit of Dance
(left) and Communication
*(right) on the north and
south flanking walls
off the Grand Lobby of
30 Rockefeller Plaza.*

The largest of the murals, titled *Time*, was the last to be commissioned and is hung on the vast ceiling of the Grand Lobby. It is an amazing triumph of technology, as more than two tons of adhesive was used to fasten the five thousand square feet of canvas to the ceiling. At the same time, extensive reconstruction of the lobby was ordered to highlight the new work. The ceiling was recessed and light fixtures were replaced, concealed at the top of the columns and over the entrance doors. The two small information desks were removed, and one long black granite counter was installed in front of the black Champlain marble wall.

Time depicts the art committee's requisite spirituality with flamboyant style and complex iconography. High above the marble floor, the ceiling is alive with light, energy, and power. Three heroic-size figures—Past, Present, and Future—symbolize the phases of man's accomplishments. The figures of Past and Future hold hour-glasses representing elapsed and future time. The sand pouring from these hour-glasses accumulates on a scale held by Present. Sert depicts the scale as great plates hung from heavy chains that are slung around huge logs. He had previously painted a Titan struggling with a huge log in the 1937 mural *American Progress*. He revisited this symbol in *Time*, referencing the other mural and linking them, thereby unifying the themes in the lobby. In *Time*, the main figure, Present, struggles to support the massive scale, which bears the burden of man's deeds. The plates are balanced, leading to the conclusion that, on the whole, man has a bearable past performance and is hopeful of a better future.

Sert's finesse is evident as he integrates the mural into the architecture. The huge figures are depicted with their feet spanning the large marble columns of the lobby. There is nothing hesitant or happenstance about the work. Sert's mastery of perspective could be construed as contrived, but the result is powerful and his message clear and well structured. Observing the scene through the huge, nearly nude figures' massive, spread legs, the viewer, starting on the south side of the lobby and slowly walking north, will think the figures are shifting or moving, a remarkable aspect of the artist's perspective.

Along the eastern edge of the ceiling, men are working on a large airplane. Here, man is creating tools and demonstrating the ability to produce machines that can aid mankind. In the center background, a fleet of aircraft exemplifies man's conquest of time and space. As they speed through space, their spiraling contrails generate a whirlpool, representing infinity. The vortex draws the viewer in toward the unknown and the future.

The outstanding effects Sert achieved with his use of chiaroscuro, heroic-size figures, modern machines, swirling forms, and unique perspective radiate drama, extraordinary grandeur, and an incontestable belief in power.

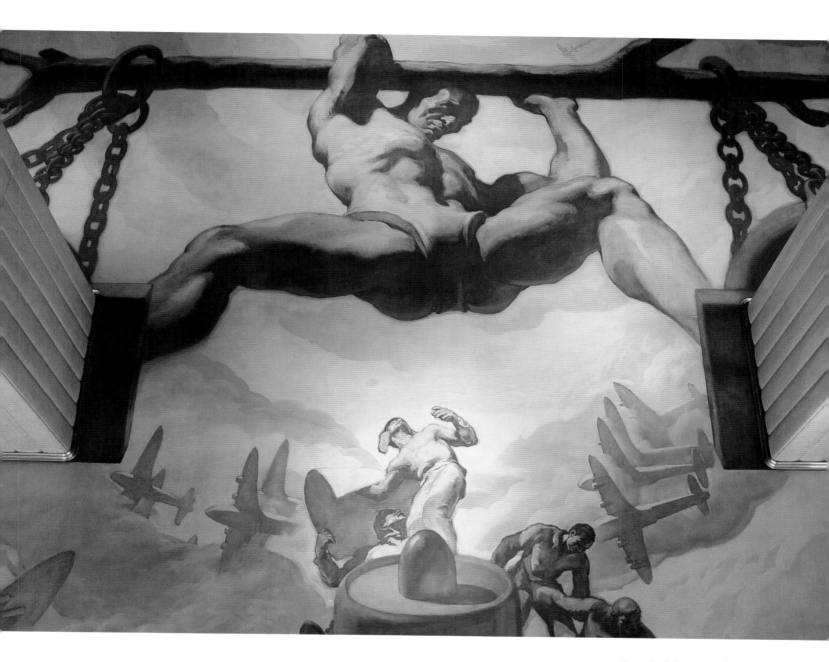

Detail of the central figure in the ceiling mural Time by José María Sert, in the Grand Lobby of 30 Rockefeller Plaza.

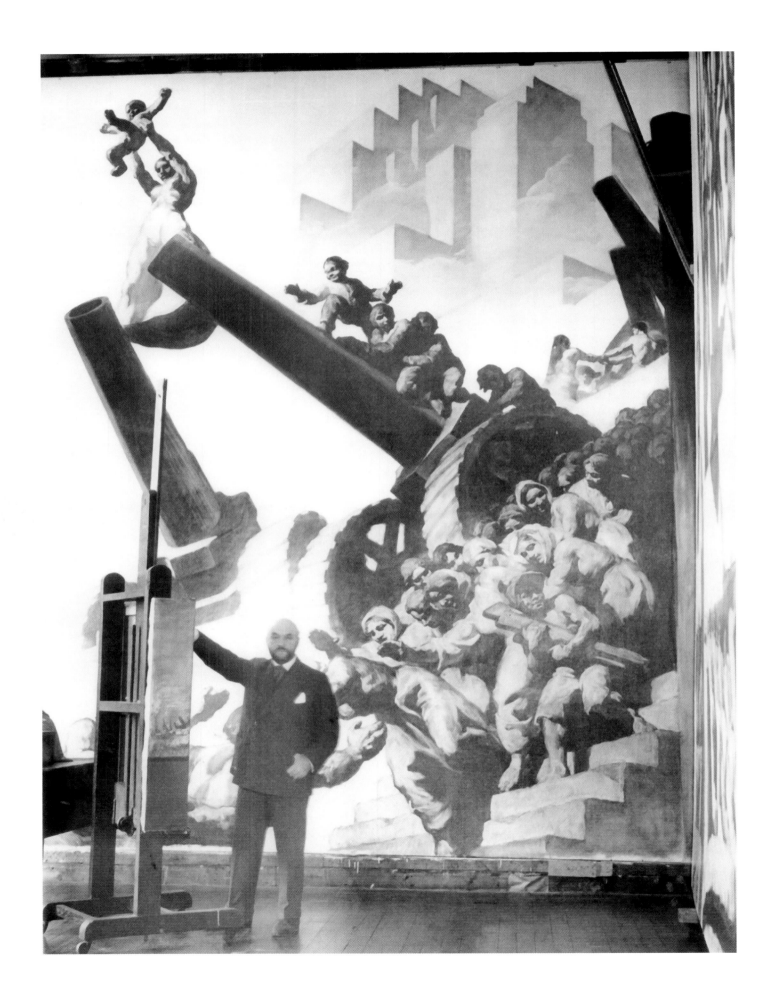

NORTH CORRIDOR MURALS

Backtracking in time and sequence, Sert's first commission was four murals for the north corridor of 30 Rockefeller Plaza. The individual murals were to wrap the ends of the four elevator banks. A public relations release outlined the theme for this optimistic group of murals: "They express man's new mastery of the material universe, through his power, his will, his imagination and his genius. These are: 1. The painful labor of former ages conquered by the creative intelligence of the machine. 2. The pest and the epidemics of yesterday conquered by scientific inventions. 3. Ancient slavery conquered by the human will. 4. The combined faculties of man applied to the quest for human happiness—which are strong enough to suppress war."[20]

Interpreting these specific themes in his own distinctive manner, Sert painted the following murals: *Abolition of War, Abolition of Bondage, Conquest of Disease*, and *Powers That Conserve Life*.

In the foreground of the mural *Abolition of War*, people joyfully triumph over the machinery of war. A vigorous baby is held aloft by a heroic-size female standing at the top of a cannon, while a boy precariously plays on the barrel. The notion that by ending war, life can continue is symbolized by the raising of the baby—an envoy of hope and the future. Below the cannon, rejoicing women rush down stairs to welcome their men home from war. The men are depicted with their arms outstretched, thrusting upward toward their wives. In the background, a triumphant army with banners waving moves toward a city of modern skyscrapers, emerging from the smoke of battle.

In the lower section of the mural *Abolition of Bondage*, slaves are toiling, painfully moving a huge lever set into a cog below a rock ledge. Above, slaves bound to stakes look hopefully and expectantly up at their liberators as others are released from their shackles. On the lower left, around the corner, a figure is bowed under the weight of a massive boulder, representing the age-old burdens of the world. Soldiers arrive from the left side of the canvas, presumably to help free more slaves.

The mural *Conquest of Disease* depicts a doctor and his assistant ministering to and inoculating lines of ailing people. Sert did not limit his vision to a specific place. The scene is set on a massive rock conveying the sense of everywhere on earth. In the center lies a great fallen column against which are huddled fearful and suspicious masses. This mass of people is symbolic of the ignorance and apprehension present during the first part of the twentieth century concerning "modern" medicine and particularly inoculations. The fallen column is a traditional symbol for earlier periods or attitudes that have been conquered.

José María Sert in his Paris studio, ca. 1933, painting the mural Abolition of War, *to be installed on the first elevator bank at 30 Rockefeller Plaza.*

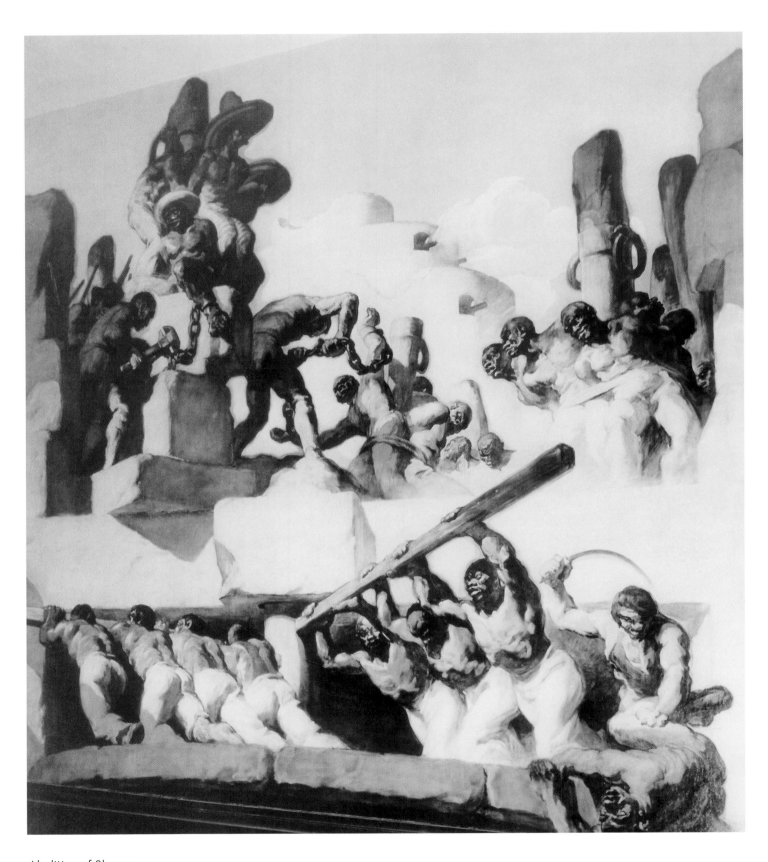

Abolition of Slavery,
*José María Sert's mural
for the fourth elevator
bank at 30 Rockefeller
Plaza, ca. 1933.*

Conquest of Disease,
José María Sert's mural
for the third elevator
bank at 30 Rockefeller
Plaza, ca. 1933.

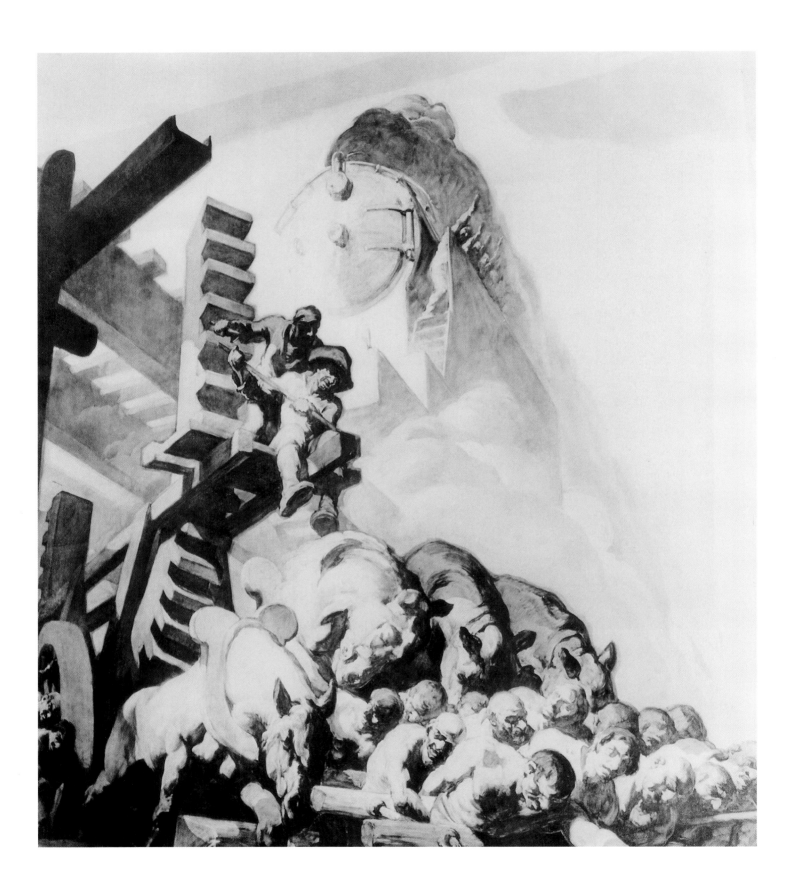

The canvas titled *Powers That Conserve Life* represents the development of machinery. The theme was described as "abolition of painful labor by the creative intelligence of the machine." A massive locomotive appears in the background as though rising from the energy of the struggling laborers in the foreground. Some of the laborers and even the horses have their eyes closed, owing to the great efforts they are making to accomplish their tasks. Symbolically they are transporting new technology represented by the gear. Knowledge and machinery will release them from their role as beasts of burden.

On the balustrades at the end of the north and south corridors, the murals *Fire* and *Light* are hung. In *Fire*, Sert represents the sun as the source of life. In *Light*, Sert has painted the supreme ruler of the world.

In the Grand Lobby, hung on the mezzanine staircase walls are two additional murals by Sert. The north staircase wall is titled *Contest 1940*. It depicts the five races of mankind: Caucasian (white), American Indian (red), Mongolian (yellow), Malay (brown), and African (black). They are shown scuffling with a globe, a symbolic football in the struggle for supremacy of the world.

On the north staircase wall is the mural *Fraternity of Men*. Men of all races reach out to join hands, their wars fought and their wrath spent. Mankind's problems are resolved, symbolized by a broken cannon resting on the ground at their feet.

Sert did more than paint the requisite themes. He was enthusiastic, extravagant, and bold. With abandon and sophistication, he depicts the struggles of mankind as universal problems. He thrust his subjects forward and imposes his messages on the viewer. He understood spatial concepts and employed unique perspectives, colors, and mass to achieve his dramatic effects. His murals dominate the lobby of 30 Rockefeller Plaza. One cannot pass through this space without having experienced the talent of José María Sert.

Powers That Conserve Life, *José María Sert's mural for the second elevator bank at 30 Rockefeller Plaza, ca. 1933.*

SIR FRANK BRANGWYN

England's most famed muralist of the time, Sir Frank Brangwyn was chosen to paint four murals for the south corridor of the Grand Lobby at 30 Rockefeller Plaza. Edward Trumbull had been very influential in getting Brangwyn to agree to this commission, as he had studied with him. However, the final determination was left to John Todd, the engineer, and Raymond Hood, the architect, who went to England to meet with the artist.

Throughout his career Brangwyn had been an atypical artist, interested in expanding his artistic reach into the business world. He followed his own muse as a muralist, an easel painter, and designer for the interior design market. He worked on a variety of commercial projects creating glass and pottery objects and designing for textile, furniture, and carpet manufacturers.

To facilitate the creation of the Rockefeller murals, Brangwyn was provided with the appropriate themes, all the necessary materials, and a description of the artistic technique that was to be employed. Edward Trumbull specified the subdued color scheme and "drawings-on-toned-canvas" technique. It was essential for the aesthetic organization of the lobby that Brangwyn's murals harmonize with the adjacent Sert murals. Even with these extensive guidelines, the result is a strange juxtaposition, as stylistically they are very different. Brangwyn's work is tranquil, a series of narrative sketches or illustrations, in contrast to the energetic quality of Sert's melodramatic paintings.

These murals need little interpretation, as Brangwyn added conspicuous text to each one while illustrating the various themes. The inscriptions were, according to Brangwyn, the work of Philip Macer-Wright, "a London literary man who is an intimate friend of mine and deeply interested throughout in the success of my undertaking."[21]

The central theme Macer-Wright developed for Brangwyn's murals is that "man in his search for truth and happiness must learn to accept the fundamental teachings of Christ." H. E. Winlock, director of the Metropolitan Museum and a member of the advisory group, wrote the following to the engineer, Webster Todd, the son of the chief engineer John Todd: "I do not believe that the introduction of Christ into a business building is in the best taste. It is likely to raise one of two thoughts in the beholder's mind: Either you are taking the stand that Christianity is a thing of the past, or you are calling to mind a certain smug type which hides behind religion to cover up business. I am not a religious person myself, but I have an idea that when Christ kicked the money-changers out of the Temple he didn't intend to follow them into their offices."[22]

The result of this concern was to send Trumbull to see Brangwyn in England to discuss removal of the text. He was also to attempt to make changes in "the Christ" figure.

Trumbull cabled John Todd from London: "BRANGWYN DOES NOT WISH TO REMOVE LETTERING BUT IS RECONSTRUCTING SAME AS SUGGESTED HE WILL CHANGE CHRIST PANEL BUT IF YOU FORCE MORE CHANGES I FEAR HE WILL QUIT."

Obviously, Brangwyn was not willing to alter his vision too drastically. At this time he was quite ill and having difficulty completing the demanding commission. He was two months behind schedule. As a last resort, the architects were considering placement of the murals in another location and reassigning the space. This move

Frank Brangwyn in the Royal Pavillion at Brighton, England, ca. 1933, painting his mural Man the Creator and Master of the Tool, *to be installed on the elevator bank walls of the south corridor at 30 Rockefeller Plaza.*

was reconsidered a number of times. By June 1936, following installation, the architects did not like the combined aesthetics of the Brangwyn and Sert murals. They considered removing the Brangwyn murals and reinstalling them in the lobby of the British building. This never happened, primarily because of cost and inconvenience or, as it was described, a "ghastly hiatus" that would ensue while that section of the lobby was bare.

Owing to his reputation, and the importance of the Rockefeller commission, the Royal Pavillion at Brighton had been placed at Brangwyn's disposal to execute the enormous canvases. He used many local people from his hometown, Ditchling, England, as models for the original sketches and conducted a public search for the perfect Eve.[23] Years later, after World War II, locals from Ditchling would come to New York to gaze up at friends and relatives from their town. A number of these people have been identified as models for the murals.

The murals are twenty-five feet high and seventeen feet wide and were transported from England to the Center for installation in December 1933. The first three murals represent the three stages in man's conquest of the physical world. The fourth suggests the nature of his destiny. Brangwyn did not title his paintings, but because the four Philip Macer-Wright inscriptions were descriptive of the individual themes, they are used to designate the murals. They hang in the south corridor at the ends of the elevator banks and turn into the elevator corridors for a distance of about six feet. The sequence described below follows from west to east (from the rearmost mural to the front lobby).

The first mural portrays the beginning of civilization. It includes the inscription "Man laboring painfully with his own hands; living precariously and adventurously with courage, fortitude and the indomitable will to survive." It depicts man and, perhaps the Eve he reportedly searched for, nude amid a background of jungle beasts.

Opposite: View of the south corridor of 30 Rockefeller Plaza with the four Brangwyn murals installed, ca. 1933.

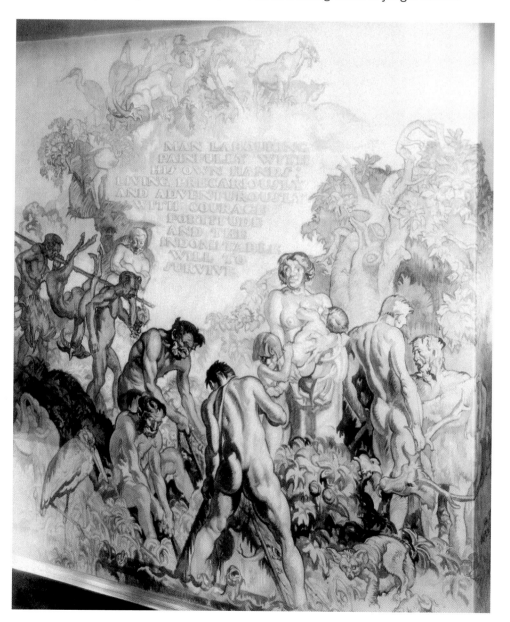

Frank Brangwyn's mural Man Labouring Painfully with His Own Hands, *installed on the fourth elevator bank walls at 30 Rockefeller Plaza, ca. 1933.*

The second mural illustrates the birth of agriculture and the tool. The inscription is, "Man the creator and master of the tool. Strengthening the foundations and multiplying the comforts of his abiding place." It illustrates man beginning to manufacture tools and work the land.

The third mural deals with the development of the machine age and the resultant comforts and problems that it can provide. The inscription reads, "Man the master and servant of the machine, harnessing to his will the forces of the material world, mechanizing labour and adding these to the promise of leisure."

Opposite: Detail of Frank Brangwyn's Man the Creator and Master of the Tool, *installed on the third elevator bank walls at 30 Rockefeller Plaza, ca. 1933.*

Frank Brangwyn's Man the Master and Servant, *installed on the second elevator bank walls at 30 Rockefeller Plaza, ca. 1933.*

MANS
ULTIMATE DESTINY
DEPENDS NOT ON
WHETHER HE CAN
LEARN NEW LESSONS
OR MAKE NEW
DISCOVERIES AND
CONQUESTS BUT ON
HIS ACCEPTANCE OF
THE LESSON TAUGHT
HIM CLOSE UPON
TWO THOUSAND
YEARS AGO.

The fourth mural brings forth the sermon on the Mount. Its inscription reads, "Man's ultimate destiny depends not on whether he can learn new lessons or make new discoveries and conquests, but his acceptance of the lesson taught him close upon two thousand years ago." In the upper central section of this mural is a vague, robed and hooded figure, with rays of light emanating from behind him as if radiating power and godliness. Frank Brangwyn wrote to John Todd about resolving the problem of this "Christ-like figure" "I have tried very hard to follow your ideas in No. 4 panel, but have had to make a compromise, as I found it impossible to do away with the central pivot of the whole composition. The result is a nebulus [sic] effect, of a figure which looks more or less like a light."[24]

Trumbull touched up all of Brangwyn's murals. Areas that were damaged during shipping and installation were carefully in-painted, and coloration at the edges blended and matched to the adjacent areas. Finally, all the surfaces were coated with a tinted varnish to mellow or tone them.

The architects expressed concern about the stylistic disparity between Sert's and Brangwyn's work. They wondered if Trumbull could successfully balance the mural's tone and coloration to integrate the aesthetic differences with the adjacent Sert murals. Even today, this apparent lack of harmony promotes conversation and debate.

Mural painting frequently is a collaborative art or an agreement between the patron and the artist; the space offered, the theme specified, and the artistic rendering or interpretations of the commission characterize the completed work. In the instance of 30 Rockefeller Plaza, each of the muralists was a brilliant painter and, with the exception of Rivera, fulfilled his commission within the specified parameters, and each played a role in individual Rockefeller lives.

Brangwyn's work would reflect John D. Rockefeller Jr.'s endeavor to portray moral values and a spiritual world. Sert was from the international society set and most likely reflected Nelson Rockefeller's efforts to attract sophisticated tenants and an exclusive clientele to the offices, restaurants, and shops. Rivera was the rebel, the avant-garde artist whose controversial works attracted Nelson and his mother, one of the founders of the Museum of Modern Art.

Unfortunately, the 1930s was a time when too much was at stake to have socially scandalous or politically reprehensible pictures that might affect leasing the new building. Regrettably the Rivera mural was lost, but the Sert and Brangwyn murals remain as evidence of a remarkable program.

Man's Ultimate Destiny, *Frank Brangwyn's mural installed on the first eleva- tor bank walls at 30 Rock- efeller Plaza, ca. 1933.*

LEO FRIEDLANDER · TRANSMISSION

Two stone carvings crown the monumental pylons that rise above the Forty-ninth Street entrance to 30 Rockefeller Plaza. These works, by the artist Leo Friedlander, are emblematic of the newly developed communications field of television. Additionally, Friedlander created two other pylon crowns for the Fiftieth Street entrance that represent radio. Collectively, the sculptures are titled *Transmission*. In the 1930s these works were important symbolically, as radio and television were thought to be devoted not only to the interests of science but also to cultural development.

During the construction of Rockefeller Center, the engineers did not limit their comments to structure and building materials but constantly expressed their opinions on the aesthetic aspects of the work, especially the members of the Todd family. In this instance, Webster B. Todd voiced his view about Friedlander's work. He wrote to his father, John Todd, "With reference to the Friedlander sculpture on Building #1, may I give you my reactions. 1) I do not care for the subject matter of the sculpture. 2) However, forgetting the unpleasantness which everyone must have on a closer examination of the work, a hasty glance at those two entrances give the feeling of a scale lacking, to me, in the other similar work done in the development."[25]

Leo Friedlander's carved stone sculptures alluding to the transmission and reception of radio, located at the top of the Fiftieth Street entrance pylons of 30 Rockefeller Plaza, ca. 1934.

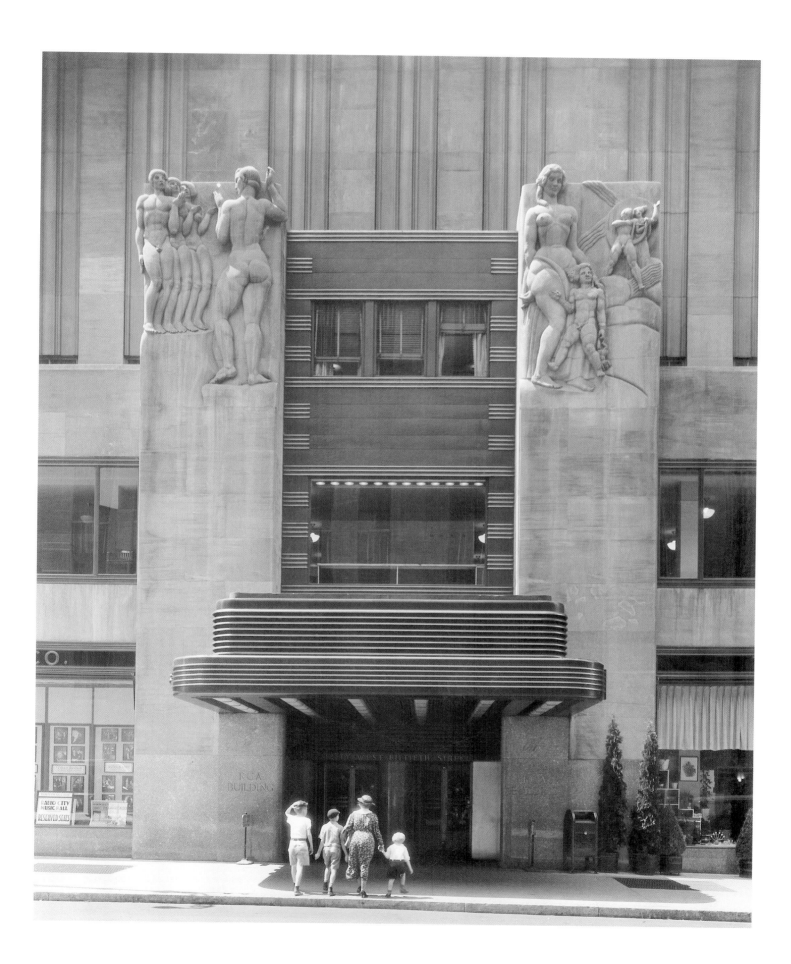

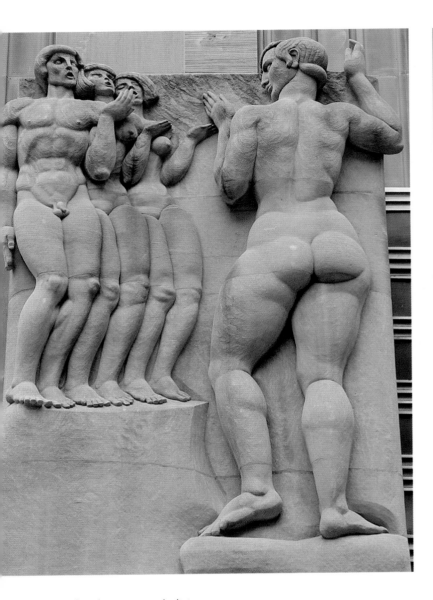

The elements symbolizing
transmission and recep-
tion in Leo Friedlander's
Radio on the pylons on top
of the Fiftieth Street
entrance at 30 Rockefeller
Plaza, ca. 1934.

High above the NBC marquee on Fiftieth Street flanking the entrance are two huge pylon crowns titled *Radio*. In them, as in *Television*, mass, texture, and repetition are used to impress the viewer and lend strength to the architecture. The theme of radio is reflected in a cryptic association of various elements: the group on the east pylon represents the concept of "broadcasting." Three figures sing to the larger figure representing "transmission," which sends the sound through the ether to the west pylon, where two figures symbolize "transmission." Here, standing before a loudspeaker, one is singing and one is playing the lyre. The figures of Mother Earth and her child in the foreground represent the people of the world receiving the sounds of radio.

Two figures from the work representing reception in Leo Friedlander's Radio, *located on the top left pylon of the Fiftieth Street entrance at 30 Rockefeller Plaza, ca. 1934.*

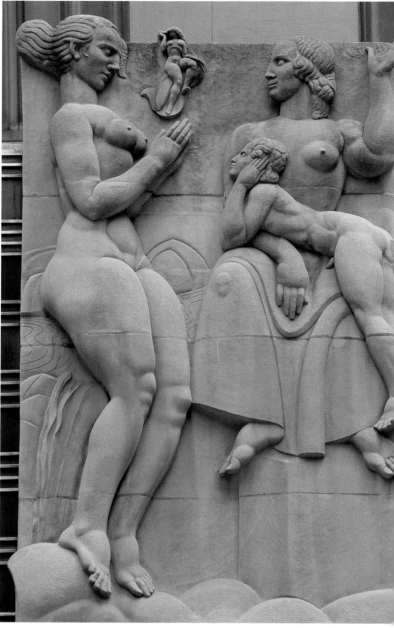

Leo Friedlander's figures symbolizing transmission and reception, from the carved stone sculptures titled Television, *located on the top of the Forty-ninth Street entrance pylons of 30 Rockefeller Plaza, ca. 1934.*

Opposite: Leo Friedlander working on his sculptures Radio *and* Television, *ca. 1934.*

The work titled *Television* is also perplexing, as Friedlander's symbolism and design do not make his concept easy to understand. The most important action in the piece is "transmission." On the west pylon the figures with their right legs lifted are dancing while that image is being "transmitted" by the larger figure. She is looking down at her hands, which frame the invisible picture of dancing figures. The transmission goes through ether to the east pylon. On this pylon, the standing figure of "reception" presents a small image of the dancing figures to the seated figures, the expectant audience.

Friedlander took an active role in the modeling, carving, and installation of his work. He was a master of the monumental Art Deco style in architecture. His Rockefeller Center work depicts figures that are "frozen," and the primary actions "transmitting and receiving" are understood by deciphering a series of visual clues. Once that is understood, *Television* and *Radio* can be appreciated as big, bold, Art Deco architectural embellishments.

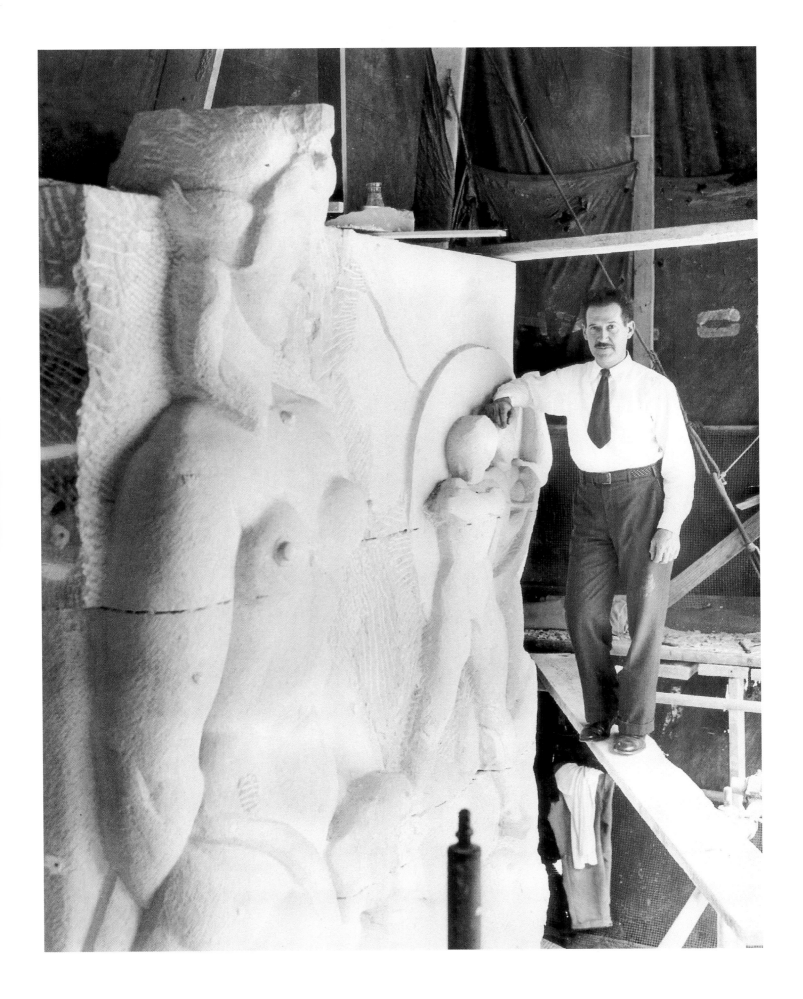

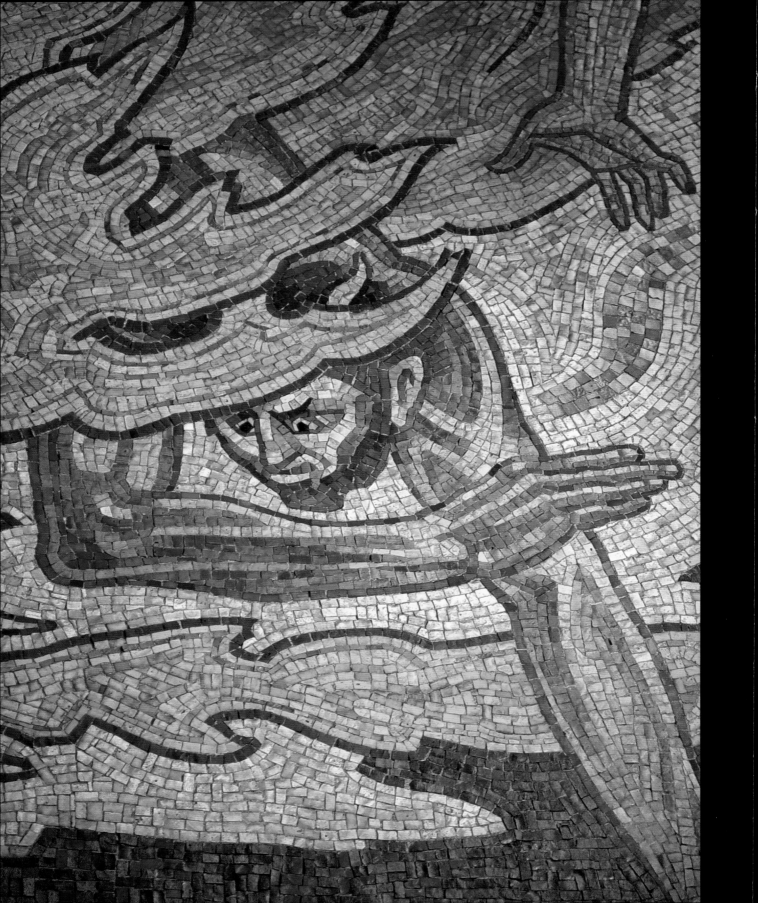

1250 AVENUE
OF THE AMERICAS

BARRY FAULKNER
INTELLIGENCE AWAKENING MANKIND

An immense and stunning mosaic designed by Barry Faulkner is set into the loggia, above the entrance to 1250 Avenue of the Americas. Over the centuries, mosaics had been traditionally used in government and religious buildings. As early as 2700 B.C., the Sumerians decorated their citadels with mosaics. The highly decorative polychromatic tiles added an iridescent and mystical radiance to any setting and enhanced the spiritual aspects of life, beautifying temples, citadels, and churches. The Romans used them to honor and revere their gods and goddesses and add magical brilliance to their shrines. Palaces were ornamented with them, heralding royalty and victories. The results were suitably awe-inspiring. The work was technically demanding, labor-intensive, and expensive, but it produced glittering effects. In the 1920s and 1930s, mosaic emerged as an artform for commercial buildings. The architects at Rockefeller Center hoped that it would be a powerful medium to reflect man's scientific advancements, that it would be inspirational and radiate shameless capitalistic success. It was to be palliative to the drudgery of life in the Depression and a sparkling vision of hope for the future.

In 1932, Barry Faulkner won the commission for the mosaic to decorate the entrance of 1250 Avenue of the Americas. The architects had requested a group of artists to submit designs based on a theme about radio communication and its potentially good influences on mankind. Barry Faulkner's first concept was titled "Thought Frees Man through Radio".[1] He knew the mosaic was to be installed on the façade of the newly built Radio Corporation Building (1250 Avenue of the Americas) and understood the theme had to reflect the activity of its major tenant in the most positive context. The final theme Barry Faulkner submitted and completed was "Intelligence Awakening Mankind."

Detail of Poverty, depicted with horns and being devoured by the flames of hell, from the right panel of Faulkner's Intelligence Awakening Mankind at 1250 Avenue of the Americas.

The space assigned for the mosaic was over the recessed Sixth Avenue entrances, in an atrium. The wall curves, following the geometric contour of the entranceway. Faulkner used this space cleverly. He divided his mosaic into a main section with two flanking areas. After John D. Rockefeller Jr. and the architects approved his original concept, Faulkner produced comprehensive, detailed drawings of each section of the huge piece. Next, he enlarged the drawings to actual-size cartoons, which specified the colors and pointed up the design. This step was to facilitate the precise placement of small hand-crafted, glass tiles called tesserae. Once these paper cartoons were finished, they were cut into small sections called paper patterns. These were distributed among various craftsmen at the Ravenna Mosaic Works, in Long Island City, New York. The workers precisely cut, fit, and glued, face down, various colored tesserae to the paper patterns, meticulously following the colored cartoon. The tesserae, affixed to the paper patterns, were delivered to the site at Rockefeller Center for attachment to the wall. The wall was leveled and a special mixture of exceptionally white, finely grained cement was applied to the surface. (The effect and color of mosaics depend on light penetrating the glass to pure, bright white cement and then reflecting, or bouncing, outward. If the background material is not a pure, bright white, the mosaic is said to go "dead.") The paper-mounted tesserae were carefully pressed into the wet cement. For a smooth mosaic surface, it was essential that the pressure be evenly applied and exactly level on the wall. Once the cement was sufficiently hardened, the paper was removed (washed away), the surface of the tesserae was cleaned of any residual work materials, and the spaces between the tiles were filled with grout. The multitude of small irregularities inherent in each tesserae enhances a glittering effect. In this manner, over one million tesserae, in over 250 colors, were handset for Rockefeller Center by the Ravenna Mosaic Company. The mosaic was completed in 1939. Barry Faulkner retained artistic control of his design and supervised each stage.

Opposite: Detailed drawings for the central figures Thought, Written Words, and Spoken Words in Barry Faulkner's mosaic Intelligence Awakening Mankind, *ca. 1932.*

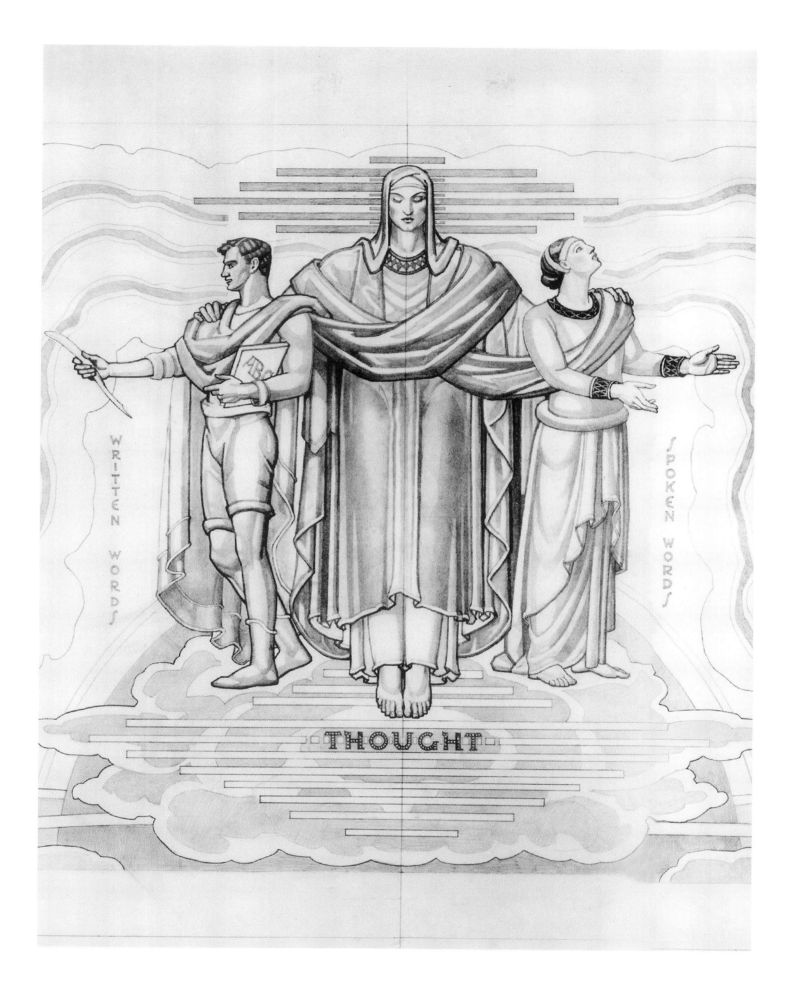

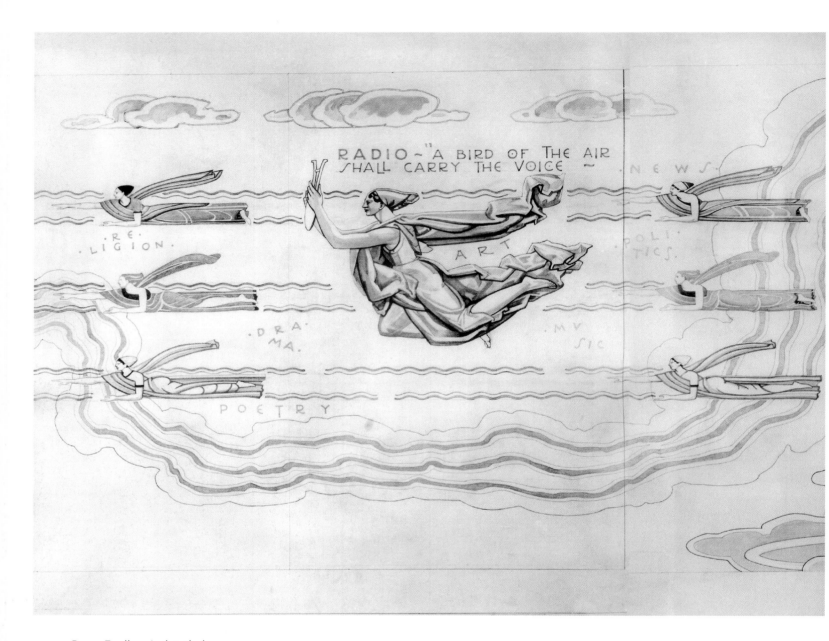

The text within the image reads:

RADIO ~ "A BIRD OF THE AIR
SHALL CARRY THE VOICE ~

RE·
LIGION·

·NEWS·

·ART·

·POLI·
TICS·

·DRA·
MA·

·MV·
SIC·

POETRY

Barry Faulkner's detailed drawings for Art, accompanied by six lesser figures, in the mosaic Intelligence Awakening Mankind, ca. 1932.

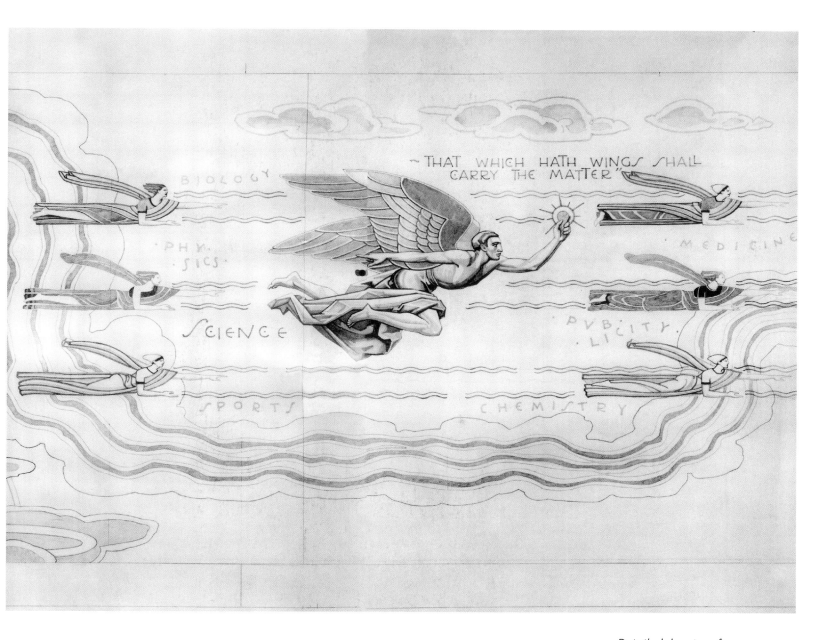

Detailed drawings for Science, accompanied by six lesser figures, for Barry Faulkner's Intelligence Awakening Mankind, ca. 1932.

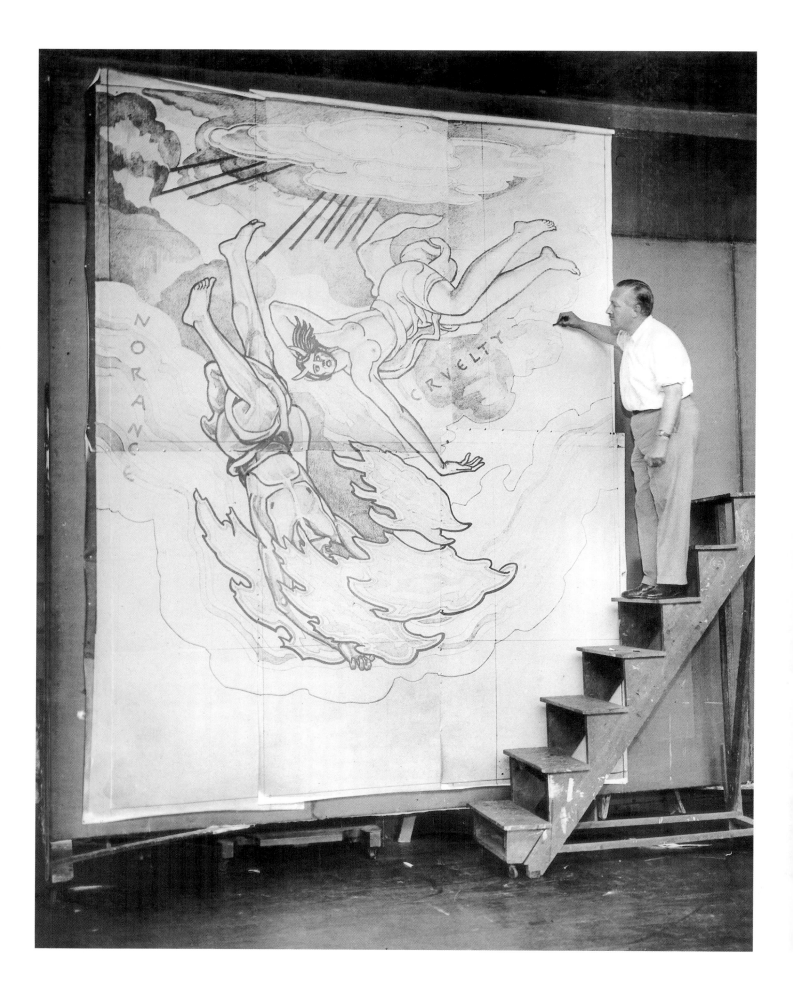

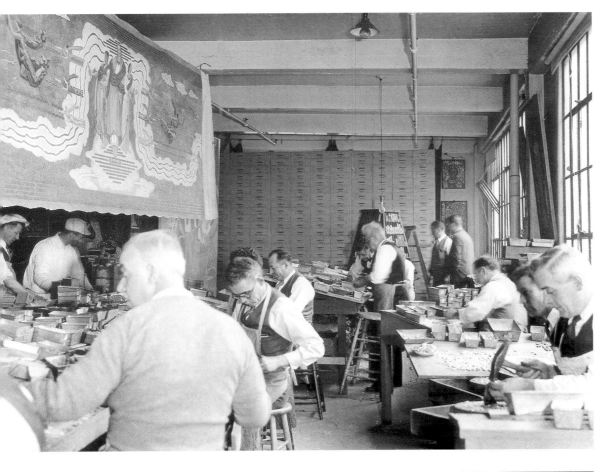

Technicians at Ravenna Mosaic Works in Long Island City, ca. 1932, working on Barry Faulkner's mosaic Intelligence Awakening Mankind.

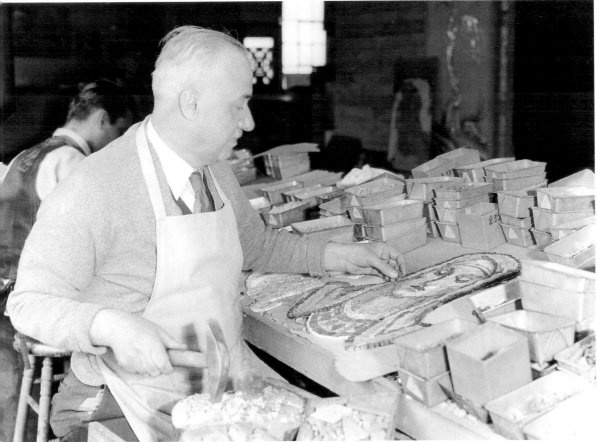

Technician at Ravenna Mosaic Works in Long Island City, ca. 1932, working on the face of the central figure for Barry Faulkner's mosaic Intelligence Awakening Mankind.

Opposite: The full-size cartoon of Ignorance and Cruelty for Barry Faulkner's Intelligence Awakening Mankind, ca. 1932.

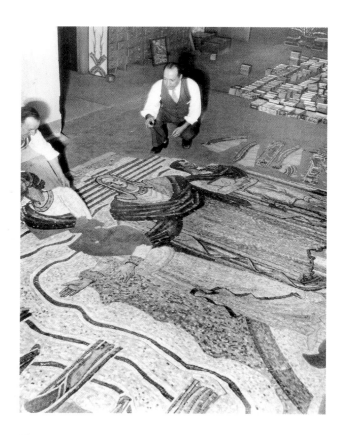

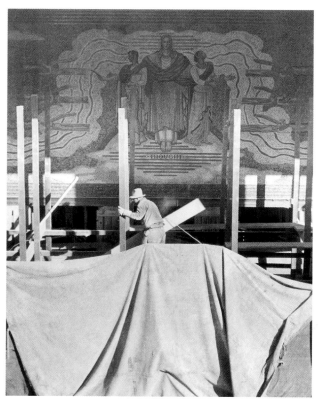

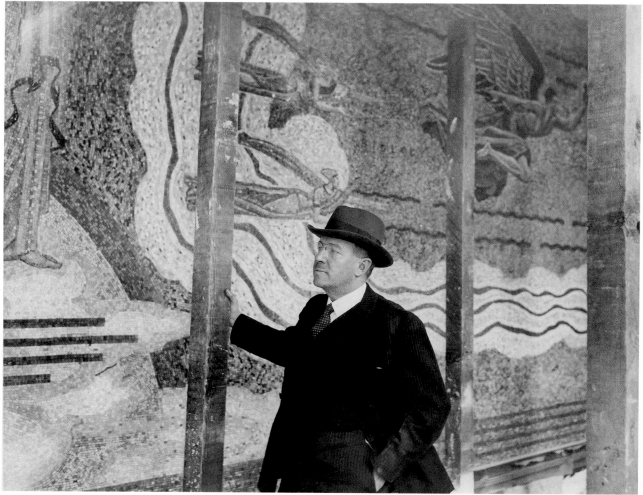

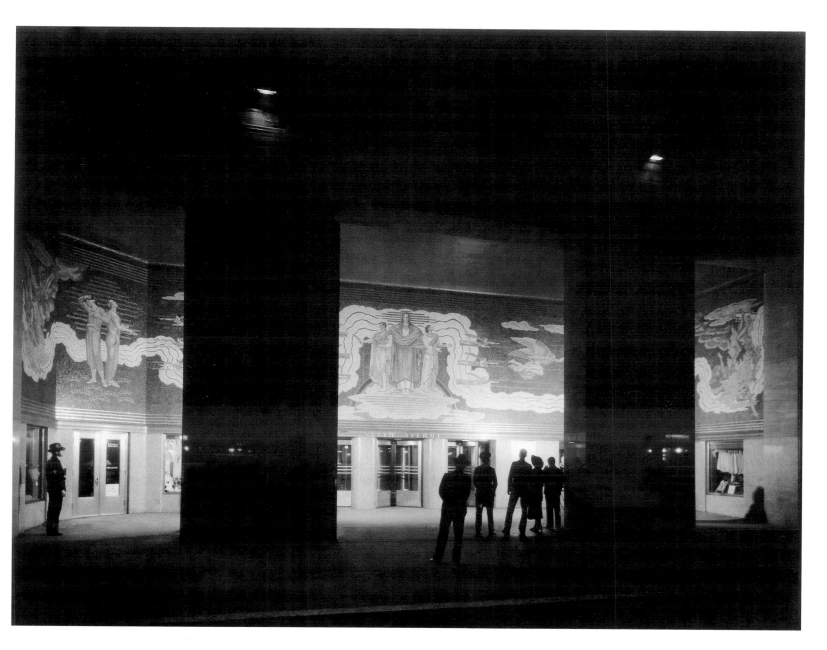

Opposite, top left: Technicians at Ravenna Mosaic Works in Long Island City, ca. 1932, laying out the central figures for Barry Faulkner's Intelligence Awakening Mankind.

Opposite, top right: Installing the mosaic Intelligence Awakening Mankind, designed by Barry Faulkner, in the loggia of 1250 Avenue of the Americas, ca. 1932.

Opposite, bottom: Barry Faulkner supervising the installation of his mosaic Intelligence Awakening Mankind in the loggia of 1250 Avenue of the Americas, ca. 1932.

Above: Night view of Barry Faulkner's mosaic Intelligence Awakening Mankind, ca. 1933, located at 1250 Avenue of the Americas.

The mosaic is richly and imaginatively conceived. It is populated with dignified, classically robed figures who convey the importance of knowledge through communication. The narrative-style tableau is specifically symbolic of the strides mankind has taken in the commercial field of communication, specifically radio. "Radio—A bird of the air shall carry the voice—" is written in the sky. This maxim is significantly near and associated with the figure of Art, who is preceded by three other splendid figures flying through the heavens: Religion, Drama, and Poetry.

Symmetry and narrative flow play an important role in this splendid, ornamental mosaic. The central panel, with its imposing robed figure, is the focal and starting point. The mosaic is then read from either side of the central subject. The dominant figure is Thought. She is placed in the most prominent, hierarchical position, depicted frontally and motionless. She stands above the world on a thought cloud. Her eyes are closed as she intensely concentrates, creating a thick white and gold current of thought energy that flows outward from behind her head. She has her arms around two significant figures completing the central representation, Spoken Words and Written Words. They are the messengers of Thought, and the two principal means of communication. A long crimson and gold scarf flows from the shoulders of Thought and encircles their shoulders, uniting the three figures and symbolizing their fundamental bond. Their tranquil stance and placement make a powerful statement, evocative of social and intellectual superiority. The action takes place in a heavenly cosmos as the figures float in the midst of clouds and deep blue skies accented by radio waves of red and gold rays.

On the panel to the right of the central figures, the winged figure of Science flies away from Thought toward the figures of Man and Woman. They stand on a hilly mound holding hands, with their other hands raised to greet Science and receive his knowledge. He, and his accompanying figures—Publicity, Medicine, Chemistry, Biology, Physics, and Sports—broadcast their messages on the radio waves.

On the panel to the left of the central figure Thought, another main character brings knowledge to mankind. This figure is Art. She is robed, holding a harp, and leading six additional figures—News, Politics, Religion, Music, Drama, and Poetry. Further left, Man and Woman are depicted again. This time they are blindfolded, protected from the enemies of mankind, while at the same time welcoming Art.

Both the end panels contain the enemies of mankind. The right panel depicts Fear and Poverty bursting into flames, being destroyed as a result of the power of thought. These figures are depicted as evil; they bear horns and appear satanic as if rising from the depths of Hell. The left panel depicts Ignorance and Cruelty in the throes of death from intelligence and knowledge.

Faulkner used symmetry, rich shimmering colors, and elongated, lavish classical figures to create his dramatic work and publicize the business of the building. In support of their radio-station tenants and the new mosaic, Rockefeller Center issued a press release: "Intelligence is broadcast through the mediums of religion, music, drama, politics, chemistry, sports, biology and publicity. The result is to free man from the terrors of ignorance, cruelty, poverty and fear."[2] Faulkner's opulent, shimmering mosaic creates a sumptuous ambiance that continues to inspire awe and kindle a vaguely spiritual experience. The message is powerful: radio promotes intelligence.

Detail of the dominant figure Thought, flanked by Spoken Words and Written Words, from Faulkner's mosaic Intelligence Awakening Mankind *at 1250 Avenue of the Americas.*

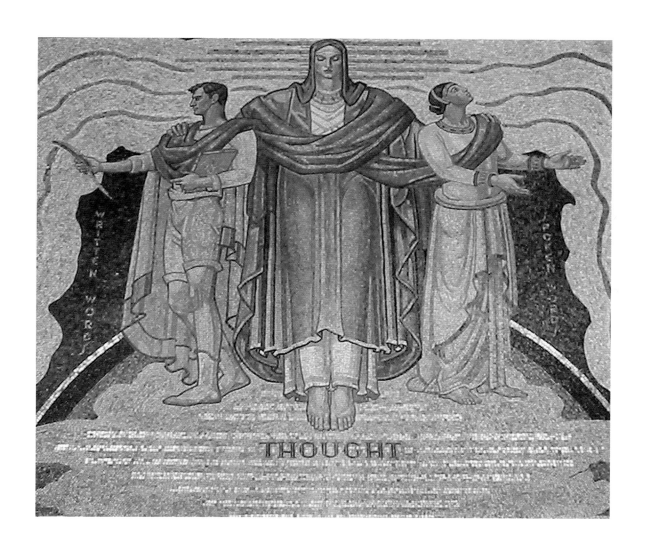

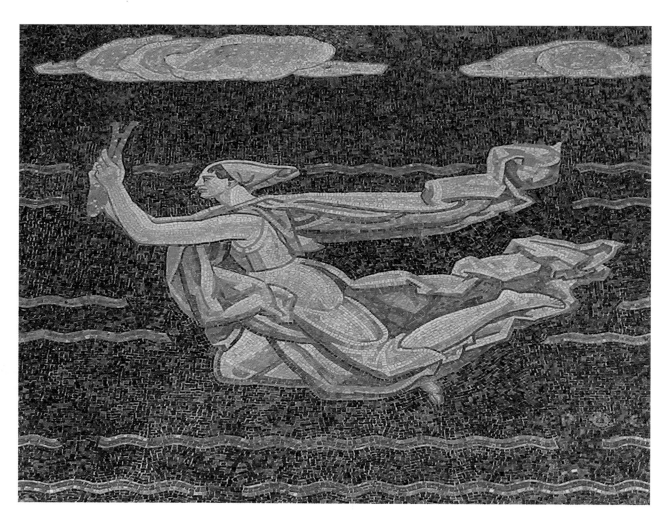

Detail of Art from the left panel of Faulkner's mosaic Intelligence Awakening Mankind *at 1250 Avenue of the Americas.*

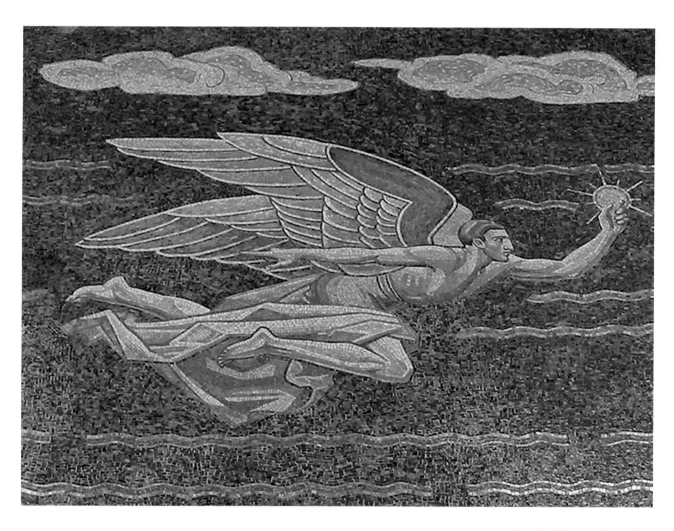

Detail of Science from the right panel of Faulkner's mosaic Intelligence Awakening Mankind *at 1250 Avenue of the Americas.*

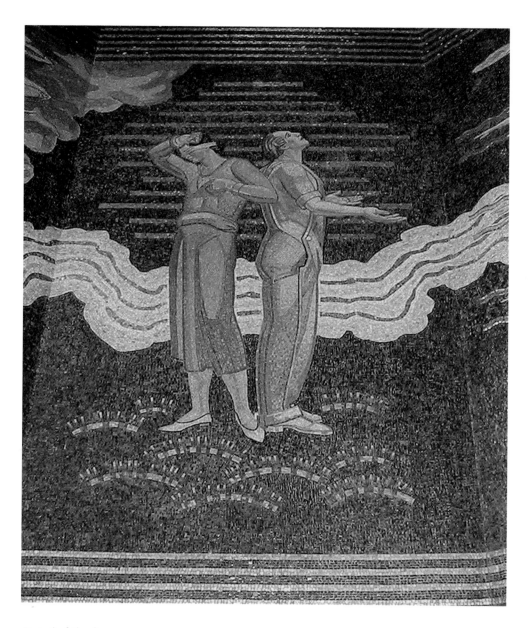

Detail of the figures representing mankind blind-folded from the left panel of Faulkner's mosaic Intelligence Awakening Mankind at 1250 *Avenue of the Americas*.

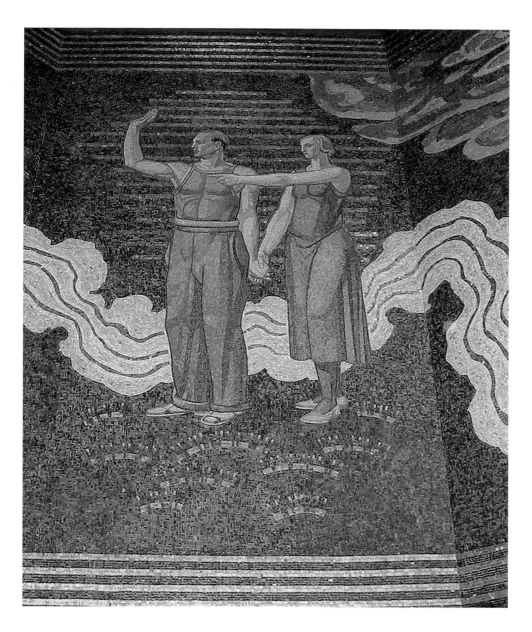

Detail of the two figures representing mankind from the right panel of Faulkner's mosaic Intelligence Awakening Mankind *at 1250 Avenue of the Americas.*

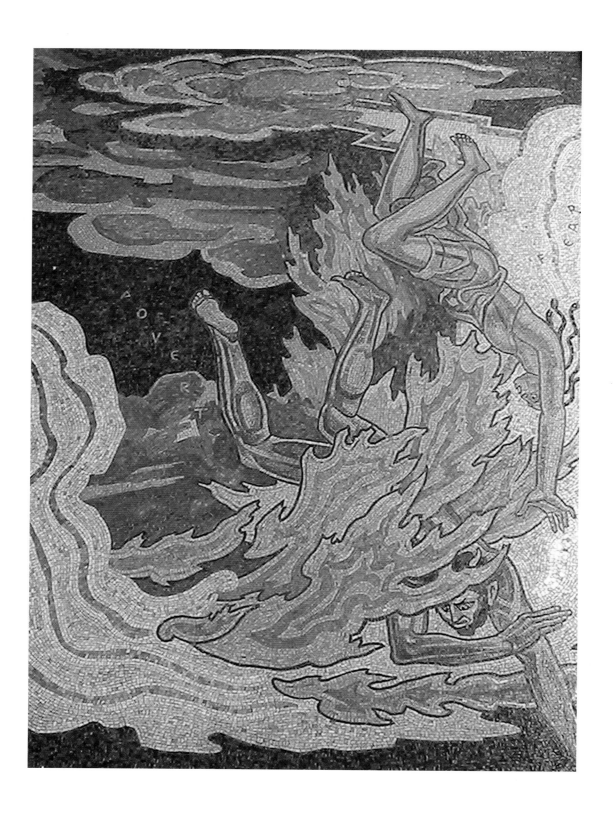

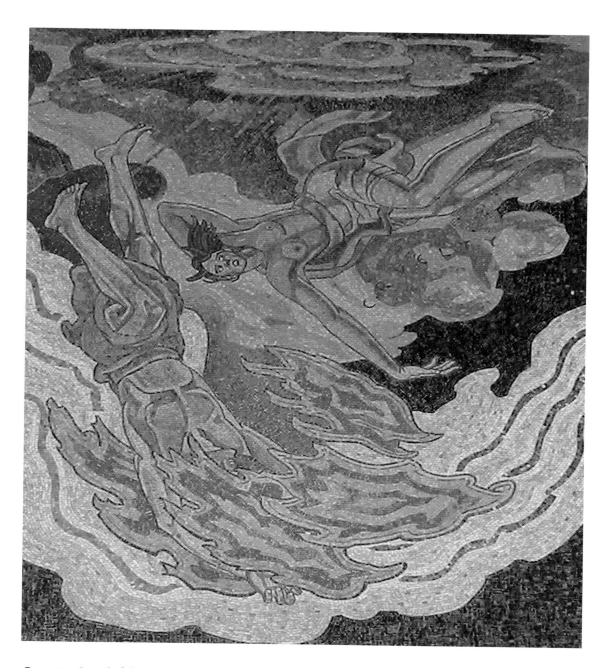

Opposite: Detail of the figures representing poverty and fear from the right panel of Faulkner's mosaic Intelligence Awakening Mankind at 1250 Avenue of the Americas.

Detail of Ignorance and Cruelty from the left panel of Barry Faulkner's Intelligence Awakening Mankind at 1250 Avenue of the Americas.

GASTON LACHAISE · ASPECTS OF MANKIND

Six stories above the entrance at 1250 Avenue of Americas are four limestone carvings by the French-born American sculptor Gaston Lachaise. In 1930, Lachaise was included in an exhibition at the newly established Museum of Modern Art (MOMA). His work was shown owing to the patronage of Mrs. Rockefeller, Raymond Hood, and the farsighted trustees of the museum. Their admiration of his work was, at the time, an act of courage. To many people, his sculpture was considered crass and offensive. It would be years before his talent, and the magnitude of his work, would become universally realized and sought after.

Much of Lachaise's work had sexual implications in the form of voluptuous women, mountainous breasts, and sumptuous buttocks; it personified and glorified sex and the human body. He frequently used his wife, Isabel Nagel, as a model. For the time, his art certainly fought the rules of "good taste" and was scandalous, even odious. While his provocative aesthetic may have been at question, his technical prowess was always esteemed, as he was commissioned time and time again to produce architectural ornamentation and portrait heads that did meet the current criteria of tastefulness. He created portraits of some of the leading figures of the time, such as Alfred Stieglitz, Georgia O'Keeffe, John Deering, and Edward M. M. Warburg. For the catalog of the Gaston Lachaise Retrospective Exhibition held at MOMA in 1935, Lincoln Kirstein wrote that Lachaise's portraits "preserve at the same time not only the man but his epoch." He also stated that Lachaise was "considered a violent offender against the rules of good taste in sculpture." He continued, "In his own studio at present there are a number of pieces in plaster and bronze which have not been included in this retrospective exhibition. Lachaise feels these works to be of paramount importance to himself and to the world's knowledge of him as an artist. If they were shown today, however, they might give offence and precipitate scandal obscuring the importance of the rest of his creation."[3] The retrospective at MOMA did indeed go far to enhance his reputation, but unfortunately too late for him to reap fully deserved recognition, or have his oeuvre completely accepted. He died a few months later, in 1935.

In 1931, Raymond Hood was organizing the Electricity Building exhibition for Chicago's Century of Progress Exposition and commissioned Lachaise to sculpt a huge polychrome plaster portal for the building. Upon completion of that project, Lachaise requested a commission from Hood for work at the Center. At first, Hood considered commissioning a bronze plaque from Lachaise for the façade of the French building. In the end, he assigned to him the rather poor site on the sixth-story façade of the (then) RCA Building on Sixth Avenue as well as an additional one for the International Building.

The Rockefeller Center art advisory committee handled the Lachaise commission, probably because of his reputation for rude art. The committee, selecting from the philosophical themes established, decreed that the commission should express four ideal and lofty aspects of modern civilization. These themes would be in the form of four panels: "Genius Seizing the Light of the Sun," "The Spirit of Progress," "The Conquest of Space," and "Gifts of Earth to Mankind." The panels would be created in a fairly grand scale, but in the rather undistinguished location.

Gaston Lachaise on a scaffold, ca. 1934, working on Gifts of Earth to Mankind, *one element from his carved four-part limestone sculpture* Aspects of Mankind, *at 1250 Avenue of the Americas.*

Lachaise made a series of sketches for approval by the committee. After certain adjustments were made, he cast the work in actual size, in plaster, which was the final step prior to carving in stone. The art committee was very vigilant during this period, indicating its apprehension about his work. It visited his studio several times, suggesting modifications, and then returned to approve each correction. When compared to his typical work, the results certainly have an aroma of the committee about them.

At the final review, so many changes were demanded that Lachaise was obliged to redo a substantial portion of the work. Some of his critics were rather harsh. A prominent member of the art committee, Professor Forbes, the director of the Fogg Museum at Harvard University, "thought the mass and effect of the panels were good and that they were well worth developing"[3]. Individually, however, he felt that they were "rather crude, disproportionate, and obscure in meaning, needing further study." After examining them in detail, he suggested the panel entitled *The Gifts of Earth to Mankind* was clumsy in its proportions. "The figure of the child gave the impression of being much too small, destroying the scale of the panel, and, if it suggests a gift, at best, it represents a meager one." He found the male figure to be "too small in the chest and shoulders while abnormally large in the hips. The female figure "lacked grace and proportion." He thought the panel titled *Understanding* was "very difficult to grasp in its meaning and symbolism. As a composition the two discs were too near the same size and shape of the heads of the figures. Again the figures seemed disproportionate, especially the right hand one." In the panel titled *Invention Seizing the Light of the Sun*, the hand, apparently supporting the Sun, "destroyed all sense of scale and distance." The symbolism, also, was "not entirely clear in its expression." Forbes believed that the panel entitled *Conquest of Space*, was "the best and that it should be a least a standard for the others." In spite of his reputation for being grumpy and taciturn, Lachaise handled his critics diplomatically, remaining coolly professional throughout the tricky and lengthy process of satisfying the committee and making the necessary alterations. It was noted that Lachaise "cooperated very willingly, redesigned and did a great deal of work to please all the critics involved."[4] After the final revisions, the director of the Pennsylvania Museum of Art and a member of the art advisory committee wrote, "I think the new Lachaise panel is swell, and a great improvement."[5] Another committee member, H. E. Winlock, the director of the Metropolitan Museum added, "Since Mr. Lachaise has introduced a large figure in his panel which would bring it into harmonious balance with the others, I approve of it."[6]

The panels were placed in an out-of-the-way site, obscured by the Sixth Avenue elevated train. This impediment was removed after World War II, when the "el" came down and the building was cleaned. Lachaise did most of the carving of the Indiana limestone panels at his studio, only touching them up once they were installed in 1934. In January of 1933 Lachaise indicated that gold leaf in areas of the background of the panels would be a desirable addition. That request was honored and the panels were leafed. The pieces are allegorical and conform to the overall thematic requirements set by the art committee. The artist used two scales for the figures: human activity is represented by life-size figures and divine activity is represented by heroic-size figures. The titles are incorporated as both decorative elements and explanatory aspects of the panels.

Gaston Lachaise on a scaffold at 1250 Avenue of the Americas, ca. 1934, working on his four-part limestone sculpture Aspects of Mankind.

The carving representing the invention of radio is titled *The Conquest of Space*. In it the central heroic-size figure represents the Spirit of Conquest. The deity's raised hands hold an elliptical form containing radio waves. The partially clothed, life-size figures represent explorers of the mysterious and deep universe. They slowly expose themselves to the Spirit of Conquest as they conquer space through radio. The figure on the right looks upward while supporting a planet (Saturn with its rings) with her right hand. The left figure is hooded but nude, quietly gazing off into the unknown. Stars representing the cosmos are carved in the background, behind the figures.

The panel titled *Genius Seizing the Light of the Sun* portrays the invention of motion pictures. In the center stands the heroic-size figure of Genius, a deity and spiritual conqueror. Radiating from behind his head are the sun and its rays. He grasps rays in his right hand to divert the sun's energy to mankind. Two of the life-size figures are holding machines that require energy, the camera and the projector. These figures have conquered the sun's power and invented the machines, making practical use of energy to create images, transmit knowledge, and benefit all mankind.

The Conquest of Space (left) *and* Genius Seizing the Light of the Sun (right), *two panels from Gaston Lachaise's four-part limestone sculpture* Aspects of Mankind, *at 1250 Avenue of the Americas, ca. 1934.*

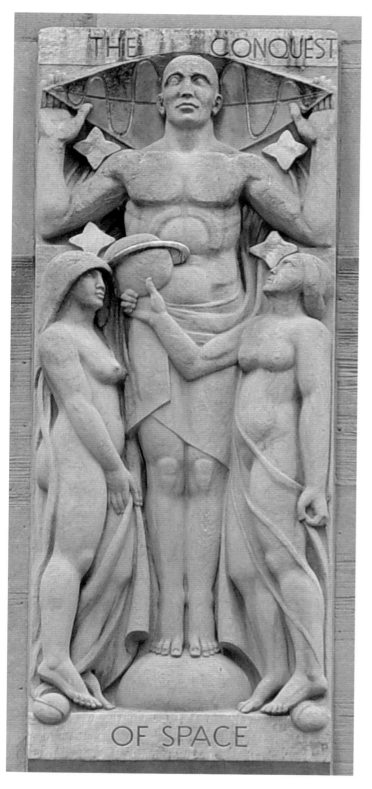

THE CONQUEST

OF SPACE

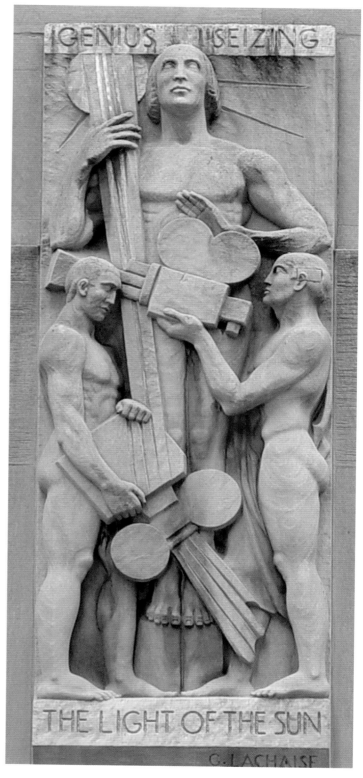

GENIUS SEIZING

THE LIGHT OF THE SUN

G. LACHAISE

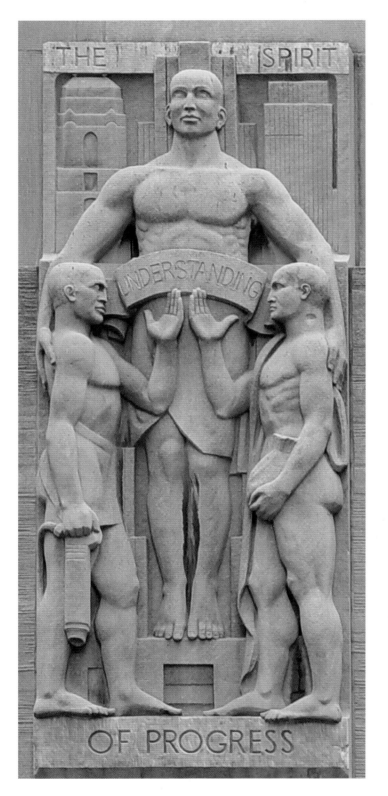

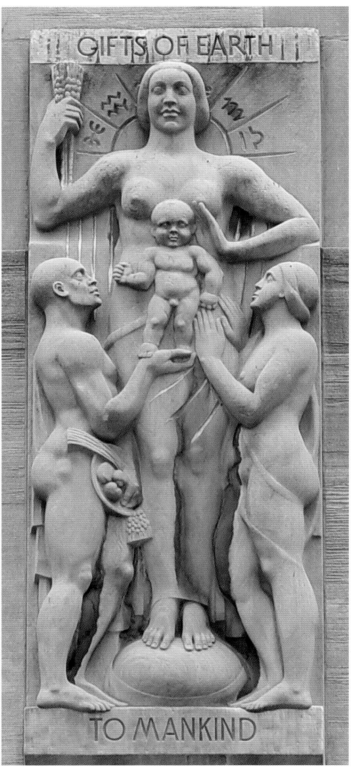

The *Spirit of Progress* portrays mankind's understanding between labor and capitalism, an essential element in the building of Rockefeller Center. The central heroic-size deity, Understanding, is portrayed standing on the roof of a skyscraper(Rockefeller Center), with additional skyscrapers rising behind him. Progress is represented by these carved buildings. Understanding holds two life-size figures in his arms. He is uniting the figures Capital, who holds a bag of gold, and Labor, who holds a riveting hammer. They extend their empty hands toward one another in a gesture of openness and agreement. This portrayal of unity was of paramount importance to the Rockefellers, who had endeavored to create exemplary relationships with myriad labor unions during the building of the Center.

The fourth work is *Gifts of Earth to Mankind*. The central heroic-size figure, Mother Earth, is standing on the top of the world. Flanking this deity are male and female life-size figures symbolic of mankind. Mother Earth is portrayed giving mankind the most precious gift of all—a child, the continuation of humankind. The male figure balances the child on his right hand, while his left hand holds a bowl of fruit, which spills toward earth. The female figure reaches to take the child. In Mother Earth's raised hand she holds golden spikes of wheat, symbolic of the harvest of the earth. She is tied to earth by bonds encircling her ankles. In the background, radiating gilded symbols form a halo behind the deity's head.

In spite of constraints placed on him by the art committee, the figures are powerful. The works are lofty symbols, glorifying man's harnessing of natural powers for the advancement of civilization. Lachaise produced a cohesive, geometrically organized group that enhances the immense façade of the building. By the time the Sixth Avenue elevated train was removed, attitudes had changed and the significance of Lachaise's work realized. The panels were cleaned of soot and filth and regilded. The gilding caused the panels to be more conspicuous and their messages more easily discerned.

The Spirit of Progress
(left) *and* Gifts of Earth
to Mankind *(right), two
panels from Gaston
Lachaise's four-part lime-
stone sculpture* Aspects of
Mankind, *at 1250 Avenue
of the Americas, ca. 1934.*

THE BRITISH EMPIRE BUILDING

The British Empire Building is one of four prominent low-rise structures facing Fifth Avenue. The concept was that they would house the commercial interests and represent and reflect the attributes of the major European nations of the time: Britain, France, Germany, and Italy. A few years later, at the time of their construction, John D. Rockefeller Jr. wrote, "We are undertaking to develop a series of buildings of unique distinction.... These buildings, embodying that architectural beauty and dignity for which we are striving, will be symbols in stone and steel of the common interests, mutual understanding and good will of three great world powers."[1] Even though Germany was eventually left out of the concept, owing to its aggressions and lack as a nation of "good will," four buildings were constructed.

The twin buildings representing England and France flanked the Promenade and from Fifth Avenue led to the nucleus of the Center. Another building fronting Fifth Avenue was representative of Italy, and the fourth was modified to reflect the business activities and enterprise of many smaller countries. Each building was to have artwork reflecting national symbolism, aspects of that nation's history, or its commercial successes. Whenever possible, artists native to the particular country were to be commissioned.

The structure at 620 Fifth Avenue was to symbolize the wealth of Britain and its colonies through the use of architectural embellishments. The artwork was to characterize that vast empire. Prior to its completion, the British Empire Building was leased in its entirety to a group of English businessmen headed by Lord Southborough (Sir Francis John Stephens Hopwood), who was an important figure in British trade and commerce. The expectation was that the building would herald the Empire, showcase its vast wealth, and act as a magnet for additional international markets. However, by the end of the 1930s, with the war raging in Europe, the building became more than just a commercial centerpiece: it was vital because it was out of harm's way, and became the off-shore center for England's vast international financial, industrial, and commercial firms. It was Britain's centerpiece in the free world.

Opposite: Detail of the gilded figure Sugar *from Carl Paul Jennewein's bas-relief* Industries of the British Empire. *This commanding bas-relief decorates the Fifth Avenue entrance to the British Empire building.*

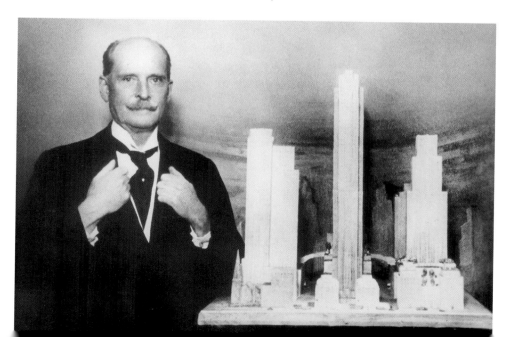

Lord Southborough (Sir Francis John Stephens Hopwood), an important figure in British trade, shown with a model of the Center and the site of the future building, ca. 1931. Southborough and a group of other English businessmen leased the proposed British Empire Building in its entirety.

CARL PAUL JENNEWEIN
INDUSTRIES OF THE BRITISH EMPIRE

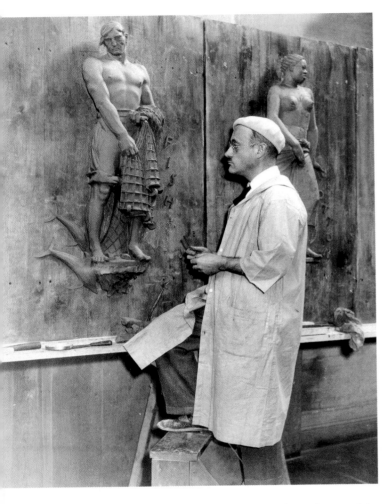

Carl Paul Jennwein in his studio at work on one of the clay models for the bas-relief Industries of the British Empire, *ca. 1932.*

Opposite: Carl Paul Jennwein and his assistants at work on models for Industries of the British Empire *and the coat of arms of Great Britain, ca. 1932.*

In 1933, the Rockefeller Center art committee sought an English artist whose work would symbolize the British Empire and be the focal point of the main entrance. Lacking a British artist, they commissioned the American sculptor Carl Paul Jennewein to create a bas-relief depicting industries found throughout the Empire. Titled *Industries of the British Empire*, the bas-relief was to be on the façade of the British building, in a prominent location on Fifth Avenue, across from the famed department store Saks Fifth Avenue.

Following approval of his sketch, Jennewein and his assistants modeled nine figures in clay at his studio in the Bronx. Jennewein organized his studio in the European "atelier style"—that is, his concepts were rendered by assistants under his direct supervision. Working from either drawings or small maquettes, they then enlarged the forms to the ultimate size. The assistants worked in Jennewein's style, with Jennewein making corrections and usually providing the finishing touches. Upon completion, the clay figures were molded and the resultant full-size plaster models were again sharpened; most frequently, Jennewein would work on this stage of the process—not his assistants. The plaster forms were considered the "master models" and were sent to a foundry to be used to cast the final bronzes figures. Jennewein wanted this casting done at Roman Bronze Works in Long Island City. He justified his request based on assistance he had received from Mr. Bertelli, the owner of Roman Bronze who, he said, "was here at my studio on several occasions advising the architects and me on the matter of gilding, construction and color. The work proceeded on the lines of his advice so that by this cooperation the best results might be obtained in the shortest time. Now, Mr. Bertelli tells me although his price was a little higher, he is willing to take the work at the price of his competitor. Still he has been refused the contract. I feel it is unjust to have had the expert advice of Mr. Bertelli on the matter and then discard him this way."[2] In spite of his request, the engineers at Todd & Brown sent the models to the Gorham Company in Providence Rhode Island. Regardless of the fact that they ignored this request, Jennewein seems to have been highly valued by the engineers. At the end of the project they gave Jennewein a $1,000 bonus "in recognition of the splendid work,"[3] a staggering amount to receive in the midst of the Depression. Jennewein had already been paid $7,500 for the six months it took to complete the clay models and full-size plasters. The bronze cast was a considerable additional cost, paid directly to the foundry.

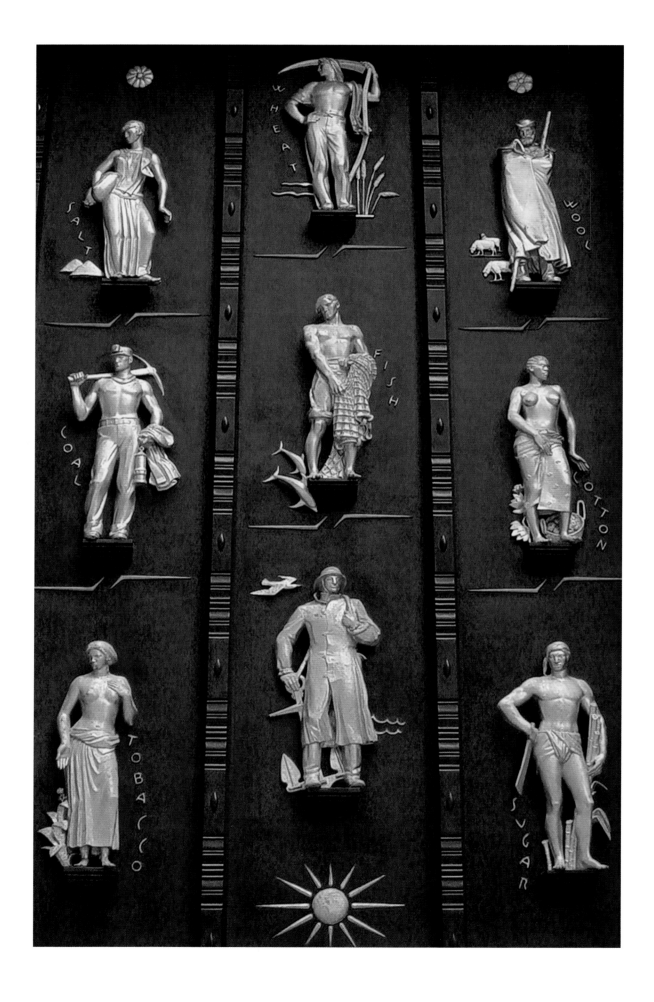

Throughout the art program, the architects and engineers, more often than not, retained control over casting, finishing, and installing. In this manner, they also controlled the time and costs of production, and the final appearance of the work.

The monumental plaque towers high over the main entrance to the building and portrays the workers and products of the British Empire prior to the Second World War. Its symbols convey a precise message with rational orderliness. It exudes power, dignity, and richness and evokes the immensity of the Empire.

Nine carefully posed, gilded figures arranged vertically in three rows symbolize the once great Empire. The figures are carved in high-relief and set against a flat, unadorned background. In case the iconography is unclear, each figure's significance, and Britain's source of wealth, is inscribed in the bronze. The plaque is formal, realistic, and direct. The presumption of power is simply and starkly stated. The nine gilded figures are as follows: three female figures representing salt, sugar, and tobacco, the products of India; three male figures representing workers of the British Isles, a fisherman, coal miner, and sailor; a male shepherd symbolizing wool, a product of Australia; a male reaper, representing wheat from Canada; and a woman with a basket, symbolizing cotton, a product of Africa. Along the bottom center of the plaque is a radiating sun that symbolizes the then-true maxim, "The sun never sets on the British Empire."

According to a press release at the time, the architects had determined that the figures were to be gilded and the background a dark bronze patina. The gold was used for emphasis and to mitigate the simplicity of Jennewein's design. The release observed, "These are virile, resolute figures. In them, from the bold seaman in oilskins to the graceful woman of India bearing a bag of salt beneath her arm, Mr. Jennewein had modeled something of the strength and stamina that have built the British Empire."[4] Today, this sculptural ornamentation not only endows the main entrance with a forceful artistic statement but also serves as a reminder of the history of that once vast empire.

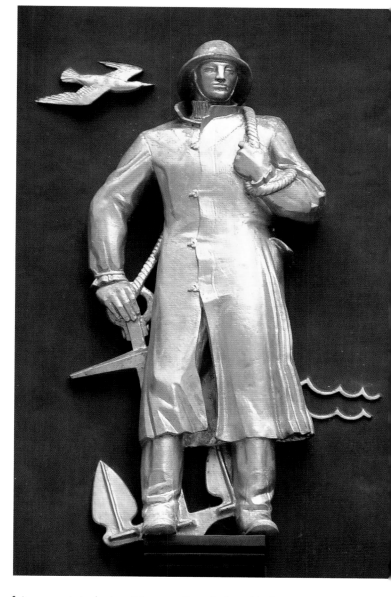

Detail of a gilded cast bronze fisherman from Carl Paul Jennewein's bas-relief Industries of the British Empire, 1933, *at the British Empire Building.*

Opposite: Carl Paul Jennwein's gilded bronze bas-relief Industries of the British Empire, 1933, *above the main entrance to the British Empire Building.*

CARL PAUL JENNEWEIN AND THE PICCIRILLI BROTHERS · COAT OF ARMS OF GREAT BRITAIN

Directly above the bronze panel *Industries of the British Empire* is a polychrome and gilded stone carving of the coat of arms of Great Britain. The Piccirilli Brothers carved the stone on site, replicating the clay model sculpted by Jennwein. Apart from its huge size, it is an exact copy, authentically reproducing the coloration of the actual British coat of arms.

Below the shield, a red banner majestically bears the gilded motto of British royalty: *Dieu et mon Droit* (French for "God and my Right"). A wide belt surrounds the shield. Inscribed on the belt is the motto of the Order of the Garter: *Honi soit qui mal y pense* (French for "Evil to him who thinks evil"). The order is the oldest Order of Chivalry, founded in 1348 by Edward III. The origin of the emblem of the Order of the Garter is obscure. The accepted historical account is that King Edward III was dancing with the Countess of Salisbury when she lost her garter. He picked it up, tied it to his own leg, and uttered the immediately celebrated remark. If the historical account is correct, he obviously had a sense of humor. In Britain being a recipient of the Order is the highest reward for loyalty and military merit.

The shield is sectioned into quarters: the first and fourth quadrants have a red (gules) background, and each contains three gilded lions passant-gardant (*passant* means walking; *gardant* means looking out of the shield); the second quadrant also has a red background but with one gilded rampant lion (*rampant* means standing erect with one leg on the ground and the other three raised); the third quadrant has green background and contains a gilded harp. The entire crest is surmounted with a royal coronet topped with a rampant, gilded-crowned lion. The shield is flanked on the left by a large rampant lion bearing the gold and red crown of England. On the right is a unicorn with a gilded horn, chain, and collar. It is the symbol of Scotland. Both figures (called supporters) stand on a grassy hill, which is engraved with the Tudor rose of England, the thistle of Scotland, and the shamrock of Ireland.

The coat of arms is the symbol of monarchy currently in use by the royal family of Great Britain. It appears on all royal documents and official letters, and is found on the façades of British embassies throughout the world.

DIEU ET MON DROIT

Carl Paul Jennwein's coat of arms of Great Britain, 1933, a carved polychrome-painted limestone cartouche installed above the main entrance to the British Empire Building.

LEE LAWRIE · ARMS OF ENGLAND

Above the 10 West Fiftieth Street entrance to the British Empire Building, Lee Lawrie carved the three lions passant-gardant, representing the arms of England. This simple decoration is punctuated by a strip of gilded and stylized Tudor roses carved below the lions. This three-lions motif emerged in the twelfth century during the reign of King Richard I, who is perhaps better known as Richard the Lion-hearted. The nickname, from the French *coeur de lion*, was given to him in France for his military prowess. The lions first appeared on the second great seal of King Richard I and then on a shield carried by him when on horseback. From the time of Richard I, they became accepted as the arms of the English sovereign and were portrayed in this simple arrangement. In the fourteenth century, the lions were incorporated into the British coat of arms.

Lee Lawrie's Arms of England, 1933, symbolized by three gilded lions with a row of red Tudor roses below. This carved and gilded limestone relief is installed over the 10 West Fiftieth Street entrance to the British Empire Building.

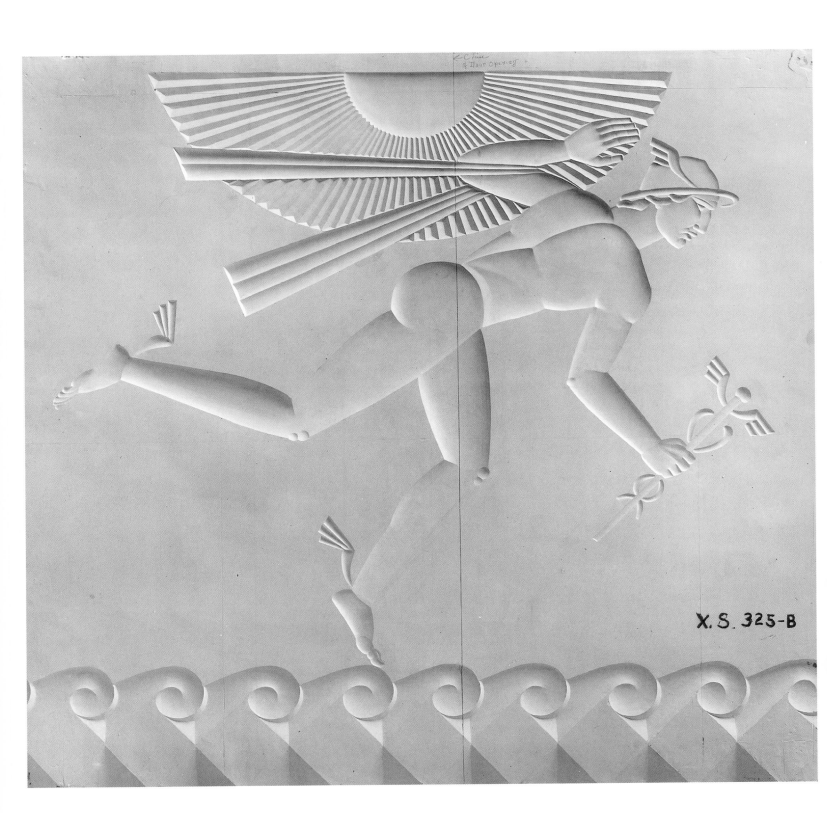

X.S. 325-B

MERCURY with BLAZING SUN

Lawrie received an additional commission to carve a huge decorative intaglio panel above the Channel Gardens entrance to the British Empire Building. The concept was first sketched and then turned into a full-size plaster model prior to being carved in the stone above the entrance. Lawrie's interpretation of the theme—the vast power and extraordinary influence England exerted in the world at that time—resulted in an enormous gilded winged figure of the mythical god Mercury. This god had many specialized and out-of-the-ordinary attributes; he was the god of commerce, trade, and, shockingly, thievery. He was also the messenger of the higher gods. Lawrie depicted him under a blazing sun, traveling swiftly over stylized blue-green seas. The muscular figure moves in a determined and forceful manner, with his eyes set on a goal in the distance. He represents the strength and resourcefulness of the famed English merchant fleets, the source of British expansion and prosperity. The blazing sun was illustrative of the familiar quotation, "The sun never sets on the British Empire."

Intaglio is a technique where the carving is engraved or incised into the stone, as opposed to carved in relief or projecting from the surface of the stone. It is more commonly used on small semiprecious stones such as those set in jewelry. Leon V. Solon designed the coloration and gilding of the intaglio.

Opposite: Lee Lawrie's full-sized plaster model of Mercury with Blazing Sun.

Lee Lawrie's Mercury with Blazing Sun, 1933, a carved and gilded limestone figure swiftly journeying across stylized waves. A geometric-designed blazing sun shines from behind the figure, representing the maxim, "The sun never sets on the British Empire."

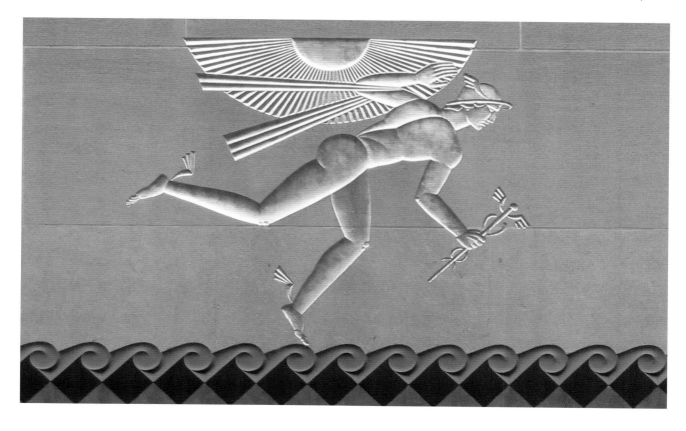

RENE CHAMBELLAN
COATS of ARMS of the BRITISH ISLES

Rene Chambellan was commissioned to carve four motifs to complete the building's decoration and to further symbolize the British Empire. He borrowed images from the coats of arms of the United Kingdom. These stone carvings are found atop the sixth floor spandrels on the Fifth Avenue façade of the British building. Decorative spandrels are devices used to indicate architectural transitions such as setbacks, which serve to emphasize a building's height. The spandrels in this case represent motifs from the different coats of arms of the four historical countries of the United Kingdom: From north to south they are as follows: Wales symbolized by the dragon and plumes; England, by the lion and Tudor rose; Scotland, by the unicorn and thistle; and Ireland, by the hart, harp, and shamrock. Each of the central creatures is posed in the classic coat-of-arms rampant posture, that is, standing on one leg with three legs raised. The modeling is crisp and precise and the group unified and cohesive. The spandrels are punctuated and strengthened by the visual effect of the group. They also relate to the other three buildings facing Fifth Avenue, as each has decorative spandrels symbolic of other European countries or continents.

Four limestone carvings designed by Rene Chambellan in 1933 for the British Empire Building and representing the coats of arms of the British Isles: England (lion and Tudor rose), Wales (dragon and plumes), Scotland (unicorn and thistle), and Ireland (hart, harp, and shamrock).

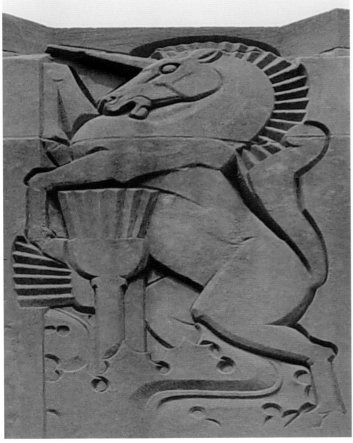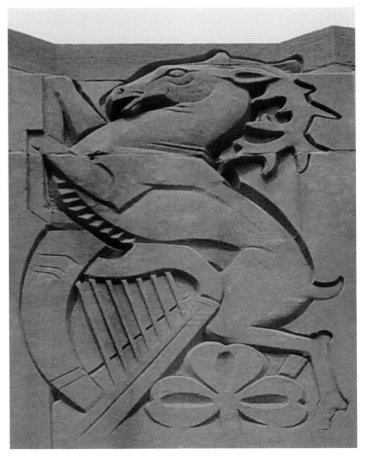

BEAVTE

LA MAISON FRANÇAISE

In 1933, the United States was in the throes of the Great Depression and American business was in a state of flux. The Rockefellers hoped that commissioning well-known foreign artists to embellish their international buildings with nationalistic themes would aid them in attracting overseas investments and entice suitable companies to the newly built office spaces.. With this in mind, the Rockefellers sought famous French artists to embellish the façade of La Maison Française. These artists were to be given the most prominent and important commissions of the building.

Raymond Hood, John Todd, and Wally Harrison traveled to France in an attempt to work out arrangements with artists who had worldwide reputations. They approached the preeminent sculptor Aristide Maillol for the commission, but it never materialized, owing in part to the strict requirements set by the architects, Maillol's price, and the building schedule. The group then sought alternative artists who would work within their parameters. In a Postal Telegraph from Paris, dated May 17, from Wally Harrison to Todd and Robertson, the engineers the situation is spelled out: "IF MAILLOL IMPOSSIBLE GIVE ME AUTHORITY TO CLOSE WITH JANNIOT FOR DELIVERY IN THREE MONTHS SOONER IF POSSIBLE FOR BETWEEN five AND SIX THOUSAND DOLLARS OR GIVE TO AMERICAN IN ANY CASE GIVE ME A DECISION."[1] Alfred Janniot was commissioned. Unknown in America, he was one of France's prevailing civic artists.

La Maison Française, dedicated to the arts, commerce, and industries of France, ca. 1934. Alfred Janniot's bronze plaque Friendship between America and France *and his carved cartouche* The Torch of Freedom *are visible above the main entrance.*

Opposite: Alfred Janniot's gilded bas-relief allegorically celebrates The Friendship between America and France *at the Fifth Avenue entrance to La Maison Francaise.*

ALFRED JANNIOT
FRIENDSHIP BETWEEN AMERICA AND FRANCE

The plaque *Friendship between America and France* by the French sculptor Alfred Janniot dominates the main entrance to La Maison Française. It is a massive, ornate, gold-leafed, bronze bas-relief.

The Rockefellers and the architects were delighted to discover Janniot. He was widely known in France for his civic commissions, style of working, and the bas-relief *Tapestry in Stone*. He had executed this latter commission two years earlier, in 1931, for the Colonial Museum in Paris. It is a huge decorative stone carving on the façade of the museum, commemorating the animals, people, lifestyles, and industries of the colonial possessions of France. The commission for Rockefeller Center was to be the artist's introduction to the United States. The choice of Janniot was fortunate, for he was a very talented sculptor who would produce an extraordinary work for an important site—a splendid combination of adornment for the building and a celebration of French-American unity.

Janniot readily agreed to the terms of the Rockefellers' initial offer and quickly produced two sketches, one for the major bas-relief and another smaller one of the seal of the French Republic. The architects submitted Janniot's sketches to John D. Rockefeller Jr. for review and approval. On June 21, 1933, Wally Harrison sent a Western Union Cable to Janniot: "SKETCH FOR BRONZE PLAQUE MUCH ADMIRED AND WANTED WITH SLIGHT CHANGES SUGGESTED BY MR ROCKEFELLER PERSONALLY STOP . . . THE ONLY CHANGE OF ANY MOMENT IS LEAVING OUT THE SMALL FIGURE OF LOVE OVER THE THREE GRACES OR IF IN YOUR JUDGEMENT SOMETHING IS NECESSARY AT THAT POINT REPLACING IT WITH A HUMAN FIGURE STOP . . . IF ABOVE SATISFACTORY PLEASE CABLE SO THAT OUR AGREEMENT TO PAY YOU 100,000 FRANCS IF AND WHEN YOU ARE ENGAGED CAN BE PUT IN FORMAL STYLE AND FORWARDED TO YOU." Assuming these terms to be acceptable, Janniot was then authorized to produce two plaster models.

One of the pieces proposed was removed from the agreement as, on June 23, Janniot sent the following Postal Telegraph: "I REFUSE TO EXECUTE THE OFFICIAL SEAL INARTISTIC." He obviously did not wish to be either an enlarger or a copier. The price was reduced by 10,000 francs. In the same cablegram, Janniot accepted the terms for the large bas-relief and began his model in clay in his studio in France.

Within five weeks Janniot cabled the architects: "NOTIFIED YOUR AGENTS MODELS FINISHED WILL SEND TOMORROW THE 28TH OF JULY TO PACKER STOP SENDING PHOTOS TODAY HOPE GIVES SATISFACTION TO MR ROCKEFELLER." He then shipped the finished plaster model to the United States, at the Rockefellers' expense. (Shipping the plaster model rather the bronze bas-relief saved the Rockefellers considerable money.)

The original sketch for Alfred Janniot's bronze plaque Friendship between America and France, *ca. 1933. Changes such as removing the figure Cupid were made prior to modeling and casting.*

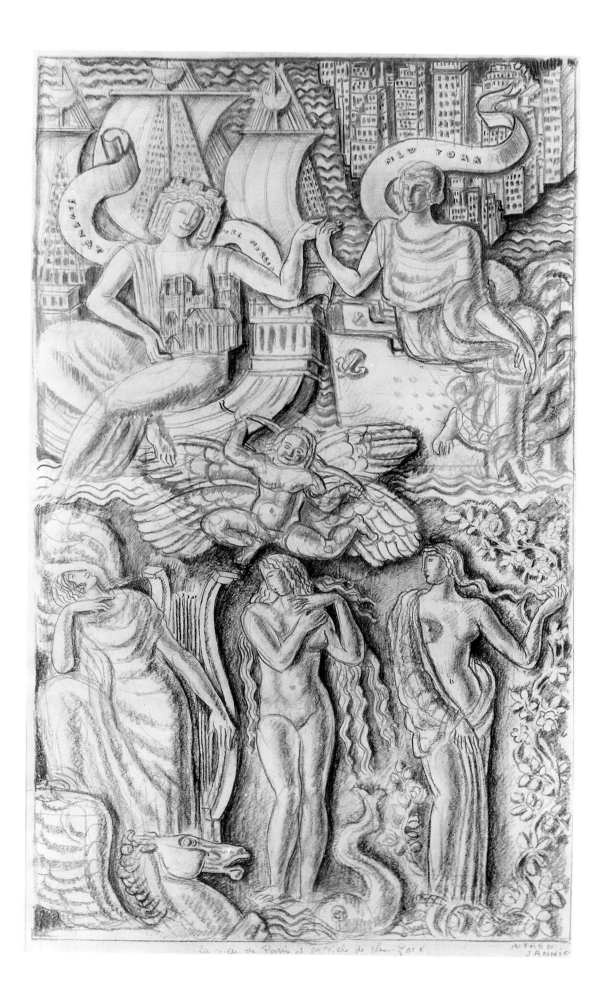

La ville de Paris et la ville de New-York.

ALFRED JANNIO

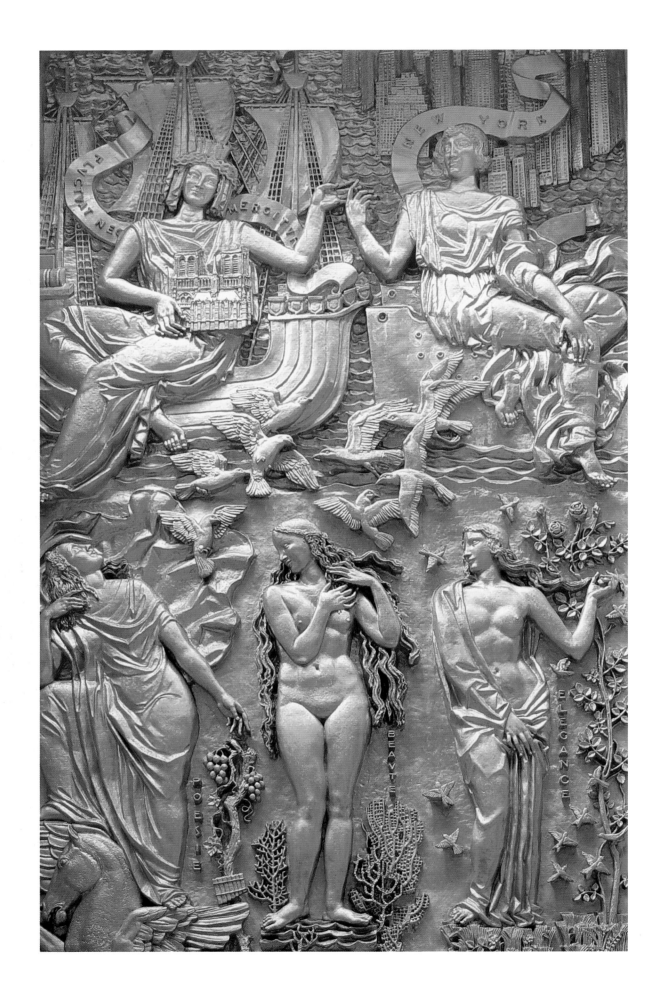

The model was enlarged and sand-cast in bronze at the Gorham foundry in Providence, Rhode Island. It took three months to produce the three-ton casting. The gilding of the bronze surface was not applied until after installation and was a subject of debate. This decision had been left to the discretion of the architects, who apparently fussed over it. The artist did not state any opinion or, perhaps, had been deliberately left out of the discussion. The architects finally chose to apply 23.75-carat, "toned" gold leaf to the entire undulating surface of the piece.

Janniot's work is characteristically intricately carved, producing an ornamental, hard, lacelike pattern. The totally gilded surface is both gaudy and inspiring; the intense contrast of glittering highlights and dark, deep undercuts creates energy, drama, and dazzle.

The panel is a complex allegory depicting, as the title states, the friendship between France and the United States. Three flamboyantly glorified, nude and seminude, languid, luscious graces—Poetry, Beauty, and Elegance—fill the lower half of the plaque. Their names are vertically carved beside them. Poetry, the figure on the left, gazes admiringly up in a dreamlike state. Beauty, the naked essence of innocence, strokes her hair while glancing coquettishly downward. Elegance, stylish and stately, gracefully observes her sisters. Seated above them, in the dominant position, on the prows of two sailing ships are majestic female figures. They are emblematic of the cities of New York and Paris and are united under the aegis of the three graces. New York is on the right and Paris to the left. They join hands in friendship. The motto of the city of Paris is inscribed on the banner floating above the figure of France: *Fluctuat nec mergiture* (Latin for "It floats but never sinks"). A banner engraved with the words *New York* floats above the other massive figure. In the upper left background, the ocean waves of the Atlantic decorate the relief behind the figure of France. A cityscape embellishes the surface behind New York. The lower relief background is intricately woven with ornamentation in the form of water, birds, and vegetation. This lends an aura of nature and physical vigor, and radiates optimism. In the extreme lower left corner are the head and wings of the mythological horse Pegasus. He represents knowledge, inspiration, flight to a higher spiritual realm, and is associated with the muses. The artist's name and casting date are inscribed in block letters on Pegasus.

It is noteworthy that a year earlier, in 1932, Abby Rockefeller was feted by the French government for her husband's $3 million donation for the restoration of French monuments. This donation may have been an endeavor to curry favor with the French cultural offices on behalf of the newly formed Museum of Modern Art, as the museum was actively seeking avant-garde French artists' work to buy or borrow. It may also have impacted on the fees other artists were seeking to produce a commission for the Center. The size of this single donation and timing also underscore the amazing depths of the Rockefellers' wealth in the 1930s and their international interest in art.

Alfred Janniot's gilded bronze plaque Friendship between America and France, *installed over the main entrance to La Maison Française.*

TORCH of FREEDOM or GALLIC FREEDOM

Based on the success of Janniot's first commission, the architects requested him to produce an additional design for a panel above the main entrance. They had given up the idea of another coat of arms or seal, but not the concept of French nationalism. Due to the ease and apparent good faith between the architects and the artist, Janniot's sketch was quickly approved and the sum of 25,000 francs forwarded to him prior to completion of the maquette.

Janniot designed an immense, heroic-size female figure representing France and the Republic. She is a voluptuous symbol and a robust allegory of revolution and Gallic freedom. The cartouche was carved directly in the limestone in high relief from Janniot's sketch, on the façade above his gilded bas-relief.

In the plaque, the powerful figure gazes down at the viewer from above the motto *Liberte, Egalite, Fraternite*, proclaiming French emancipation, equality, and brotherhood to the world. Liberty is depicted as "Marianne," the feminine allegory in France for the Republic. She is a majestic female figure in classical Roman dress wearing a Phrygian cap (the red cap of liberty). The liberty cap was used by French revolutionists as a symbol of freedom and state. The people who fought for liberty were "citizens of the state," as opposed to "subjects of the monarchy." The figure is depicted exultant. She has exposed herself to danger and has triumphed. Her toga and cloak swirl and flow about her in a whirlwind of activity. She is arrayed with symbols of victory and peace: laurel and palm branches.

The clutter of symbols, the energy, and the agitation of the scene are reminiscent of Delacroix's 1830 painting *Liberty Leading the People*. The draped figure in Janniot's piece is in a bizarre, contorted position, seemingly half squatting, half moving. Her legs are twisted and placed awkwardly—one leg is bent forward, the other, almost disfigured, turns in another direction. Her massive right arm thrusts downward. Her left arm is twisted, her hand dramatically holding her trophy aloft— the flaming, gilded torch of freedom. Portrayed in this impossible pose, she is a powerhouse of energy, which radiates from her gigantic physique. Deep undercuts, swelling forms, and her massive figure exaggerate the intensity of her emotions.

For added dramatic effect, and to highlight it against the monochromatic architectural limestone, the figure is deftly painted and gilded. The red cap of liberty stands out against her green cloak, cream-colored gown, and white skin. The torch, branches, flowers, and inscriptions are all gilded. The polychrome and gilding format was developed by the colorist, Leon V. Solon, and has been rigorously maintained by the Center since 1936.

The Torch of Freedom, *Alfred Janniot's carved polychrome-painted limestone cartouche installed above the main entrance to La Maison Française.*

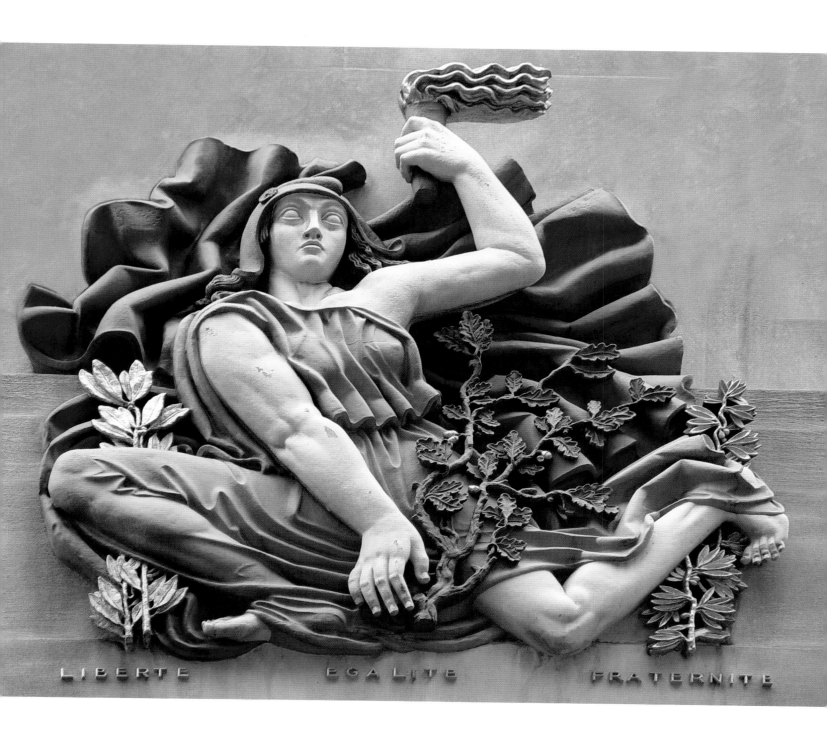

LIBERTE EGALITE FRATERNITE

RENE CHAMBELLAN · HISTORY of FRANCE

The theme "the history of France," as illustrated at the La Maison Française, continues upward to the sixth floor, culminating in four panels carved into the limestone spandrels. These setbacks match those on the other three buildings facing Fifth Avenue and create the effect of a vast expanse, space and height.

Rene Chambellan was commissioned to create the panels for La Maison Française. They symbolize four important aspects of France's past: Charlemagne's empire is symbolized by a gigantic sword and the letters *S.P.Q.R.* (Latin, *Senatus Populus Que Romanus*, meaning "The Senate and the People of Rome"); the united new France is symbolized by spears bound together and surrounded by drapery covered with fleur-de-lis. Absolute monarchy established under Louis XIV is symbolized by a crown under the rays of the sun, two shields embellished with fleur-de-lis, and the epigram *"L'Etat, c'est moi"* (French for "I am the state"). The birth of the French Republic is represented by the large letters *RF* (Republic Française), the motto *Liberté, Egalité, Fraternité*, and three symbols: fasces (a bundle of rods) for unity, the Phrygian cap for democracy, and a laurel crown for success.

Rene Chambellan's four carved limestone spandrel figures representing pageant of French history: Rise of Charlemagne (sword and S.P.Q.R.); Unification of New France (clustered spears and fleur-de-lis); Absolute Monarchy (two shields with fleur-de-lis, a crown under the rays of the sun and the epigram L'Etat c'est moi); and Birth of the Republic (the letters RF (Republic Française), the motto Liberté Equalité Fraternité, a Phygian cap, and a laurel crown).

LEE LAWRIE · FLEUR-DE-LIS

Above the 9 West Forty-ninth Street entrance to La Maison Française, Lee Lawrie was commissioned to carve rows of stylized fleur-de-lis in the limestone façade. These graceful and very stylish gilded lilies are found in the coat of arms of the former monarchs of France. The simplicity of the design is the perfect unaffected testimonial for the concept of "monarchy."

SEEDS of GOOD CITIZENSHIP

In addition, Lee Lawrie was commissioned to decorate the Channel Gardens entrance of La Maison Française. Here he carved the figure of a robust French peasant woman striding across garden rows scattering the seeds of good citizenship. These seeds are in the form of fleur-de-lis. The figure, the seeds, and the fleur-de-lis are gilded. The garden rows are polychrome-painted. This work was originally executed by the Rambusch Decorating Company of *New York City* as directed by the colorist Leon V. Solon. The gilding and coloration scheme has been faithfully maintained by the Center since 1937. these simple over-the-entrance carvings would be insignificant in most settings, but owing to their integration with the overall themes and coloration used throughout the Center, they take on greater importance. The harmonious design concepts applied to the overall ornamentation of the Center provide a sense of civility.

Bottom left: Lee Lawrie's Fleur-de-lis, three simplified, gilded, carved limestone forms of the flower most associated with France, installed over the 9 West Forty-ninth Street entrance to La Maison Française.

Bottom right: Seeds of Good Citizenship, a gilded limestone panel carved by Lee Lawrie, showing a figure sowing fleur-de-lis above rounded rows of earth. This piece is installed over the Channel Gardens entrance to La Maison Française.

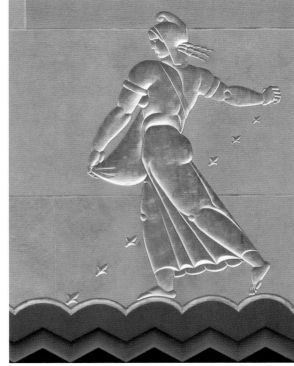

Cartier Silversmith's precision model Le Point d'Interrogation (The Question Mark), *a gift from France to Rockefeller Center upon the opening of La Maison Française, located in the lobby.*

CARTIER SILVERSMITHS
LE POINT D'INTERROGATION

A sterling silver model of the airplane *Le Point d'Interrogation* (French for "The Question Mark") is the main feature in the lobby of La Maison Française. *Le Point d'Interrogation* is the airplane in which the French aviators Dieudonné Costes and Maurice Bellonte flew westward from Le Bourget, France, to Curtiss Field, New York, in September of 1930. This was a reverse of the historic transatlantic crossing Charles Lindbergh made from New York to Paris in 1927. The model was created as a unique gift from the Republic of France to Rockefeller Center. On November 8, 1933, the French ambassador to the United States, His Excellency Andre Lefevre de Latoulaye, presented the model to Rockefeller Center as a public endorsement of the newly built La Maison Française.

The model was crafted in Paris by Cartier, the famed French silversmith company. Technicians of the aircraft company, Avion Braguet, that built the full-size plane, supplied the original blueprints for the model and technical assistance for the Cartier craftsmen during all aspects of its construction. The model plane was crafted as both a precious object and an exact replica. Its propeller turns, the flaps work, the wheels rotate, and the cockpit opens. Each element was meticulously shaped from sheets of sterling silver to precise specifications. Each joint was painstakingly fused and every millimeter of surface thoroughly hand-chased and finished. The red, white, and blue colors of France are finely enameled on its wings and fuselage. Engravers memorialized the event, hand-tooling a commemorative inscription on the side panels. Finally, the silver was exhaustively hand-polished to a high gloss, then protected by a thin layer of clear lacquer. The model measures forty-eight inches from wingtip to wingtip. It is installed in an alarmed, airtight case with humidity controls.

THE CHANNEL GARDENS
AND PROMENADE

The Promenade is a sixty-foot-wide, two-hundred-foot-long, gently sloping walkway from Fifth Avenue to the Lower Plaza. An architectural stroke of genius, this open, attractive artery entices people away from the busy avenue toward the heart of the Center. It is a welcome respite from a frenzied city.

In the middle of the walkway are six small raised gardens. Each contains a shallow rectangular pool decorated with a unique fountainhead sculpture. In 1933, the New York press began calling the Promenade gardens "The Channel" because the pools stand between the British building and La Maison Française, just like the English Channel separates England from France. The nickname caught on. Not wanting to miss a public relations opportunity, on August 26, 1935, Henry McA. Schley, the chief coordinator for the Center's building program, officially designated the area "The Channel Gardens."[1] The architects were to replace "Promenade" signs with "Channel" signs. (The Rockefellers were concerned with geographic clarity and how the public viewed the Center, so names and designations were carefully thought out throughout the building program.) In spite of this attempt, the walkway is still referred to as the Promenade and the six small gardens and pools as "The Channel Gardens."

The small gardens are impeccably maintained. The plantings are changed with the seasons and holidays or to acknowledge a special event. Many people visit the Center just to view the elaborate displays at Easter, Thanksgiving, and Christmas.

The pools are twelve feet long. Each is constructed of polished Deer Island granite. The bottoms are structural glass blocks lined with silver leaf. This architectural device, used to mirror or reflect light, makes the pools appear bottomless and the water shimmering. Given the confined urban setting, the architects set this open-air scene with surprising luxury and lushness. This private walkway with its imaginative gardens and fountains brings charm and panache to the bustling city.

Leadership, a Triton and
one of the six fountain-
head figures created by
Rene Chambellan, in
the second pool of the
Channel Gardens.

Above: A 1934 view looking east. The broad staircase to the Lower Plaza was altered at the time the skating rink was installed.

The six Channel Garden pools are empty and awaiting the installation of Rene Chambellan's fountainhead figures.

Opposite: A 1934 view looking west through the Channel Gardens and Promenade toward 30 Rockefeller Center.

The French building (on the left) and the British Building (on the right) flank the gardens.

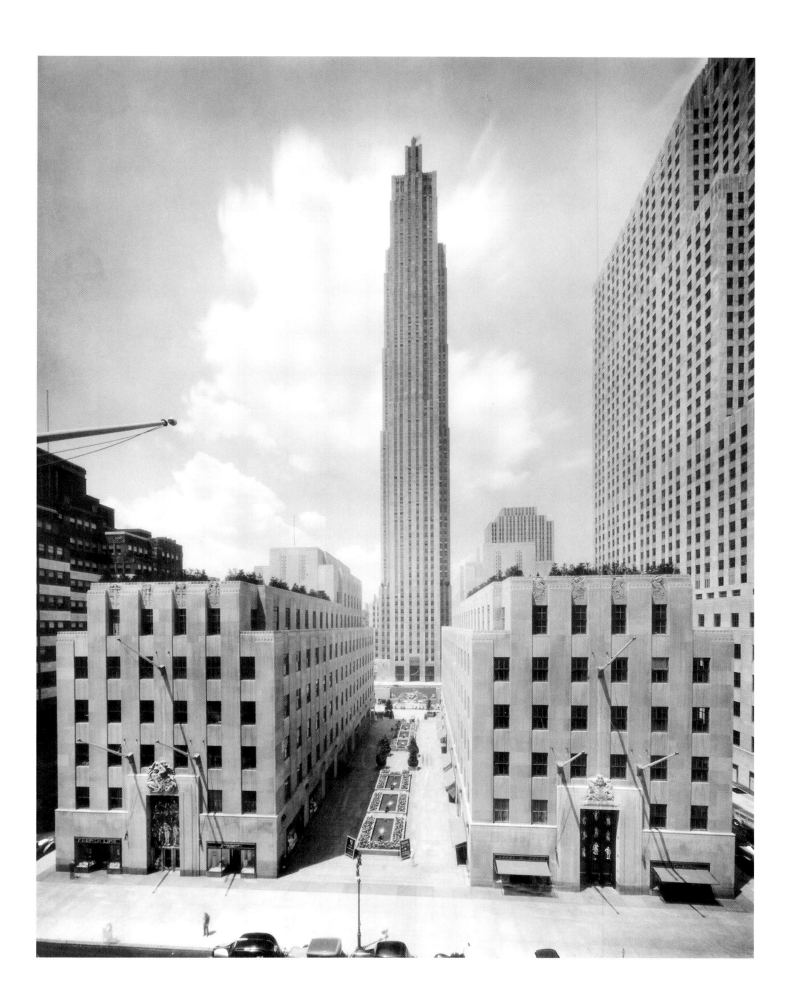

RENE CHAMBELLAN
SIX FOUNTAINHEAD FIGURES

The centers of attention in the Channel Gardens are Rene Chambellan's fountainhead sculptures. The fountainheads are bronze castings of Tritons and Nereids astride large sea creatures. These four-foot-long pieces were described in an early press release as "free, untrammeled spirits full of energy and motion."[2] Water surges from the mouths of the sea creatures in broad torrents, reaching almost the entire length of the long pools. The flow is so strong that the water in the pools roils, creating the effect of a wild sea. This dynamic surge enhances the fountainhead figures, conveying strength and a sense of purpose—harnessing their sea mounts, diving through surging waves, while intensely focusing on their missions. They seem driven by tremendous unseen forces and hasten to achieve their goals.

In addition to these powerful figures, each of the pools contains bronze castings of more humble sea life, including starfish, turtles, octopuses, and crabs. These charming castings, which rest on small bronze rocks and shells located at the ends of the rippling pools, function as drain covers. For several weeks in 1933, the design for these caps was an item on the agenda of the weekly architects' meetings. The idea originated with John D. Rockefeller Jr.

To visually explain his father's notion, Nelson Rockefeller took Chambellan to Kykuit, the "country place" in Pocantico, New York, where he would have an opportunity to "look at all the different fountain heads and pool drains"[3] in the grotto and pools and adapt some of these ideas to the Center. Kykuit (from the Dutch *Kikjuit* for "lookout"), is a magnificent Georgian mansion standing atop a spectacular knoll in the rolling hills overlooking the Hudson River. It was built at the turn of the century by John D. Rockefeller Sr. at a time when his every whim and extravagant desire could be met and was.

The addition of these bronze details was brilliant, symbolically supporting the concept of the great salty waterway, the English Channel. The excitement lies primarily with sea-creature fountainheads gushing broad streams of water. The large female fountainheads are Nereids, mythological daughters of a benevolent sea god named Nereus (the truth-teller) and his wife Doris (the daughter of Oceanus—the unending stream of water encircling the earth). The most celebrated of the Nereids is Amphitrite, a goddess of the sea and wife of Poseidon, the bad-tempered lord of the sea and earth-shaker. Chambellan has depicted his Nereids astride fanciful fish and dolphin-like creatures. They are considered gentle, lovely mermaids who were protective of sailors and used their beautiful voices to amuse their father—unlike Sirens, nymphs that lure sailors to their deaths. The male figures are Tritons, also hybrids, having human heads and bodies but with legs ending in fish tails. The first Triton lived in a golden palace at the bottom of the sea with his parents, the aquatic deities Poseidon and Amphitrite. The following generations became attendants of the sea gods and were also named Tritons. Tritons had somewhat bawdy reputations but were considered compassionate creatures who sought

A crab, starfish, and turtle, designed by Rene Chambellan as imaginative drain covers that hide the plumbing and continue the sea-creature and salt-water themes.

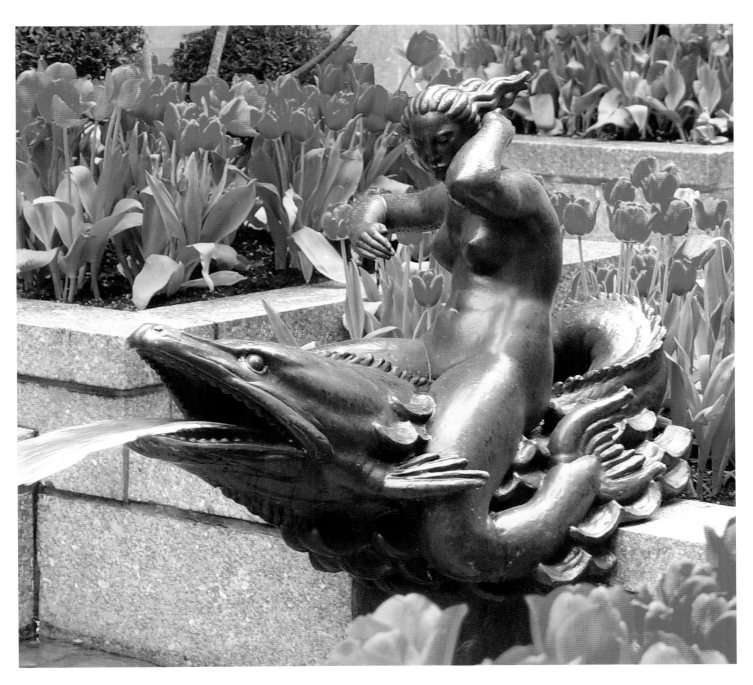

to frolic and enjoy life while disseminating their messages. Depictions of Tritons and Nereids have been used over the centuries to prop up myths and embellish art. The traditional portrayal of a Triton is one blowing a large conch shell that could calm or agitate the sea and herald events. A sanitized version of the Roman myth of Jupiter and Europa's union is that Tritons blew their conch shells to trumpet marriage music and lead the wedding procession. They were followed by long lines of singing Nereids gliding through the waters escorting the blissful couple to Crete. This myth is more commonly depicted as the "Rape of Europa."

Rene Chambellan's Imagination, *one of six fountainhead figures installed in the pools of the Channel Gardens.*

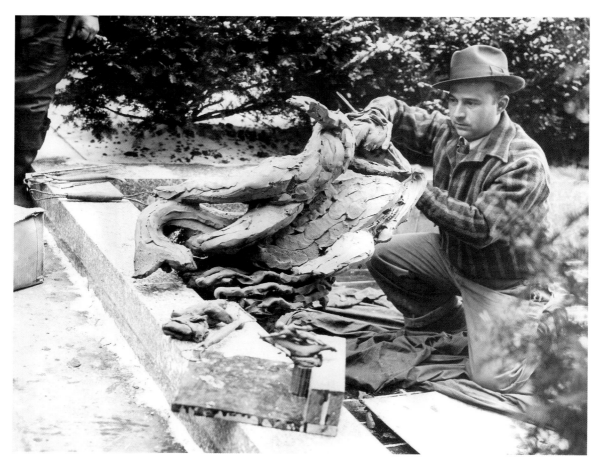

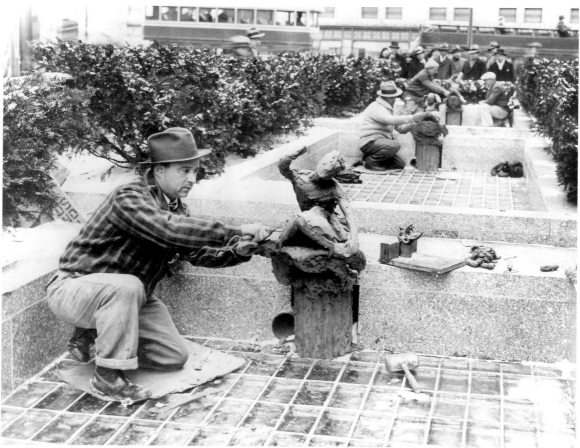

Borrowing from these legends and the sumptuous influence of Kykuit, and at the same time incorporating the Centers' requisite morality, Rene Chambellan sketched his ideas on paper and then carved the initial models in clay. The six pools gave Chambellan an opportunity to introduce variety while maintaining thematic unity. He started forming these models in the pools to achieve proportion and formulate the positioning of the sculptures. They were then transported to his studio for completion. After review and acceptance by the art committee, the full-size clay models were molded and cast in plaster. The plaster models were precisely detailed, chased, and sharpened, to create the final molds. Wax models (also called patterns) were then cast from these molds. These models were carefully detailed and finished by hand so they could be used in casting the bronzes by the lost-wax method. They were cast at Roman Bronze Works in New York.

The six allegorical fountainheads are individually emblematic of the impressive overall theme, represented by the title *Qualities That Spurred Mankind*. They are, in sequence from Fifth Avenue to the skating rink, *Leadership, Will, Thought, Imagination, Energy,* and *Alertness.*

Opposite: Rene Chambellan and his assistants modeling clay for the proposed fountainhead figures for the Channel Garden pools, ca. 1932.

The full-size plaster model for Rene Chambellan's Leadership, *ca. 1932.*

Leadership, *Rene Chambellan's cast bronze figure installed in the pool nearest Fifth Avenue in the Channel Gardens.*

Leadership is symbolized by a muscular young Triton astride a fanciful fish. Set nearest to Fifth Avenue, the deftly carved figure trumpets his presence in the Channel and confidently signals the way to the heart of the Center. He is the harbinger of the Promenade. His head is boldly raised high as he blows a large conch shell, heralding his key position and indicating the appropriate path for mankind to follow. He is young, strong with a graceful, sinuous body. According to the theme, leadership facilitates mankind to forge ahead transforming the world. The fish he rides is large and elegant, like a superb stallion. It appears groomed owing to its beautiful detailing—the fins and gills are neatly carved, rhythmic, and well defined. It stylishly surges through the sea holding its head high as if in a show ring. The fish and the youth are in complete harmony. At the west end of this pool, a small bronze crab cleverly conceals the drain.

Will is characterized by a Nereid who is determined and focused on her mission. She sits aside a fanciful fish surging out of the rippling waves. The Nereid's face is set with resolve and her body leans forward with resilience. Her gaze is focused on the fish. Her right arm stretches diagonally across the fish, touching its side and seemingly directing its course. Her other arm is held high and appears ready to aid if necessary. Her legs are bent and firmly grasp the body of her mount, with her fishtail feet showing at the top of the waves. The fish holds its head high and its tail is curved upward, appearing to move back and forth behind the Nereid. The scene is fast paced, indicated by her flowing hair and the position of their bodies. She seems to be directing a spirited mount by sheer willpower. An octopus rests at the foot of this pool, covering the drain pipe.

In the third fountainhead, Chambellan portrayed the complex notion of thought by means of posture and gesture. *Thought* is personified by a Nereid deep in contemplation and concentration. This is the channel through which man develops his inspiration and reaches his goals. The Nereid's head is bowed, and her arms shield her from her surroundings, shutting out any distractions. Sitting sidesaddle, she is firmly balanced on a fanciful fish. Her body is slightly twisted to one side with one leg resting on the shark's head and the other merging into the surf. The fish's back is bowed from her weight and its head is raised with eyes wide open as if challenging its surroundings. Chambellan posed the Nereid in juxtaposition to the forceful fish; the combination of the two figures, one confrontational and the other withdrawing, props up the concept of the Nereid pondering some great notion. A turtle rests on a seashell covered mount, the drain pipe in the pool. He appears to be curious as his face is tilted upward toward the viewer.

Imagination symbolizes the creative energy that has aided mankind's efforts to develop and master the material universe. It typifies the resourcefulness and inventiveness of humans. This sleek Nereid sits astride a dolphin-like creature with one arm raised up in front; the other arm is bent back near her neck, steadying her seat as if her mount might buck. Her wavy hair flows in a triangular shape behind her. Her legs with their fishtail feet are completely visible. Her body appears flexible and she poses gracefully while coyly glancing downward, apparently unaware of her surroundings while ensuring her balance. The creature's pectoral fins overlap her legs and his tail curves gracefully out behind her and over the granite edge. The bodies of both the figure and the sea creature are smooth forms with the waves, hair and fins forming the design details. The sculpture has a playful quality that supports the concept of imagination. At the foot of this pool are two starfish. Their legs encompass a conch and the drain.

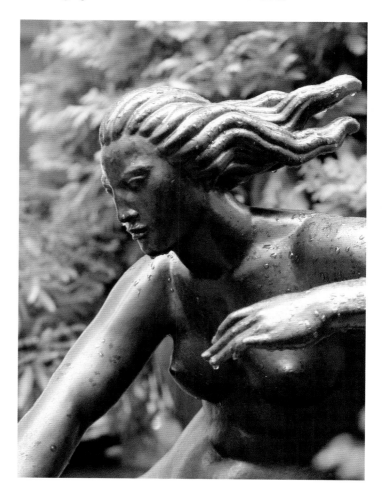

Will, a Nereid and one of the six fountainhead figures created by Rene Chambellan, in the second pool of the Channel Gardens.

Energy is a remarkable portrayal of the power and vigor capable of overcoming any challenge or impediment to mankind's progress. This Triton sits astride a dolphin-like creature leaping out of the churning water. Chambellan carved the stylized waves in five neat, undulating rows. The rider's fish tail feet, small and fan-shaped, overhang the granite pool edge. The creature's tail is like a precisely fluted arc that is held high behind the Triton, adding to the forward motion of the sculpture. The Triton leans forward grasping the creature's pectoral fin in his left hand while holding his other arm frontward, slicing the air, ready to dive again. His body is taut and muscular and his hair flows straight out behind him. The mood created by his strength, coupled with his dynamic mount, imbues this sculpture with larger-than-life energy. A bronze crab clasping a scallop shell decorates the drain in the pool.

Alertness, the fountainhead closest to the Lower Plaza, is symbolized by an aggressive Triton astride another fabulous sea creature. The strong, young figure leans forward at an angle. His face is rugged and his brow furrowed, tense with amassing power.

Rene Chambellan's Energy astride a dolphin-like creature spouting a broad stream of water. The figure is located in the fifth pool from Fifth Avenue.

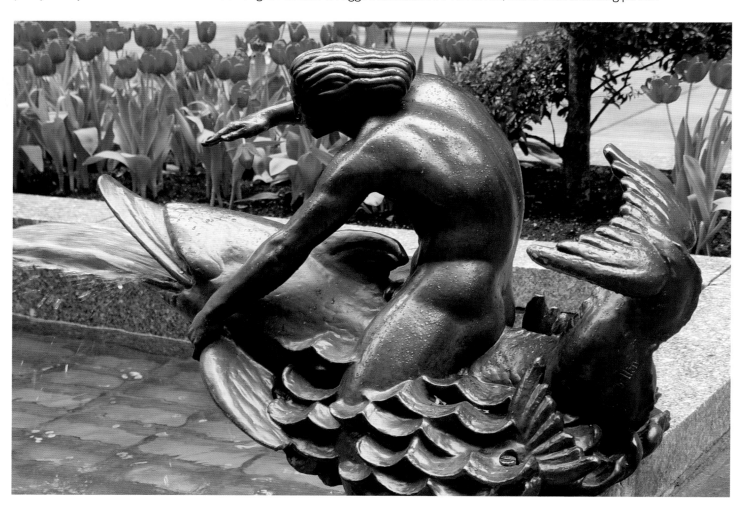

Both his arms are reaching out, with open hands, toward the side of the pool. His eyes are focused on this side as if anticipating an event. The sea creature he rides appears heavy and strong. It has two long uneven ridges down its back, thick folds in its skin, and massive pectoral fins, giving the appearance of an armored mount. As it swims a steady path, its head rises, causing its body to arc out of the sea. A broad jet of water surges from its mouth. The moment portrayed suggests that, with vigilance and watchfulness, man is able to ward off hazards or snare a prize. Given this interpretation, alertness represents the infinite reach of human intelligence. At the foot of the pool two drains are hidden by a turtle on a rock and an octopus.

Chambellan's technical virtuosity and great understanding of both the human body and sea life are apparent in the figures' muscular tension and dynamic movement. His careful observation of nature is reflected in the realistic diversity he created while maintaining an overall unified composition. After being cast in bronze, the vibrant sculptures were skillfully hand-chased (flaws removed and details sharpened), and

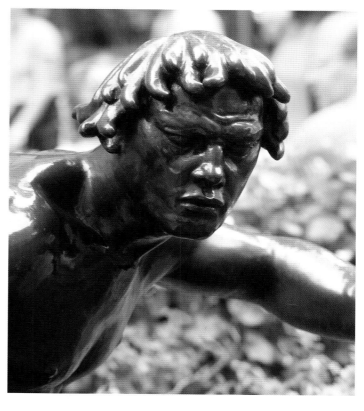

Detail of the head of Rene Chambellan's Alertness, *a* Triton *and the sixth figure in the Channel Garden pools.*

then came a lively discussion about color or patina. The architect L. Andrew Reinhard wrote to John Todd, the engineer, "It would be fatal to finish these figures the same as the Manship fountain as the color and finish in their present state is magnificent."[4] Todd lived up to his reputation for being brusque and opinionated. He answered, "If anyone touches the color of these things, there will be murder committed in the cellar."[5]

The architectural sculptor Rene Chambellan was a gifted and versatile sculptor as well as a remarkable technician. His studio was in constant demand by other artists and architects to create finished sculptural works from their sketches or models. He had the ability to get the work done on schedule and within the technical and diverse stylistic requirements made by the great variety of architects who relied on him. He was fastidious, industrious, and frequently expected to work evenings and weekends to meet the schedule at Rockefeller Center. It can be said that Rene Chambellan is the unsung artist-hero of Rockefeller Center, producing over twenty-two sculptural works of his own, as well as many for Lee Lawrie and other artists who received Rockefeller Center commissions. Unfortunately, much of Chambellan's work is not labeled or identified as coming from his studio because he was a subcontractor for the artists and architects who received the commissions. Only recently has his collaboration with Lee Lawrie for the figure of Atlas been recognized.

VALERIE CLAREBOUT · ANGELS

In winter the fountains are turned off and twelve wire-sculpture angels are installed in the six Channel Gardens amidst small pines and Christmas boughs. Each angel is eight feet high and made of twisted aluminum and brass wires painted white. The figures hold six-foot-long brass trumpets angled toward the famed Christmas tree. Wire-sculpture snowflakes and thousands of tiny glittering lights enhance the Yuletide brilliance.

These delicate figures are the work of the English-born artist Valerie Clarebout . They were installed for the first time in 1954 and have been an annual Christmas feature since 1969, becoming an admired highlight of the Center's holiday displays. In 1958 Clarebout created deer using the same wire technique. These appear periodically. Every year, until the early 1980s, the artist returned to the Center to oversee the reinstallation of her work and make any necessary repairs.

Clarebout designed the figures to sparkle with light and energy. She handcrafted each one, bundling or weaving hundreds of individual lengths of different-gauge wires to create the forms around an aluminum armature. After connecting the wires, she painted the figures white and then strung them with twinkling small lights. The wire sculptures are so translucent and ethereal they appear as if they have just materialized to herald the Christmas season.

Opposite: View of the Christmas angels by Valerie Clarebout. These Christmas decorations are installed for about six weeks in the Channel Gardens overlooking the pools and fountains.

Valerie Clarebout fabricating one of her eight-foot-high Christmas angels, ca. 1954.

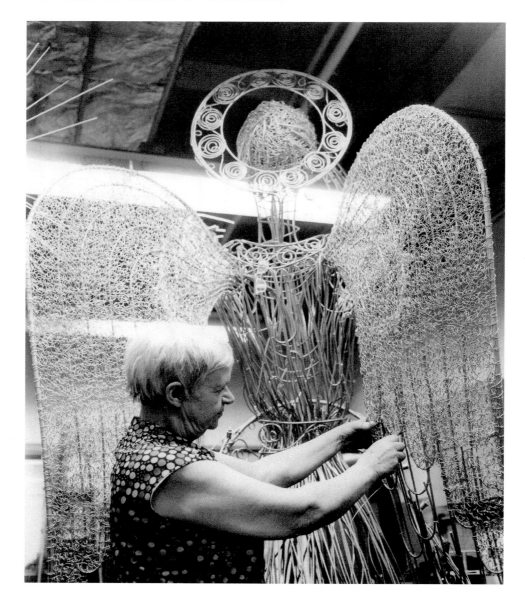

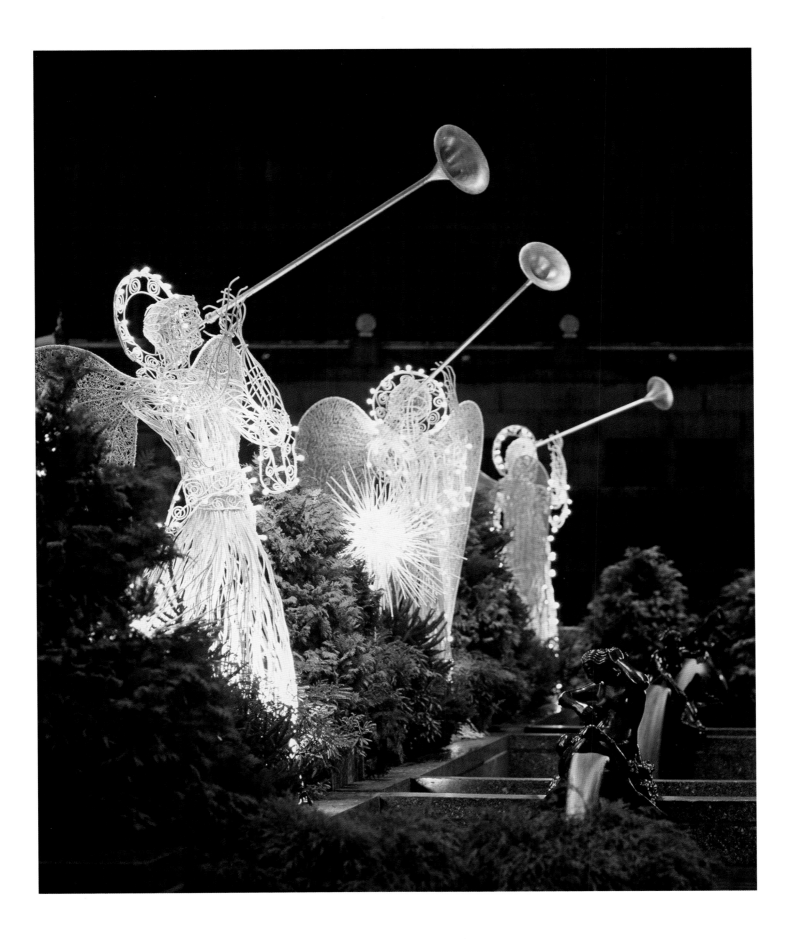

THE LOWER PLAZA

The Lower Plaza is located in front of 30 Rockefeller Plaza, at the very center of the complex. The architects intended it to be a grand entrance to a series of underground luxury shops and restaurants. They envisioned an imposing, European-type plaza that would be a centerpiece and gathering place. A series of designs initially drawn up included impressive central fountains, mosaic pavements, large sculptural figures, and gardens. None seemed to be acceptable. Eventually artist Paul Manship was asked to develop a plan for a huge sculpture and fountain set against the west wall. The central part of the plaza was left unadorned and over the years has been used as an area for exhibits, car shows, flower displays, and musical and theatrical performances. It remains that way today, with millions of visitors drawn to a variety of events from around the world.

In 1936, M. C. Carpenter, a Cleveland inventor, approached the management of Rockefeller Center and asked if his new "artificial ice-skating rink" could be tested in the central space. At this early period in the development of the Center, management was willing to experiment with the space if it didn't cost them anything and might prove commercially viable.

Ice-skating commenced in Rockefeller Center on Christmas Day in 1936. It was a huge success. Ice-skating is a simple sport that many people can do, and to ice-skate in the very heart of the city highlighted the distinctiveness of the Center. It became a spectator sport as well, with hundreds of people leaning over the walls to watch the skaters. By this time, Nelson Rockefeller was in charge of the Center and realized the commercial and public relations potentials of the rink. He ordered the grand staircase altered to fit the skating rink and permanent ice-making equipment installed. That was 1939, the year the last rivet was driven into the final building of the Center.

The head of Paul Manship's Prometheus, *at the Lower Plaza. The red granite wall behind the figure is inscribed with a quotation from Aeschylus.*

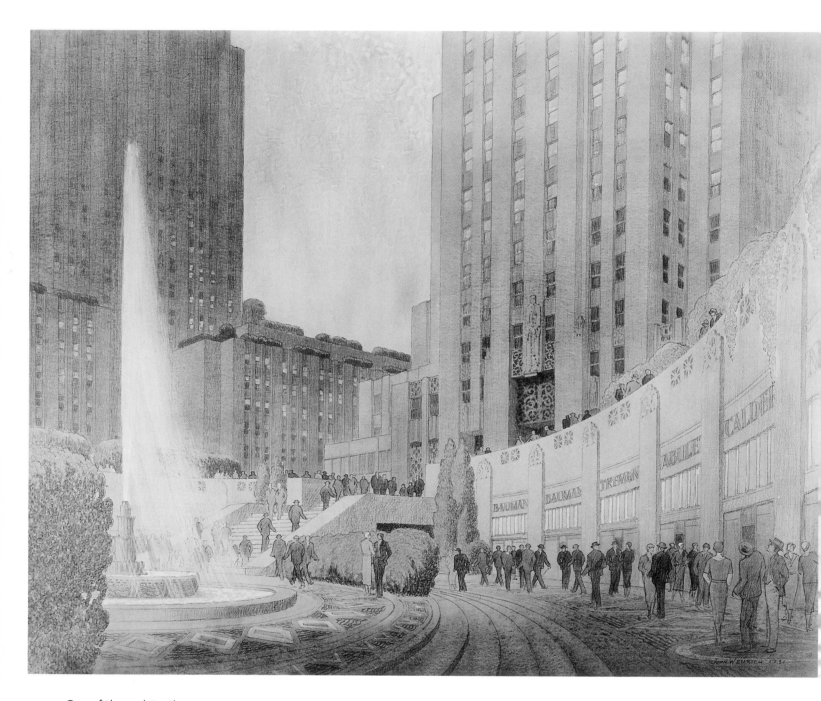

One of the architect's
proposed plans for the
Lower Plaza rendered
by John Wenrich, 1931.
The drawing depicts
a central fountain, broad
stairs leading onto
the private street, and
shop windows fronting
the Lower Plaza.

Opposite: Two views of the
Lower Plaza in 1934. Over
the years the plaza has
been used for many memo-
rable events including dog
shows, car exhibits, flower
shows, musicals, and
the Christmas Pageant.

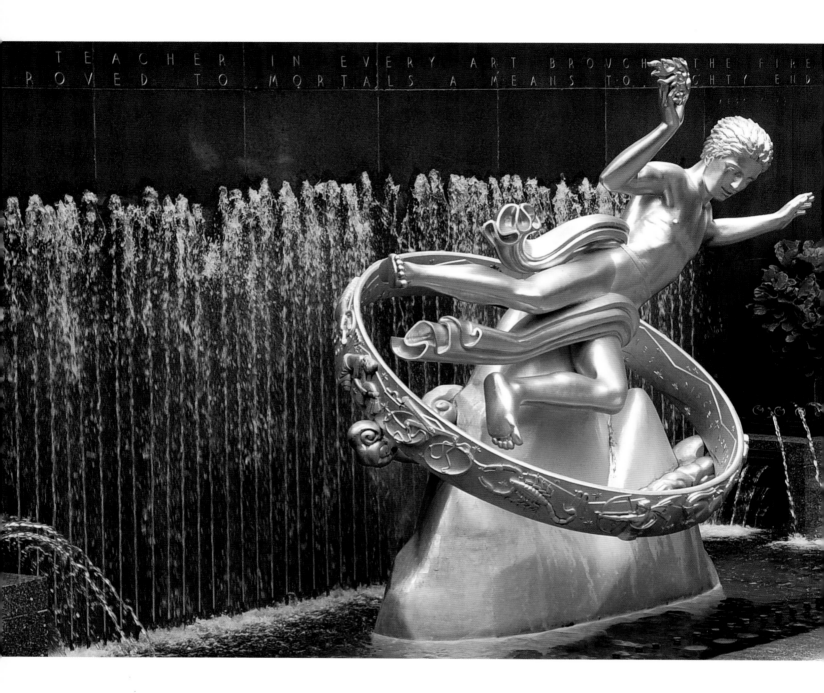

PAUL MANSHIP

In 1933, Paul Manship's talents were widely celebrated in America. He was the country's most acclaimed and well-paid sculptor. He had achieved success in the first part of the century, at a time when public museums and private galleries were opening and people from a new class of wealth wanted to signal their achievements by embellishing their lives with art. This newly established class commissioned artists to create paintings and sculptures for their homes. Manship rode that affluent wave.

PROMETHEUS

The architects at Rockefeller Center sought Manship out and commissioned him to create a masterwork to adorn the central axis of the plaza. This was in spite of the fact that, in the midst of the Depression, Manship still commanded the highest prices of any American artist. He was selected not only for his preeminence within America but also for his highly developed individualistic style in the American Moderne vernacular. He was also renowned for his workman-like ability to get the job done on time and on budget. Style, speed, and schedule were at the core of the architects' decision. They had previously considered cost a major factor when making their choices, but they no longer had this option. There was only one year remaining before the central building, 30 Rockefeller Plaza, would be completed. One of the focal points would be the Lower Plaza in front of the building. It needed a dazzling masterwork. Manship's *Prometheus* would be the answer.

Manship had presented over a dozen ideas to the architects before he proposed the Greek legend of the Titan Prometheus. He had wanted to create a sculpture that dealt with time, space, or the elements, and he was keenly interested in iconography of Greek mythology. In accordance with the general mythological themes set by Hartley Burr Alexander, Manship proposed Prometheus. He suggested the famed mythological Titan would dominate the scene, surrounded by the elements of fire, water, and earth.

According to Greek mythology, Prometheus defied the gods of Mount Olympus twice: first, when he fashioned mankind from clay, and then when he stole fire from Mount Olympus and taught man to use it. With this second act Prometheus bestowed the gift of civilization on mankind. He had treated the gods with contempt and given man an element for survival and a link to immortality. Immortality was reserved for the gods. This act enraged them.

Prometheus was captured and made to pay for his crime. Zeus had him chained to a rock where a vulture pecked out his liver every night. Zeus renewed it every day and so the torment was repeated. According to legend, this went on for thirty years until Hercules, a son of Zeus and Alemene, slew the vulture and released Prometheus from the rock. In gratitude, Prometheus told him the secret of obtaining the Golden Apples of the Hesperides. He sent Hercules to his brother Titan, Atlas, to aid him in this labor.

Paul Manship's Prometheus, the gilded bronze Titan descending through a zodiac ring and clouds bearing his gift of fire to mankind, located in the Lower Plaza.

On the granite wall behind *Prometheus* is an inscription, a quotation from the Greek writer Aeschylus: "Prometheus, teacher in every art, brought the fire that hath proved to mortals a means to mighty ends." Manship had proposed this quote after consulting with Professor Perry of the Greek Department at Columbia University.

In his sculpture, Manship depicts and celebrates the crucial moment of the crime when Prometheus descends from Mount Olympus bearing a fireball to man in his raised right hand. His robes fly around him as he plummets towards earth, holding his prize aloft. He gazes downward; his mouth is slightly open as if he is a little anxious. His left hand reaches out to balance himself during this precarious descent. Surrounding Mount Olympus is a broad bronze ring, decorated with the signs of the zodiac, representing the heaven through which Prometheus must descend. Below Mount Olympus is a pool into which jets of water flow, creating a dancing sea of water.

In his studio, on East seventy-second Street, Manship created a scale model (¼ inch: 1 foot) of the western side of the sunken plaza in order to work out his various ideas. In his effort to find the right composition, he revised his models a number of times. It appears he gave a great deal of thought to the central figure. "He finally hit upon Prometheus ... hoping it would be interesting and inspiring as the legendary contributor of one of man's greatest aids: Fire."[1] Manship created the full-size plaster model in his studio and transported it to Roman Bronze Works, where it was cast in bronze. True to form, he created the sculpture with astonishing speed, taking just one year from the time the sketch was approved and the contract signed to its actual placement in the plaza, in January 1934.

The bronze, two-and-one-half-times life size, weighs eight tons. The top of Prometheus's head is eighteen feet above the ground, and from the tip of his left hand to his big right toe he is twenty feet five inches long.

Because of its size, the sculpture had to be trucked to the Center in three sections: the figure, the mountain, and the zodiac ring. A "locomotive" crane lowered the sections into the fountain and bolted them together.

Considerable attention was then given to the surface. What color would be most desirable? What finish would be most effective? For three years the statue remained uncoated bronze. During that period the architects discussed every possibility, including gold plating and green patina, before settling on gilding. The first gilding took place in 1937.

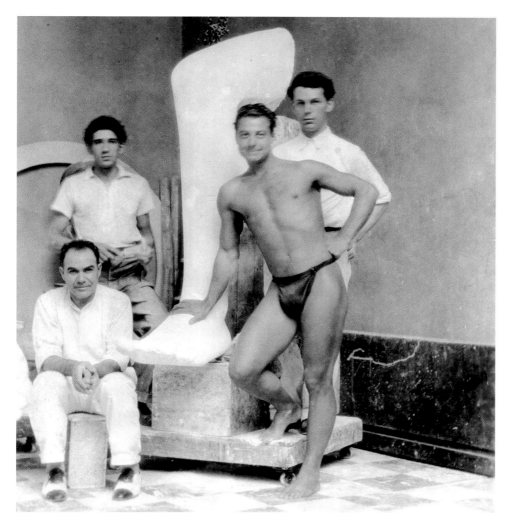

Leonard Nole poses for the statue of Prometheus with technicians in Manship's studio, ca. 1932. Armando Aroffo, lead technician, is seated in the foreground.

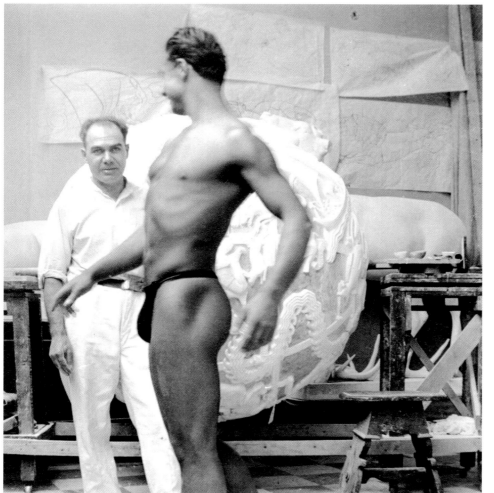

Leonard Nole models for Prometheus with lead technician, Armando Aroffo, ca. 1932.

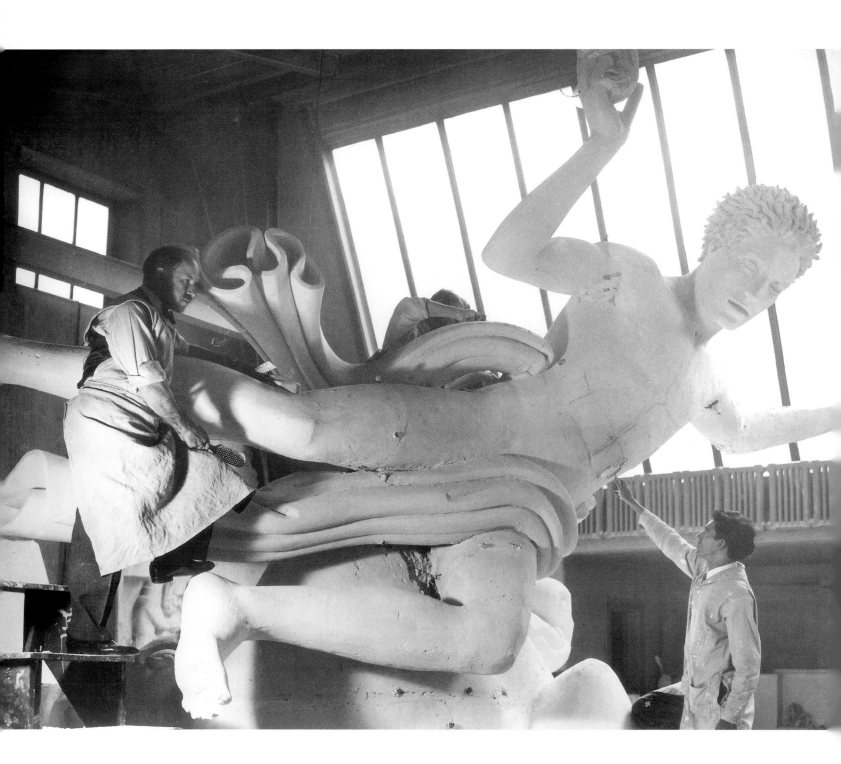

Today, gilded statues are synonymous with *Prometheus*. Gilding is a fragile and fickle technique. It is subject to wear and erosion from the constant blast of the fountain's water jets and the varying and harsh climate of the Northeast. Since 1937, Prometheus has required regilding seven times (1947, 1958, 1963, 1974, 1982, 1999, and 2001).

Before the most recent regilding, in January 2001, the statue was in poor condition, the gilding was breaking down, the underlying coatings were failing, and corrosion was present.

To restore it, the pool was drained and a protective shed was built around the entire site. The shed provided a temperature-controlled, clean, dust-free environment. A multilevel scaffold was erected within the shed. All old layers of gilding, size (a varnish that acts as "glue" causing gold leaf to adhere to the surface), and primer coatings were removed from the statue, down to bare metal. Sections of the metal were repaired, internal areas were cleaned of old casting materials, and the surface was thoroughly rid of any residual chemicals, hand oils, or work products. The entire site was then painstakingly recleaned. Every inch was vacuumed, washed, and thoroughly dried. Next, the statue was completely coated with a primer layer. This acts a barrier coating and fills any remaining small defects. Then size was applied section by section, and Italian-made 23-carat, double-weight gold leaf was placed by hand. Areas exposed to water were given two layers of gold leaf, as water constantly hitting the surface causes the gold and size to break down. This restoration took three months. By the end, Prometheus was once again golden and gleaming for his descent from Mount Olympus to earth.

Following the restoration, the sculpture was lit by a series of glowing colored lights that change hues and intensity as the fountain sprays rose and fall. This was a return to a 1958 concept for an "after-dusk show," when "a fountain of lights was installed behind Prometheus to form a backdrop curtain of water upon which is projected a constantly changing symphony of color from underwater lighting."[2] After several months the new light show was cancelled; it was an evocation of the past and too flamboyant for the setting and current style.

At the time it was installed, *Prometheus* was not well received by everyone. The press termed it "Leaping Louie." In a 1934 cartoon, Abner Dean mocked it as being suitable for a "radiator cap."[3] Even Manship, fifteen years later in 1959 when John D. Morse was interviewing him and asked, "Do you like Prometheus, Mr. Manship, as much as most people seem to when they come to New York City?," answered, "I don't have any particular feeling about it. I don't like it too well, no, I don't think too well of it".[4] His disappointment appears to have stemmed from compromises he had to make in deference to the architects and the art committee.

They may have all been mistaken, as *Prometheus* is said to be the best-known and most-photographed sculpture in New York City. In 1936, Rockefeller Center claimed that forty million people visited the area annually and that the Lower Plaza was the most frequent spot. By 2000, the number of visitors to the Center had risen to seventy-five million. During the Christmas season, Prometheus's image is prominently displayed on televisions across America, glittering below the famed Yule tree. It has become an icon of Rockefeller Center.

Paul Manship and an assistant, ca. 1933, working on the full-size plaster model that will be used by Roman Bronze Works to cast the bronze figure for Prometheus.

MANKIND (YOUTH AND MAIDEN)

During this same period, Manship created two other sculptures to flank *Prometheus*. Originally, these figures were titled *People of the Earth* and stood on the small flanking ledges on the wall behind the fountain. They were actually installed six months prior to Manship completing *Prometheus*. Currently, they are individually titled *Youth* and *Maiden* and collectively *Mankind*. According to the myth, they were created by Prometheus from the clay he stole from Mount Olympus. They represent the first humans.

Youth and *Maiden* are placid, sleek sculptures standing before massive bronze vegetation that symbolizes the Garden of Eden. Their demeanor is stilted. They stand calmly, with mildly quizzical expressions and outstretched hands to receive Prometheus's precious gift of fire. There is no excitement here, just a tranquil, bland acceptance of the event about to change the course of mankind. Actually, they appear quite bored.

Each figure is partially clothed, the Youth in a toga and the Maiden in a long neatly pleated sarong. There is nothing sensual about either one. The vegetation behind them is overwhelming—too heavy, too hulking to be supple and sinuous, and, for the Garden of Eden, not too appetizing.

Shortly after installing *Prometheus*, in March 1936, Manship suggested breaking up the ensemble. At that time only the figures had been gilded. The architects were still working to determine how to handle the finish on Prometheus and especially the mountain as it was constantly standing in a pool of water and eventually would discolor. They considered a range of options including plating, patina, and gilding. Ultimately, the entire sculpture was gilded. The human figures were removed after "they were tried out, and the composition was better without them. The central figure [Prometheus] in the group would be more effective and in better scale if it stood alone."[5] With their removal, Prometheus was left to find mankind on his own for the next fifty years. In 1985, after being stored on the rooftop of the British building for all those years, *Youth* and *Maiden* were cleaned of thick corrosion, dirt, and a few remnants of gilding. They were restored with a warm brown patina and, in 2001, installed flanking the top of the staircase leading to the skating rink.

Paul Manship working in 1933 on the full-size plaster model used by Roman Bronze Works to cast the bronze figure Maiden. *This figure was originally designated to flank one side of Prometheus.*

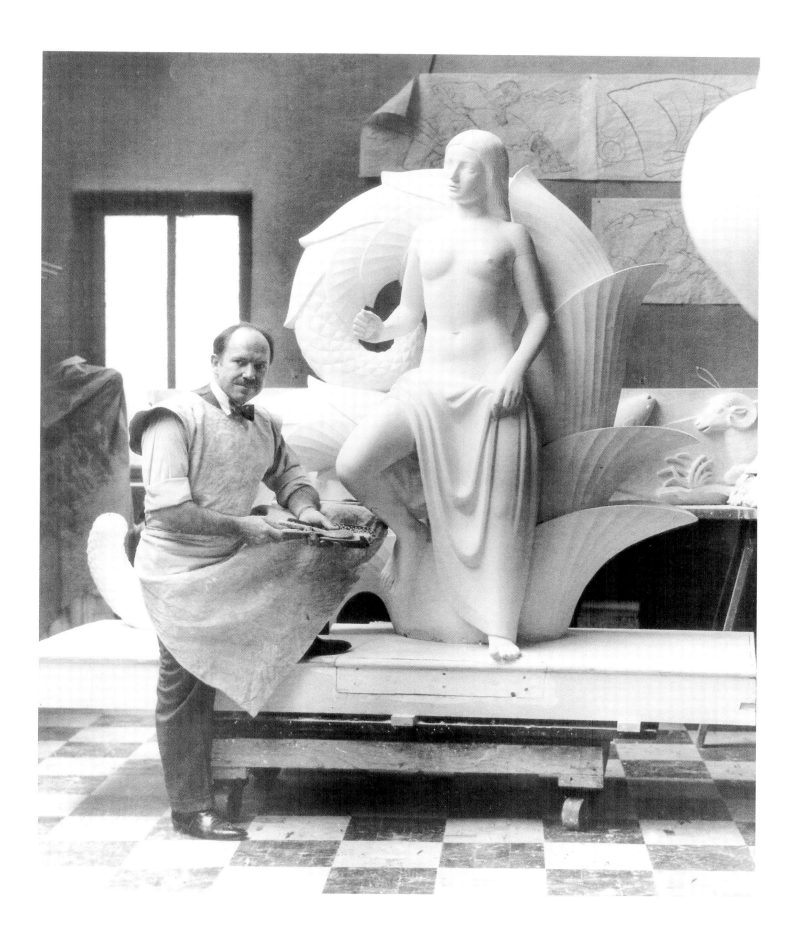

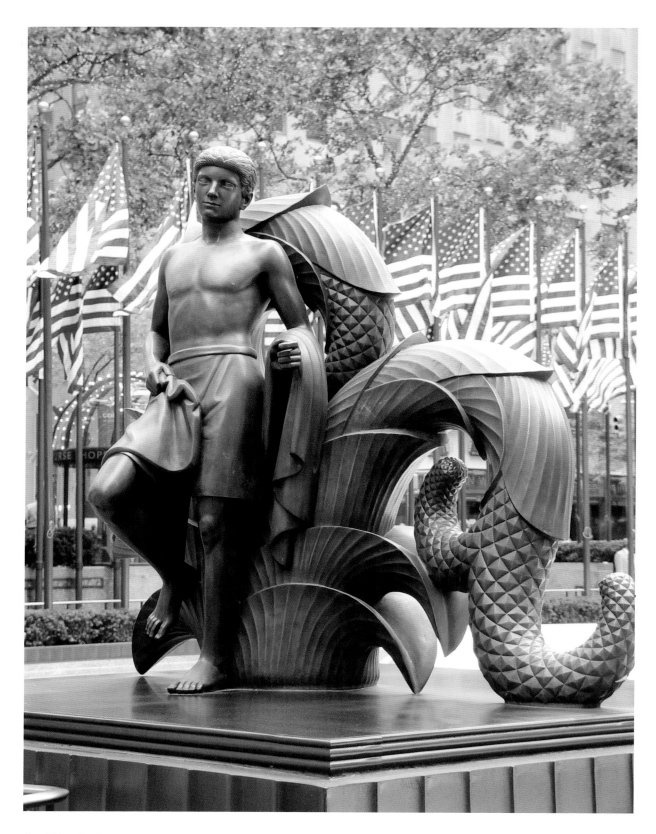

*Paul Manship's cast
bronze Youth, one of the
two figures that form the
sculptural group Mankind,
originally designated to
flank Prometheus.*

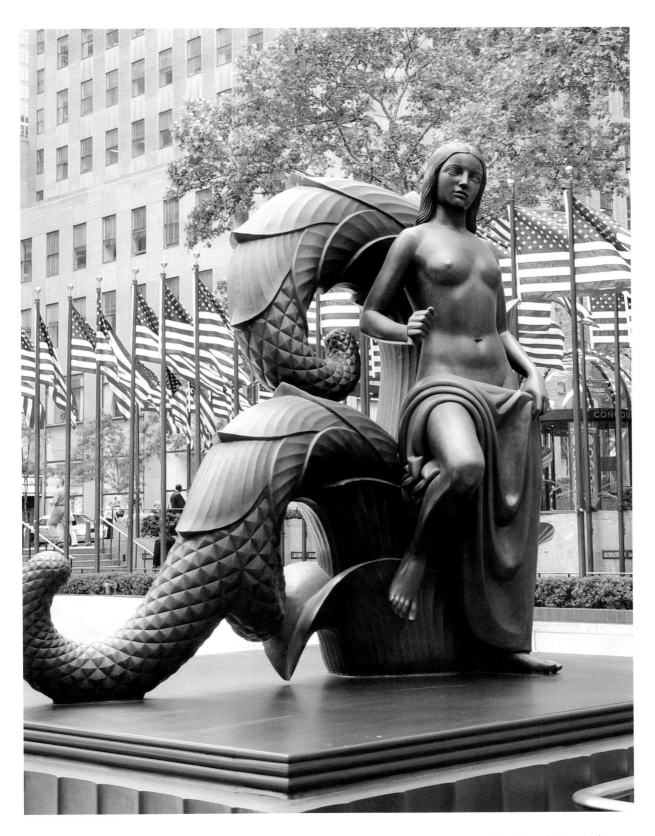

Paul Manship's cast bronze Maiden, the other figure for Mankind, currently installed at the top corner of the staircase leading to the Lower Plaza.

PALAZZO D'ITALIA

In 1933, John D. Rockefeller Jr. sent representatives to Italy to meet with the Fascist dictator, Benito Mussolini. They carried with them a scale model of the proposed Rockefeller Center, including a building they hoped to name the Palazzo d'Italia. This tribute was to identify the Italians as major tenants in an internationally distinct building. The representatives anticipated the government of Italy would lease substantial trade and cultural offices within the building, attract additional Italian tenants, and provide a focal point for Italian commerce with America. This, of course, was to change in the next few years, as the war took its course in Europe.

In 1935, the year the Palazzo d'Italia was completed, John Todd's influence and power had grown and he became increasingly vocal. As chief engineer for the Center he had a hand in many aspects of the building program and was prone to putting lofty opinions in proclamation-like memos. He held forth in one memo regarding the overall objectives of the builders and what influenced the success of Rockefeller Center:

. . . utility, beauty and economy. As to beauty. We have in mind that the success of Rockefeller Center so far has been as much influenced by beauty as it has been by utility. Beauty must be kept in mind all the time and increased to the maximum reasonable limit. In beautification there are several things to consider, some of which are hard to figure. One is the personal satisfaction and pleasure of Mr. Rockefeller. Another is what it does to our office rentals. Another is the numbers of people it draws to the Center and the effect of those people on our shop business.[1]

To achieve the "beauty" John Todd described in his memo, and to enhance the concept of an Italian building, the architects sought materials native to Italy. Travatino limestone was used on the lobby walls, and lighting fixtures copied from a system found in the ruins of Pompeii were installed. The lobby floor is paved with Venetian terrazzo squares.

Art-related items—sculptures, paintings, mosaics, bas-reliefs, and gardens and materials, down to the smallest details—were frequently included on the agendas of the planning-committee meetings. The status of each project was constantly reviewed, and new ideas were frequently explored. The builders were fortunate; they were able to place great added value to the art and decoration in their plans. It wasn't enough to build edifices—they had to be well-adorned structures, eclipsing the past and addressing the future. It was an enormous group effort to achieve the "finest job" in the modern world of urban commercial architecture. By May, the month the Palazzo d'Italia was completed, the architects had accomplished that goal and the results were stunning.

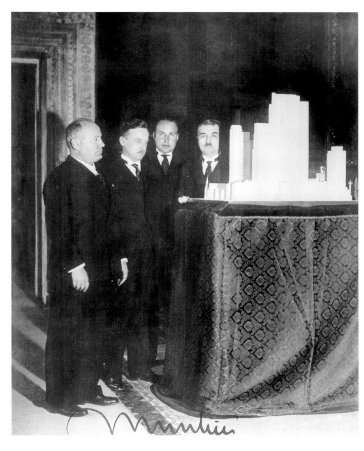

Representatives from Rockefeller Center in 1932 presenting the Fascist leader Benito Mussolini with a model of the Center showing the proposed Palazzo d'Italia and its location. It was hoped that Mussolini would sanction this building and lease space, making it the New York headquarters for Italian government and commercial offices.

Opposite: Detail of Giacomo Manzu's bronze plaque Italia, *depicting grape vines and shafts of wheat, on the main façade of the Palazzo d'Italia.*

ATTILIO PICCIRILLI AND THE PICCIRILLI BROTHERS

Attilio Piccirilli was one of the most skilled artists to work on the art and decoration of Rockefeller Center. He was born in 1866, in Massa Carrara, Italy, the son of a stone carver. In 1888, after attending the Accademia di Belle Arti, in Rome, his entire, large family immigrated to New York. Within a few months they had a studio on Thirty-ninth Street. They imported marble and set up a traditional European-style atelier, a workshop that can undertake any task to complete a sculpture from beginning concept to end result. They could draw, sculpt, carve, make models, make molds, finish bronze, and cut any size and type of stone. Attilio, his father, and six brothers performed all the tasks associated with the studio. They had all been trained to be technicians and sculptors in the most traditional and challenging art schools in Italy.

At the outset of their business in America, the Piccirillis provided technical assistance to sculptors. They received the artist's concepts (drawings or models) and turned them into full-sized sculptures. They also could take the idea or maquette and enlarge it to whatever size was indicated. They worked in their atelier or frequently on site, directly in stone already set into place on a building's façade. They quickly gained recognition due to their high standards, range of skills, and technical virtuosity.

Daniel Chester French was one of the Piccirillis first clients and continued to work with them for over thirty-five years. During that period he introduced them to all the major American artists of the time. Soon they had established the largest full-service studio in America and were receiving work from artists such as Augustus Saint-Gaudens, Frederick W. MacMonnies, and John Quincy Adams Ward.

By the time they set up a new larger workshop in the Bronx, the Piccirillis were operating the most prominent stone-carving studio in America. It was set up as a Florentine *bottega*—that is, a workshop where sculptors, their assistants, and apprentices worked together as a team on commissions.

In 1920, Daniel Chester French brought a five-foot-high clay model to them. They enlarged it to twenty-one feet high, carved in 175 tons of marble. That remarkable effort resulted in French's famous *Seated Lincoln*, in Washington, D.C. Attilio, the most skilled of the brothers, carved the head and hands; the rest was carved in the studio by various workers under his supervision. After completion in the studio, the carved blocks were transported to Washington for joining and installation.

Not only did the Piccirillis work for other artists, they were also commissioned by architects and patrons directly. Two of the brothers, Attilio and Furio, achieved individual fame as sculptors. Attilio became the most recognized of the brothers and his reputation as an artist and carver grew.

ATTILIO PICCIRILLI · SEMPRE AVANTI ETERNA GIOVINEZZA (ADVANCE FOREVER ETERNAL YOUTH)

Attilio Piccirilli had achieved an extraordinary reputation and body of work by the time he was commissioned by the Rockefellers to design architectural embellishments and bas-reliefs for a new building, the Palazzo d'Italia. In 1935, just prior to the outbreak of the Second World War in Europe, he created a huge plaster model for his sculpture for the entrance to the building. The model was cut into sections and sent to Corning Glass Works, where it would be cast in Pyrex glass blocks.

Attilio Piccirilli's final plaster model for the plaque Advance Forever Eternal Youth, *ca. 1934. The cast glass-block bas-relief was boarded up, removed, and eventually destroyed due to anti-Fascist sentiments.*

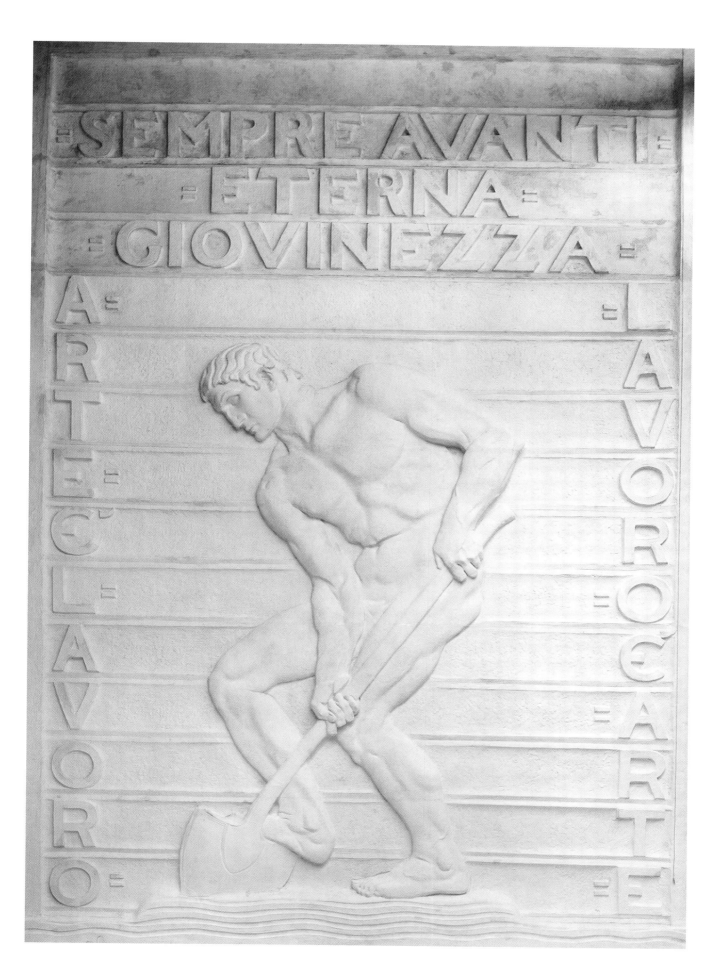

A unique application and an ambitious undertaking, his work was the first and largest decorative sculpture ever cast in Pyrex. Composed of forty-five glass blocks, weighing three and a half tons, and towering sixteen feet high and eleven feet wide, the piece would dominate the entranceway. It took nearly two years of trial and error to produce glass castings of this scale and accuracy. For the project Corning used a newly developed Pyrex glass that required special treatment to reduce transparency. Each block had its own mold, which could be used only once because the mold had to be destroyed to remove the hardened glass. If a casting was defective, a new mold from the original plaster model had to be made and the process of casting molten glass repeated. Molten glass was hand-poured into the molds in small quantities to form bubbles and imperfections that reduced the clearness and produced the effect of fluidity. During installation above the entrance, each block was joined to adjacent blocks with transparent "cement" (an early type of synthetic sealer). This adhesive had the same refractory power as the glass, creating the effect of a single transparent panel. It was a technical tour-de-force for both the artist and Corning Glass.

Unfortunately, like the Diego Rivera mural at 30 Rockefeller Plaza, the theme of this work soon became too controversial for the Rockefellers because it appeared to sanction Fascism. Its symbolism and mottos were noticeably imitative of the neoclassical public art and slogans of Fascist Italy. The title, *Sempre Avanti Eterna Giovinezza* (Italian for "Advance Forever Eternal Youth"), which was carved in raised block letters at the top of the panel, derived from two slogans Mussolini used. *Eterna Giovanni*, a favorite of Mussolini's, is believed to have originated with Giosuè Carducci, an Italian poet and teacher of the late nineteenth century. *Sempre Avanti*, also borrowed, had originally gained fame as the battle cry of the House of Savoy, the long-reigning dynasty of the kingdom of Italy.

Extraordinary for its simplicity and striking owing to the deep undercutting around the form, the massive glass panel depicted a heroic-size, muscular youth thrusting a spade into the earth against a background of horizontal ridges. Flanking the figure were lateral inscriptions: *Arte E Lavoro* and *Lavoro E Arte* (Latin for "Art Is Labor" and "Labor Is Art"), also favorite mottos of Mussolini. It was a bold, brash work of art celebrating the beauty of masculine vigor and symbolizing the worker as a creator. Without the characteristically Fascist inscriptions, the panel would be there today.

COAT of ARMS of SAVOY

Surmounting the glass panel, cut into the limestone façade of the building, were the coat of arms of Savoy and the Fascist's symbolic cartouche: a bundle of rods bound together around an axe with its blade projecting outward. This fasces had become one of the main icons of Mussolini's new order and was recognizable worldwide, it represented strength and unity and harkened back to Roman times.

The carving offended many of the anti-Fascist Italian business tenants. It had been installed in 1935, just as Italy brutally invaded and annexed Abyssinia (Ethiopia). The tenants quietly lobbied for its removal. Not until 1941, the year Japan attacked Pearl Harbor and the United States entered the war, did this "propaganda art" finally distress the patriotic Rockefellers. They boarded up the offending work and renamed the Palazzo d'Italia the International Building South. This name lasted for duration of the Second World War.

When the war was over, at the request of the Italian government, the stone carving and glass panel were removed and replaced by plain stone panels. During removal, the carved stonework was smashed and the glass panel stored in a subbasement. In 1973, when Corning Glass Works attempted to locate it, Rockefeller Center stated the panel was "lost." It was a companion piece to *Youth Leading Industry*, which fortunately remains installed over the entrance to the International Building North. No matter the theme, the loss of this unique work of art is tragic.

By 1949, the Italian Tourist Office signed a new lease for prime space in the building, and it once again regained its original name, Palazzo d'Italia. The Rockefellers, the Italian ambassador, and the Fiat company began to work out plans for commissioning new artwork for the vacant site. Several attempts were made to find an artist who could create a suitable piece to replace the destroyed works.

Giovanni Agnelli, president of Fiat and a longtime friend of the Rockefellers, influenced the celebrated Italian artist Giacomo Manzu to take the commission. At first, Manzu was reluctant because of his age and other commitments. He was just completing the bronze doors of St. Peter's Cathedral in the Vatican. Eventually, Agnelli and the Rockefellers enticed him with this major site and presence on Fifth Avenue.

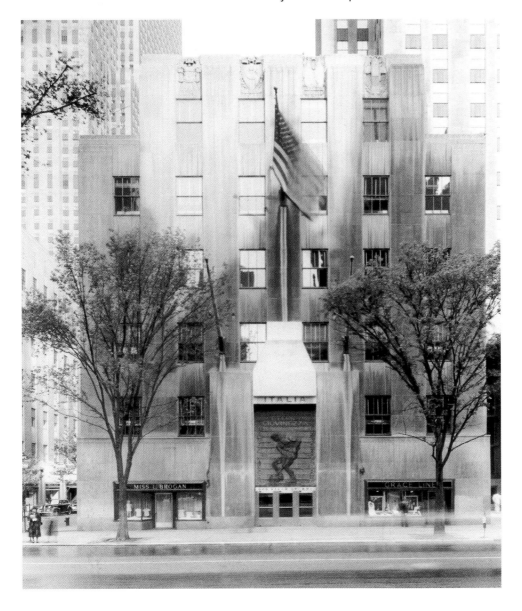

The Palazzo d'Italia prior to the destruction of Attilio Piccirilli's Advance Forever Eternal Youth, *ca. 1949.*

GIACOMO MANZU · ITALIA AND THE IMMIGRANT

In 1963 Manzu submitted a design for the important space that had been occupied by the lost Piccirilli plaque. The commission resulted in the installation of a two-part, bronze bas-relief, *Italia* and *The Immigrant*. It was a gift from Giovanni Agnelli and Fiat to Rockefeller Center.

After the Rockefellers' and Agnelli's approval of the artist's sketches, Manzu set to work creating both pieces in his studio near Milan. He worked in clay, rendering his ideas in full-size models. The models were then cast in plaster and sent to a foundry in Milan for bronze casting. The bronze castings were shipped to New York for installation. Late one evening in May of 1965, a huge crane rigged the plaque into place over the main entrance to the Palazzo d'Italia.

A major contemporary public sculpture, *Italia* is a clear statement directly addressing the subject of nationalism. The central motif sculpted in high relief and depicting sections of cut vine, grape leaves, and wheat stalks symbolizes the fruitfulness of Italy and the productivity of man's labors. The word *ITALIA* is in large stark letters above the central motif. The background is completely flat and barren, devoid of symbolism—only the warm brown patina is present. *Italia* is a masterpiece of simplicity and an innovative and down-to-earth tribute to Manzu's native country.

Opposite: Giacomo Manzu's 1964 clay model of the central motif of Italia—a grapevine and shafts of wheat, representing the bounty of Italy.

Artist Giacomo Manzu and G. S. Eyssell, president of Rockefeller Center, standing in front of the full-size clay model of Italia in the artist's studio in Rome in 1964.

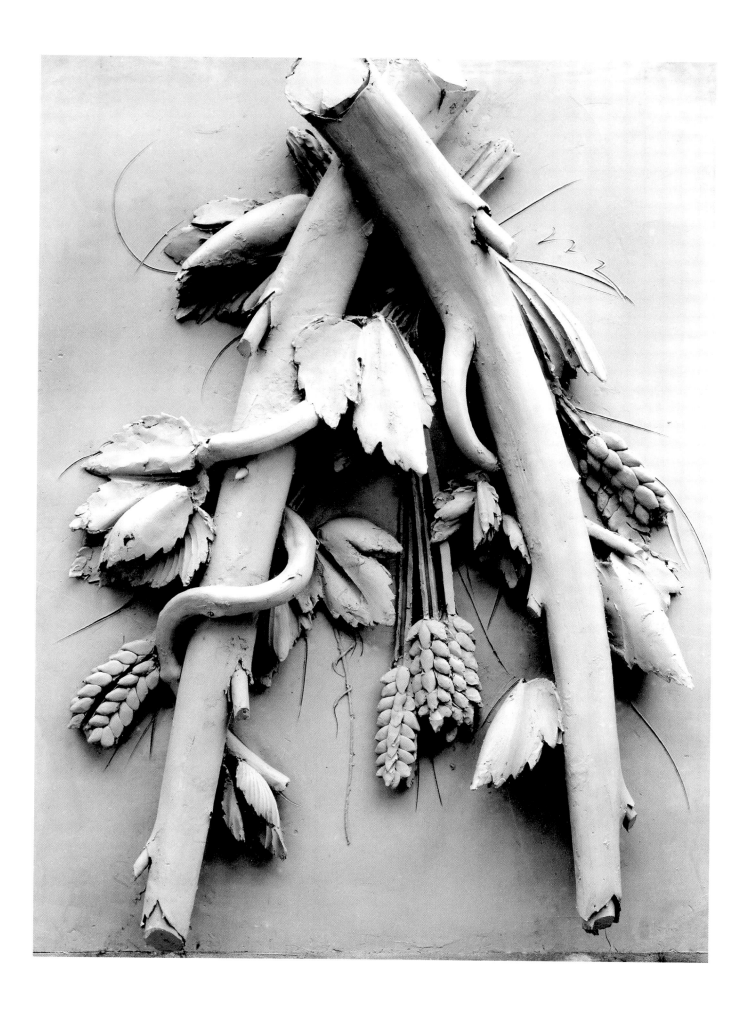

The view of the back
of Giacomo Manzu's
cast bronze bas-relief
Italia *arriving in New
York in 1965.*

Giacomo Manzu's Italia,
*installed at night in 1965,
owing to the use of a
crane on Fifth Avenue and
the interruption of traffic.*

Opposite: The bronze bas-
relief Italia *with a deep
golden brown patina, on
the main façade of the
Palazzo d'Italia.*

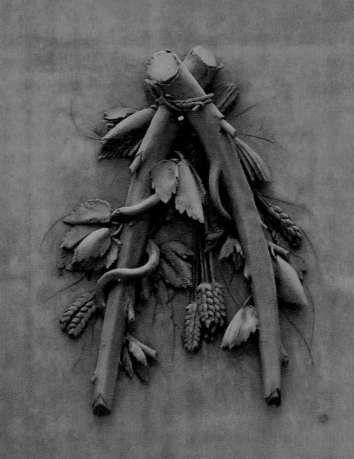

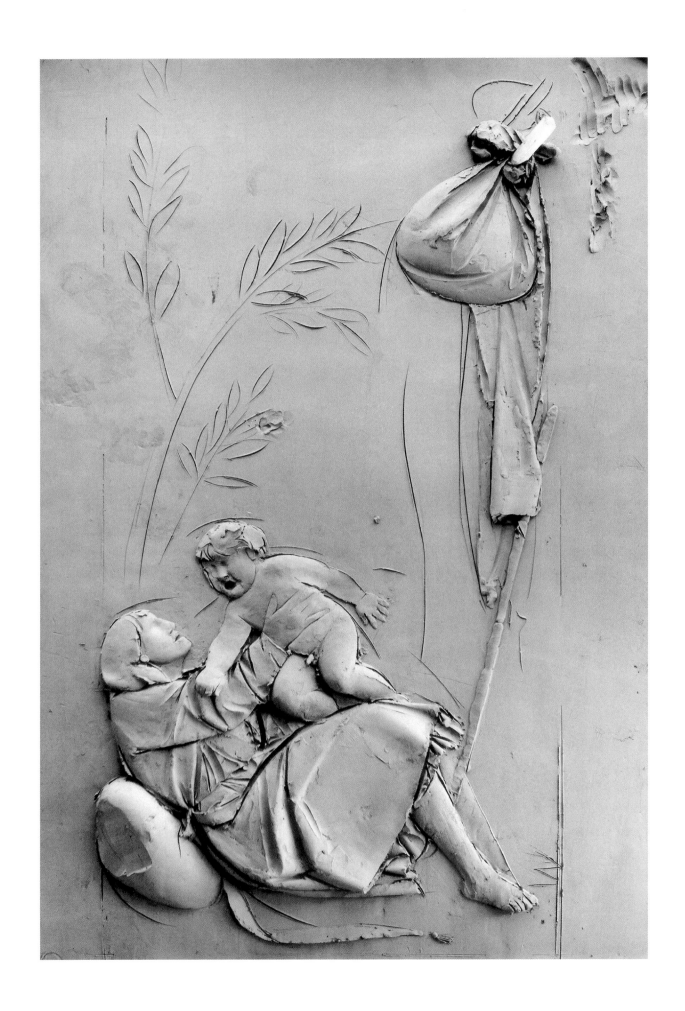

The smaller plaque, *The Immigrant*, is an uncluttered portrayal of a poor Italian refugee making her way to America. The barefoot peasant woman rests against a rock while holding her naked child aloft. Their small bundle of belongings is tied to a stick and lies against a nearby wall. The depiction of poverty and the lack of a male figure appear to be statements about the numbers of Italian men lost during World War II and the consequences that war inflicted on the common Italian family. A public relations statement describes this bas-relief as "a poignant picture of a mother and child with a traveling pack, and is the artist's tribute to the Italian immigrant in America".[2] The figures are similar to Manzu's portal *War and Peace* in Rotterdam, created in 1968.

The background technique is "schiacciato": the surface is simply incised with a sketch of branches and leaves as if they are drawings in the bronze. The finished plaque retains the hand of the artist: it is vibrant and appears fresh—as if the artist has just completed the clay model. The simplicity and delicacy of the plaque, in contrast to the dynamic and highly controversial prewar work by Piccirilli, appear to have been a calculated political statement. It wipes the slate clean, casting aside the war years and bringing a straightforward message of hope to the millions of Italian immigrants who made their way to America.

In October of 1999, to facilitate commerce and access to the retail store, *The Immigrant* was quietly removed and relegated to a side entrance of the building. *Italia* was left to reign over the entrance and designate the Palazzo d'Italia.

Giacomo Manzu's clay model for The Immigrant *in 1964. The vertical lines, along the right, scratched into the clay surface are an indicator of the final size.*

Opposite: The raw, bronze bas-relief The Immigrant, *created by Giacomo Manzu. Patination, as determined by Rockefeller Center, took place after the bronze arrived in New York in 1965.*

Giacomo Manzu's bronze bas-relief The Immigrant *following installation and patination. Symbolic of the many widows of the two world wars and of the Italian immigration to America, the plaque is currently located at the West Fiftieth Street entrance to the Palazzo d'Italia.*

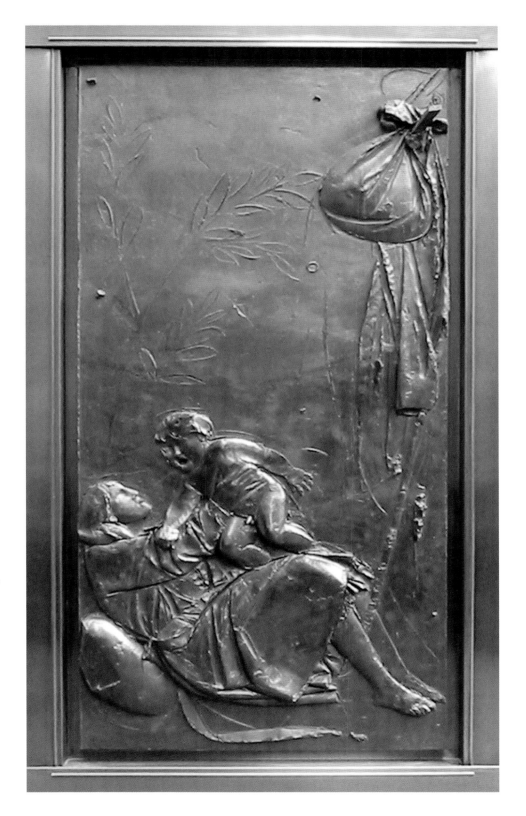

LEO LENTELLI

Four limestone panels carved by Leo Lentelli embellish the seventh-floor spandrels of the Palazzo d'Italia. They symbolize four periods in Italian history: the Roman era, the Italian Renaissance, the Italian independence of 1870, and the Fascist regime of the 1930s.

The Roman period is represented by the letters *S.P.Q.R.*, for the Latin phrase *Senatus Populus Que Romanus* ("The Senate and the People of Rome"). These initials are surmounted by a Roman soldier's kilt and breastplate. The breastplate is flanked by columns culminating in sword hilts. A crown rests above the breastplate and is surrounded by a wreath.

The Italian Renaissance is represented by a shield surrounded by a garland of fruit. The shield is decorated with a palette and brushes set on a square, symbolic of the arts and sciences. The shield is surmounted with a ferocious, snarling lion's head positioned between flowing banners. The banner reappears at the lower edge, where it is inscribed with the Roman numerals *MCCCC* (1400), the date recognized as the beginning of the Italian Renaissance.

The Italian independence of 1870 is represented by two heavily draped flags flanking a shining and rising star. Below the flags is the motto *Morte o Liberta* (Latin for "Death or Liberty").

The Fascist regime is represented by bold fasces (a bundle of rods symbolizing unity). It is surmounted by an eagle with its wings outstretched, the classic representation of power. Originally the Roman letters *AXII* (for "Anno XII") were carved across the center of the fasces. That signified the twelfth year of Fascism, the year this carving was installed. This date was chiseled out after World War II in the scurry to obliterate any obvious traces of Fascism.

The panels were installed in 1935. Leo Lentelli did the sketches and the plaster models for the group. He worked on his models in the Piccirilli studio, and the Piccirillis enlarged and carved the limestone spandrels on site. The anti-Fascistic campaign waged against the art on this building obliterated much of the pre–World War II decoration. Because of their high location and obscure imagery, these panels survived mostly intact.

Leo Lentelli's carved limestone spandrel figures on the Palazzo d'Italia, representing four periods in Roman civilization: The Roman period is represented primarily by the letters S.P.Q.R., for the Latin phrase Senatus Populus Que Romanus *("The Senate and the People of Rome"). The Italian Renaissance main motif is a shield with symbols for the arts and sciences (a palette and a right angle); the date MCCCC (1400) is recognized as the beginning of the Italian Renaissance. Italian independence of 1870 is depicted by flags flanking a shining and rising star; the motto* Morteo Liberta *(Latin for "Death and Liberty") can be found below the flags. The Fascist regime symbolism comprises bold fasces and an eagle's head and stretched wings.*

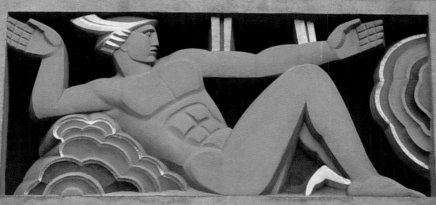

THE INTERNATIONAL BUILDING

The Rockefellers managed to lease three of the four low-rise buildings facing Fifth Avenue to major international tenants prior to completing construction of any of them. The British, French, and Italian governments and international corporations all committed to renting extensive spaces in these impressive structures in the center of New York. The buildings reflected the Rockefeller view of a global economy, a ground-breaking vision that was far ahead of its time. They would be designated by their international names and clearly associated with the major lease-holders. After this commercial triumph, the idea of a major international building was the obvious next step.

A large high-rise would provide an opportunity for smaller international companies to lease spaces with a prestigious Fifth Avenue address. The resulting building was an immediate and huge success. Set back from Fifth Avenue and facing St. Patrick's Cathedral, the efficient, modern skyscraper had an ultramodern lobby with soaring ceilings, high-speed elevators, and escalators to whisk travelers to the mezzanine, where the United States Passport Agency would eventually be located. It was also the premiere location for international banking, currency exchange, and the best place to book a trip through the many shipping and rail-lines offices found along its hallways. This new building imparted the concept of "internationalism" for over half a century.

The god Mercury in one of the fifteen panels that make up The Purpose of the International Building *or* The Story of Mankind, *created by sculptor Lee Lawrie working with model-maker Rene Chambellan, and colorist Leon V. Solon.*

LEE LAWRIE AND RENE CHAMBELLAN · ATLAS

In 1934, Lee Lawrie received the commission to create a monument that would effectively illustrate "internationalism" and help create a magnificent and dignified atmosphere to the newly conceived International Building. It was to serve as a prologue to the myriad of other artworks enhancing the Center as well as symbolize the building's commercial activities. The piece was to occupy a prominent site opposite St. Patrick's Cathedral, in the Fifth Avenue forecourt of the building. The monument had to ooze power and be eminently distinctive, provocative, and emblematic of modern design. It had to clearly demonstrate the Rockefellers' quest for a new American urban setting while incorporating a global view.

The architects valued the concept of the Fifth Avenue forecourt as "the statement," and a forceful expression of authority. It is the part of the International Building that everybody views, even the passersby. Sculpture placed here had to be extraordinary, sumptuous, and awesome.

The architects approached Lee Lawrie to provide such a sculpture. The commission had certain caveats. His concept must be contained within a restricted space: the shallow and narrow forecourt of the forty-one-story building. Additional provisos were that the sculpture was not to obstruct views from the building or light to the building, or impede passage in or out of the building. Lastly, it was to celebrate a mythological theme, tying it into the Channel Gardens and Lower Plaza sculptures.

The overall design of the sculpture, including the height, volume, and mass, was controlled by these factors and other limitations set by the architects. Its fundamental character, including using detailing quite sparingly and a golden brown patina, was also determined by these parameters.

The sculpture was to be a "power figure," dominating the site without compromising the architecture. It was to be both a majestic and a spatial statement. *Atlas* turned out to be an extraordinary sculptural achievement. A crisp, powerful design that was sparsely and brilliantly rendered, it portrays a theme from mythology, the story of Atlas and his burden. It is a companion piece to Manship's *Prometheus*. Their myths are interwoven. Atlas had waged and lost a ten-year war against the gods of Mount Olympus. As punishment, the gods condemned Atlas to support the earth and the heavens on his back for eternity. He had grown weary of the task and was only too glad when Hercules offered to take over his burden. In turn, Hercules said he needed help to complete his eleventh labor, fetching the Golden Apples, which were closely guarded by nymphs called the Hesperides. Prometheus had told Hercules that Atlas could easily complete this labor as he was the nymphs' father and knew their secrets. When Atlas returned with the apples, Hercules tricked him into resuming the burden of bearing the earth and the heavens on his back for eternity. This statue depicts that never-ending punishment.

The twenty-one-foot-diameter, openwork sphere bears the signs of the zodiac. Its axis points to the North Star. Atlas carries this giant armillary on his massive arms, each measuring six feet in length. The celestial sphere indicates the earth's path around the sun, the change of the earth's axis on its orbit, and the equinoxes. These are the cosmic forces that affect all people of the earth.

Lee Lawrie's Atlas *in the forecourt of the International Building, a recognizable symbol of strength and internationalism.*

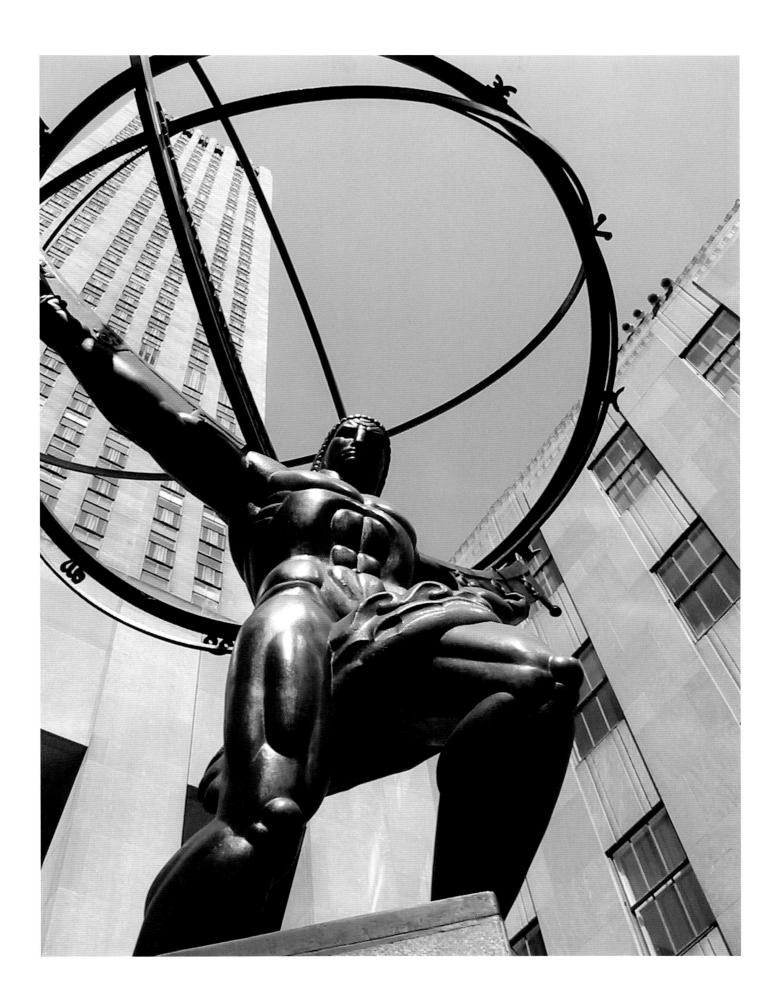

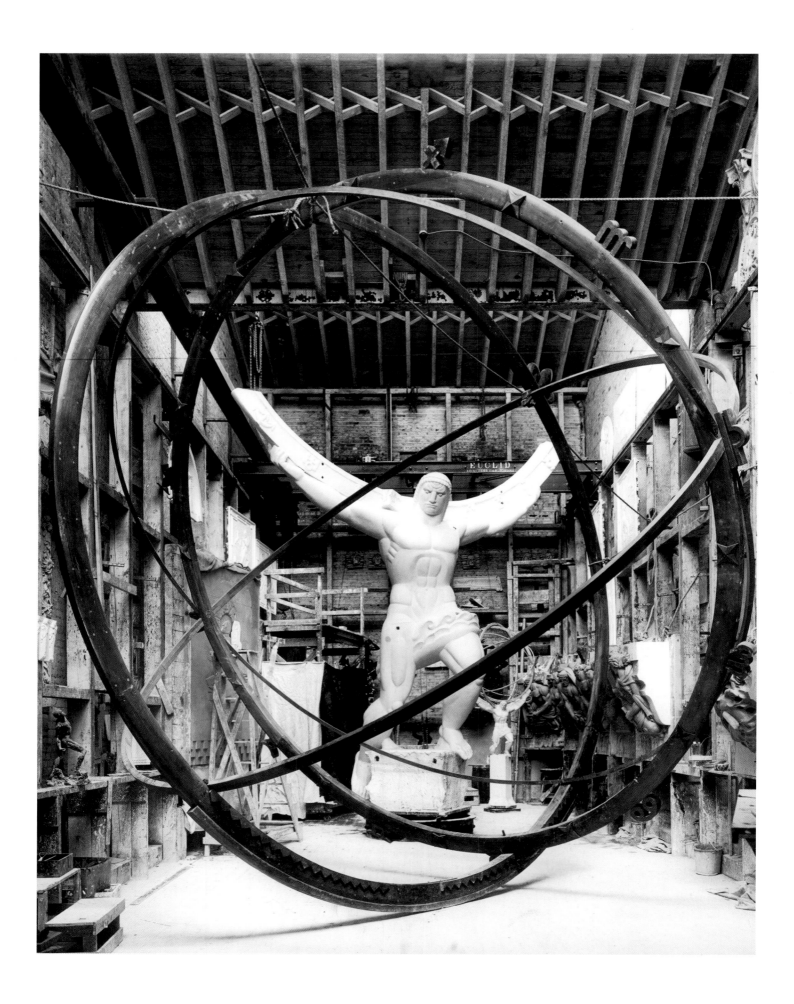

The commission was fully worked out in collaboration with the gifted sculptor Rene Chambellan, in one of the most successful artistic partnerships in the Center. Lawrie conceived it, and Chambellan modeled the full-size muscular Titan, working from his maquette. A memo indicates that "Atlas was designed by Mr. Lee Lawrie, in conjunction with Mr. Rene P. Chambellan." It mentioned the fee paid to the caster was $16,500 and the "additional fees paid to Lawrie and Chambellan brought the total cost to approximately $35,000."[1] This memo underscores how dependent Lawrie, the designer-artist, was on Chambellan, the technician–model maker, and how inextricably they functioned.

Following approval of the final plaster model, the Roman Bronze Works in Long Island City, New York, received the plaster model from Chambellan and prepared to cast the sculpture in bronze. First, the model had to be cut into sixty-nine pieces, making each individual part small enough for casting. After casting, the parts would be hand-chased to remove flaws. The parts were then welded together to form twelve large sections. These sections were then assembled to form the complete sculpture. The assembly was done by roman-jointing the sections, then bolting them, and finally hammering bronze pins in place to permanently affix them. Seam lines were chased flush and true to the adjoining surfaces. In a letter to Roman Bronze Company, the engineers at Todd & Brown wrote, "All of the work will be cast as modeled and it will not be necessary to do any touching up of the figure after it is cast, as it is Mr. Lawrie's desire that the finish of the bronze casting be the same as that of the model." In the same letter the patina was discussed: "The main figure and the sphere is to be of ordinary statuary bronze—finish to be grey-green Patino, which is accomplished by the use of acid."[2] This decision was most likely altered in the field, as the patina has always been a traditional "museum brown."

Opposite: Seen through the cast bronze armillary sphere, the full-size plaster model of Lee Lawrie's Atlas *stands beside the original maquette in 1936 in the Long Island City foundry Roman Bronze Works.*

A view into a workshop at Roman Bronze Works in 1936, where the cut-up plaster sections of Lee Lawrie's Atlas *are being readied for casting in bronze.*

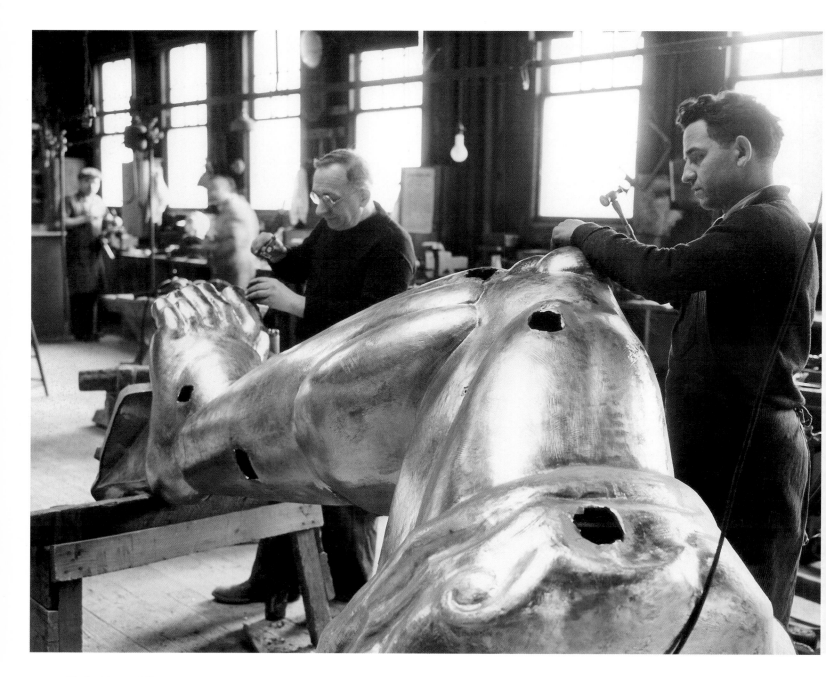

Technicians at Roman Bronze Works in 1936 finishing the surfaces and chasing flaws of the bronze sections of Lee Lawrie's Atlas *prior to joining.*

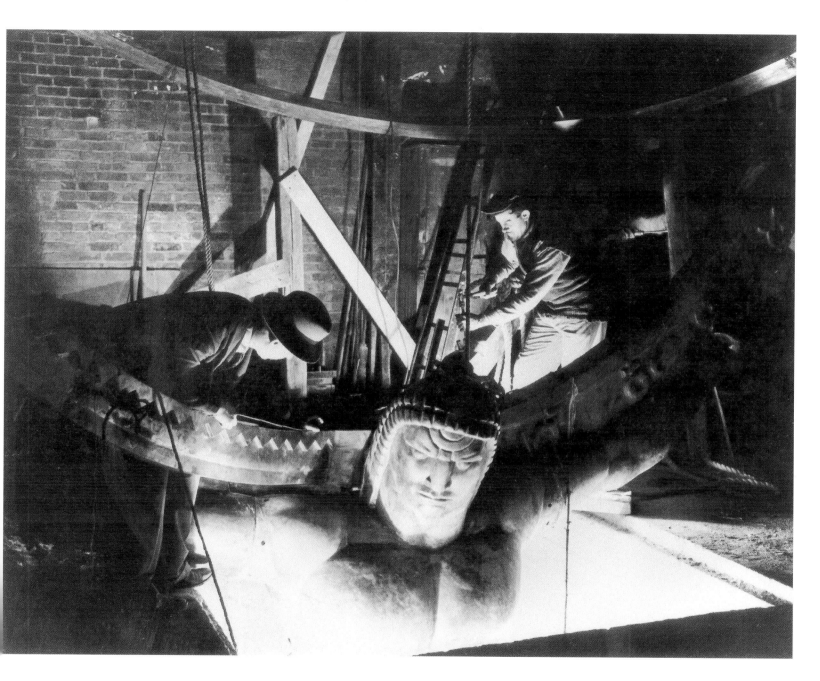

Technicians joining the sections of Atlas in 1936. It is so massive, they are working on a scaffold.

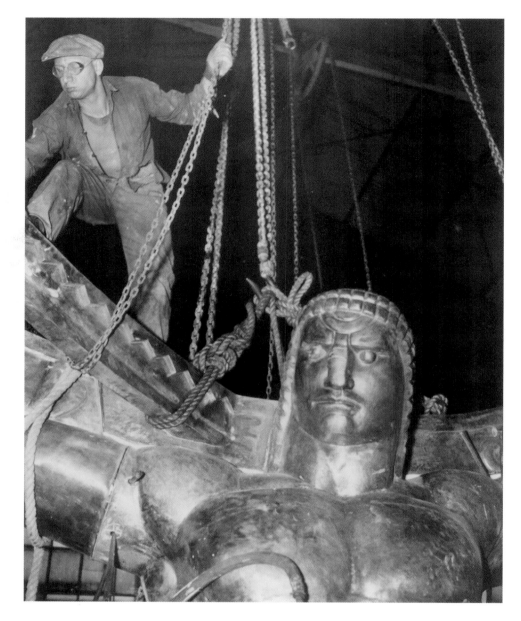

Closeup view of technicians joining the sections of Lee Lawrie's Atlas *in 1936. Note the bronze "pins" on his arm, used to secure the joints.*

Opposite: The 1937 installation of Lee Lawrie's Atlas *in the forecourt of the International Building. The open, hollow granite plinth houses the structural steel framework used to support the massive figure. Steel pins are attached to the framework within the plinth and go up into Atlas's legs.*

The completed sculpture weighs seven tons. Rockefeller's architects, working with Lawrie, designed the gray granite pedestal, and the engineers designed the mounting system and specified the precise placement: "The base is to be set diagonally on the axis of the building."[3] The base was placed so that a corner, not a side, would face Fifth Avenue, making the junction of the stone slabs indiscernible to the passersby, but the sculpture itself facing Fifth Avenue. The massive piece is held in place by rods that extend from the bronze legs into the steel framework of the pedestal. There is no supporting armature within the sculpture. In this manner the architects and engineers contributed to, and intensified, the aesthetic impact of the piece. Every detail, each specification, and all angles were meticulously considered as this sculpture was to be the pinnacle of the Rockefeller presence on Fifth Avenue.

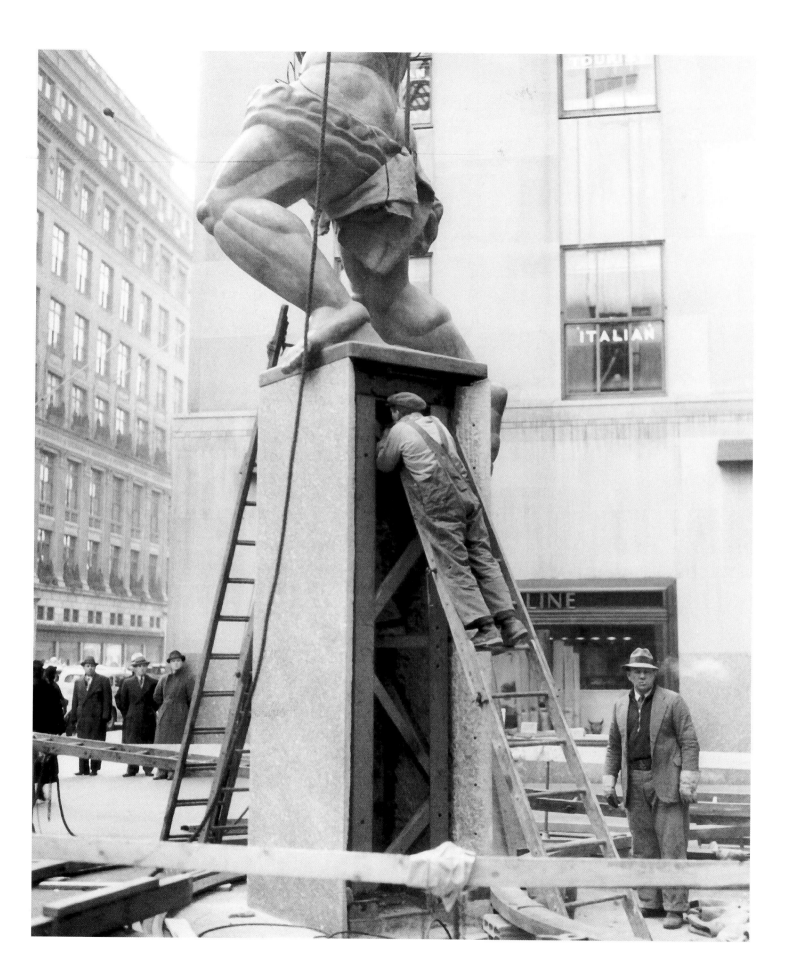

Upon completion, Lawrie ordered the original models destroyed, since he believed "it is wrong to keep models after the work has been executed in permanent material, as there is danger of their being used improperly, at some future time."[4]

Atlas is the largest statue in the Center, towering forty-five feet above the pavement. Originally the mammoth figure appeared to be delicately balanced on a simple, slender, nine-foot-high granite plinth, facilitating the illusion of Atlas being "poised" on his perch, as if he is preparing to go onward and upward. In recent years two lower tiers have been added to the pedestal and filled with shrubbery. These additions surround the bottom half of the plinth, significantly altering the effect of an adroitly balanced figure.

The Titan's foot overhangs the slim pedestal, creating the effect of a counterbalanced sculpture. This strengthens the overall impact of the piece, imparting determination and animation to the colossal Titan as he concentrates all his energy on the task ahead. *Atlas*'s legs are bent as, struggling with the weight of his burden, he attempts to rise up onto the pedestal. His arms are outstretched. His hands grip the armillary sphere while he supports the heavens on his massive shoulders. His angular features are deeply incised and furrows line his brow. Every muscle in his body is articulated from the weight of the huge sphere and the force he must exert to endure his punishment. The physical strain appears almost unbearable. Like a modern-day muscle-man, his bronze skin is luminous and glowing from the reflected light bouncing off its well-proportioned mass.

The dynamics of muscular tension, combined with the bold composition and the unique site, provide stunning, expressive power to the figure. The bronze conveys strength and authority. The forecourt and the sculpture reflect an innovative use of art-in-architecture, remaining an exceptional urban setting to this day. Lawrie enjoyed great artistic achievement during his lifetime, owing in large part to his work at Rockefeller Center. Until recently, Rene Chambellan's role in this sculpture went unrecognized. Lately he has been given the credit he deserves, as his hand in the work is clearly apparent.

Lee Lawrie making an inspection of Atlas *during its installation in 1937. The upper portion of the armillary sphere is yet to be installed.*

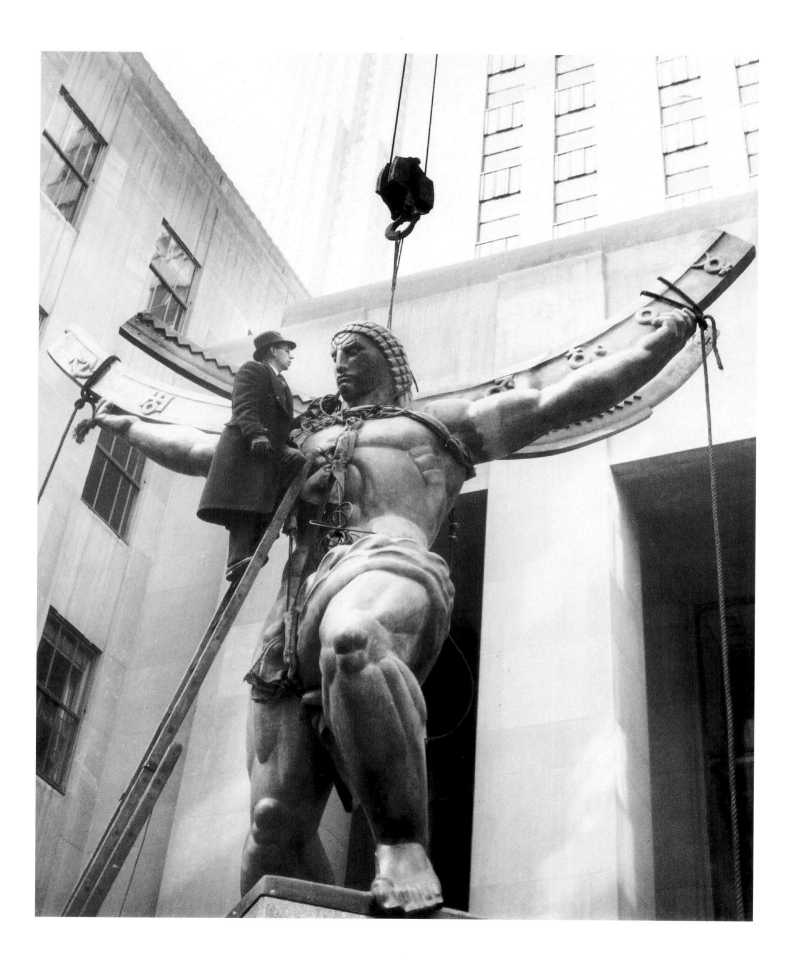

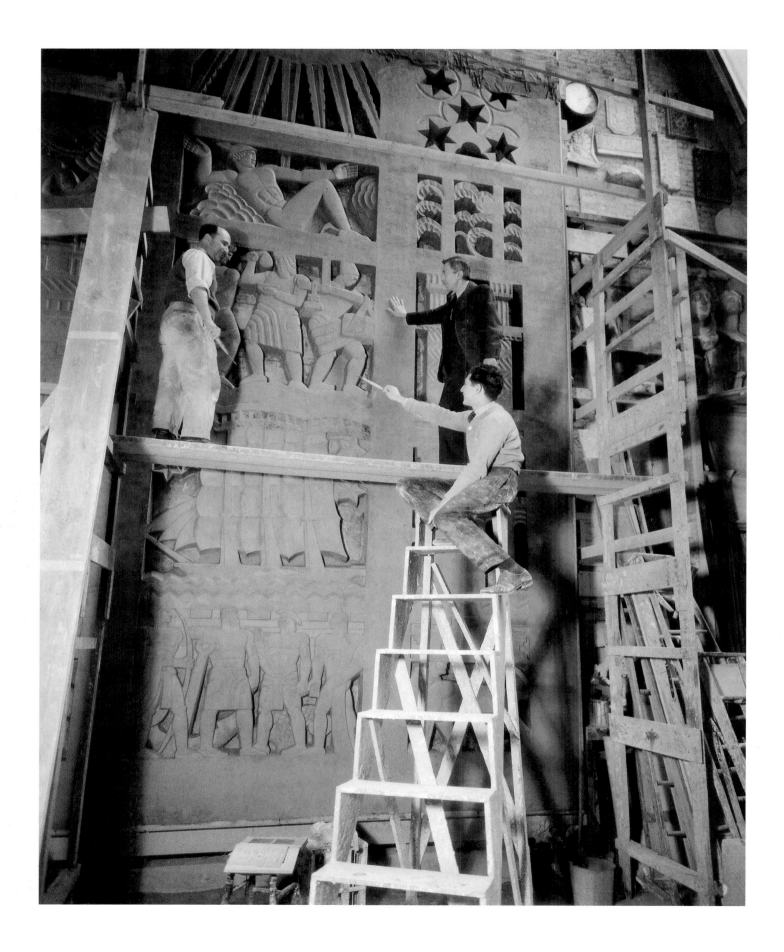

LEE LAWRIE
THE PURPOSE OF THE INTERNATIONAL BUILDING

The south façade of the building, overlooking the skating rink, is one of the largest and most elaborate polychrome-painted stone carvings in the Center. Titled *The Purpose of the International Building* or *The Story of Man*, the piece was created by Lee Lawrie in 1935.

The symbolism in this fifteen-section screen has been termed *hieroglyphic*, as it is a pictogram and read in a specific manner. It represents all the races of mankind, their individual habitats, and their past and present accomplishments.

Working from Lawrie's sketches, Rene Chambellan rendered the actual-size plaster models in the new Modernist style, resulting in stylized, geometric, two-dimensional openwork. The stone-carving contract went to Piccirilli Brothers to complete the work. Chambellan employed an artist's mirror to correct perspective and used every artistic technique to make the screen readable to the passersby. By using two dimensions, the artists created openwork spaces that became extremely important forms within the panel. The modeling and shapes are clear and simple; organization prevails.

Leon V. Solon, the color specialist, worked out a harmonious and appropriate color scheme. Lawrie had his hand in the coloration as he approved or altered various hues and combinations. The collective efforts of these artists, craftsmen, and designers—the strict geometric forms, clean straight lines, the openwork, the checkerboard design, and the coloration—resulted in a forceful statement that personifies Modernism. The original color scheme is maintained to this day.

The panel is read starting from the bottom center with four figures representing the races of mankind; red, yellow, black, white. Above them, on the second row, in the center, a square rigged ship, under full sail, designates international commerce. On the third row, in the center, three figures represent endeavors common to all people: "Art" carries a jug, "Science" measures a potion, and "Industry" bears a load of bricks. Above them is Mercury, the god of trade. His arms are spread wide with open hands, an all-embracing gesture. At the top center, the earth is symbolized as a large clock with radiating golden beams. The hemispheres of earth are represented by two stylized groups of stars signifying the Big Dipper and the Southern Cross. The northern regions of earth are symbolized by a seagull flying above the sea and whale's fluke; two palm trees indicate the southern regions; a mosque represents the East and the West is portrayed by an Aztec temple. A Norman tower and a lion represent history and monarchies, respectively. Smoke stacks and an eagle symbolize the Industrial Age and republics, respectively.

Opposite: Rene Chambellan and Lee Lawrie modeling the openwork plaque Purpose of the International Building *in 1935.*

Rene Chambellan and Lee Lawrie in 1935, making use of a sculptor's mirror to determine how the installed panel Purpose of the International Building *will be seen from ground level.*

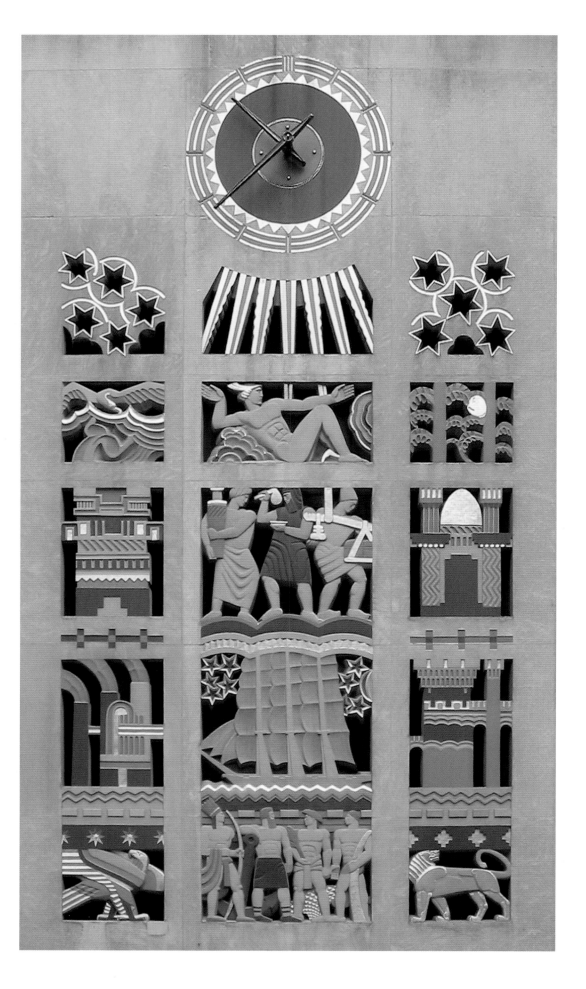

Lee Lawrie's installed, polychrome-painted and gilded openwork limestone plaque, The Purpose of the International Building.

Opposite: Three details from Lee Lawrie's Purpose of the International Building—the 4 Races of Mankind (top); an eagle representing the Republic (bottom left); and a lion representing the Monarchy (bottom right).

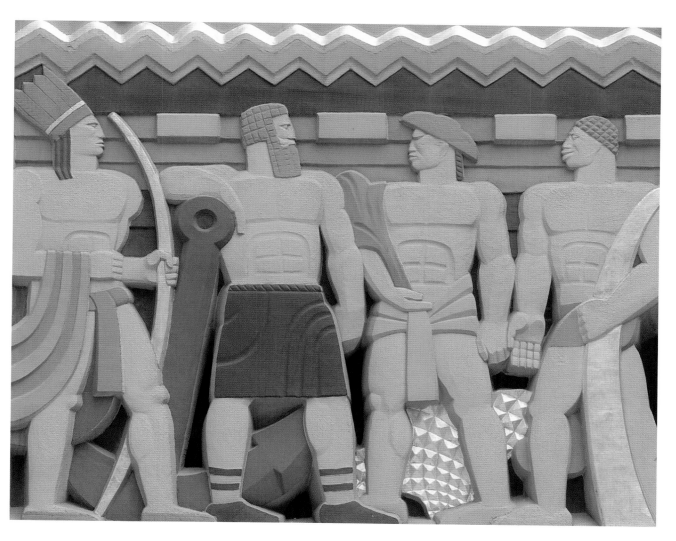

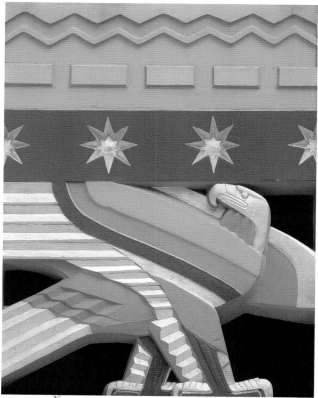

ISAIAH
II
IV

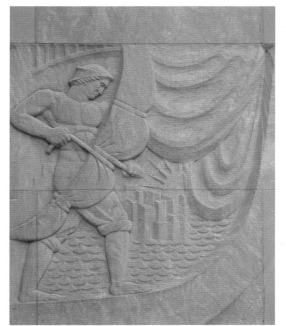

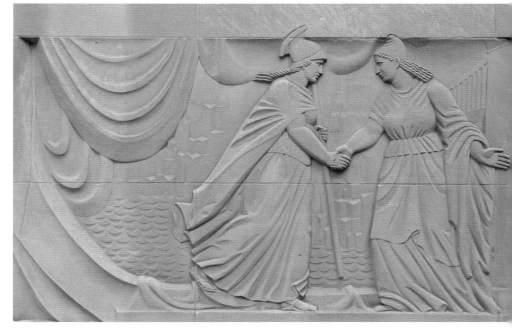

WORLD PEACE

Lee Lawrie designed three bas-reliefs for the 10 West Fiftieth Street entrance as "an appeal in sculpture for World Peace and Understanding."[5] These limestone panels, collectively titled *World Peace*, are carved intaglio style with the depth of carving reduced to a minimum.

Above the entrance is the first panel, *Swords into Plowshares*. It is the only gilded element. It is capped with a simple inscription, "Isaiah II:IV" ("And He shall judge among the nations and shall rebuke many people; and they shall beat their swords into plowshares, and their spears into pruning hooks; nations shall not lift sword against nation; neither shall they learn war any more").

At eye level on the building's corner are the other two elements of this work. Forming the actual corner is a bas-relief depicting the prow of a ship, a symbol of international trade, with its sails festooning symmetrically right and left from the buildings corner the elongated prow. The panel continues west of the corner and depicts a muscular boatman furling sails on a ship. The south side depicts a woman disembarking the ship and being welcomed to the new world by the majestic figure of Columbia, the feminine symbol of America. The waters of the harbor and the towers of New York are carved in the backgrounds of both panels. The two lower panels signify America's hospitality and generosity to the immigrant and the world.

Rene Chambellan prepared the full-sized plaster models at his studio and the Piccirilli Brothers carved the bas-reliefs on site, working from scaffolds. Leon V. Solon suggested limiting the coloration to gilding the plowshare, as the panel would be a distraction to the highly colored openwork grille *The Story of Mankind*, which is located nearby.

Opposite, top: Lee Lawrie's intaglio-carved limestone and gilded work Swords into Plowshares, *located at the West Fiftieth Street entrance to the International Building. This work is one of three elements of* World Peace. *The inscription "Isaiah II:IV" references a biblical passage.*

Opposite, bottom left: Lee Lawrie's carved limestone work Boatman, *one of three elements of* World Peace, *at the International Building's West Fiftieth Street entrance. It symbolizes free trade and travel between nations.*

Opposite, bottom right: Lee Lawrie's carved limestone work Columbia Greeting a Woman, *at the International Building's West Fiftieth Street entrance. This work is one of three elements of* World Peace. *It symbolizes the open immigration polices of America. Columbia, the female symbol of America, welcomes an immigrant. A modern city, symbolizing the future, rises in the background.*

ST. FRANCIS OF ASSISI WITH BIRDS

St. Francis is recognized as an international symbol of love, of both self and neighbor. Born into the wealthy merchant class in 1181 in Umbria, Italy, he was a wild, young boy, finding himself at odds with his family and the law. During an imprisonment he had a conversion experience, receiving a message from Christ that was to alter his life and affect the Christian world. He renounced the material world, devoted himself to the Gospels, and served mankind. St. Francis worked with lepers, did manual labor, cleaned churches, preached in the street, and slowly began to attract followers to his pious and simple way of life.

In 1212, with Papal blessing, St. Francis founded the Order of Friars Minor (Franciscans). These first mendicant friars never had a material monastery—they lived in poverty, grateful for the charity of others. Late in his life, while meditating he received the stigmata, which periodically bled for the remainder of his life. He was the first person of record to receive the stigmata. Two years after his death he was canonized by Pope Gregory IX.

St. Francis has been a favorite subject of artists throughout the ages and is often depicted surrounded by animals and birds, as his love of nature is well known. In Lee Lawrie's carving, St. Francis wears the symbol of the order he founded: the simple brown cinctured friar's robe tied with a cord. His feet are bare as was also the tradition. Ordained a deacon, he has the symbolic tonsure on his head. Behind his head is the halo of sainthood in which gilded doves fly; doves are the sign of the Holy Spirit. St. Francis is shown sharing a meager meal in his begging bowl with a bird, while he gazes upward, seemingly thankful for what he has received.

Conceived in 1935, Lawrie's panel represents Italy's importance to the world. Reflecting on the country's rich history and its current position as a belligerent nation, he wrote, "About the 50th street door to the Italian Building entrance, which I have been pondering, an ancient war galley would be the appropriate symbol, but I should like to do just the opposite thing—a St. Francis of Assisi Feeding Birds. This would really be a symbol of Renaissance Italy's great contribution to the development of the Christian Church. Although it may seem incongruous in the light of present events, it is a symbol of Italy that connotes Giotto, Dante, and all of the humanities."[6]

Upon completion, Lawrie stated his wishes concerning the coloration of the piece: "I suggest that the birds and the dish be gold; the saint's beard and tonsure black; and his habit brown."[7] To a large extent, Leon V. Solon, the colorist, followed Lawrie's directive. Solon's minor changes were to make the black a dark brown and the dish a bright blue with a gilded bird on its rim.

The result is beautiful. The use of intaglio, jewel-like carving, and the formality of Lawrie's composition and simplicity of design, combined with Solon's dazzling application of color and gilding, gives this architectural embellishment the appearance of an illuminated manuscript.

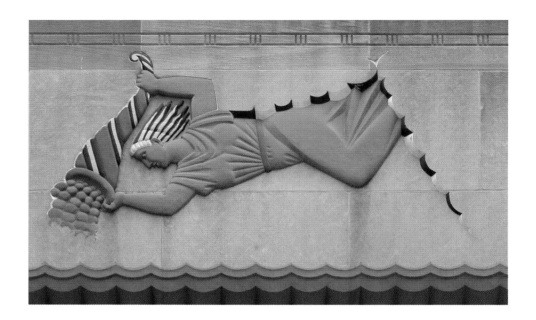

PLENITUDE FROM INTERNATIONAL TRADE

A stone carving of a flying female figure presides over the entrance to 10 West Fifty-first Street. Sweeping across the façade with a sense of great power and focus, she is a messenger from the heavens bearing a cornucopia, from which flows a multitude of round, bean-shaped fruits. In the words of Lee Lawrie, the figure symbolizes "the plenitude that would result from well-organized international trade."[8] Even given this interpretation, part of the iconography is unintelligible. Plenitude is clearly represented by the overflowing cornucopia. However, no other symbols hint at the rest of Lawrie's theme, "well organized international trade," unless the green, blue, and red wavy lines symbolize the sea and, therefore, international trade. In spite of the lack of an evocative symbol that would specify the complete theme, the work is lovely and presents a bold, welcoming aspect to the entrance.

The green-robed figure is partially shown. The heavens are symbolized by the V-shaped cloud line above her, and the cloud's edge of alternate colors of dark blue and gold. The cornucopia is voluminous curving horn bound with a gilded cord. As this benefactor descends toward earth, her golden tresses flow upward, as if they are a bundle of lightning bolts, conveying velocity and energy to the work. The mighty figure is engrossed in her mission and clearly is spilling the "beans" to mankind. The coloration was designed by Leon V. Solon.

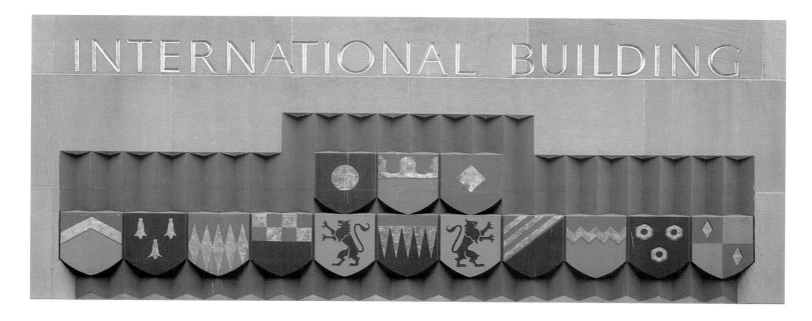

FOURTEEN HERALDIC SHIELDS

Lee Lawrie created fourteen shields to decorate the façade over one of the entrances on Fifty-first Street. During the period he was working out the final design, his sketches were sent by Schley to Nelson Rockefeller for approval. The concept had already been approved by the engineers and architects. In an accompanying letter, Schley wrote, "We are sending herewith the sketch for the shield entrance on 51st Street of the International Building. Sorry that it is just a rough one. The insignia on the shields are simply heraldic and should therefore cause no confusion."⁹

The International Building was to be the center for worldwide trade and travel and not representative of any specific nation. The 20 West Fifty-first Street entrance required embellishment to maintain consistency with the rest of the Center, but to endow it with specific elements seemed too explicit and might limit the rental market. Originally, the insignia on the shields represented various individual nations. This was changed to reflect heraldic symbols, inferring history and internationalism, without being explicitly devoted to one part of the world or any one country.

Prior to the panel being carved, Leon V. Solon designed a color scheme or rendering, working from a sketch provided by Lawrie. Solon frequently had to work in advance from sketches or photographs of the work he was to color. He would then submit this rendering to the architects, the artist, and the Rockefellers for review and approval. Once the panel was carved, Solon supervised workers of the Rambusch Decorating Company who did the actual coloration of this piece in 1937.

Lee Lawrie's carved and gilded limestone work Fourteen Heraldic Shields at the International Building. These decorative shields were to suggest internationalism and not to be representative of any one nation.

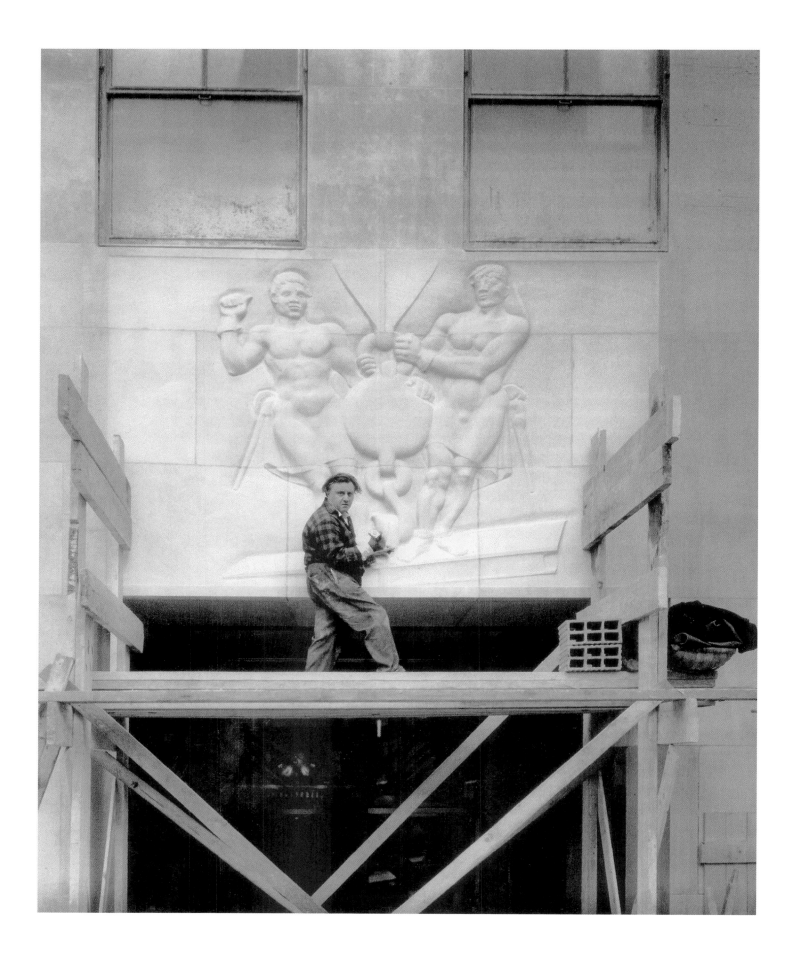

GASTON LACHAISE
TO COMMEMORATE the WORKMEN of the CENTER: DEMOLITION and CONSTRUCTION

In the 1930s, the choice of commissioning Gaston Lachaise was an audacious act for the Rockefellers. At that time in his career Lachaise was producing work that was erotic and sexually explicit. Unquestionably, left to his own devices, his genre of work would have been totally inappropriate for a Rockefeller building. But he frequently set aside his own aesthetic to produce work that was more socially supportable as he was habitually in need of money. He often had to hold his own work and ideas in reserve and seek portrait work or architectural commissions to meet his financial requirements. This was the case when he was offered two Rockefeller commissions.

Both Nelson and Abby Rockefeller admired Lachaise's work and bought it for their private collections. They were eager to help the artist in any way possible and certainly were influential in his obtaining these commissions. He had already completed four carvings on the façade of 1250 Avenue of the Americas. He was awarded this second contract chiefly because Nelson Rockefeller admired his work and understood his dire financial situation, and because Lachaise was willing to fulfill the requirements of the commission in a manner suitable for a commercial building. Without question, he was recognized as a superb craftsman and tireless workman capable of carving whatever was commissioned.

For this site he created two bold, unpretentious carvings: one that bestows tribute to the men who cleared the site prior to construction, *Demolition*, and one to the workers who constructed the Center, *Construction*.

Lachaise carved these low intaglios on-site directly into the limestone wall flanking the west entrance. It would appear that, in spite of the eroticism of his work, he was given nearly unfettered control over these carvings. They are refreshing and a fairly corporeal view of labor. The dynamism of the figures is heightened by distinct volumes and the impact of tension created by muscular forms. The weight of their bodies and the power of their stance and strength symbolize the effort that went into building The Center. These carvings are the insignia of construction.

Gaston Lachaise carving the limestone panel Construction *in 1935, one of two elements that comprise* To Commemorate the Workmen of the Center *located at the International Building.*

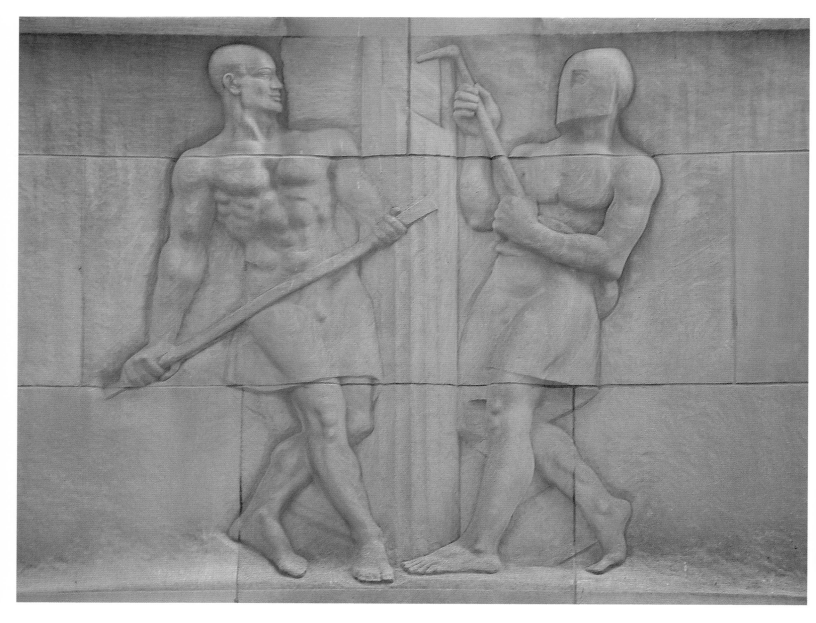

Gaston Lachaise's low-relief carving Demolition, *one of two elements that comprise* To Commemorate the Workmen of the Center, *at the International Building.*

The figures in the south relief, *Demolition,* are dismantling a Greek column, symbolizing the razing and removal of the architecture of the past. Both figures' faces are in profile: the man on the right wears a welding helmet and holds an acetylene torch, while his companion wields a crowbar. In the north relief, *Construction,* workers are depicted riding a steel beam to be riveted to other steel girders, creating the buildings of the future Rockefeller Center. The figures are grasping the hoisting block while one raises his left hand and gives the construction signal to "raise the beam."

Lachaise's omissions are as intriguing as the symbols he selected to sculpt. In both carvings, the figures are scantily clad, wearing only work gloves, smooth (leather) aprons, and the tools of their trades. The aura of these carvings is visceral. The muscular figures were carved from sketches he made using male friends as models. The purity of his forms and austere carving make powerful statements.

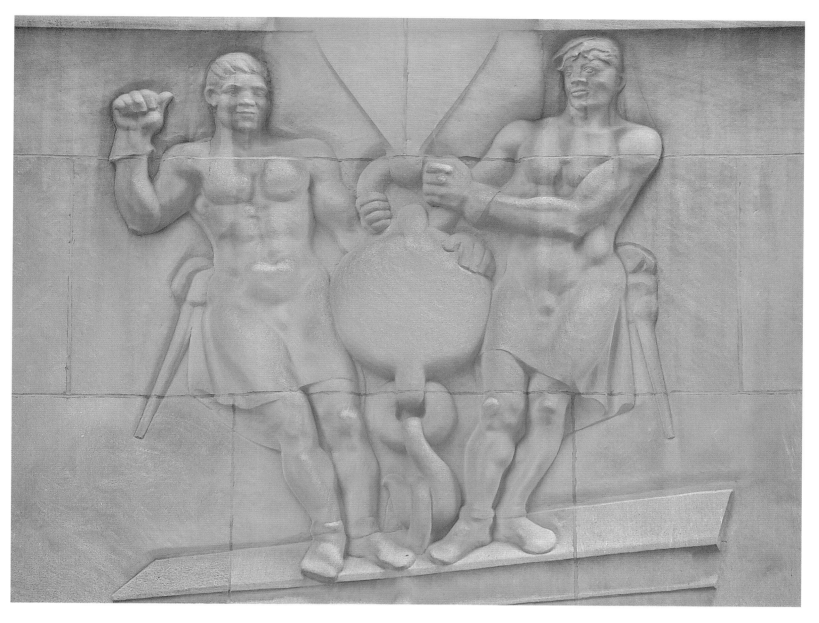

Although done at the height of the art program, these compelling carvings are a departure from the strict Art Deco style encountered in most of the art in the Center. Receiving the commission directly from Nelson Rockefeller permitted Lachaise great artistic freedom. The subject matter—a down-to-earth portrayal of hard work, not lofty idealism—provided Lachaise the opportunity to carve his figures and pose them more naturally than in his other work at the Center. With this unassuming theme and lack of restrictions, the works exude Lachaise's vibrant, sensual style and demonstrate his ability to combine imagination with primal elegance. The powerful figures appear relaxed and confident, like real men, while still pulsating with heroic qualities.

It was an audacious act for Nelson Rockefeller to remove the heavy hand of the committee and give carte blanche to Lachaise. The result is an immense tribute to the men who cleared and built Rockefeller Center steel beam by steel beam.

Gaston Lachaise's low-relief carving Construction, *one of two elements that comprise* To Commemorate the Workmen of the Center, *at the International Building.*

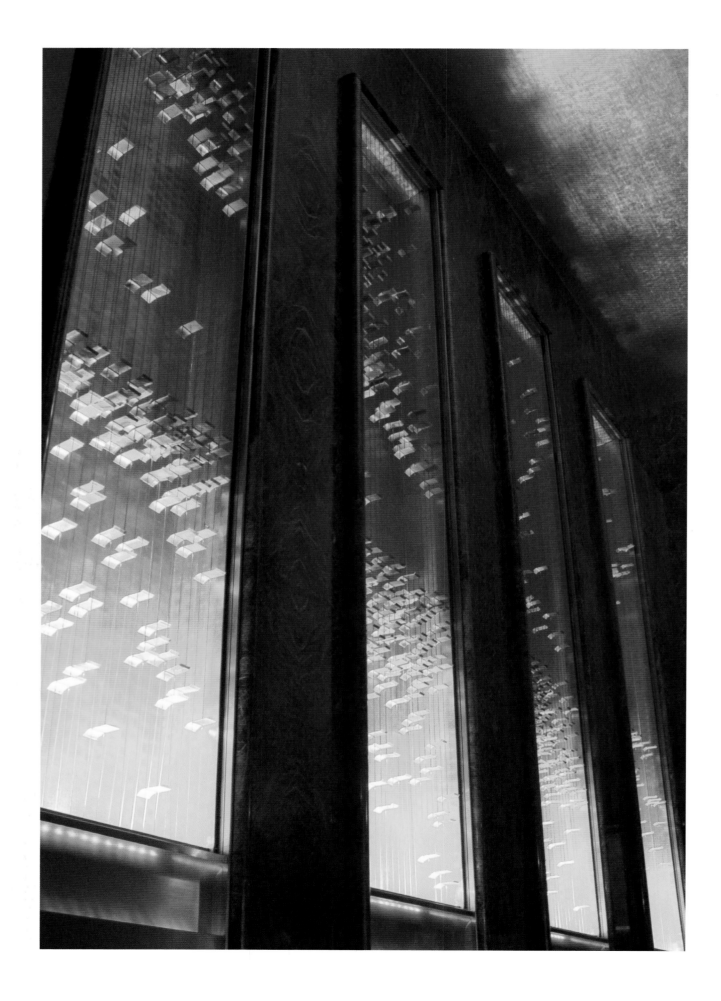

MICHIO IHARA
SCULPTURES of LIGHT and MOVEMENT

In the main lobby is the ten-part lighted metal sculpture by Michio Ihara informally titled *Sculptures of Light and Movement*. Commissioned for the Center by Nelson Rockefeller and installed in 1978, the large piece spans both the north and south walls of the lobby.

The sculpture is composed of 1,600 gilded steel leaves attached to vertical stainless-steel cables set into ten shallow, rectangular gilded boxes. It was executed with precision and a flawless sense of space. Depending on where the sculpture is viewed from, the designs and light patterns appear to change. Light emanates from the bottom of the boxes, shimmering and reflecting off the fluttering leaves and creating a delicate, almost religious ambiance. Originally small fans set the leaves fluttering, but because of time and dust, the fans have been halted. Some movement is still caused by the draft of warm air rising from the heat of the lamps set in the bases.

Sculptures of Light and Movement is an environmental work, creating a subtle atmosphere. It is so immense, and at the same time understated, that many visitors pass through the lobby not comprehending it as art.

Opposite: Four elements of Michio Ihara's ten-part work Sculptures of Light and Movement *in the lobby of the International Building.*

Michio Ihara in 1978 fabricating his multisectioned work Sculptures of Light and Movement, *which covers the lobby walls in the International Building.*

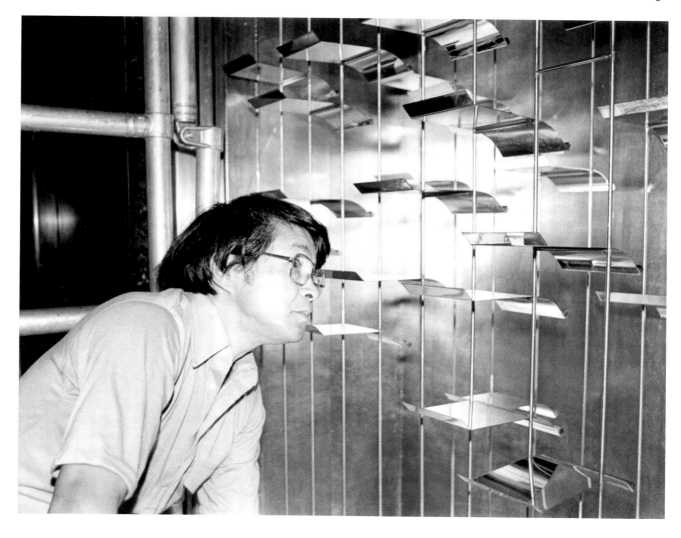

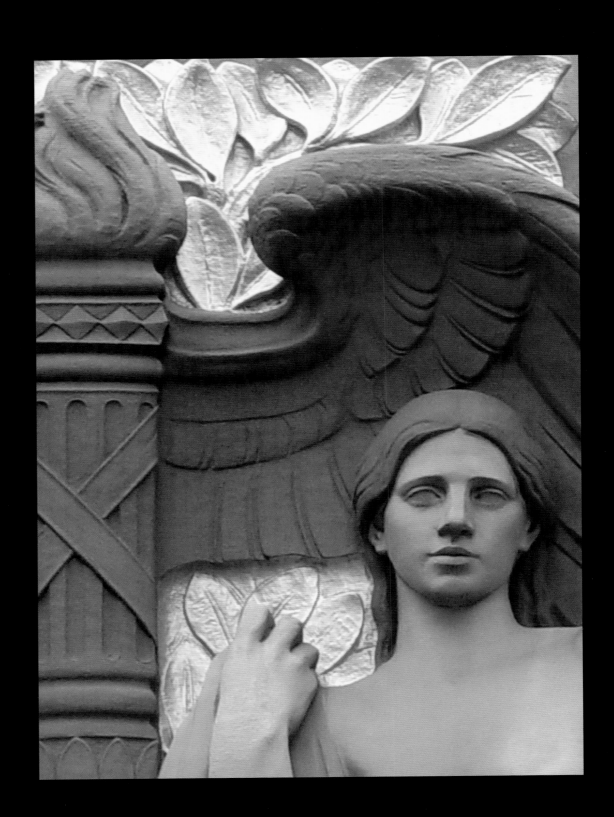

THE INTERNATIONAL BUILDING NORTH

ATTILIO PICCIRILLI · YOUTH LEADING INDUSTRY

In 1936, Attilio Piccirilli was commissioned to design a second massive glass panel as a companion piece to the now lost *Advance Forever Eternal Youth*. This new panel, titled *Youth Leading Industry*, has many of the same controversial, Fascist characteristics as the destroyed one. It utilizes idealized, muscular young men to symbolize strength, vision, and leadership. Fortunately, this panel escaped censure and destruction, surviving as purely a work of art in its prominent location at the main entrance to the International Building North. It lacked obvious, controversial mottos and was not surrounded by blatant symbols of Fascism. Consequently, it was not viewed as manifestly political or patently symbolic of a distressing period in history.

The panel is elegant, direct, and forceful—a distinct and commanding accent for the main entrance to the building. Imbued with a glittering, animated presence, it is a splendid example of public art of the Art Deco period, combining an unusual material with a heroic theme. The panel depicts two audacious figures. The first muscular youth sprints ahead of two wildly rearing horses pulling a chariot. He is the romanticized presence of the new, young, fearless, and reinvigorated leadership of Italy. The second figure, a forceful charioteer, drives the chariot and horses, representing youth skillfully and surely guiding industry and commerce into the future. The dynamism of the lunging horses being restrained and led by confident, godlike figures provides theatrical grandeur to the work. At night it is backlit and shines dramatically onto Fifth Avenue.

Detail of the head of Industry *from Attilio Piccirilli's stone carving* Commerce and Industry with Caduceus *surmounting the main entrance to the International Building North; Leon V. Solon designed the coloration.*

Originally Piccirilli's first small model, which he rendered in clay, included two large airplanes flying above the charioteer. The only record of this is found in early photographs of Piccirilli in his studio standing alongside this preliminary model. The planes were removed prior to the design being approved for enlargement to a full-size clay model. Perhaps the inclusion of a modern air-travel theme with the manifestly classical theme was too divergent. Fortunately, this panel remains an extraordinary work and provides a glimpse of what was "lost" with the destruction of *Advance Forever Eternal Youth.*

Attilio Piccirilli working on the mid-size enlargement of his model for the panel Youth Leading Industry. *The plaster model underwent further development. The airplanes in the top section were removed. Above this model is the plaster model for* Commerce and Industry with a Caduceus *(1935) for installation in the International Building North.*

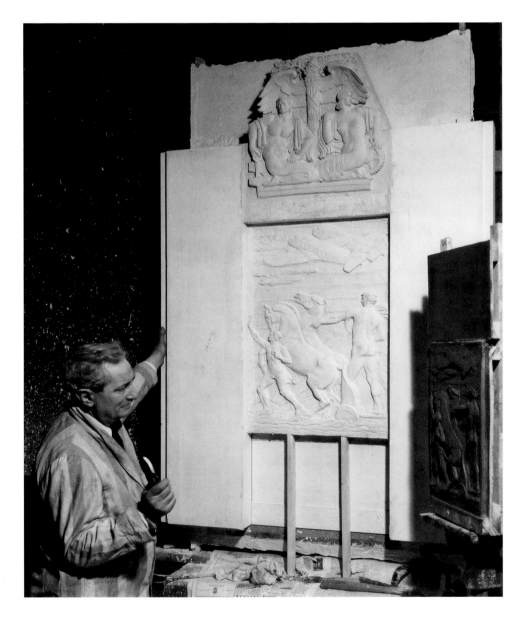

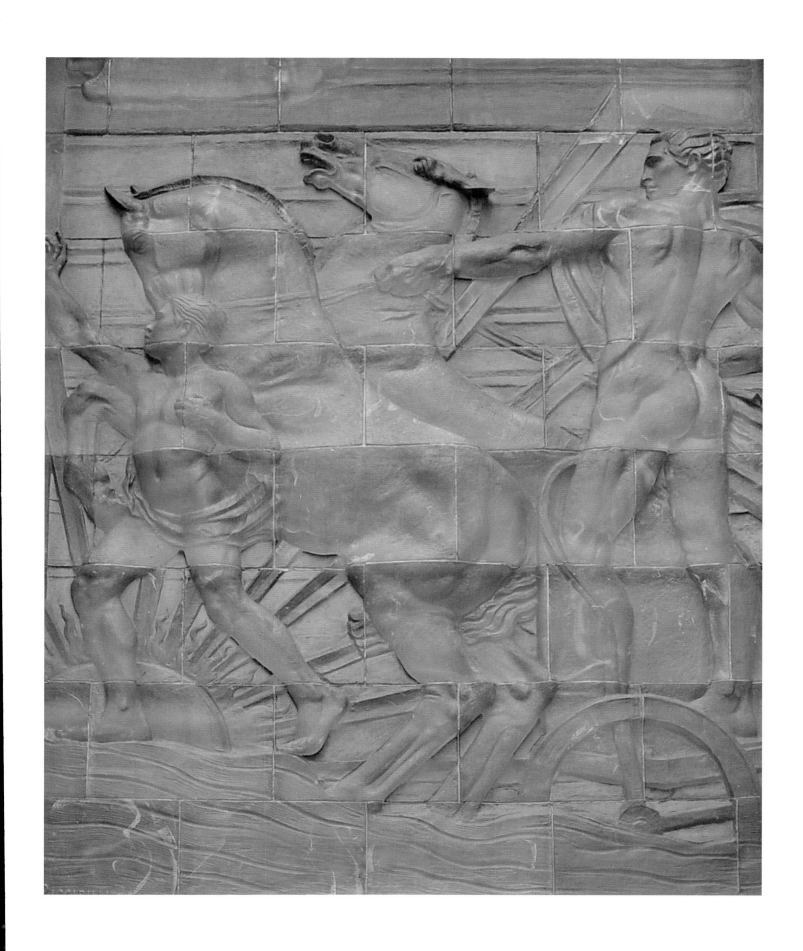

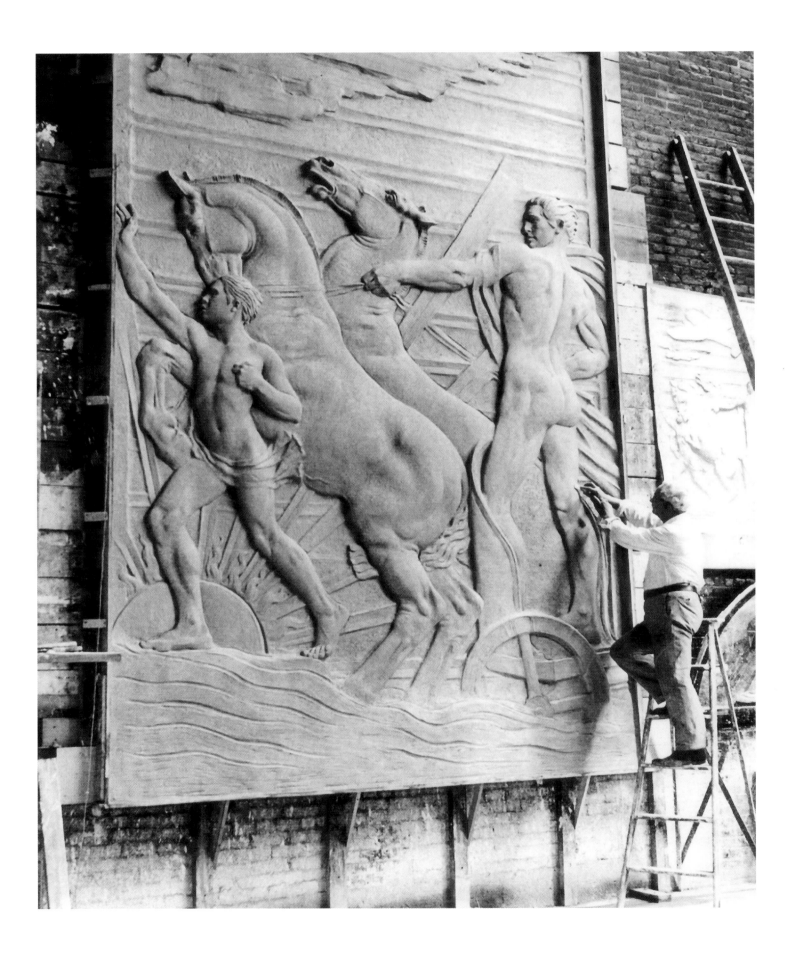

The theme of both this work and the destroyed glass panel glorified the new Republic of Italy and, consequently, Fascism. At the time the Piccirilli family immigrated to America, Italy was in the throes of poverty and political upheaval. They viewed the new Italy, and Fascism, with hope and the expectation of change for the better. This optimistic view was to change for them as war raged in Europe. Attilio Piccirilli's nephew fought and died in the Second World War for America.

Youth Leading Industry weighs four tons and is composed of forty-five unique Pyrex castings of glass blocks. Corning Glass Works termed the material "poetic glass."[1] In 1937, Rockefeller Center's public relations department released the following description: "The molten glass was poured in small quantities by hand in such a way to cause bubbles and striations which break up the glass's crystal clearness, giving it the effect of fluidity and hand molding, and the general appearance of a huge slab of onyx."[2] The edge of each block was honed to create a perfect level surface for mounting on the building's façade. Piccirilli was involved in every aspect of the work's creation. Part of the background is painted, emphasizing the central action and figures.

Opposite: Attilio Piccirilli working on the full-size clay model for the panel Youth Leading Industry *in 1935.*

Glass blocks being hand-poured in 1935 at Corning Glass Works for Attilio Piccirilli's panel Youth Leading Industry. *The molten glass is "gathered" in small quantities and poured into the molds to form uneven textures and bubbles. Corning Glass Works termed this material "poetic glass."*

Hand-honing the edge of each glass block in 1935 for Attilio Piccirilli's Youth Leading Industry, to ensure a tight and even fit at installation.

Opposite: Attilio Piccirilli confirming the measurements in 1935, prior to Youth Leading Industry being installed on the façade of the International Building North.

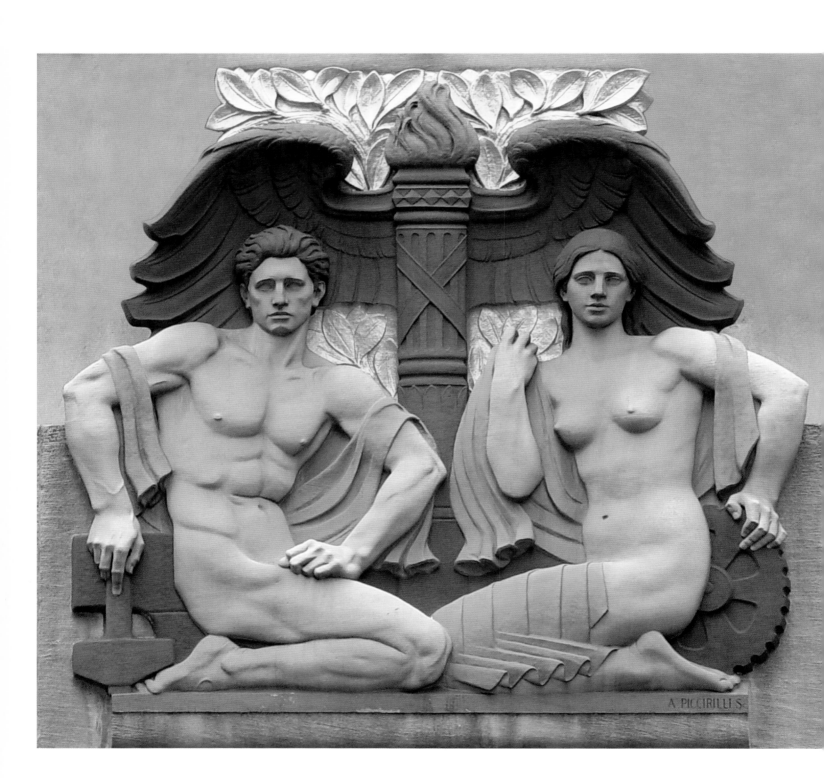

COMMERCE and INDUSTRY with CADUCEUS

Surmounting *Youth Leading Industry* is the second panel sculpted by Attilio Piccirilli specifically for this site on the Fifth Avenue façade. It depicts heroic-size male and female figures representing commerce and industry. Between them is a caduceus (a winged staff), a symbol of Mercury, the messenger of the gods of Mount Olympus. Mercury was a versatile lesser god with many attributes, including the representation of authority and commerce.

Piccirilli sculpted the outspread wings of Mercury's staff disproportionately large, indicating recognition and protection for the figures below. The classically draped and posed kneeling figures are depicted frontally, with their hands touching a wheel and hammer, symbols of their roles.

The panel is carved in stone and painted in polychrome. The surfaces and strong bold forms, with the use of industrial iconography, typify the Art Deco style in architectural decoration. As seen here, the roles of industry and technology are emphasized and portrayed time and again in Rockefeller Center's art program, reaffirming the central themes, New Frontiers and The March of Civilization.

Attilio Piccirilli's carved, polychrome-painted and gilded limestone sculpture titled Commerce and Industry with Caduceus, *installed above the glass-block work* Youth Leading Industry.

LEO LENTELLI · FOUR CONTINENTS

Opposite: Leo Lentelli's Four Continents, *installed on the seventh-floor spandrels of the International Building North. The carvings represent Asia (Buddha and sacred elephant), Europe (Neptune), Africa (figure with a necklace), and the Americas (buffalo head, head, Mayan head, and ears of corn).*

High above the pavement on the Fifth Avenue spandrels of the International Building North are four bas-reliefs by Leo Lentelli. Lentelli, an Italian artisan, created the models for these pieces in the Piccirilli studio. He worked closely with Attilio Piccirilli, whose workshop did the actual stone carving from Lentelli's plaster models.

Continuing the international theme of the building, these stone allegorical carvings represent four continents of the world. They are, from south to north, *Asia*, represented by Buddha; *Europe*, represented by Neptune; *Africa*, represented by an African figure; and the *Americas*, represented by a buffalo, a Mayan head, and ears of corn.

The artist's use of rounded forms and stylized details characterizes the architectural decoration of the period, and provides texture and visual interest to the plain limestone and emphasizes the building's spandrels.

Leo Lentelli working on the maquette of Four Continents. *He frequently worked in the atelier of Attilio Piccirilli. Piccirilli Brothers did the final stone carving of this work prior to its being installed on the seventh-floor spandrels of the International Building North.*

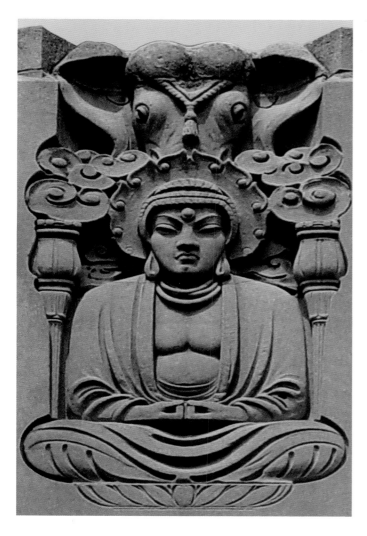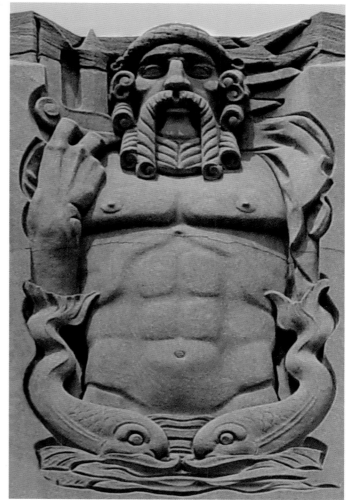
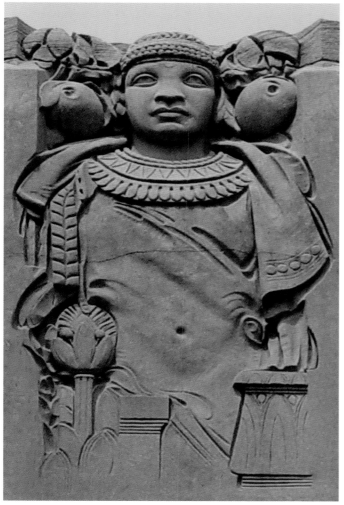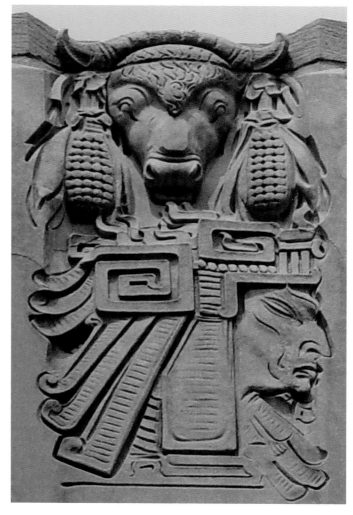

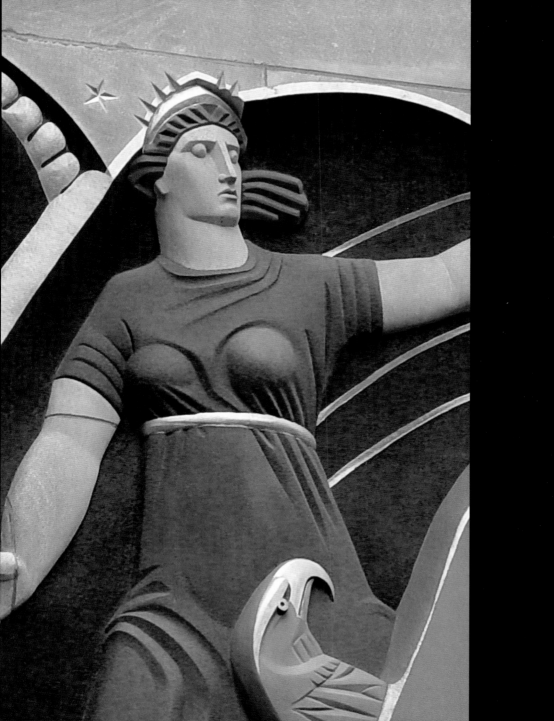

ONE ROCKEFELLER PLAZA

One Rockefeller Plaza has one of the most unobtrusive and modest main entrances in the Center. It faces west onto a pedestrian walkway, and is not grand in appearance or embellishment. By July 1936, the building was nearly completed and the engineers and architects were finalizing the decorative details. They were enumerating "things" such as the exterior decoration, elevator cabs, murals, and floor treatments that could make this "an individual, outstanding building—very attractive and beautiful, and distinctly better than Nos. 1 and 6."[1] (No. 1 being their centerpiece, 30 Rockefeller Plaza, and No. 6, the International Building). These goals were never achieved. The building is a plain Jane among brilliant skyscrapers.

One Rockefeller Plaza has the feel of design-by-committee, one that had run out of fresh ideas. Raymond Hood, the primary architect of the Center, had died in 1934. Perhaps by 1936, there was a creative void and loss of stimulation or ideas. At best, One Rockefeller Center is harmoniously sited.

Each of the building's three entrances is modestly embellished on its exterior. The decorations are restrained. Materials and ideas that were considered unique and unusual, such as glass panels and mosaics, were not sought. Instead, the architects ordered stone carvings, which were then polychrome-painted. These straightforward, over-the-doorway decorations are classic Art Deco statements and the most effective aspects of this building's art program. The lobby is bland modernism and functional. The interior public art was created in a unique manner and could have been imposing, but it is misplaced in its site and therefore of little consequence.

Detail of Lee Lawrie's Progress, *a polychrome painted limestone bas-relief carved over the Forty-ninth Street entrance on the façade of One Rockefeller Plaza.*

CARL PAUL JENNEWEIN
INDUSTRY AND AGRICULTURE

In 1937, Carl Paul Jennewein was commissioned to design the ornamentation for One Rockefeller Plaza's unimposing main entrance. His concept was simple—two intaglio-style carvings to flanking the doorway. The straightforward, classically proportioned designs of two scantily clad, muscular male figures symbolize industry and agriculture, which according to a Rockefeller Center brochure, are "the keystones of our civilization."[2] Agriculture is carrying a scythe, and Industry is holding the handle of a shovel.

Upon completion and acceptance of his designs, Jennewein turned to the Piccirillis for enlarging and carving. Their craftsmen carved the figures on limestone panels already flanking the main entrance. Workers entering the building gaze daily at these carvings, receiving a fundamental message of America's strength and rectitude.

The figures are chaste outlines carved into the stone. Their facial expressions severe and unyielding; they are "power figures." Each has his head turned facing the entrance, creating a bond between them and unifying the elements of the sculpture. Agriculture stands next to a row of wheat and leans one elbow on the pillar flanking his side of the entrance. He carries a short-handled scythe in that hand. With his free hand he is gesturing downward, seemingly inquiring if the wheat is ready to cut. Industry's right arm rests on the opposite flanking pillar. His left hand holds the shovel handle as if he has just completed a task. Both are powerfully built and virile; the epitome of the masculine ideal and the work ethic.

These intaglio carvings are gilded along the edges and in the backgrounds. The gilding catches the light, lending elegance to the entrance and subtlety creating a greater impression on the passerby.

Carl Paul Jennewein's carved limestone and partially gilded figures of Industry and Agriculture, which flank the main entranceway to One Rockefeller Plaza.

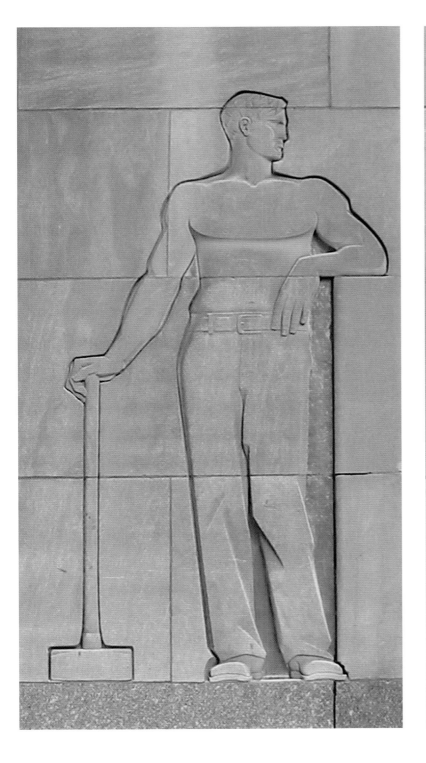
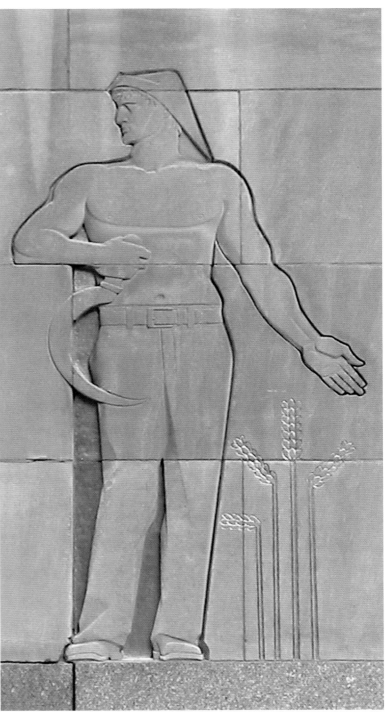

CARL MILLES · MAN AND NATURE

The main lobby continues the unpretentious theme established by the modest entranceway. As a core public space, it is relatively small and seemingly unadorned. However, high up on the west wall there is a three-part carved wood sculpture by the Swedish artist Carl Milles titled *Man and Nature.*

Man and Nature is beautifully crafted in high relief, almost in the round. It was created over a three-year period in Michigan, at the studio of Carl Milles, who was director of the Sculpture Department of Cranbrook School. Milles preferred direct carving, especially with wood, to casting, as his principal means of sculptural expression. The immense solid blocks of wood he worked with were constructed from hundreds of dried planks of northern Michigan pine that had been glued together and held under great pressure for days. A huge amount of wood had to be chiseled away to form the figures for *Man and Nature.* Milles did the carving with the aid of his students at Cranbrook.

The Swedish sculptor Carl Milles in his Cranbrook School studio examining the central figure "the rider" from his three-part work Man and Nature. *The finished work was installed in the lobby of One Rockefeller Plaza in 1941.*

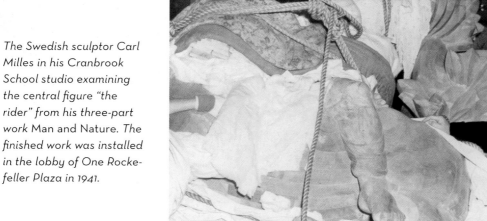

A view into Carl Milles's studio at Cranbrook in 1941, showing blocks of wood being pressed together and joined to create huge pieces for carving the three-part work Man and Nature.

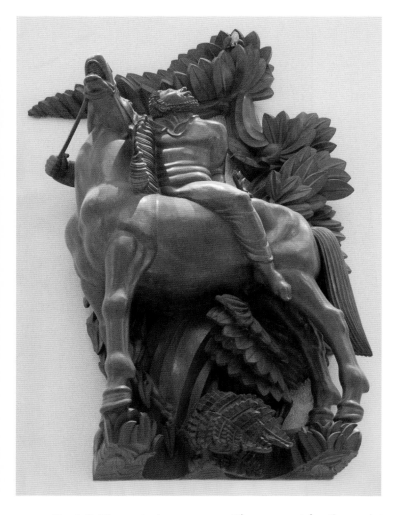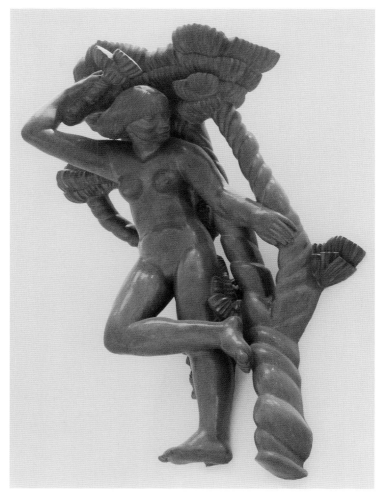

The concept for the sculpture was taken from the work of the nineteenth-century German poet Johann Gottfried Seume. He wrote, "Where song is, pause and listen; evil people have no song." The artist captured "pause and listen" in the center relief, in the form of a rider reining in his horse and raising his head toward a song. A nymph, located to the rider's right, is also drawn toward the sound. A faun, on the rider's other flank, shrinks from the song. The nymph and faun represent a struggle between good and evil. Unfortunately, the portrayal is quite feeble. The contrived, static postures of the figures give the effect of great world-weariness rather than immense effort in the battle of good against evil. The nymph lounges, and the faun hides his head. This sculpture might be hailed as technical virtuosity in wood, but it simply lacks aesthetic vigor.

At the top of the center relief, above the horse and rider, rests a small silver bird, crafted from the silver workshop at Cranbrook. It flutters its wings and opens its beak in song as a recording of a Mexican nightingale is played at regular intervals in the background. The bird's song was actually recorded at the home of Fairfield Osborn, president of the New York Zoological Society in the 1940s, who owned a Mexican nightingale.

Man and Nature is believed to be the first sculpture in America with sound and motion in a permanent interior installation. It was hailed as a symbol of hope and peace by Henry R. Luce, who was the publisher of *Time and Life* and the major tenant in the building at that time.

In spite of Milles's international reputation, and his sculpture in One Rockefeller Plaza, his relationship with Rockefeller Center had not always been easy. First

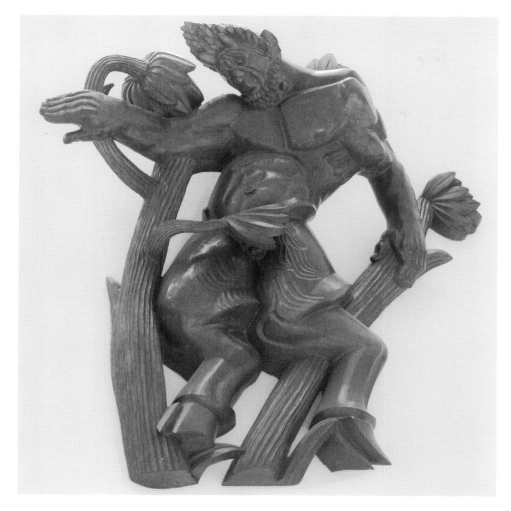

The faun from Carl Milles's three-part work Man and Nature *in the lobby of One Rockefeller Plaza.*

approached to work at the Center in 1933, he had been requested to submit suggestions to replace the demolished Rivera fresco at 30 Rockefeller Plaza. The architect, Raymond Hood, was exploring a number of ideas for the lobby and had contacted Milles.

Milles worked on sketches and plaster models for a sculpture for the site and made several trips to New York. During one of those trips he apparently was rudely treated by the engineer, John D. Todd, who was in charge of construction. Todd was personally dealing with the problem of the "wailing wall," and attempting to find suitable alternatives. Milles's sketches were of rather explicit nude figures of Adam and Eve. Sometime during 1933, Todd asked him to eliminate the nudity. The artist refused and the situation deteriorated, coming to an impasse with Todd treating Milles shabbily and reportedly saying, "Throw this Swede out of my office."[3] The embarrassment and anger Milles felt was confirmed in a letter he wrote to Todd & Brown following the incident. In it he states, "I shall not call on you for the reason, that, in the presence of several distinguished persons Mr. John Todd greviously [sic] insulted me."[4] Sometime later, Milles requested reimbursement for his time, models, and trips to New York from Cranbrook. He wasn't paid and began a legal action that embarrassed the Rockefellers because the newspapers quickly picked up the story. Soon afterward, the Rockefellers settled "expenses" with him.

In 1938, Milles was again approached to work at the Center. This time the requests came directly from John D. Rockefeller Jr. and Laurance Rockefeller, and the new commission proceeded smoothly. The result is the *Man and Nature* sculpture in One Rockefeller Plaza.

LEE LAWRIE · PROGRESS

Lee Lawrie created the design for the bas-relief titled *Progress*, located above the 14 West Forty-ninth Street entrance to One Rockefeller Plaza. Following Lawrie's drawing, Alex Mascetti, an artist's technician working for the Piccirilli Brothers, made the enlargement and model. In a memo dated March 2, 1937, Mr. H. McA. Schley, who coordinated all aspects of the building program between the architects and engineers, suggested that the Piccirilli Brothers do the carving as "it definitely states in their contract for the modeling that it should be so designed as to have the carving not exceed $1,000."[5] The control exercised by the engineers and architects over the costs of architectural decoration and over the art and artists frequently affected the creative outcome. The Piccirilli Brothers did the actual stone carving on site from a scaffold set up over the building's entrance.

After the Piccirilli Brothers completed their work, Lawrie inspected it and felt it necessary to do some additional work himself, to remove imperfections. The stone the Piccirilli's had used had not been originally scheduled to be carved and was not of sculptural quality, resulting in defects in the design. Once Lawrie completed the piece to his satisfaction, the bas-relief was polychrome-painted and gilded by Rambusch Decorating Company. They followed the striking colors and gilding pattern developed by the colorist Leon V. Solon.

Frequently several artists and technicians work on one piece. The artists design the work and then move on to the next assignment. Next, the technical studios and craftsmen (model makers, enlargers, mold makers, carvers, casters, colorist, painters, etc.) execute the work. Each of these technicians consults with the artist at critical stages. Even in the relatively small bas-relief *Progress*, five artists-craftsmen had a hand in its creation: the artist, the model maker, the carver, the colorist, and finally the painters.

Progress is symbolic of inspiration, aspiration, and divine fire. The dominant figure, Progress, is depicted as a classically dressed, vigorous, powerful woman. She bears, in her raised left hand, a pan of divine fire. The fire is symbolic of inventiveness and creativity. In her other hand she holds a branch of bay leaves, symbolic of honor or excellence. Upon her head rests a golden tiara.

Behind Progress is the winged horse Pegasus, representing inspiration. He is depicted with an open mouth and rearing as if both eager and apprehensive. An imprint of his hoof was to have caused the fountain of the Muses, Hippocrene, to flow from Mount Helicon.

In front of Progress is a mighty eagle with its wings spread, its talons extended, and its head raised toward the divine fire. The eagle is symbolic of aspiration and power. The three figures forcefully advance in the same direction on a wall sparsely decorated with stars and clouds.

In this low-relief sculpture, these powerful gifts to mankind—creativity, inventiveness, and aspiration—allow society to flourish and civilization to advance. The implication is that people imbued with these characteristics will lead the human race.

Lee Lawrie's carved, polychrome-painted and gilded limestone work Progress, *installed in 1937 over the Forty-ninth Street entrance to One Rockefeller Plaza.*

ATTILIO PICCIRILLI · THE JOY OF LIFE

Over the entrance to 15 West Forty-eighth Street is Piccirilli's bas-relief titled *The Joy of Life*. It depicts seven seminude figures set against a strikingly blue and starry background.

The central figure is a youthful Bacchus, the god of wine and revelry. Portrayed as a hermaphroditic figure with long wavy golden hair and a toned, firm body, he is reclining and holding a bunch of golden grapes aloft. As the central figure he has set the stage for the drama taking place around him.

Bacchus is flanked by three figures on both sides. The figures to his right carry golden jugs of wine and beckon the other standing figures. A nude boy in this group leans on a staff and looks fixedly over Bacchus to the figures on the left. They appear reluctant to join the festivities. One looks away, her arms held high to shield her head, which is covered in long flowing golden locks. The other two figures hold hands and gaze at the group who summons them. Only two of the six figures are clothed; they are wrapped in pale saffron-colored togas.

The use of gilding in this panel is masterful. It unites and accentuates figures and the pertinent symbols. The simplicity of the pale gray-skinned figures set against the smooth blue sky with golden floral stars as background reinforces the harmony of the design.

The mastery of carving, the simplicity of composition, and the pictorial quality of this doorway bas-relief reflect the skill that Attilio Piccirilli and his brothers brought to each commission. The panel was carved by Piccirilli Brothers on site and the coloration was designed by Leon V. Solon.

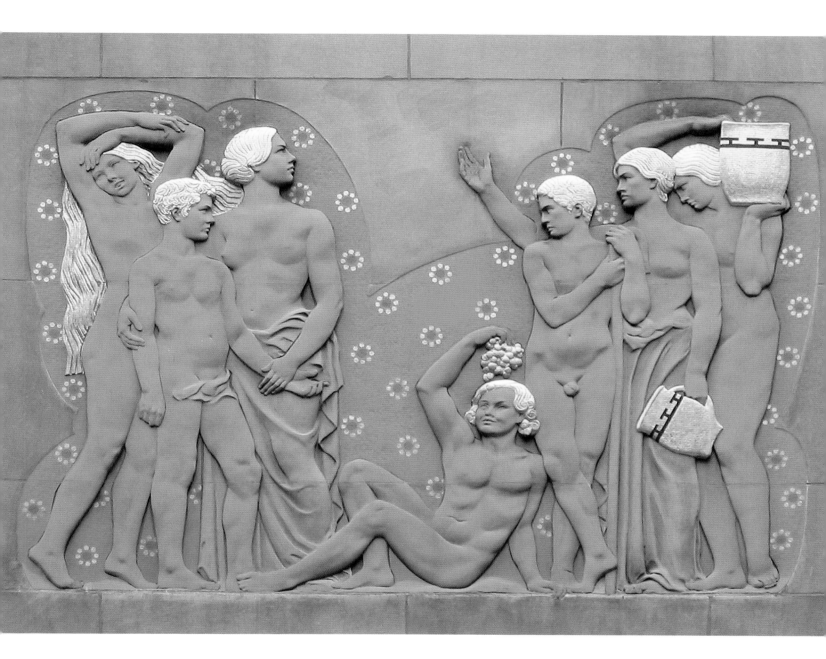

Attilio Piccirilli's carved, polychrome-painted and gilded limestone work The Joy of Life, *installed in 1937 over the Forty-eight Street entrance to One Rockefeller Plaza.*

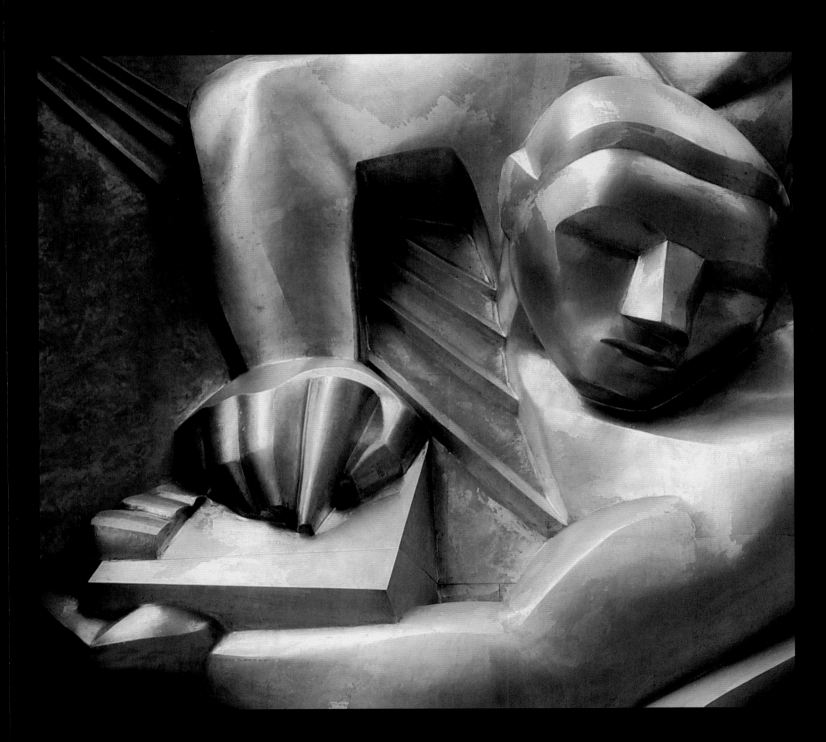

THE ASSOCIATED PRESS BUILDING

ISAMU NOGUCHI · NEWS

There is no way of missing the huge gleaming bas-relief over the main entrance to the Associated Press Building. *News* is sheer energy, an intense expression of gripping urgency as reporters at work leap off the massive plaque. The artist, Isamu Noguchi, captured this instant of urgency and excitement and made it infinite.

The plaque depicts five newsmen working on different aspects of "getting the story": the camera, the telephone, wire photo, teletype, and the notepad. Cutting diagonally across the background are the wires that symbolize the Associated Press's worldwide network. It is high drama rendered in the new aesthetic of the 1930s: Art Deco.

The bas-relief is cast in stainless steel, an eloquent, enriching, and modern material. This bright substance provides clean, hard lines and a vivid, reflective surface. It imparts a sense of tensile strength that intensifies the drama in the imagery.

The construction of the colossal plaque is a tale of ego, anger, and opportunism. In 1938, the Rockefeller held an open competition for a work of art to adorn this space and represent the Associated Press, the major tenant of 50 Rockefeller Plaza. There were 188 entries. The commission was awarded to Japanese-American artist Isamu Noguchi for his work titled *News*.

Noguchi had been working on a design for several months, but just three days prior to the deadline he changed his mind and redesigned the entire concept. He claims the concept for casting in stainless steel was his idea; however, it is apparent from correspondence that the architects had been mulling over a change to this medium for a while, even though the competition specified bronze. Noguchi, most likely, had been made aware of their change, and this put him at a great advantage as he designed specifically for the material and even indicated stainless steel as preferred for his plan. His entry was a small plaster maquette that was found "faultless" and skillfully rendered.

Detail from Isamu Noguchi's News, *installed above the main entrance to the Associated Press Building, showing a reporter with his pad and pencil noting the news.*

Isamu Noguchi, with the design for the large bronze panel of the new Associated Press Building, won the first prize of $1,000 from a field of 188 entries. The small figure (lower right) was removed in the final model.

Noguchi's early figurative style was perfectly suited to work in this metal, owing to his use of precise lines, solid rounded figures, and broad flat planes. His plaque captures the dynamic force of the moment when the press springs into action. It aesthetically embodies both the power of the modern-day newsroom and the cultural concepts of the Center. Rendered in this contemporary and innovative metal, his piece is an aesthetic and technical tour-de-force.

Following creation of the full-size plaster models, the sculpture was cast in nine sections in a super stainless steel called "Eternal Metal" that had been developed at General Alloys, a Boston foundry. Casting was fraught with problems because of the size and artistic nature of the subject; workers at the foundry were experienced at casting relatively small industrial parts, not large works of art. They experimented for months and finally formulated an alloy and worked out a method to distribute large quantities of molten metal relatively quickly and consistently.

Opposite: In a dramatic fashion, Isamu Noguchi's stainless-steel plaque News *informs visitors about the activities occurring inside the Associated Press Building.*

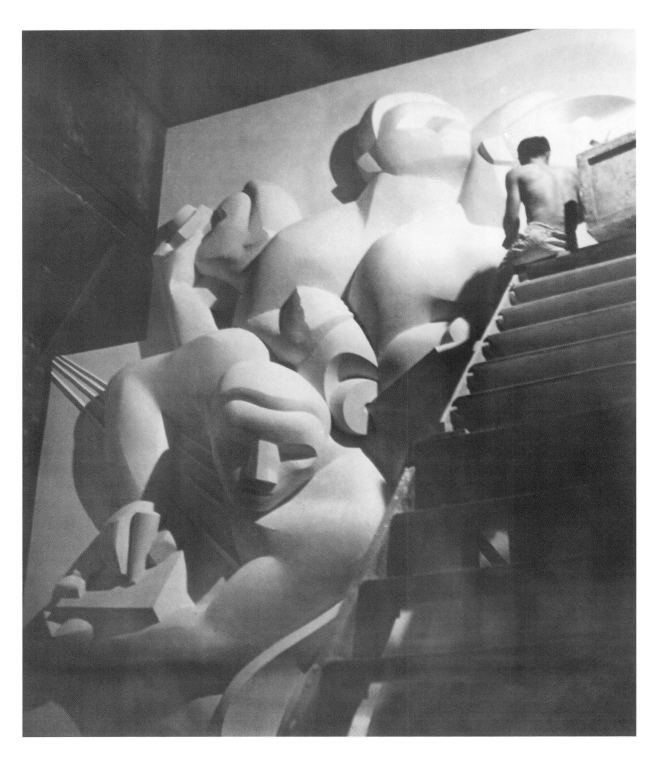

*Isamu Noguchi working on
the full-size plaster model
of News. This model would
be cut into nine sections for
casting in stainless steel.*

The casting took a long time, owing to these technical problems and the relationship between Noguchi and the foundry. By the time Noguchi was finished creating his work at General Alloys, the company and the artist were at odds about his hands-on involvement with the actual work, as well as artistic credit for its fabrication.

Once all nine parts were cast, they were welded into three sections, weighing a total of nearly ten tons. The final three sections of the sculpture required extensive finishing. In a pique, Noguchi undertook much of the machining, grinding, and polishing work himself. He was indignant about the workers and resentful of the efforts made by the management of General Alloys. He wrote to Schley, the coordinator for Rockefeller Center, "I am hopelessly disheartened by these continuous delays which have destroyed my hopes and plans for a winter vacation in Hawaii. The necessity of my being here cannot be dispensed with for the reason that not only am I doing all the contouring and finishing in the grinding of the plaque, but also I am the only one who cares to expedite matters, and so have the responsibility of seeing things done against the inertia of people unaccustomed to this kind of work and resentful of intrusion into their regular production schedule."[1]

The workshops of General Alloys in 1939, the foundry that cast News *in a super stainless-steel alloy called "Eternal Metal." In the foreground, sections of the plaque are being finished. In the background, another element can be seen with the diagonal lines representing electronic transmission.*

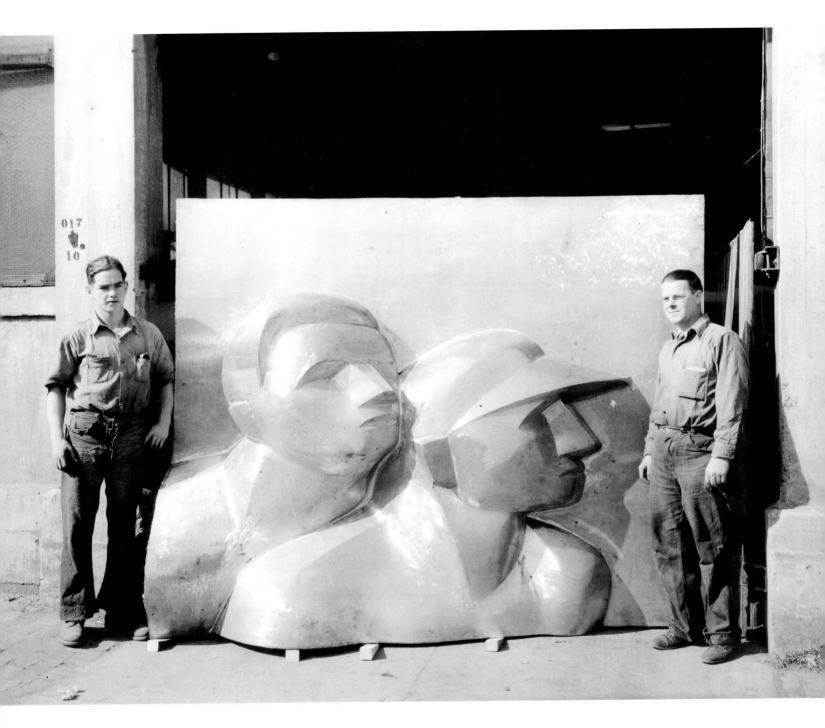

Workers from General Alloys in 1939 supporting the upper right section of the cast stainless-steel bas-relief News, one of nine sections joined to form the final three sections of the bas-relief.

The disappointment was not one-sided. H. H. Harris, president of General Alloys, also wrote to Schley: "His only interest is the plaque and the expediting of this work, he endeavors to expedite it in every way possible, and to shuffle our organization to that end. He talks freely with workmen who have nothing to do with the job, has the run of the place, and is, frankly, a hell of a problem to put it mildly." He continued: "Mr. Noguchi wanted to do some welding, had the piece removed, and did the welding on it, with the result that it was badly warped out of shape and the people doing the work are thoroughly unhappy and the progress of the job has been retarded very considerably.", "I have seen some of Mr. Noguchi's correspondence with you and appreciate his great personal distress that he is part in a foundry and not in the pineapple fields of Hawaii,—the answer to which (you will pardon the vernacular) is that it is just too damn bad. I would like to be in Hawaii too."[2]

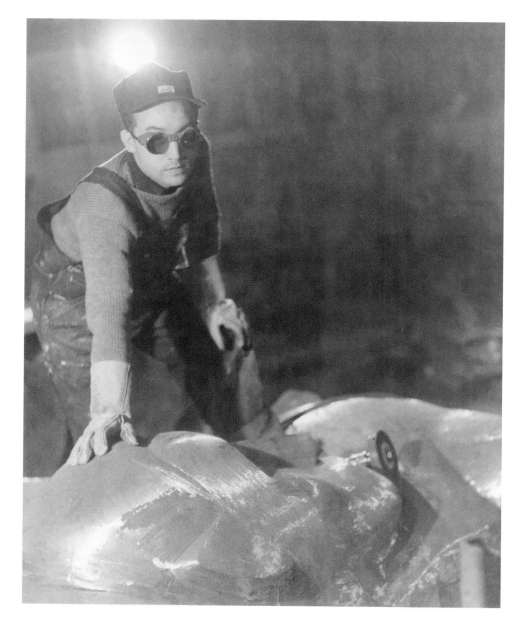

Isamu Noguchi working in 1939 at General Alloys grinding the surface of News. He personally finished the surface, achieving the reflective qualities he desired for his work.

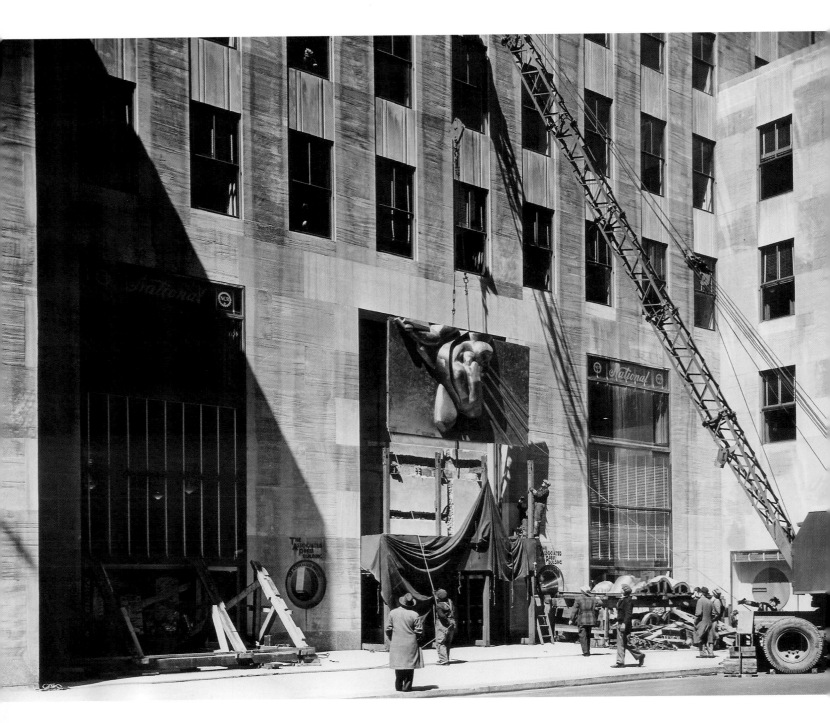

The installation of Isamu
Noguchi's News in 1939 at
the façade and main
entrance to the Associated
Press Building. A "locomo-
tive crane" was used to
install the three sections.

The plaque was crafted as a modern machine might have been. The edges were trimmed and polished to one-thousandth of an inch, and the milling and joining so exact, that the various pieces would not be discernible from a distance of five feet. The three massive sections were shipped to Rockefeller Center for installation. Noguchi went to the Center to finish the carving and contouring of the plaque after it was installed.

News was the first major sculptural use of stainless steel and, at the time, the largest metal bas-relief in the world. It was heralded as a shrewd investment for saving money on maintenance, as bronze and brass and the usual architectural metals require constant expensive upkeep but stainless steel would not.

On April 29, 1940, in a spate of publicity, Nelson Rockefeller unveiled the Noguchi plaque. In his speech he called it "a powerful, beautifully executed, sculptural interpretation of the gathering of the news—symbolic of the freedom and vitality of the press." His speech went on warning against totalitarian ideologies and urged each American to preserve and protect our intellectual freedom. World War II was on the horizon.

This figurative work by Noguchi reflects his ethnic background and his family's creativity. His American mother was a writer and teacher who constantly encouraged her son to be an artist. His Japanese father was a poet and teacher who had abandoned his mother before Noguchi was born. In spite of this rejection, Noguchi paid tribute to his Japanese heritage throughout his life. *News* integrates the diverse traits of this heritage, spanning the influences and cultures of the East and West. The work expresses the minimalism and restraint of the Orient with the vitality and extroversion of the West.

In 1938, a time when Japanese-American relations were strained, the Rockefellers, fortunately, were far-sighted and open-minded in their selection of Noguchi. Since then, Noguchi has been internationally recognized as one of the most important artists of the twentieth century, and his bas-relief *News* has, without doubt, passed the test of time.

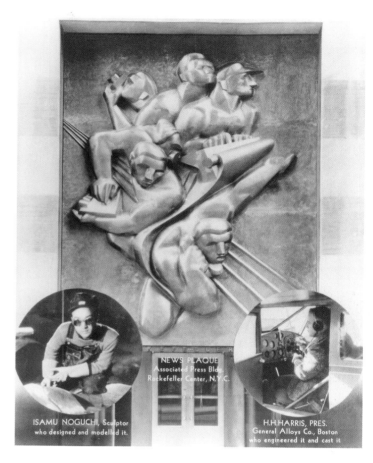

A reprint of the publicity photo in 1939 that was widely distributed upon the installation of News. *It gives credit to both the artist, Noguchi, and the manufacturer, General Alloys, as they contended for recognition for their roles and efforts in producing the world's first stainless-steel bas-relief.*

10 ROCKEFELLER PLAZA

DEAN CORNWELL
THE STORY OF TRANSPORTATION

The stark lobby of 10 Rockefeller Plaza is countered by a large, sumptuous mural titled *The Story of Transportation*, a three-part pastiche created by Dean Cornwell. *The Story of Transportation* celebrates technology and attempts to thwart the dehumanizing effects of the overly sleek, aerodynamic lobby. In this austere, business-building environment of metallic trim, stone, recessed lighting, and glass, Cornwell's mural provides stylish, cheerful energy to the surroundings.

Cornwell owed his skill as a muralist to Frank Brangwyn, who, in 1932, had provided murals for 30 Rockefeller Plaza. As a young man, Cornwell had been his student and assistant in England. In 1915 he had worked with him creating the British Empire Panels for the House of Lords. Dean Cornwell was equally talented as an illustrator. By the end of World War II he was a household name for his patriotic war posters and magazine illustrations. In 1946, he was at the top of his game as a muralist.

In 1946, when the Rockefellers opened this building, their major tenant was Eastern Airlines and Laurance Rockefeller was a major investor in it. Although the building was not included in the original 1930s art program, the postwar Rockefellers retained the concept of embellishing buildings with pertinent themes. They recognized the importance of the rapidly expanding air industry and wanted to identify and celebrate that achievement with a mural. With the airline's participation,

Opposite: Golden gulls, representing natural flight, in detail from The Story of Transportation, *painted by Dean Cornwell.*

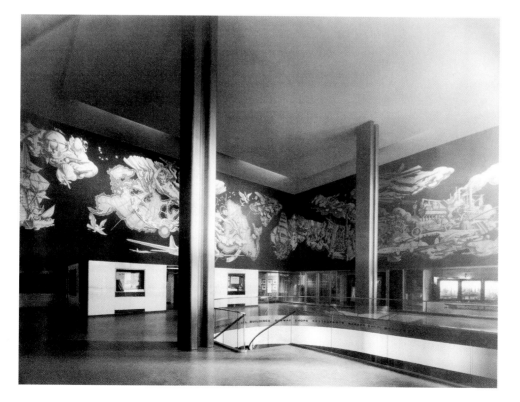

The lobby of 10 Rockefeller Plaza in 1945, with two sections of Dean Cornwell's three-part mural The Story of Transportation.

they quickly commissioned Dean Cornwell to appropriately decorate the lobby of 10 Rockefeller Center. Unfortunately for the Rockefellers, some controversy would attached to the unveiling of this mural, owing mainly to the Rivera debacle still being a cause célèbre in the art world.

By this time, nearly twenty years later, the Rockefellers had become more skilled at public relations and handling controversy, and could set the stage for good publicity. At the unveiling ceremony, Captain Eddie Rickenbacker, the famed flier of both world wars, and the then-current president of Eastern Airlines, presided. Rickenbacker was a true American war hero and a flamboyant figure. His plane had been shot down in the Pacific. He and his crew survived at sea on a raft for thirty days by eating raw seagulls and harvesting what rain water they could. That feat sealed his celebrity. Prior to the war, he had been a famed race-car driver. According to friends, he and his equally spontaneous wife were always out to enjoy life and live it to the fullest. In some circles her fanciful hats and endless martinis were legendary. His fame and fortitude were public record.[1]

On May 28, 1946, the mural was dedicated. Laurance Rockefeller spoke of the "important and permanent contribution to the art program which we have always considered essential in the design of the modern, well-planned community we want Rockefeller Center to represent."[2] He stated an aspect of the mural's importance was its updated perspective on the original theme, New Frontiers, by depicting modern commercial air travel. Eddie Rickenbacker arrived driving his famed Maxwell Special and accompanied by his wife sporting one of her famous hats. At the time the mural was being unveiled, a controversy arose over its artistic significance and contribution to modern culture. Members of the art department of Vassar College had been invited to participate in the dedication of the mural. They turned down the invitation as they felt the mural was, from an artistic view, backward-looking. Captain Rickenbacker, never known to avoid a dispute, took hold of the situation head-on. At the dedication he read a telegram from Vassar College's art department that stated, "Vassar College cannot indulge in backing anyone so reactionary as Dean Cornwell." The head of the art department later clarified her comments and wrote, "The members of the Department are concerned with the many unimaginative public monuments of our day and therefore regret that in commemorating the newest and most progressive means of transportation an outmoded style of art was chosen." Referring back to the Rivera fresco scandal that took place thirteen years earlier, Rickenbacker's comment to the press was, "John D. Rockefeller Jr. wasn't taking any chances on anything being put over on him this time." Then, as a retort to Vassar, he told Cornwell, "I'd like to be your kind of reactionary."[3]

Dean Cornwell had worked for two years developing the theme and researching his ideas. He spent days in museums, sketching models and poring over old photographs. At first, Cornwell sketched his ideas in a scale of 2 inches to the foot, then enlarged his work to 4 feet by 10 feet prior to producing full-size paper cartoons. These cartoons enabled him to view the entire mural and alter his design or render it as conceived. He also used them to transfer the work to the wall: he perforated the outlines on the paper with a sharp needle and then laid it against the wall and pounced the holes with dry color, leaving a dotted outline on the wall.

The central theme of the mural is the evolution of air transportation and a vision of America thrust into the future by the conquest of time and space. This is exemplified throughout the mural by illustrations of various gleaming aircraft. The countertheme is outmoded means of transportation: the stagecoach, the locomotive, the sailing ship.

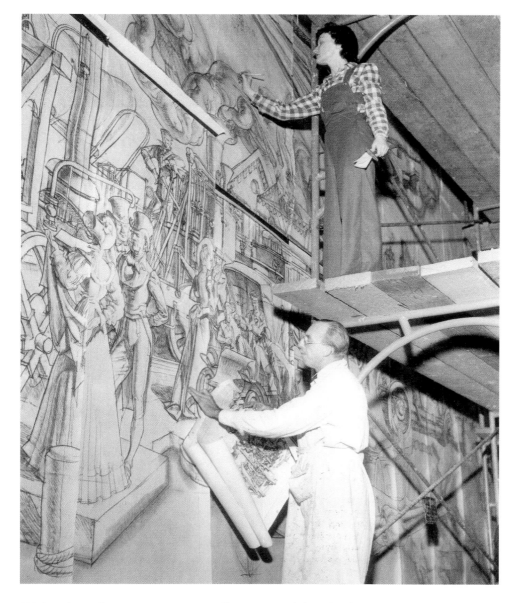

Dean Cornwell and his assistant, Wilmuth Masden Stevens, preparing the cartoons for transfer to the walls, ca. 1944. Stevens was also the model for the four goddesses in the mural of The Story of Transportation.

Within this subject matter, Cornwell juxtaposed the obsolete with the potential for unlimited progress. He ignored the obvious use of the narrative and depicted his theme in montage style, a medley of various scenes set in different times.

The unfolding and disparate scenes are unified by a limited palette. The montage uses two distinct gilded surfaces set against a flat crimson background, an original technique not usually found in murals. Gold leaf is for land, sea, and obsolete transportation. Silver leaf is for the goddess of flight, and all airborne subjects such as clouds, birds, and stars, as well as all modes of transportation, especially the famed "silver fleet" of Eastern Airlines. The mural was painted on a canvas that had been imported from Holland and adhered to the walls of the lobby prior to the war. Obviously, whatever idea had been planned for this space had been put on hold for the duration of the war.

During the execution of the murals, Dean Cornwell was aided by Wilmuth Masden Stevens, his assistant, and Louis Ross, a gilder. Dean Cornwell paid enduring tribute to Stevens, as she is obviously the model for all the silver goddesses. The murals appear as fresh today as when they were painted fifty-six years ago—a tribute to the technical skill of the muralist and his assistants, as well as the care and treatment they have received over the years.

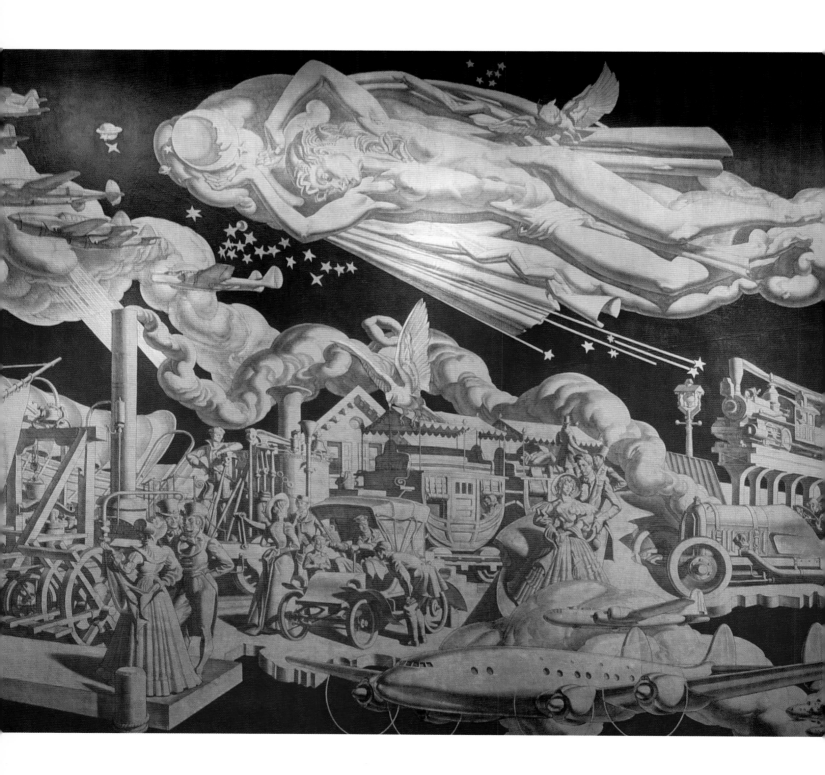

The north-wall mural depicts the heroic-size figure of a goddess, representative of Night Flight. The goddess is executed in lustrous silver leaf. Her eyes are closed, her face turned down, and she grasps the moon in her hands as she floats in the clouds above the antiquated modes of travel below. In the sky before her, a fleet of silver United Nations fighter planes of World War II soar through the starlit night.

On the crimson-colored background is a panorama of past modes of transport depicted in gold leaf; a Civil War stagecoach, a paddle-wheel boat on the Mississippi, and a 1930s racing car—a Maxwell Special, the type that Captain Rickenbacker rode to racing fame. It is a portrait of him in his famed racing car. Above the car are two urban motifs, an elevated train and one of the first twin-arc streetlamps designed by Edison, the pride of New York City in the 1880s. Next is a fragment of the *Clermont*, the first steamboat on the Hudson River, and a 1902 Pierce-Arrow, one of the first private commercial automobiles. Traveling back through time we find an ox team, a prairie schooner, and a scout on horseback. These vignettes attest to the historic vitality of America set against the optimistic future of industry and commerce.

The lower foreground brings the time line to the 1940s and portrays the second aviation theme in this mural: a squadron of World War II bombers. The silver planes are depicted streaking from the clouds toward the center of the canvas in military formation. Artistic and thematic balance is achieved by placing the large silver bomber in the lower center and the silver goddess of Night Flight at the top.

In the left section of the background, cliffs rise and a typical western town develops. Then the cliffs drop to the sea and the mural turns the corner to the west wall, where a clipper ship can be found on the corner of the central mural.

Opposite: Detail of the north mural of The Story of Transportation *at 10 Rockefeller Plaza, showing the silver Goddess of Night Flight gilding through a starry night. She bears a crescent moon and her eyes are closed. Below her is a gilded montage of disparate scenes representing historical modes of transportation and the famed "silver fleet" of Eastern Airlines.*

Detail of the north mural of The Story of Transportation *at 10 Rockefeller Plaza, showing Eddie Rickenbacker and a teammate in one of the racing cars he made famous.*

The central mural on the west wall is the focal point of the story of transportation in America. It vividly underscores the main theme: unification of the continents by air travel. It conveys through time and space what air travel has done to bring the world closer with a "golden band of spiritual understanding and progressive contacts."[4]

Dominating the center of the mural, two heroic-size silver goddesses are encircled by a thin gold band as they glide through space, symbolizing "New World Unity" through air transport. They proclaim and celebrate the country's rapid progress through technological might in aerodynamics.

Behind and flanking these figures, and representing space, are the continents of North and South America. Upon the continents the signs of the zodiac, symbolic of time, are superimposed. Directly beneath this group is the peregrine falcon, the fastest bird on earth, allegorical of speed. Below the falcon are double-decked, multiengine transport planes with twice the speed and double the range of any plane in existence prior to 1946. In the upper right and left corners are fanciful concepts of mankind's efforts to fly, from Leonardo da Vinci's imaginary flight machine to enormous balloons with huge boatlike gondolas. In the bottom center, an enormous silver airplane, symbolic of the great silver fleets, is propelled toward the viewers, confronting them with man's achievements and a vision of the future. Henry Hudson's ship *Half Moon* is depicted in the lower left corner and ties the central mural with the south-wall mural. This was the ship aboard which Hudson discovered the river that bears his name.

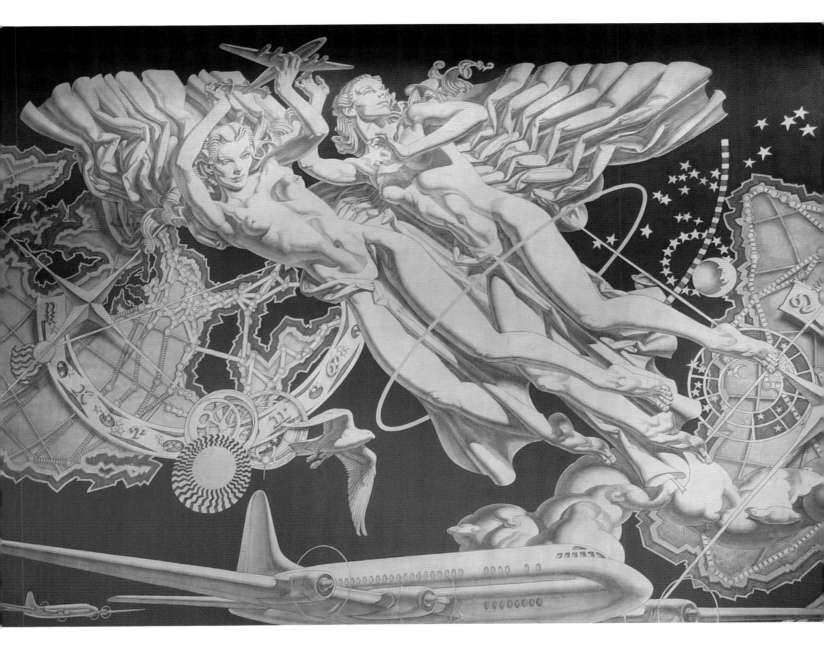

Detail of the central (west-wall) mural of The Story of Transportation at 10 Rockefeller Plaza. Dominating the scene are two silver goddesses that symbolize "New World Unity." They are encircled by a thin gold band as they glide through the skies uniting the world through air travel. A huge silver plane dominates the lower edge of the mural.

In the south-wall mural, Cornwell depicted the story of Day Flight as represented by another heroic-size female figure. She, too, is a silver goddess. This gleaming figure glides above the historic scenes and speeds through space as she grasps the sun in her hands.

In the surrounding montage is a horse-drawn trolley car, the steamboat *Mary Powell*, the pioneer locomotive *Lafayette*, and a physician's horse and buggy. There is a Conestoga wagon (a prairie schooner) used by pioneers in the westward migration and a pony express rider representing the men who rode the mail run to California in the days of the Gold Rush. There is a crowded dock scene filled with people waiting to board a sailing ship for a sea journey.

In all three murals these background settings serve as stark contrasts to the foreground, where, at the top, the goddesses reign and, below, the airplane represents America's air power and prospects. Air travel breaks the barriers of time and space.

The south-wall mural portrays the rapid evolution of the airplane from the Wright brothers and the Curtiss flying machines up through the years of pioneer mail and cargo planes. In the lower foreground, each model grows larger and more imposing until the time line arrives at the 1940s, symbolized by an airplane from the great silver flee—a huge four-engine Constellation Silverliner.

The north- and south-wall murals are painted with the action facing and moving toward the central mural, where the culmination of air travel is to be found.

The Story of Transportation was Cornwell's premier opportunity to create a large-scale work in a major urban location. The mural is not an orderly interpretation of history: It is meant to encapsulate optimism and celebrate man's scientific achievements. It is a brilliant series of nonchronological scenes that mingle fact with fantasy while highlighting the permutations and inevitable advancement of transportation. Cornwell excluded any negative images that might attest to the efforts that went into the achievement of these immense commercial developments. There are no failures in his view, only triumphs. Historical vignettes form the backdrop of the panels. Innovative, modern themes powerfully erupt in the foreground, becoming the most salient. Idealism and air travel predominate. The work is symbolic of world unity through America's coming of age with the airplane.

Although the murals promote a commercial enterprise—air transportation—and are specific to a precise date in time, there is a power, verve, and an ageless modernism to them that has seldom been matched in a business setting.

The head of the silver Goddess of Day Flight in the south-wall mural of The Story of Transportation at 10 Rockefeller Plaza. She grasps the sun above her head with its rays streaming passed her. Her eyes are focused on the skies above.

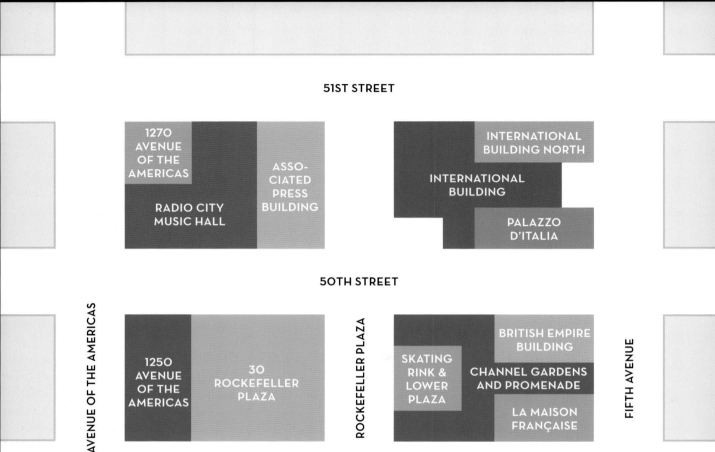

ROCKEFELLER CENTER

51ST STREET

1270
AVENUE
OF THE
AMERICAS

ASSO-
CIATED
PRESS
BUILDING

RADIO CITY
MUSIC HALL

INTERNATIONAL
BUILDING NORTH

INTERNATIONAL
BUILDING

PALAZZO
D'ITALIA

50TH STREET

AVENUE OF THE AMERICAS

1250
AVENUE
OF THE
AMERICAS

30
ROCKEFELLER
PLAZA

ROCKEFELLER PLAZA

SKATING
RINK &
LOWER
PLAZA

BRITISH EMPIRE
BUILDING

CHANNEL GARDENS
AND PROMENADE

LA MAISON
FRANÇAISE

FIFTH AVENUE

49TH STREET

10
ROCKEFELLER
PLAZA

ONE ROCKEFELLER PLAZA

48TH STREET

ACKNOWLEDGMENTS

The idea for this book originated when my company, Roussel Studios, was commissioned to restore works of art in Rockefeller Center. As we worked on various pieces, we researched and documented each one and the artist who created it. Many knowledgeable people provided immeasurable help in the research and preparation of those restorations and, ultimately, this book. It is a pleasure to recognize their efforts and encouragement and express my gratitude.

At the very beginning I enlisted the help of my daughter, Dianne Roussel, an artist and designer. Her devotion to the project, design skills, and intuitive photoediting were essential to its creation. I have also been fortunate to have had the support and encouragement of members of the Rockefeller family. I owe a fundamental debt to Vice President Nelson Rockefeller, whose enthusiasm for art was contagious and who, during the 1970s, shared his love of the Center with me. In recent years, generous behind-the-scene support and unique recollections were graciously offered by Laurance Rockefeller. David Rockefeller was a motivating force. Happy Rockefeller's enthusiasm was inspiring. It is a pleasure to acknowledge the contributions of two individuals at the Rockefeller family offices who were immensely helpful. Clayton W. Frye, Jr., provided unflagging support and wholehearted encouragement to the project. Peter Johnson willingly shared his wise counsel and considerable knowledge of the Center with me. The managing director of Rockefeller Center Tishman Speyer Properties, Tom Madden, generously arranged access to the Center. Glenn Mahoney, director of special events, and his staff, were exceptionally accommodating during photographic sessions. Sincere thanks to Sandra Manley, assistant vice president of corporate communications of the Rockefeller Group, for being so supportive and responsive to my inquiries. Radio City Entertainment graciously provided access to Radio City Music Hall, where Jennifer Katz, a guide, enthusiastically helped track down elusive art. Numerous other people at the Center have contributed time and energy. Maintenance staff, security guards, receptionists, and local police kindly and capably facilitated the documentation.

From its inception in 1929, the Center was continually photographed and documented. These valuable resources are preserved in the Rockefeller Center Archive Center under the care of its director, James V. Reed. I am grateful to him for access to these historic files, his expert guidance and willingness to share his unparalleled knowledge of the Center. Many new photographs are included in this book. Roger Leo's superb photographs must be singled out. They brilliantly capture the colors and excitement of the Center at Christmastime. Louise Meiere Dunn cordially permitted me access to her mother's work. I am grateful to Darwin Stapleton, executive director, and Tom Rosenbaum, chief archivist, who graciously assisted me at the Rockefeller Archive in Pocantico Hills. Special mention has to be made of another indispensable resource, the Smithsonian Archives of American Art. I am indebted to additional family members and other skilled individuals who assisted in the preparation of this book. Marc-Christian Roussel contributed his impressive conservation background, photographic talent, and hands-on knowledge of Rockefeller Center art. Elizabeth Roussel helped plan and improve the format. Sara Bixler deftly copyedited my preliminary manuscript. Christine Marie Colette Roussel was an erudite interpreter of biblical quotations and symbols. Ben Leo solved baffling computer glitches ensuring the work flow. Mary Babcock meticulously copyedited and contributed constructive suggestions to the final manuscript. Robert L. Wiser, with seemingly elegant ease, designed a book that fulfills my vision.

Without Robert Lescher, my literary agent and a most generous man, none of this would have happened. His selfless manner and relaxed presence were essential during the long and frequently bewildering process of research and writing. Lastly, it is a privilege to acknowledge James L. Mairs, senior editor at W. W. Norton. He skillfully guided the book through every phase of planning and production and his knowledge of art and architecture was invaluable. It has been a great pleasure working with him.

Writing this book, with all of you supporting me, has made these past three years worthwhile. Thank you all so very much.

ENDNOTES

PREFACE

1. *The Last Rivet*, Columbia University Press, New York, 1940, p. 17.
2. Rockefeller Center, Report No. 69, May 16, 1932, p. 5, Rockefeller Center Archive Center, New York (hereafter RCAC).

INTRODUCTION

1. Rockefeller Center, Report No. 60, April 5, 1932, p. 1, RCAC.
2. Correspondence between Todd & Brown and Edward Waldo Forbes, Esq., February 2, 1932, RCAC.
3. Rockefeller Center, Public Relations Department, Theme for Decorative Work, May 1932, RCAC.
4. Rockefeller Center, Report No. 60, p. 3.

1270 AVENUE OF THE AMERICAS

1. *The Last Rivet*, Columbia University Press, New York, 1940, pp. 17–18.
2. Rockefeller Center, Press Release re: Robert Kushner, April 4, 1991, RCAC.

RADIO CITY MUSIC HALL

1. Rockefeller Center, Public Relations Release No. 88, File: Press Releases, September 3, 1932, RCAC.
2. Rockefeller Center, Public Relations Release No. 89, File: Press Releases, October 4, 1932, RCAC.
3. Correspondence from Ezra Winter to Rockefeller Center, April 12, 1932, File: Artists, Folder: Ezra Winter, RCAC.
4. Rockefeller Center, Press Release No. 46, April 19, 1932, File: Public Relations, Folder: no title, RCAC.
5. Rockefeller Center, Public Relations Department, Departmental Memo, "The Art Program of Rockefeller Center and Its Contributing Artists," written and compiled by Maria Lombard, ca. 1935, p. #9, File: Public Relations, RCAC.
6. Rockefeller Center, Public Relations Release No. 89, October 4, 1932, File: Press Releases, RCAC.

30 ROCKEFELLER PLAZA

1. Letter to Edward Trumbull from Metropolitan Square Corporation, signed by John R. Todd, James M. Todd, Webster B. Todd, Joseph O. Brown, January 21, 1931, File: Cats and Dogs, Folder: no title, RCAC.
2. Letter from Lee Lawrie to John Todd, 1934 File: Cats and Dogs, RCAC.
3. Metropolitan Square Corporation, Publicity Department, Report No. 40, 1932, p. 2, RCAC.
4. Purchase Order M-889 for Building No. 5 from Rockefeller Center, Inc. to Mr. Leon V. Solon, May 26, 1937, File: Cats and Dogs, Folder: Schley, RCAC.
5. Bid from Rambusch Decorating Company to Reinhard & Hofmeister, Architects, May 11, 1936, File: Cats and Dogs, Folder: Schley, RCAC.
6. Memo, n.d., File: Cats and Dogs, Folder: Schley, RCAC.

7. Ibid.
8. Letter from the Metropolitan Square Corporation to Edward Trumbull, January 21, 1931, File: Cats and Dogs, Folder: Schley, RCAC.
9. Ibid.
10. Letter from Todd & Brown, Inc. to Edward Trumbull, Esq., March 25, 1932, File: Cats and Dogs, Folder: Schley, RCAC.
11. Letter from Reinhard & Hofmeister; Corbett, Harrison & Mac Murray; Hood & Fouilhoux Architects to Mr. Webster Todd, signed Ed. Trumbull, January 27, 1933, File: Cats and Dogs, Folder: Schley, RCAC.
12. "Rockefeller Center, Public Relations Release, "Re Painting in Great Hall of No.1 Building Rockefeller Center," September 30, 1932, File: Cats and Dogs, RCAC.
13. *Diego Rivera's Mural at Rockefeller Center* by Irene Herner de Larrea. Edicupes S.A. & C.V., Mexico City, 1990, p. 82. Attributed to "Rockefellers Ban Lenin in RCA Mural and Dismiss Rivera," *New York Times*. April 10, 1933, Article 10.
14. Ibid., p. 32. Attributed to Alfredo Cardona Pena, *El Monstruo en su Laberinto* [Conversations with Diego Rivera]. Edit. Diana, Mexico, 1980, p. 36.
15. Letter from Nelson A. Rockefeller to Diego Rivera, May 4, 1933, File: Diego Rivera, RCAC.
16. Letter from Diego Rivera to Nelson Rockefeller, May 6, 1933, File: Diego Rivera, RCAC.
17. Release issued by Rockefeller Center, for Immediate Release No. 393, February 12, 1934, File: Diego Rivera, RCAC.
18. Letter from Mr. John R. Todd to Mr. H. M. Schley, October 1, 1935, File: Cats and Dogs, Folder: Schley, RCAC.
19. Handwritten notes taken at a meeting in the architect's office at 2:30 p.m., September 2, 1936, under the section titled Wailing Wall. File: Cats and Dogs, Folder: Schley, RCAC.
20. Rockefeller Center, public relations release, "The Rockefeller Center Decorative Program," no date (ca. 1933), no reference number, File: Public Relations, RCAC.
21. Letter from Frank Brangwyn to H. Schley, August 1934, File: Cats and Dogs, RCAC.
22. Letter from H. E. Winlock to Webster Todd, May 9, 1932, File: Cats and Dogs, RCAC.
23. Extracts from the *Daily Mail*, "Quest for the Perfect Woman," November 3, 1932, and "Eves Ring Up Mr. Brangwyn," November 12, 1932, File: Cats and Dogs, RCAC.
24. Letter from Frank Brangwyn to John Todd, November 19, 1933, File: Cats and Dogs, RCAC.
25. Memo from W. B. Todd to J. R. Todd, October 5, 1933, File: Cats and Dogs, RCAC.

1250 AVENUE OF THE AMERICAS

1. "Competition for mosaic on Radio Corporation Building by Barry Faulkner," File document attached to letter dated June 14, 1932, File: Artists, Folder: Faulkner, RCAC.
2. Rockefeller Center, Press Release No. 113, February 17, 1933, File: Artists, Folder: Faulkner, RCAC.
3. *Gaston Lachaise Retrospective Exhibition* (catalogue), January 30–March 7, 1933, Museum of Modern Art, New York, 1935, pp. 14–15.

4. Memo titled "A CRITICISM OF THE SCULPTURED PANELS BY GASTON LACHAISE," signed by Walter H. Kilham, Jr. cc: Prof. Forbes, J.R. Todd, Webster Todd, Mr. Trumbull, Mr. Kilham, ca. September 1932, File: Lachaise, RCAC.
5. Letter from Fiske Kimball signed (Sdge.), October 15, 1932, File: Lachaise, RCAC.
6. Letter from H. E. Winlock to Harvey W. Corbett, Esq. Messrs. Reinhard & Hofmeister, Corbett, Harrison & Mac Murray, Hood & Fouilhoux, October 14, 1932, File: Lachaise, RCAC.

THE BRITISH EMPIRE BUILDING

1. Letter from John D. Rockefeller Jr. to the Rt. Hon. Lord Southborough, November 4, 1931, File: British Empire Building, RCAC.
2. Correspondence from C. P. Jennewein to Todd & Brown, January 19, 1932, File: Jennewein, RCAC.
3. Correspondence from Todd & Brown to C. P. Jennewein, May 26, 1933, File: Jennewein, RCAC.
4. Rockefeller Center, Press Release, no date, no reference number, File: Artists, Folder: Jennewein, RCAC.

LA MAISON FRANÇAISE

1. *Source for All telegrams are in* File: Cats and Dogs, Folder: Schley, RCAC.

THE CHANNEL GARDENS AND PROMENADE

1. Memo to Reinhard & Hofmeister from H. McA. Schley, August 26, 1935, File: Cats and Dogs, Folder: Schley, RCAC.
2. Rockefeller Center, Press Release No. 848A, May 4, 1935, File: Press Releases, RCAC.
3. Memorandum from meeting of architects and engineers, November 1, 1933, p. 2, Item 14, File: Cats and Dogs, Folder: Schley, RCAC.
4. Correspondence from L. Andrew Reinhard to Mr. John R. Todd, July 5, 1934, File: Cats and Dogs, Folder: Schley, RCAC.
5. Correspondence from Mr. John R. Todd to L. Andrew Reinhard, July 11, 1934, File: Cats and Dogs, Folder: Schley, RCAC.

THE LOWER PLAZA

1. Rockefeller Center interoffice memo to Mr. Crowell from Mr. Benjamin, "Paul Manship's Composition," January 4, 1933, File: Manship, RCAC.
2. Rockefeller Center, Release No. 383, July 2, 1959, File: Public Relations Releases, RCAC.
3. *Rockefeller Center Weekly*, October 25, 1934, p. 6.
4. Transcript of tape-recorded interview with Paul Manship at his studio on 901 Broadway, New York, NY, by James D. Morse, February 18, 1959, p. 2, Archives of American Art, Smithsonian Institute, Washington, D.C.
5. Ibid., pp. 1–2.

PALAZZO D'ITALIA

1. Memo signed by John Todd, June 20, 1935, File: Cats and Dogs, RCAC.
2. Rockefeller Center, Release No. 4380 March 29, 1965, File: Manzu, RCAC.

THE INTERNATIONAL BUILDING

1. Rockefeller Center, memo, undated (it references the minutes of the January 16, 1936, planning committee meeting), File: Lawrie, RCAC.
2. Correspondence from Todd & Brown to Roman Bronze Company, June 19, 1936, File: Lawrie, RCAC.
3. Memo from Ernst L. Smith to Mr. J. O. Brown (Todd & Brown), July 1, 1936, File: Lawrie, RCAC.
4. Letter to Mr. H. McA. Schley, Rockefeller Center, Inc., from Lee Lawrie, June 7, 1937, File: Lawrie, RCAC.
5. Rockefeller Center, Release dated September 12 (no year), File: Lawrie, RCAC.
6. Letter from Lee Lawrie to Messrs. Reinhard and Hofmeister, Corbett, Harrison and Mac Murray, Hood & Fouilhoux, October 19, 1935, File: Lawrie, RCAC.
7. Letter from Lee Lawrie to Messrs. Reinhard and Hofmeister, Corbett, Harrison and Mac Murry, Hood & Fouilhoux, October 16, 1935, File: Lawrie, RCAC.
8. Rockefeller Center, For Release Sunday Morning, September 12 (no year), File: Lawrie, RCAC.
9. Correspondence from H. McA. Schley to Nelson Rockefeller, June 16, 1937, File: Cats and Dogs, Folder: Schley, RCAC.

THE INTERNATIONAL BUILDING NORTH

1. Rockefeller Center, P.R. Release, "The Art Program of Rockefeller Center and Its Contributing Artists," revised September 1972, p. 8. File: Public Relations, RCAC.
2. Rockefeller Center, Release, For Release Wednesday July 3rd, 1935, File: Piccirilli, RCAC.

ONE ROCKEFELLER PLAZA

1. Correspondence from John R. Todd to Reinhard & Hofmeister, July 9, 1936, File: Cats and Dogs, Folder: Schley, RCAC.
2. The Story of *Rockefeller Center from Facts to Fine Art*. Rockefeller Group, New York, revised 1987, p. 33.
3. Ralph Holmes, "Cranbrook Sculptor Sues On Adam, Eve in Radio City," *Free Press* [Detroit], March 25, 1934.
4. Correspondence from Carl Milles to Todd & Brown, Inc., Copy to Mr. Nelson Rockefeller, September 25, 1933, File: Milles, RCAC.
5. Rockefeller Center, Inc. memo from Schley, September 25, 1933, File: Cats and Dogs, Folder: Schley, RCAC.

THE ASSOCIATED PRESS BUILDING

1. Correspondence from Noguchi to Mr. H. McA. Schley, February 8, 1940, File: Noguchi, RCAC.
2. Correspondence from H. H. Harris to Mr. H. McA. Schley, February 17, 1940, File: Noguchi, RCAC.

10 ROCKEFELLER PLAZA

1. I am indebted to Elinore Leo for her personal reminiscences of the Rickenbackers.
2. Rockefeller Center, Release No. 3127, Copy of remarks by Laurance Rockefeller made in accepting the Dean Corwell mural for the Center, May 28, 1946, File: Cornwell, RCAC.
3. AP Night Lead, May 28, 1946, File: Cornwell, RCAC.
4. Eastern Air Lines News Bureau Release No. 3128, "Murals Dedicated in Eastern Air Lines Building Depict Unification of Continents By Air Travel," May 28, 1946, p. 3, File: Cornwell, RCAC.

ARTISTS AND SPECIFICATIONS OF THEIR WORKS

OSCAR BRUNO BACH (1884–1957): Sculptor, designer, metalurgist.

Oscar Bach studied at the Berlin Royal Art Academy and then immigrated to England and to the United States in 1913. He developed a corrosion-resistant process for ferrous metals, and maintained his own laboratory and business. Well known for his enamel work and metal repousse applications for large exterior plaques, his art can be found at the Empire State Building, Riverside Church, and Yale University.

Work: Collaborated with Hildreth Meiere on Radio City Music Hall

HENRY BILLINGS (1901–1985): Painter.

Henry Billing's artwork can be found at the Whitney Museum of American Art in New York City and the William Allen White Library at Emporia State University (formerly Kansas State Teachers College) in Emporia, Kansas.

Title: *Crouching Panther*
Type: mural
Subject: panther
Installed: 1932
Medium: oil paint on canvas
Fabricator: artist
Measurements: 10 feet wide, 5 feet high
Location: third-floor ladies' powder room, Radio City Music Hall

LOUIS BOUCHE (1896–1969): Easel painter, muralist.

Louis Bouche studied at the École de la Grande Chaumiere and Beaux-Arts in Paris. He received a Guggenheim Fellowship in 1933 and taught at the Art Students League in New York from 1934 to 1969. He also served as director of the Belle Maisons Gallery. Shortly after completing his work at Radio City Music Hall, he had the first of many exhibitions of his easel art at the Kraushaar Gallery in New York. He was actively painting and teaching until his death in 1969. Bouche's art can be seen at the Metropolitan Museum of Art and the Whitney Museum of American Art, New York City; the Eisenhower Foundation Building, Abilene, Kansas; and the Department of the Interior, Washington, D.C. His work, was exhibited in 1970 at the American Academy of Arts and Letters.

Title: *The Phantasmagoria of the Theater*
Type: murals
Subject: five vignettes from the theater
Installed: 1932
Medium: paint on Permatex
Fabricator: artist on site
Measurements: vary
Location: Grand Lounge, Radio City Music Hall

FRANK BRANGWYN (1867–1956): Easel painter, muralist, printmaker, designer, illustrator.

Frank Brangwyn was born in Belgium of Welsh and English parents. His first work was exhibited at age eighteen by the British Royal Academy. He designed furniture, ceramics, fabrics, prints, and posters, and decorated the Royal Exchange in London. In 1952 he became the first living artist to have a one-man show at the Royal Academy.

Title: *Man in Search for Eternal Truth*
Type: murals
Installed: 1933
Subject: four views of mankind's destiny
Medium: paint on canvas
Fabricator: artist
Measurements: each 25 feet high by 17 feet wide
Location: south corridor lobby, 30 Rockefeller Plaza
Subtitles and locations:
 Man the Creator: fifth elevator bank from lobby
 Man Labouring: fourth elevator bank from lobby
 Man the Master: third elevator bank from lobby
 Sermon on the Mount: second elevator bank from lobby

CARTIER SILVERSMITHS

Title: *Le Point d' Interrogation*, or *The Question Mark*
Type: precision model
Subject: replica of airplane
Installed: 1933
Medium: silver and enamel
Fabricator: Cartier Silversmiths, Paris
Measurements: 48 inches from wingtip to wingtip; 28 inches long; 10½ inches high
Gift of: government of the Republic of France
Location: lobby, La Maison Française

RENE CHAMBELLAN (1893–1955): Sculptor, model maker.

Born in New Jersey, Rene Chambellan attended New York University from 1912 to 1914 and the Beaux-Arts Institute of Design from 1914 to 1917. He then traveled to Paris to study at the École Julien from 1918 to 1919. He served in the U.S. Army in France during the First World War. Chambellan was an architectural modeler and sculptor from the time he was nineteen years old. From the 1920s on he was an established architectural sculptor, attracting numerous public and private commissions. His work includes ornamentation for the Criminal Courts Building, New York City; architectural decoration for the King's County Hospital, Queens, New York; the North Corona Gate for the 1939 World's Fair; Metropolitan Museum of Art, New York; Attorney General's Office, Washington, D.C.; and four panels in the Chanin Building, New York. He was a member of the National Society of Mural Painters.

Title: Qualities That Spurred Mankind
Type: sculpture (fountainheads)
Subject: six mythological figures on fanciful fish
Installed: ca. 1935
Medium: cast bronze
Foundry: Roman Bronze Works, Long Island City, NY
Measurements: each 3 feet high
Location: reflecting pools in the Channel Gardens
Subtitles, locations (from Fifth Avenue to skating rink), and subjects:
 Leadership: Pool 1, Triton with conch riding a fanciful fish
 Will: Pool 2, Nereid riding a sea creature
 Thought: Pool 3, Nereid riding sidesaddle on a shark
 Imagination: Pool 4, Nereid riding a dolphin-like creature
 Energy: Pool 5, Triton riding a dolphin-like creature
 Alertness: Pool 6, Triton riding a sea creature

Title: coats of arms of the British Isles
Type: carved panels
Subject: four heraldic shields
Installed: 1933
Medium: limestone and polychrome paint
Location: sixth-floor façade, British Empire Building
Subtitles and subjects:
 Wales: griffin and heraldic plumes
 England: lion and Tudor rose
 Scotland: unicorn and thistle
 Ireland: harp Hart, and shamrock

Title: *Pageant of French History*
Type: carved panels
Subject: four shields
Installed: 1934
Medium: limestone
Location: sixth-floor façade, French building
Subtitles and subjects:
 Rise of Charlemagne: sword and *S.P.O.R.*
 Unification of New France: clustered spears and fleur-de-lis
 Absolute Monarchy: two shields with fleur-de-lis, crown, and *L'Etat, c'est moi*
 Birth of Republic: Phrygian cap, laurel crown, *Liberté, Equalité, Fraternité*, and *RF*

Title: *Acts from Vaudeville*
Type: plaques
Subject: six vaudeville acts
Installed: 1932
Medium: cast brass
Location: over Avenue of Americas entrance, Radio City Music Hall
Subtitles and subjects (from north to south):
 Russian: five musicians and a gypsy dancer
 Negro: two musicians and a tap dancer
 German: two musicians and a cat
 American: five Rockettes
 French: two musicians and a dog
 Jewish: one musician and a dancer

Title: *Scenes from Theater*
Type: bas-reliefs (sixty-six casts)
Subject: twelve scenes from theater acts
Installed: ca. 1932
Medium: cast bronze on stainless-steel doors
Measurements: each plaque 15 inches square
Location: auditorium doors, Radio City Music Hall

Descriptions: Two seals and a woman with a sword
Tamborine and guitar players
Two clowns and a drum
Two dancers
Two oriental sword fighters
Lyre player and dancer
Two dancers
Lion tamer and two lions
Flute player and snake dancer
Clown and juggler
Dogs through a hoop and jester
Two spanish dancers

Title: *Musicians*
Type: low-relief plaques
Subject: eight musicians and their instruments (flutist, guitarist, tambourine player)
Installed: 1932
Medium: cast metal
Measurements: 15 inches high, 8 inches wide
Location: elevator doors, main lobby, Radio City Music Hall

VALERIE CLAREBOUT (dates unknown): Sculptor.

Born in Farncombe, Surrey, England, Valerie Clarebout studied at the Royal Academy in London and, in 1934, at the *Atelier Julien* in Paris. In 1937, she moved to Buenos Aires. She returned to England in 1942 and served as a volunteer in the Air Defense. She then returned to Buenos Aires and studied painting. In 1949 she moved to France and in the early 1950s to the United States, where she continued to work as a sculptor.

Title: *Angels*
Type: sculpture
Subject: Christmas angels
Installed: 1954
Medium: painted wire and brass
Fabricator: artist
Measurements: 8-feet-high figure with a 6-foot-long trumpet
Location: Channel Gardens (installed for Christmas holidays)

DEAN CORNWELL (1892–1960): Painter, muralist, illustrator.

Dean Cornwell studied at the Art Institute of Chicago. His work was exhibited at the National Academy of Design in New York; Royal Academy of London, England; Whitney Museum, New York; and Los Angeles Public Library, California. He created two gold and silver leaf murals for the General Motors Building for the 1939 World's Fair in New York. His illustrations appeared in leading magazines. Cornwell was awarded the gold medal by the Architectural League of New York. He illustrated *The Robe* and *The Big Fisherman* by Lloyd Douglas.

Title: *The Story of Transportation*
Type: mural
Subject: modes of travel depicted in 3 parts
Installed: May 1946
Media: paint, gold and silver leaf on canvas
Fabricators: artist and assistants on site
Measurements: center mural 54 feet wide, 20 feet high; side murals 45 feet wide, 20 feet high
Location: lobby, 10 Rockefeller Plaza

STUART DAVIS (1894–1964): Painter.

Stuart Davis studied at the Henri School of Art in New York City and taught at the Art Student's League in New York. His works have been exhibited at the 1939 World's Fair Communications Building; Indiana University; University of Georgia; Museum of Modern Art, New York; and Whitney Museum of American Art, New York. In the 1930s he became a member of the Easel Painters Project as part of the Works Progress Administration.

Title: *Men without Women*
Type: mural
Subject: masculine symbols of the 1930s
Installed: 1932; removed April 1975; reinstalled 1999 (on loan from MOMA)
Measurements: 128 inches high, 205 inches wide
Medium: oil on canvas
Fabricator: artist
Location: men's lounge off Grand Lobby, Radio City Music Hall

DONALD DESKEY (1894–1989): Interior designer, industrial designer.

Donald Deskey was born in Blue Earth, Minnesota. He studied at the University of Chicago and the Art Institute of Chicago, as well as at École de la Grande Chaumiere in Paris. His work has been exhibited at the Metropolitan Museum of Art, Brooklyn Museum of Art, and Newark Museum in New Jersey.

Title: *Nicotine*
Type: wallpaper
Subject: masculine themes
Installed: 1932
Media: paint on aluminum foil
Location: men's lounge, second mezzanine, Radio City Music Hall

BARRY FAULKNER (1881–1966): Muralist.

Born in Keene, New Hampshire, Barry Faulkner studied at the American Academy in Rome. His work has been exhibited at the National Archives, Washington, D.C.; State Capitol, Salem, Oregon; State House, Concord, New Hampshire; and the American Academy, Rome.

Title: *Intelligence Awakening Mankind*
Type: mosaic
Subject: man's attributes and ignorance
Installed: 1933
Medium: glass tesserae
Measurements: 79 feet long, 14 feet high
Fabricator: Ravenna Mosaic Works, Long Island City, NY
Location: loggia, 1250 Avenue of Americas

ABE FEDER (1910–1997): Lighting designer, architectural illumination specialist.

Abe Feder studied architecture at the Carnegie Institute in Pittsburgh. He designed lighting for the following Broadway shows: *The Boy Friend, My Fair Lady, Camelot,* and *On a Clear Day You Can See Forever.* He designed the exterior illumination for St. Patrick's Cathedral, the Empire State Building, and the Bronx Zoo in New York City; John F. Kennedy Center for the Performing Arts in Washington, D.C.; and the National Museum in Jerusalem.

Exterior illumination: façade, 30 Rockefeller Center; *Prometheus* fountain

Interior illumination: lobby murals, 30 Rockefeller Center

LEO FRIEDLANDER (1890–1966): Sculptor.

Leo Friedlander studied at the École de Beaux-Arts in Brussels and Paris and then became a Fellow at the American Academy in Rome. His works include the Washington Memorial Arch in Valley Forge, Pennsylvania, and the heads of Beethoven and Bach at the Eastman School of Music in Rochester, New York. He was awarded the Prix de Rome in 1913.

Title: *Transmission*
Type: carved pylons (two sets, each containing two pylons)
Subject: communication
Installed: ca. 1934
Media: limestone
Measurements: each 15 feet high, 10 inches wide
Subtitle and location:
Television: Forty-ninth Street entrance, 30 Rockefeller Plaza
Radio: Fiftieth Street entrance, 30 Rockefeller Plaza

ROBERT GARRISON (1895–1946): Sculptor.

Robert Garrison studied with Gutzon Borglum. His works include the frieze for the Midland Savings and Trust Company in Denver, Colorado, and a fountain for King's County Hospital in Brooklyn, New York. He was a consulting sculptor for Riverside Church in New York City. Garrison was awarded the gold medal at the Oklahoma State Fair in 1913.

Title: *Morning, Present, Evening*
Type: carved panels
Subjects: three allegories of man's knowledge and communication
Installed: 1930
Media: limestone
Measurements: 21 feet long
Location: façade, 1270 Avenue of the Americas

WITOLD GORDON (1898–1947): Illustrator, designer, muralist, easel painter.

Witold Gordon was a multitalented artist who studied in Paris and worked as an illustrator, cartoonist, painter, and designer. His work in illustration includes a series of thirty-two block prints for the *The Travels of Marco Polo,* edited by Manuel Kromroff. In the late 1920s he designed an Art Deco–styled harp with the famous harpist Carlos Salzedo. At the 1939 World's Fair, he exhibited the book *Cinderella Married,* which he illustrated. He was the costume designer for the Metropolitan Opera in New York City.

Title: *Continents*
Type: mural
Subject: stylized maps
Installed: 1932
Medium: oil paint on canvas
Fabricator: artist on site
Measurements: vary
Location: men's lounge, first mezzanine, Radio City Music Hall

Title: *History of Cosmetics*
Type: mural
Subject: vignettes
Installed: 1932
Medium: oil paint
Fabricator: artist on site
Measurements: vary
Location: ladies' main powder room, Radio City Music Hall

MICHIO IHARA (1928–): Sculptor.

Born in Japan, Michio Ihara studied at the Tokyo University of Fine Arts and then at MIT under a Fulbright grant. He became a Fellow at the Center for Advanced Visual Studies at MIT and received a John D. Rockefeller III grant. Ihara served as artist-in-residence at the Newcastle College of Advanced Education at the University of Newcastle in Australia. His first one-man show was at the Staempfli Gallery in New York City. He received architectural commissions in Japan, New Zealand, and the United States. He works with abstract forms in stainless steel and brass, using light, shadow, and movement as elements. Self-described as an architectural sculptor, Ihara currently lives and works in Massachusetts.

Title: *Sculptures of Light and Movement*
Type: sculpture in ten parts
Subject: abstract
Installed: 1978
Media: stainless-steel wires and gilded stainless-steel leaves
Fabricator: artist in studio and on site
Measurements: each part approx. 35 feet high, 7 feet wide, 2 feet deep
Location: north and south walls, main lobby, International Building

ALFRED JANNIOT (1889–1969): Sculptor, painter.

Alfred Janniot was a member of the French Academy in Rome and awarded the Legion of Honor following the Exposition des Arts Decoratifs in 1926 for the importance of his work to French prestige and the economy. His most famous sculptural works in France are *Tapestry in Stone* at the Oceanographic Museum in Paris and a memorial to the war dead in Nice.

Title: *Friendship between America and France*
Type: bas-relief
Installed: 1934
Subject: allegory of French-American relationship
Media: gilded bronze
Measurements: 18 feet high, 11 feet wide
Marked: C. P. Jennewein/ c / 1933
Foundry: Gorham Company, Providence, RI
Location: over 610 Fifth Avenue entrance, La Maison Française

Title: *The Torch of Freedom*
Type: cartouche
Subject: symbol of France
Installed: June 1934
Medium: polychrome-painted limestone
Measurements: 10 feet high
Location: over 610 Fifth Avenue entrance, La Maison Française

CARL PAUL JENNWEIN (1890–1978): Sculptor.

Carl Paul Jennwein immigrated to the United States in 1907 and became a citizen in 1915. He studied at the Art Students League and became a Prix de Rome scholar. His works can be found at the Brooklyn Central Library in New York, Arlington Memorial Bridge in Washington, D.C., the Metropolitan Museum of Art in New York, the Brookgreen Gardens in South Carolina, and the Tampa Museum of Fine Arts in Florida.

Title: *Industries of the British Empire*
Type: bas-relief
Installed: 1933
Subject: British industries of 1930s

Medium: cast bronze with patina and gilding
Foundry: Gorham Company, Providence, RI
Measurements: 18 feet high, 11 feet wide
Location: over 620 Fifth Avenue entrance, British Empire Building

Title: Cartouche with British coat of arms
Type: bas-relief
Installed: 1933
Subject: British coat of arms and mottos: British royalty and Order of the Garter
Medium: polychrome-painted carved limestone
Stone carved by: Piccirilli Brothers
Measurements: 7 feet high
Location: over 620 Fifth Avenue entrance, British Empire Building

Title: *Industry* and *Agriculture*
Type: carved panels
Installed: 1937
Subject: two allegorical figures
Media: partially gilded carved limestone
Stone carved by: Piccirilli Brothers
Measurements: monumental
Location: flanking entrance to One Rockefeller Plaza

YASHO KUNIYOSHI (1893–1953): Painter, printmaker

Yasho Kuniyoshi studied at the Los Angles School of Art, National Academy of Design, and the Art Students League. His works can be found at the Library of Congress Museum, Art Institute of Chicago, Metropolitan Museum of Art, and Whitney Museum of American Art.

Title: *Exotic Flowers*
Type: mural
Installed: 1932
Subject: decorative motif
Media: oil paint on primed plaster
Fabricator: artist on site; restored in 1998
Location: ladies' powder room, second mezzanine, Radio City Music Hall

ROBERT KUSHNER (1949–): Painter, sculptor.

Born in 1949 in California, Robert Kushner currently resides in New York. Kushner's work can be found in many museums in New York including the Brooklyn Museum, the Metropolitan Museum of Art, the Museum of Modern Art, and the Whitney Museum of American Art. Additional museums collecting his work are the Los Angeles County Museum, California; Nelson-Atkins Museum of Art, Kansas City, Missouri; the Denver Art Museum; and the University of Michigan Museum of Art, Ann Arbor. In 1998, the New Jersey Center for Visual Arts exhibited a survey of his work titled *Robert Kushner: 25 Years of Making Art*.

Title: *Sentinels*
Type: sculpture
Installed: 1991
Subject: three angels
Media: cast bronze
Fabricator: Tallix Morris Singer Foundry, Beacon, NY
Measurements: vary
Location: lobby, 1270 Avenue of the Americas

GASTON LACHAISE (1882–1935): Sculptor.

Gaston Lachaise was born in Paris. His father was a prominent cabinetmaker who designed the Eiffel apartment in the renowned tower in Paris. From an early age, Gaston was his father's protégé, accompanying and assisting him to fulfill his commissions. By the time he was thirteen, Gaston was enrolled in the École Bernard Palissy, which was one of the most elite schools for artist-craftsmen in Europe. Three years later he was granted early admission to the famed Académie National des Beaux-Arts. Between 1900 and 1903 he met and fell deeply in love with a Canadian-American woman named Isabel Dutard Nagle. Both his extraordinary passion for Isabel and the looming conscription into the French army at age twenty-one inspired the young artist to abandon his studies in France and move to Boston. There, he became an assistant to the academic sculptor Henry Hudson Kitson, first in Boston and then in New York. In New York he met Gutzon Borglum and Paul Manship, and was soon Manship's studio assistant. By 1927 he had his first one-man show at the Intimate Gallery and the following year at the Brummer Gallery. Commissions followed and 1930 saw his figure titled *Man* exhibited at the newly opened Museum of Modern Art, whose founding owes much to Abby Aldrich Rockefeller. The commissions he received in 1932 for Rockefeller Center were a result of her admiration and support of his work. In 1935 the Museum of Modern Art gave him a one-man show just eight months before his premature death at age fifty-three from leukemia.

Title: *Aspects of Mankind*
Type: carved panels
Subject: four views of man's progress
Installed: 1933
Medium: carved limestone with gilding
Fabricator: artist on site
Measurements: each panel 11½ feet high, 4 feet wide
Location: 33 feet above sidewalk on façade, 1250 Avenue of the Americas (RCA Building)
Subtitles:
 Gifts of Earth to Mankind
 Genius Seizing the Light of the Sun
 The Conquest of Space
 The Spirit of Progress

Title: *To Commemorate the Workmen of the Center*
Type: carved panels
Installed: 1935
Subject: two tributes to the workers of Rockefeller Center
Medium: limestone
Fabricator: artist on site
Measurements: monumental
Location: façade, 45 Rockefeller Plaza entrance, International Building
Subtitle and subjects:
 Construction: two workers riding a steel beam
 Demolition: worker holds crowbar, another an acetylene torch

ROBERT LAURENT (1890–1970): Sculptor.

Hamilton Easter Field, an American painter, editor, and teacher, was a surrogate father and mentor to Robert Laurent. Both in Europe and in America, Field introduced the young Laurent to various teachers and artists, and soon Laurent joined the group of Modernists working in New York City. His first exhibit was a two-man show he shared with Field at the Daniel Gallery in 1915. After Field's death in 1922 Laurent inherited his estate as well as a summer art school Field had started in Ogunquit, Maine, which Laurent continued to run. Laurent's first one-man show was at the Bourgeois Gallery in New York in 1922. He exhibited direct carvings of three-dimensional forms in wood and various stones. By the late 1920s he was working in cast bronze. He taught at the Art Students League, Vassar and Goucher Colleges, and the art schools at the Corcoran Gallery and the Brooklyn Museum of Art before settling into a permanent position in 1942 as resident sculptor at Indiana University. During the time he was at the Art Students League, he received the commission for *Girl and Goose*, an over-life-size nude, for Radio City Music Hall.

Title: *Girl and Goose*
Type: statue
Subject: female figure with goose
Installed: 1932
Medium: cast aluminum
Measurements: 82 inches high including self-base, on 6-inch-high Bakelite base
Foundry: Roman Bronze Works, Long Island City, New York
Markings: Laurant 1932 (right front edge of top surface of self-base)
Location: first mezzanine, Radio City Music Hall

LEE LAWRIE (1877–1963): Sculptor.

Lee Lawrie studied at Yale University, where he received his BFA and later (in 1932) an honorary MA. He studied with Augustus Saint-Gaudens. Famed as an architectural sculptor, Lawrie's works can be found at the U.S. Military Academy at West Point, New York; St. Thomas Church and Church of St. Vincent Ferrer in New York City; Boys Town, Nebraska; and the Soldiers and Sailors Memorial Bridge in Harrisburg, Pennsylvania.

Title: *Wisdom* with *Sound* and *Light*
Type: bas-reliefs (stone panel and glass screen with two side stone carvings)
Subject: allegory: laws and forces of the universe and communication
Installed: 1933
Media:
 Wisdom above: polychrome-painted and gilded limestone
 Wisdom below: cast glass blocks with gilding
 Sound and Light: polychrome-painted limestone
Measurements: *Wisdom* 15 feet high, 55 feet wide
Produced: Corning Glass Works, Ithaca, NY
Location: main entrance, 30 Rockefeller Plaza

Title: *Atlas*
Type: statue
Installed: January 1937
Subject: mythology
Medium: sand-cast bronze
Measurements: figure 15 feet high; granite pedestal 9 feet high
Weight: 14,000 lb.
Foundry: Roman Bronze Works, Long Island City, NY
Location: main entrance, 630 Fifth Avenue, International Building

Title: *Fleur-de-lis*
Type: intaglio carved panel
Installed: ca. 1937
Subject: decorative reference to France
Media: gilded limestone
Location: façade, 9 West Forty-ninth Street entrance, La Maison Française

Title: *Seeds of Good Citizenship*
Type: carved intaglio panel
Subject: allegorical female figure
Installed: ca. 1937
Medium: gilded limestone
Location: Channel Gardens entrance, La Maison Française façade

Title: *Arms of England*
Type: low relief
Subject: three lions passant
Installed: 1933
Medium: gilded limestone
Location: 10 West Fiftieth Street façade, British Empire Building

Title: *Mercury with Blazing Sun*
Type: intaglio carved panel
Installed: 1933
Subject: messenger of commerce with symbol of sun
Medium: gilded and polychrome-painted limestone
Measurements: 7 feet high, 7 feet wide
Location: Channel Gardens entrance, British Empire Building façade

Title: *Progress*
Type: low relief
Subject: Pegasus (inspiration), eagle (aspiration), woman (divine progress)
Installed: September 1937
Medium: polychrome-painted limestone
Model maker: Alex Mascetti
Fabricator: Piccirilli Brothers
Measurements: approx. 10 feet high, 10 feet wide
Location: 14 West Forty-ninth Street entrance façade, One Rockefeller Plaza

Title: *St. Francis of Assisi with Birds*
Type: intaglio carved panel
Subject: biblical figure
Installed: September 1937
Medium: polychrome-painted and gilded limestone
Model maker: Rene Chambellan
Carver: Rene Chambellan
Original painters: Rambusch Decorating Company
Location: 9 West Fiftieth Street entrance, International Building

Title: *World Peace*
Type: bas-reliefs
Installed: 1937
Media: polychrome-painted and gilded limestone
Model maker: Rene Chambellan
Carver: Piccirilli Brothers
Original painters: Rambusch Decorating Company
Location: 19 West Fiftieth Street, International Building
Subject: Swords into plowshares, with Isaiah II:IV inscription
 boatman unfurling sail
 Woman and Columbia
The screen is divided into the following sections:
 Bottom center: Four figures symbolize the races of mankind—red, yellow, black, white.
 Bottom row sides: A lion symbolizes monarchies; an eagle symbolizes the republics.
 Second row center: A square-rigged ship symbolizes international commerce.
 Second row sides: Smoke stacks symbolize the Industrial Age; a Norman tower represents history.

Third row center: Three figures symbolize endeavors common to all people—art carries a jug, science measures a potion, and industry bears a load of bricks.
Third row sides: The West is symbolized by an Aztec temple; the East by a mosque.
Fourth row center: Mercury the god of trade is depicted.
Fourth row sides: The North is symbolized by a seagull and a whale's fluke; the South by two palm trees.
Top row center: The earth is symbolized by a large clock with radiating golden beams.
Top row sides: Earth's hemispheres are represented by two stylized groups of stars symbolizing the Big Dipper and the Southern Cross.

Title: *The Purpose of the International Building* or *The Story of Man*
Type: architectural screen with clock
Subject: series of fifteen hieroglyphs depicting man's history
Installed: August 1935
Media: polychrome-painted and gilded limestone and metal
Model maker: Rene Chambellan
Measurements: screen 21 feet high, 15 feet wide; clock 6 feet in diameter
Location: 25 West Fiftieth Street entrance, International Building

Title: *Plentitude from International Trade*
Type: low relief
Installed: ca. 1937
Medium: polychrome-painted limestone
Location: 10 West Fifty-first Street, International Building

Title: *Fourteen Heraldic Shields*
Type: low relief
Installed: September 1937
Subject: international symbols
Medium: polychrome-painted and gilded limestone
Location: 20 West Fifty-first Street entrance, International Building

LEO LENTELLI (1879–1961): Sculptor.

Leo Lentelli came to the United States at age twenty-four and was naturalized nine years later. His work can be found in Brookgreen Gardens, South Carolina; the Department of the Interior, Washington, D.C.; the Oakland Museum in California; Sullivan Gateway, Denver, Colorado; Steinway Building, New York; Sixteenth Bridge, Pittsburg, Pennsylvania; National Academy of Design, New York; Cathedral Church of Christ the King, Kalamazoo, Michigan; and the United States General Service Administration, Washington, D.C.

Title: *Four Continents*
Type: bas-reliefs
Subject: symbols representing four continents
Installed: May 1935
Medium: limestone
Fabricator: Piccirilli Brothers
Location: seventh-floor façade above Fifth Avenue, International Building North
Subtitles and Subjects:
 Asia: Buddha and the sacred elephant
 Europe: Neptune
 Africa: African figure
 America: buffalo head, Mayan head, ears of corn

Title: *Roman Civilization*
Type: bas-reliefs
Installed: 1935
Subject: four aspects of Italian history
Medium: limestone
Fabricator: Piccirilli Brothers
Location: seventh-floor spandrels of International Building South façade
Subjects:
 Armor with *S.P.Q.R.* "The Senate and the People of Rome"
 Shield with *MCCCC* (1400)
 Flags with *MORT. O LIBERTA* Death "or Liberty"
 Facies an eagle's head

GWEN LUX (1910–1988): Sculptor, industrial designer, mosaics, pottery.

A member of the Associated American Artists, Gwen Lux designed pottery at Stonelain. Her work included bas-reliefs for the façade of the McGraw-Hill Building in Chicago and a fiberglass sculpture titled: *Four Freedoms* for the first-class dining room of the SS *United States*.

Title: *Eve*
Type: statue
Subject: female figure
Installed: 1932
Medium: cast aluminum
Measurements: figure 68 inches high; Bakelite base 10 inches high
Foundry: Roman Bronze Works, Long Island City, NY
Markings: artist's initials (monogram)
Location: first mezzanine, Radio City Music Hall

PAUL MANSHIP (1885–1966): Sculptor.

Paul Manship's first training was at the St. Paul Institute of Art. By the time he was eighteen, he left school and worked for an engraving company and independently as a designer and illustrator. In 1905 he moved to New York City and became Solon H. Borglum's assistant and then two years later assisted Isidore Konti. In 1909 he won the Prix de Rome and spent the next three years in Rome studying at the American Academy. Upon his return to New York in 1912, he became established and received many commissions, including some for Abby Rockefeller. In 1922 Manship established a studio in Paris, and was a professor of sculpture at the American Academy in Rome during a one-year stay in Rome. Five years later, he returned to New York and completed some of his most famous commissions, including the statue of *Prometheus* at Rockefeller Center and the *Celestial Sphere* in Geneva, Switzerland, until his death in 1944.

Title: *Prometheus*
Type: monumental statue
Subject: mythological Titan
Installed: January 9, 1934
Media: sand-cast bronze, gilded
Measurements: 18 feet high, 8 tons
Foundry: Roman Bronze Works, Long Island City, NY
Markings: artist's signature and date (on mountain)
Location: Lower Plaza/skating rink

Title: *Mankind*
Type: statues
Subjects: youth and maiden
Installed: 1934; reinstalled in 1999
Media: cast bronze; originally gilded, currently brown patina
Measurements: 6 feet high
Foundry: Roman Bronze Works, Long Island City, NY
Location: Channel Gardens staircase to Lower Plaza

GIACOMO MANZU (1908–1994): Sculptor.

Giacomo Manzu studied at the Accademia Cicognini in Verona, Italy. His work includes bronze doors at the Vatican.

Title: *Italia*
Type: high relief
Subject: symbol of harvest in Italy
Installed: May 1965
Media: sand-cast bronze
Measurements: 10 feet 5 inches wide, 15 feet 7 inches high
Foundry: Milan, Italy
Markings: artist's signature
Location: above Fifth Avenue entrance, Palazzo d'Italia

Title: *The Immigrant*
Type: bas-relief
Subject: mother and child
Installed: May 1965; relocated October 1999
Media: sand-cast bronze
Measurements: 3 feet 2 inches wide, 6 feet high
Foundry: Milan, Italy
Location: adjacent to Fiftieth Street entrance, Palazzo d'Italia

HILDRETH MEIERE (1893–1961): Sculptor, painter, ceramist, muralist.

Hildreth Meiere studied in Florence, Italy, and at the Art Students League in New York City. Her work is found in St. Patrick's Cathedral and St. Bartholomew's Church in New York City; the National Academy of Science in Washington, D.C.; the Nebraska State Capitol; and ornamentation in the Capitol in Washington, D.C. She was awarded the Architectural League gold medal for mural decoration in 1928.

Title: *Dance, Drama, Song*
Type: three plaques
Subject: representations of the theater
Installed: 1932
Media: cast aluminum, brass, chrome nickel steel, and vitreous enamel
Measurements: each medallion approx. 20 feet in diameter
Fabricator: Oscar B. Bach
Location: Fiftieth Street façade, Radio City Music Hall

MARGUERITA MERGENTIME (Unknown—1941): Designer of woven and printed fabrics and textiles.

A pupil of Ilonka Karasz, Marguerita Mergentime exhibited at the Brooklyn Museum of Art and at American Union of Decorative Artists and Craftsmen shows. She designed for Kohn-Hall-Marx Company and Schwartzenbach-Huber.

Type: wall fabric and carpet design
Installed: 1932
Locations: lower level and ladies' lounge, Radio City Music Hall

CARL MILLES (1875–1955): Sculptor.

By 1929, Carl Milles was a professor of art at the Royal Academy of Stockholm and was recognized in Sweden as its leading sculptor. In 1929 he immigrated to the United States, becoming a citizen in 1945. He taught and was director of the Department of Sculpture at the Cranbrook School in Michigan until the early 1950s, when he returned to Sweden and established the Milles Garden, a museum for his own works and collection. The *New York Herald Tribune* (September 19, 1955) called him "one of the world's great modern day sculptors."

Title: *Man and Nature*
Type: three-part sculpture
Subject: allegorical
Installed: February 1941
Media: northern Michigan pine planks laminated, carved and stained
Measurements: central unit 11 feet 6 inches high
Fabricator: studio of the artist at Cranbrook
Location: lobby, One Rockefeller Plaza

ISAMU NOGUCHI (1904–1988): Sculptor, theatrical and industrial designer.

From age two, Noguchi spent his childhood in Japan; his father was a Japanese poet and his mother an American writer and teacher. As a teenager he was sent back to the United States, where he was born, to attend high school. By the time he was eighteen, he was apprenticed briefly to Gutzon Borglum, who told him he would never become a sculptor, motivating Noguchi to move to New York City and enroll in medical school at Columbia University. Fortunately, he continued to sculpt part-time, as two years later, in 1924, he had his first one-man show at the Eugene Schoen Gallery. He received a Guggenheim Fellowship in 1927 and went to Paris to study. There he became a studio assistant to Constantin Brancusi and met Alexander Calder. The following years brought trips and studies in places like China and Japan before he settled down in New York again. His artistic interests ranged from ballet sets for Martha Graham to designing playgrounds and furniture as well as sculpture. Throughout his lifetime he worked in a variety of materials including paper, wood, stainless steel, bronze, and illuminated paper constructions. His major, monumental works were created primarily in stone as they were usually destined for exterior sites. These were directly carved by him. In 1956 he designed the gardens at UNESCO in Paris and in 1951, Hiroshima's Peace Park. His work can be found in every major museum in the world. In 1932 his entry titled *News* won the invitational contest for the sculpture to be placed at the Associated Press Building in Rockefeller Center. A small museum in Long Island City, New York, is dedicated to his work. Many of his smaller works can be viewed here and personal papers are to be found in the archives.

Title: *News*
Type: bas-relief
Subject: newsmen
Installed: April 1940
Media: cast in stainless-steel sections
Measurements: 22 feet high, 17 feet wide
Foundry: General Alloys Company, Boston, MA
Markings: artist's signature in lower left corner
Location: over main entrance, 50 Rockefeller Plaza (Associated Press Building)

ATTILIO PICCIRILLI (1868–1945): Sculptor, model maker, stone carver.

After studying at the Academia San Luca in Rome, Attilio Piccirilli immigrated to the United States in 1887 with his parents and six brothers. In 1893 he and his brothers opened an atelier and workshop on 142nd Street in the Mott Haven section of the Bronx. The studio specialized in stone—molding, modeling, and carving for the leading sculptors of the day as well as creating works of their own. Major works in New York City include the Maine Monument at Columbus Circle, the Soldiers' Monument in the Bronx, the Pediment of the New York Stock Exchange, the lions at the main branch of the New York Public Library, and the Firemen's Memorial on Riverside Drive.

Title: *Youth Leading Industry*
Type: bas-relief
Subject: youth and charioteer
Installed: May 1936
Media: cast glass blocks (Pyrex, or "poetic glass") with paint
Measurements: 16 feet high, 10 feet wide, 3 tons
Foundry: Corning Glass Works, Ithaca, NY
Location: over main entrance, 636 Fifth Avenue, International Building North

Title: *Advance Forever Eternal Youth*
Type: bas-relief
Installed: 1935
Subject: young man
Media: cast glass blocks (Pyrex)
Measurements: 16 feet high, 10 feet wide, 3½ to 4 tons
Foundry: Corning Glass Works, Ithaca, NY
Location: over entrance to Palazzo d'Italia; destroyed in 1949

Title: *Commerce and Industry with Caduceus*
Type: bas-relief
Subject: monumental figures flanking the caduceus (symbol of Mercury)
Installed: May 1936
Media: polychrome-painted and gilded limestone
Fabricator: Piccirilli Brothers
Location: over main entrance, International Building North façade

Title: *The Joy of Life*
Type: bas-relief
Installed: September 1937
Subject: seven seminude figures set against a background of stars
Media: polychrome-painted limestone
Fabricator: Piccirilli Brothers
Location: 15 West Forty-eighth Street entrance, One Rockefeller Plaza façade

HENRY VARNUM POOR (1887–): Painter, ceramist, author.

Henry Varnum Poor's works were sold through Belle Maisons Gallery, Montross Gallery, and American Designers Gallery. He created tile murals for Hotel Shelton in New York and completed other private commissions.

Type: lamp bases and vases
Installed: 1933
Media: glazed pottery
Fabricator: artist's studio
Location: throughout Radio City Music Hall (though no work remains there)

RUTH REEVES (1892–1966): Fabric designer, author.

Ruth Reeves studied at Pratt Institute, the San Francisco School of Design, and Académie Moderne in Paris with Fernand Léger, with whom she studied painting. Her flat, geometric style was ideally suited to fabrics and textiles. By 1920 she had earned a reputation for hand-printed textiles and was recognized as a leader in the American modern-design movement. Her work can be found in the Metropolitan Museum of Art, Cooper-Hewitt National Design Museum, Smithsonian Institution, Brooklyn Museum of Art, Cleveland Museum, Chicago Art Institute, and the Victoria and Albert Museum in London. She authored a book on Indian cire perdue, published in 1962.

Title: *History of the Theatre*
Type: wall covering
Subject: theatrical activities
Installed: 1932; remade 1998
Media: hand-blocked linen
Location: rear and side walls, auditorium, Radio City Music Hall

Title: *Musical Instruments*
Type: carpet
Subject: abstract design of instruments
Installed: 1932; remade 1998
Location: Grand Lounge, staircase, and mezzanines

DIEGO RIVERA (1887–1957): Muralist.

Diego Rivera studied at San Carlos Academy. From 1907 he traveled to Europe on scholarship and met and became influenced by Élie Faure, Amedeo Modigliani, the "Blaue Reiter" group, Wassily Kandinsky, Georges Braque, Fernand Léger, and Juan Gris. By 1921 Rivera was back in Mexico and had joined the Communist Party. He painted a mural in the Bolivar Amphitheater and one in the Department of Education. With José Orozco painting in the United States in 1929, Rivera followed in 1930 and had an exhibition in San Francisco and a group show at the Metropolitan Museum of Art in New York City. In 1931 Rivera painted a mural at the California Stock Exchange Club in San Francisco. He returned to Mexico to paint a fresco in the National Palace. Owing to Abby Rockefeller's patronage, Diego returned to New York for an exhibit at the Museum of Modern Art. In 1932 he began work on the Chrysler murals, and in 1933 started his fresco for Rockefeller Center. He was dismissed prior to completion, and the fresco was destroyed. Rivera returned to Mexico and painted a new fresco based on the Rockefeller theme for the destroyed one.

Title: *Man at the Crossroads*
Type: mural
Subject: philosophical mural concerning civilization
Media: fresco
Started: April 1933
Measurements: 63 feet long, 17 feet high
Painter: Rivera and assistants
Location: Grand Lobby, 30 Rockefeller Plaza; no work remains; destroyed in February 1934

JOSÉ MARÍA SERT (1876–1945): Painter, muralist.

José María Sert spent his adult life living in Paris. He was internationally famous as a mural painter and his works can be found in private homes in Argentina, Florida and Spain; the Hôtel de Ville in Paris; the League of Nations in Geneva; and in the Waldorf-Astoria in New York. The murals in the Cathedral of Vich in Catalan, Spain, are considered his masterwork.

Title: *American Progress*
Type: mural
Subject: building American with philosophical men and men of action
Installed: December 1937
Media: oil paint on canvas
Measurements: 41 feet long, 16 feet 7 inches high
Painted: Sert Studio, Paris
Location: east wall, Grand Lobby, 30 Rockefeller Plaza

Title: *Time*
Type: mural
Subject: Titans (Past, Present, and Future) set against a spiral pattern of airplanes in sky
Installed: March 1941
Media: oil paint on canvas
Measurements: 5,000 square feet
Painted: Sert Studio, Paris
Location: ceiling, Grand Lobby, 30 Rockefeller Plaza

Title: *Spirit of Dance*
Type: mural
Subject: figures expressing joy, dance
Installed: March 1941
Media: oil paint on canvas
Measurements: approx. 25 feet high, 17 feet wide
Painted: Sert Studio, Paris
Location: north flanking wall, 30 Rockefeller Plaza

Title: *Communication*
Type: mural
Subject: figures with huge globe
Installed: December 1937
Media: oil paint on canvas
Measurements: approx. 25 feet high, 17 feet wide
Painted: Sert Studio, Paris
Location: south wall, first elevator bank, lobby, 30 Rockefeller Plaza

Title: *Contest 1940*
Type: mural
Subject: five races of mankind struggling with a globe (earth)
Installed: December 1937
Media: oil paint on canvas
Measurements: approx. 25 feet high, 17 feet wide
Painted: Sert Studio, Paris
Location: east wall of north staircase, 30 Rockefeller Plaza

Title: *Fraternity of Men*
Type: mural
Subject: five races of mankind clasping hands
Installed: December 1937
Media: oil paint on canvas
Measurements: approx. 25 feet high, 17 feet wide
Painted: Sert Studio, Paris
Location: east wall of south staircase, 30 Rockefeller Plaza

Title: *Abolition of War*
Type: mural
Subject: mankind rejecting war
Installed: 1933
Media: oil paint on canvas
Measurements: approx. 25 feet high, 17 feet wide
Painted: Sert Studio, Paris
Location: wall of south staircase, lobby, 30 Rockefeller Plaza

Title: *Abolition of Bondage*
Type: mural
Installed: 1933
Subject: abolition of slavery
Media: oil paint on canvas
Measurements: approx. 25 feet high, 17 feet wide
Painted: Sert Studio, Paris
Location: wall of fourth elevator bank, lobby, 30 Rockefeller Plaza

Title: *Conquest of Disease*
Type: mural
Installed: 1933
Subject: conquest of disease through development of medicine
Media: oil paint on canvas
Measurements: approx. 25 feet high, 17 feet wide
Painted: Sert Studio, Paris
Location: wall of third elevator bank, lobby, 30 Rockefeller Plaza

Title: *Powers That Conserve Life*
Type: mural
Installed: 1933
Subject: evolution of machinery to relieve mankind
Media: oil paint on canvas
Measurements: approx. 25 feet high, 17 feet wide
Painted: Sert Studio, Paris
Location: wall of second elevator bank, lobby, 30 Rockefeller Plaza

Title: *Fire*
Type: mural
Subject: sun, the source of life
Installed: 1933
Media: oil paint on canvas
Measurements: approx. 25 feet high, 17 feet wide
Painter: Sert Studio, Paris
Location: north balustrade, lobby, 30 Rockefeller Plaza

Title: *Light*
Type: mural
Subject: the supreme ruler of the world
Installed: 1933
Media: oil paint on canvas
Fabricator: Sert Studio, Paris
Location: south balustrade, lobby, 30 Rockefeller Plaza

EDWARD BUK ULREICH (1889–1966): Muralist, WPA artist, mosaics.

Edward Buk Ulreich attended the Kansas City Art School and the Pennsylvania Academy of the Fine Arts. He designed murals for the Temple Building in Chicago and marble mosaics for the Century of Progress Exhibition, also in Chicago. He exhibited at the Art Director's Club, Anderson Galleries, and Dudensing Gallery.

Title: *Wild West*
Type: mural
Subject: early American West
Installed: 1932
Media: oil paint and sand on leather
Fabricator: artist's studio
Measurements: 6 feet high, 6 feet wide
Location: men's lounge, third mezzanine, Radio City Music Hall

EZRA A. WINTER (1886–1966): Easel painter, muralist.

Ezra A. Winter studied at the Chicago Academy of Fine Arts. He was a winner of the American Academy in Rome Scholarship. His works can be found at the New York Cotton Exchange and the Library of Congress in Washington, D.C.

Title: *Fountain of Youth*
Type: mural
Subject: Indian legend: the fountain of youth
Installed: October 1932
Media: oil paint on canvas
Measurements: 60 feet long, 40 feet high
Fabricator: artist and assistants at Winter's studio
Markings: artist's signature and date in lower right corner
Location: Grand Foyer staircase, Radio City Music Hall

WILLIAM ZORACH (1887–1966): Sculptor.

When William Zorach was four years old, his family immigrated to the United States and settled in Cleveland, Ohio. By the time he was thirteen, he was an apprentice to a lithographer and in night school at the Cleveland School of Art. When he was nineteen, he moved to New York City and enrolled at the National Academy of Design, studying with A. M. Ward and George Maynard. The following year he was studying in Paris and exhibited paintings in the Salon d'Automne. He returned to New York, married, and enjoyed success with his paintings, which were widely exhibited. In 1922 he decided to stop painting and start sculpting directly in stone and wood—an American revival approach to sculpture where the material is the primary factor in the artistic statement. In 1924 Krushaar Galleries gave him a one-man show. In 1929 he began a long career of teaching at the Art Students League in New York. In 1959 the Whitney Museum of American Art presented a retrospective of his work.

Title: *Dancing Figure*
Type: sculpture
Subject: female figure
Installed: 1932
Media: cast aluminum
Measurements: figure 77 inches high; self-base 3⅜ inches high, 31 inches deep, 47 inches long
Markings: artist's signature and date (top left corner of self-base)
Foundry: Roman Bronze Works, Long Island City, New York (marked on back lower edge of self-base)
Location: Grand Lounge, Radio City Music Hall

INDEX

Page numbers in *italics* refer to illustrations.

Abolition of Bondage (Sert), 113, *114*, 313

Abolition of War (Sert), 113, *113*, 313

Accademia di Belle Arti, 214

Acts from Vaudeville (Chambellan), 42, *43*, *44*, 305

 American, 42, 305

 French, 42, 305

 German, 42, 305

 Jewish, 42, *42*, 305

 Negro, 42, 305

 Russian, 42, 305

Advance Forever Eternal Youth (Piccirilli), 214–16, *214*, *217*, 257, 258, 311

Aeschylus, *199*, 204

Agnelli, Giovanni, 217, 218

Agriculture (Jennewein), *270*, 270, 307

Aldrich, Abby, 11

Alexander, Hartley Burr, 12, 18, 35, 52, 83, 203

American Designers Gallery, 54

American Modernism, 17, 29, 57, 58, 79, 80, 203

 see also Modernism

American Progress (Sert), 106, *107*, 110, 312

American Union of Decorative Artists and Craftsmen (AUDAC), 54

Angels (Clarebout), 196, *196*, 305

Arms of England (Lawrie), 167, *167*, 309

Aroffo, Armando, 205

Art Advisory Service of the Museum of Modern Art, 22

Art Deco, 17, 18, *21*, *28*, 29, 31, 36, *39*, 42, 72, 76, 130, 253, 257, 265, 269, 281

Art Students League, 60

Aspects of Mankind (Lachaise), 150–57, *153*, 308

 Conquest of Space, The, 150, 153, 154, *154*, 308

 Genius Seizing the Light of the Sun, 150, 153, 154, *154*, 308

 Gifts of Earth to Mankind, 150, *150*, 153, 157, *157*, 308

 Spirit of Progress, The, 150, 154, 157, *157*, 308

Associated Press Building, 280–89, *281*, *282*, *288*

Atlas (Lawrie), 230–38, *230*, *233*, *234*, *235*, *236*, *238*, 308

"Author of Life," 52

Avion Braguet, 183

Bach, Oscar Bruno, 35–41, *39*, 304

"Bachite Process, The," 36

Beaux-Arts, 17, 83

Belle Maisons Gallery, 60, 79

Bellonte, Maurice, 183

Bertelli, Mr., 160

Billings, Henry, 76–77, *77*, 304

Bouche, Louis, 31, 60–63, *60*, *62*, *63*, 79, 304

Brangwyn, Frank, 92, 94–95, 96, 118–25, *119*, *121*, *123*, *125*, 291, 304

Braque, Georges, 26

British Empire Building, 158–71, *159*, *163*, *165*, *167*, 170, 185, *186*

British Isles, coats of arms (Chambellan), 170, *170*, 305

 of England, 170, *170*, 305

 of Ireland, 170, *170*, 305

 of Scotland, 170, *170*, 305

 of Wales, 170, *170*, 305

Carducci, Giosuè, 216

Carpenter, M. C., 199

Cartier Silversmiths, 183, *183*, 304

Cartouche with British coat of arms (Jennewein), *160*, 164, *165*, 307

Cathedral of Vic, 104

Center Theater, Radio City Music Hall, 14

Century of Progress Exposition (Chicago), 75, 150

Chambellan, Rene, 35, 42–45, *42*, *43*, *45*, 104, 170–71, *170*, 180–81, *181*, 185, *186*, 188–95, *188*, *189*, *191*, *192*, *193*, *194*, *195*, 229, 230–39, 241, *241*, 245, 304–5

Chanin Building, 92

Channel Gardens and Promenade, 83, 159, 169, 182, *182*, 184–97, *186*, *196*, 230

 fountainhead figures in, 185, *186*, 188–95, *189*, *191*, *192*, *193*, *194*, 195

Chicago Temple Building, 75

Chrysler, 95

Chrysler Building, 14, 92

Clarebout, Valerie, 196–97, *196*, 305

Colonial Museum, Paris, 174

Commerce and Industry with Caduceus (Piccirilli), *257, 258, 265, 265,* 311

Communication (Sert), *109,* 312

Conquest of Disease (Sert), 113, *115,* 313

Contest-1940 (Sert), 117, 312

Continents (Gordon), 64, *64, 65,* 66, 306

Corbett, Harrison & Mac Murray, 12

Corning Glass Works, 88, 214, 216, 217, 261, *261*

Cornwell, Dean, *281,* 291–99, *293,* 305

Costes, Dieudonné, 183

Cranbook School, Sculpture Department of, 272, *272, 273*

Crouching Panther (Billings), 76–77, *77,* 304

Dance, Drama, Song (Meiere), 35–41, *35, 39, 40,* 310

Dancing Figure (Zorach), 66–67, *66, 67,* 313

Dante Alighieri, 246

Davis, Stuart, 80–81, *80,* 306

Dean, Abner, 207

Deering, John, 150

Delacroix, Eugène, 178

Delano, William A., 104

Depression, Great, 11, 12, 17, 26, 54, 95, 133, 160, 173, 203

Deskey, Donald, 14, 25, 26–34, *27, 28, 31, 32, 33, 34,* 35, 42, 44, 52, 54, 57, 58, 60, 63, 64, 67, 68, 72, 75, *75,* 76, 79, *79,* 80, 306

Detroit Industry (Rivera), 98

Eastern Airlines, 291, 292, 293, 295

Edward Caldwell, Inc., 48, *48,* 52

Edward III, King of England, 164

E. H. and A. C. Friedrichs Company, 95

Electricity Building exhibition, 150

Emerson, Ralph Waldo, 107, *107*

Esquire Magazine, 60

"Eternal Metal," 282, 285

European Modernism, 25, 26

Eve (Lux), 68–69, *68,* 310

Exotic Flowers (Kuniyoshi), 72–73, *73,* 307

Eyssell, G. S., *218*

Faulkner, Barry, 132–49, *133, 134, 136, 137, 139, 141, 142, 144, 145, 146, 147, 149,* 306

Feder, Abe, *11,* 306

Fiat, 217, 218

50 Rockefeller Plaza, *see* Associated Press Building

Fire (Sert), 117, 313

Fleur-de-lis (Lawrie), 182, *182,* 308

Forbes, Professor, 153

Ford, Edsel B., 98

fountainhead figures, Channel Gardens, *185, 186,* 188–95, *189, 191, 192, 193, 194, 195*

Fountain of Youth (Winter), 48–53, *48, 50, 51, 52, 53,* 313

Four Contintents (Lentelli), 266, *266,* 309

 Africa, 266, *266,* 309

 America, 266, *266,* 309

 Asia, 266, *266,* 309

 Europe, 266, *266,* 309

Fourteen Heraldic Shields (Lawrie), 249, *249,* 309

Francis of Assisi, Saint, 246, *246*

Fraternity of Men (Sert), 117, 312

French, Daniel Chester, 214

Friedlander, Leo, 126–31, *126, 128, 129, 130,* 306

Friendship between America and France (Janniot), *173,* 174–77, *174, 177,* 307

"Frozen Assets" (Rivera), 95

Gallic Freedom (Janniot), *see Torch of Freedom, The*

Garrison, Robert, *17,* 18–21, *18, 19, 20, 21,* 306

Gaston Lachaise Retrospective Exhibition, 150

General Alloys, 282, 285, *285, 286, 287, 289*

Gilbert, Cass, 36

Giotto di Bondone, 246

Girl and Goose (Laurent), 70–71, *70, 71,* 308

Gordon, Withold, 32, 64–65, *65,* 306

Gorham Company, 160, 177

Grand Foyer, Radio City Music Hall, 34, 48, *48, 51,* 52, 55

Grand Lobby, 30 Rockefeller Plaza, *92,* 106, 107, *107, 109,* 110, *111,* 117, 118

Grand Lounge, Radio City Music Hall, 31, *32, 33,* 58, *59,* 60, 63, *63*

Great Depression, 11, 12, 17, 26, 54, 95, 133, 160, 173, 203

Gregory IX, Pope, 246

Half Moon, 296

Harris, H. H., 287

Harrison, Wallace, 14, *14*, 173, 174

Hemingway, Ernest, 80

hieroglyphic, 241

History of Cosmetics (Gordon), 64, *64*, *65*, 306

History of France (Chambellan), 181, *181*

History of the Theatre (Reeves), 56, 57, *57*, 312

Hood, Raymond, *14*, 83, 118, 150, 173, 269, 275

Hood & Fouilhoux, 12

Hopwood, Francis John Stephens, 159, *159*

Hotel Sheldon, 79

Hudson, Henry, 296

Ihara, Michio, 254–55, *255*, 307

Immigrant, The (Manzu), 218–23, *223*, *224*, 310

Industries of the British Empire (Jennewein), 159, 160–63, *160*, *163*, 164, 307

Industry (Jennewein), 270, *270*, 307

Intelligence Awakening Mankind (Faulkner), 133–49, *133*, *134*, *136*, *137*, *139*, *141*, *142*, *144*, *145*, *146*, *147*, *149*, 306

International Building, 150, 228–55, *230*, *236*, *245*, *246*, *248*, *249*, *251*, *252*, *253*, *255*, 269

International Building North, 217, 256–67, *257*, *258*, *262*, *266*

International Building South, see Palazzo d'Italia

Italia (Manzu), *213*, 218–23, *218*, *220*, 310

Italian Renaissance, 226, *226*, 246

Italian Tourist Office, 217

Janniot, Alfred, 173, *173*, 174–79, *174*, *177*, *178*, 307

Jennewein, Carl Paul, 159, 160–65, *160*, *163*, *165*, 270–71, *270*, 307

Jones, Robert Edmond, 25

Joy of Life, The (Piccirilli), 278, *279*, 311

Kahlo, Frieda, 96, *96*

Keim Mineralfarben, 89, 91

Kevorkian Galleries, 79

Kirstein, Lincoln, 150

Kuniyoshi, Yasho, 72–73, *73*, 307

Kushner, Robert, 22–23, *22*, 307

Kykuit mansion, 188, 191

Lachaise, Gaston, 12, 150–57, *150*, *153*, *154*, *157*, 250–53, *251*, *252*, *253*, 308

Laurent, Robert, 66, 67, 68, 70–71, *71*, 308

Lawrie, Lee, 12, 83, 84–89, *85*, *86*, *89*, 91, 92, 166–69, *167*, *169*, 182, 195, 229, 230–49, *230*, *233*, *234*, *236*, *238*, *241*, *242*, *245*, *246*, *248*, *249*, 269, 276–77, *277*, 308–9

Lefevre de Latoulaye, Andre, 183

Lenin controversy, 98, *98*, 99–100, *99*, *100*, 216, 275, 292

Lentelli, Leo, 226–27, 266–67, *266*, 309–10

Leonardo da Vinci, 296

Leo XIII, Pope, 36

Liberty Leading the People (Delacroix), 178

Light (Lawrie), 88–89, 91, *91*, 308

Light (Sert), 117, 313

Lincoln, Abraham, 107, *107*

Lindbergh, Charles, 183

Lord & Taylor, 26

Lower Plaza, 83, *103*, 185, *186*, 194, 198–211, *199*, *200*, *203*, *211*, 230 skating rink in, *186*, 199, 208, 241

Luce, Henry R., 274

Lux, Gwen, 66, 67, 68–69, *68*, 71, 310

Macer-Wright, Philip, 118, 121

MacMonnies, Frederick W., 214

Maiden (Manship), *103*, 208, *208*, 211

Maillol, Aristide, 173

Maison Française, La, 172–83, *173*, *177*, *178*, 182, *183*, 185, 186

Man and Nature (Milles), 272–75, *272*, *273*, *274*, *275*, 311

Man at the Crossroads (Rivera), 94, 96–100, *96*, *98*, *99*, *100*, 312

Man Controller of the Universe (Rivera), 100

Man in Search for Eternal Truth (Brangwyn), 304

Man Labouring, 121, 304

Man the Creator, 119, 123, 304

Man the Master, 119, 123, 304
 Sermon on the Mount, 125, *125*, 304

Mankind (Manship), 208, *210*, *211*, 310

Manship, Paul, *103*, 195, 199, *199*, 202–11, *203*, *207*, *208*, *210*, *211*, 230, 310

Manzu, Giacomo, *213*, 217, 218–25, *218*, *220*, *223*, *224*, 310

Map Room, Radio City Music Hall, 64, *64*

"March of Civilization" theme, 12, 265

Marx, Karl, 100

Mascetti, Alex, 277

Matisse, Henri, 94

Meiere, Hildreth, 35–41, *35, 36, 39, 40,* 310

Men Without Women (Davis), 80–81, *80, 81,* 306

Mercury with Blazing Sun (Lawrie), 169, *169,* 309

Mergentime, Marguerite, 58–59, *58, 59,* 310

Metropolitan Life Building, 92

Metropolitan Museum of Art, 26

Metropolitan Square Corporation, 92

Milles, Carl, 103, 272–75, *272, 273, 274, 275,* 311

Mirror Room, Radio City Music Hall, 31, *31*

Moderne Art, 17, 83, 203

Modernism, 67, 85, 241

 see also American Modernism

Morning, Present, Evening (Garrison), *17,* 18–21, *18, 19, 20, 21,* 306

Morse, John D., 207

Museum of Modern Art (MOMA), 12, 80, *80,* 95, 125, 150, 177

 Art Advisory Service of, 22

Musical Instruments (Reeves), 54, *55,* 312

Musicians (Chambellan), *45,* 305

Mussolini, Benito, 213, *213,* 216

Nagel, Isabel, 150

Nebraska State Capitol, 35

"New Frontiers" theme, 18, 83, 94, 265, 292

News (Noguchi), 281–89, *281, 282, 284, 285, 286, 287, 288, 289,* 311

New York School of Interior Design, 60

New York Times, 58

Nicotine (Deskey), *27, 29,* 306

1939 World's Fair (New York), 17

Noguchi, Isamu, 280–89, *281, 282, 284, 287, 288, 289,* 311

Nole, Leonard, 205

O'Keeffe, Georgia, 72, 150

One Rockefeller Plaza, 268–79, *269, 270, 272, 274, 275, 277, 279*

Osborn, Fairfield, 274

Pageant of French History (Chambellan), 305

 Absolute Monarchy, 305

 Birth of Republic, 305

 Rise of Charlemagne, 305

 Unification of New France, 305

Palacio de Bellas Artes, Mexico City, 100

Palazzo d'Italia, 212–27, *213, 217, 220, 224, 226*

 limestone panels at, 226, *226*

Perry, Professor, 204

Phantasmagoria of the Theater, The (Bouche), 31, 60–63, *60, 62, 63,* 304

Picasso, Pablo, 26, 94

Piccirilli, Attilio, 164–65, 214–17, *214, 217,* 218, 223, 256–65, *257, 258, 261, 262, 265, 266, 266,* 278–79, *279,* 311

Piccirilli, Furio, 214

Piccirilli Brothers, 164, 214, 241, 245, 266, 270, 277, 278

Plentitude from International Trade (Lawrie), 248, *248,* 309

Point d'Interrogation, Le (Cartier Silversmiths), 183, *183,* 304

Poor, Henry Varnum, 78–79, *79,* 311

Powers That Conserve Life (Sert), 113, 117, *117,* 313

Progress (Lawrie), 269, 277, *277,* 309

Prometheus (Manship), 103, 199, 203–7, *203, 205, 207, 208, 208, 210,* 230, 310

Pupin, M. I., 83

Purpose of the International Building, The (Lawrie), 229, 241, *241, 242, 245,* 309

Qualities That Spurred Mankind (Chambellan), 305

 Alertness, 305

 Energy, 305

 Imagination, 305

 Leadership, 305

 Thought, 305

 Will, 305

Question Mark, The, see *Point d'Interrogation, Le*

Radio City Music Hall, 12, 14, 25–81, *25, 27, 28, 50, 55, 57, 59, 71, 74, 75, 77, 78, 79, 80*

 auditorium and elevator door plaques of, 29, 33, 44–45, *44, 45*

 elevator interiors of, 29, 46–47, *47*

 exterior plaques of, 35–40, *35, 36, 37, 40,* 42–43, *42, 43*

 Grand Foyer in, 34, 48, *48, 51,* 52, 54, 55

 Grand Lounge in, 31, *32, 33,* 59, 60, 63, *63,* 64, 65

 Map Room in, 64, *64*

 Mirror Room in, 31, *31*

 textiles and carpets of, 29, 31, *31, 32, 33,* 54–59, *55, 59,* 76

 Ticket Lobby of, 34, *34*

Rambusch Decorating Company, 91, 182, 249, 277

"Rape of Europa," 189

Ravenna Mosaic Works, 134, *139*, *141*

RCA Building, see 1250 Avenue of the Americas

Reeves, Ruth, 52, 54–57, *55*, *57*, 312

Reinhard, L. Andrew, 14, *14*, 53, 195

Reinhard & Hofmeister, 12

Richard I, King of England, 167

Rickenbacker, Eddie, 292, 295, *295*

Rivera, Diego, 92, 93, *94–101*, *94*, *96*, *98*, *99*, *100*, *104*, 125, 216, 275, 292, 312

Riverside Church, 36

R. J. Reynolds Tobacco Company, 29

Rockefeller, Abby Aldrich, 93, 94, 95, 98, 99, 100, 150 177, 251

Rockefeller, John D., Jr., 11, 12, 17, 18, 100, 125, 134, 159, 174, 188, 213, 275, 292

Rockefeller, John D., Sr., 188

Rockefeller, Laurance S., 9, 275, 291, 292

Rockefeller, Nelson, 11, 17, 93, 94, 95, 98, 99–100, 125, 188, 199, 249, 251, 253, 255, 289

Rockefeller Center, 80

 art program of, 12–14, 83, 89, 92, 160, 163, 253, 269, 292 color work of, 14, 88–89, 91–93, *91*, *92*, 95, 109, 125, 178, 182, 229, 241, 245, 246, 248, 249, *257*, 277, 278

 development and construction of, 11, 12, 14, *14*, 126

 genesis of, 11

 map of, 300

 skating rink at, *186*, 199, 208, 241

 timelessness of, 11

Rockefeller Center, Inc., 91

Rockefeller Corporation, 22

Rockefeller family, 52, *80*, 83, 86, 89, 103, 157, 173, 174, 177, 185, 216, 217, 229, 251, 275, 289, 292

Roman Bronze Works, 66, 67, *67*, 68, 71, *71*, 160, 191, 204, 207, 208, 233, *233*, *234*

Roman Civilization (Lentelli), 310

Romans, 133

Ross, Louis, 293

Rothafel, Samuel "Roxy," 26, 31, 44, 67

Royal Pavillion, 119, *119*

Ruhlmann, Émile-Jacques, 26

St. Francis of Assisi with Birds (Lawrie), 246, *246*, 309

Saint-Gaudens, Augustus, 214

St. Patrick's Cathedral, 229, 230

St. Peter's Cathedral, 217

Savoy, coat of arms (Piccirilli), 216–17

Scenes from Theater (Chambellan), 305

"schiacciato," 223

Schley, Henry McA., 103, 185, 249, 277, 285, 287

Schoen, Eugene, 14

Sculptures of Light and Movement (Ihara), 255, *255*, 307

Seated Lincoln (French), 214

Seeds of Good Citizenship (Lawrie), 182, *182*, 309

"Selected Collection of Modern Decorative and Industrial Art" exhibit, 26

Sentinels (Kushner), 22–23, *22*, 307

Sert, José Mariá, 92, *92*, 94–95, 96, 103, 104–13, *104*, *106*, *107*, *109*, *111*, 113–17, *113*, *114*, *115*, *117*, 118, 119, 125, 312–13

Seume, Johann Gottfried, 274

Singing Heads (Deskey), 31, 33

skating rink, *186*, 199, 208, 241

Solon, Leon V., 14, 88–89, 90–91, *91*, 178, 182, 229, 241, 245, 246, 248, 249, *257*, 277, 278

Sound (Lawrie), 88, 89, 91, 308

Southborough, Lord, see Hopwood, Francis John Stephens

Spirit of Dance (Sert), 108, 109, *109*, 312

Spirit of the Dance (Zorach), 67, *67*, 71

Standard Oil of New Jersey, 36

Stevens, Wilmuth Masden, 293, *293*

Stieglitz, Alfred, 72, 150

Stone, Edward Durrell, 12–14, 25, 34

Story of Man, The, see *Purpose of the International Building, The*

Story of Transportation, The (Cornwell), 291–99, *291*, *293*, *295*, *297*, *299*, 305

Sumerians, 133

Tallix Morris Singer Foundry, 22

Tapestry in Stone (Janniot), 174

Temple Emanu-El, 36

10 Rockefeller Plaza, 12, 290–99, *291*, *295*, *297*, *299*

30 Rockefeller Plaza, *11*, 82–131, *85*, *86*, 89, *91*, *94*, *96*, *104*, 126, *128*, *129*, *130*, *186*, 199, 203, 269

 Grand Lobby of, *92*, *106*, *107*, *107*, *109*, 110, *111*, *117*, 118

 Lenin controversy at, *98*, 98, 99–100, *99*, *100*, 216, 275, 292

 north corridor murals of, 113–17, *113*, *114*, *115*, *117*

 south corridor murals of, 118–25, *119*, *121*, *123*, *125*

 Wailing Wall, 102–3, *103*, *106*, 275

Ticket Lobby, Radio City Music Hall, 34, *34*

Time (Sert), 92, 110, *111*, 312

To Commemorate the Workmen of the Center (Lachaise), 251–53, 308

 Construction, 251, *251*, 252, 253

 Demolition, 251, 252, *252*

Todd, John R., 14, 92, 103, 118, 125, 126, 173, 195, 213, 275

Todd, Webster B., 92, 118, 216

Todd & Brown, 14, 26, 92, 160, 233, 275

Torch of Freedom, The (Janniot), 178, *178*, 307

Transmission (Friedlander), *126*, 306

 Radio, *128*, 129, *129*, 130, *130*, 306

 Television, 129, 130, *130*, 306

Trotsky, Leon, 100

Trumbull, Edward, 14, 46–47, *47*, 83, 92–93, *92*, 95, 109, 118

1250 Avenue of Americas, *14*, *17*, 133–57, *133*, *134*, *141*, *142*, *144*, *145*, *146*, *147*, *149*, *150*, *153*, *154*, *157*, 251

1270 Avenue of Americas, 17–23, *18*, *19*, *20*, *21*, *22*

Ulreich, Edward Buk, 74–75, *74*, *75*, 313

United States Passport Agency, 229

Vaccination (Rivera), 98

Vassar College, 292

Vincent, George, 83

Wailing Wall, 30 Rockefeller Plaza, 102–3, *103*, *106*, 275

Waldorf-Astoria, 104

Wanamakers, 60, 79

War and Peace (Manzu), 223

Warburg, Edward M. M., 150

Ward, John Quincy Adams, 214

Weber and Fields, *62*, *63*, 63

Wenrich, John, *12*, 200

White, Sanford, 60

Wild West (Ulreich), 74–75, *74*, *75*, 313

Winlock, H. E., 118, 153

Winter, Ezra A., 48–53, *48*, *50*, *51*, *52*, *53*, 313

Wisdom (Lawrie), *83*, 84–87, *85*, *86*, 89, *89*, 91, 308

Woolworth Building, 36

Works Progress Administration (WPA), 89

World Peace (Lawrie), 245, *245*, 309

World War II, 216–17, 223, 261, 289, 295

Youth (Manship), *103*, 208, *210*

Youth Leading Industry (Piccirilli), 217, 257–61, *258*, *261*, *262*, 265, *265*, 311

Zorach, William, 66–67, *66*, *67*, 68, 71, 313

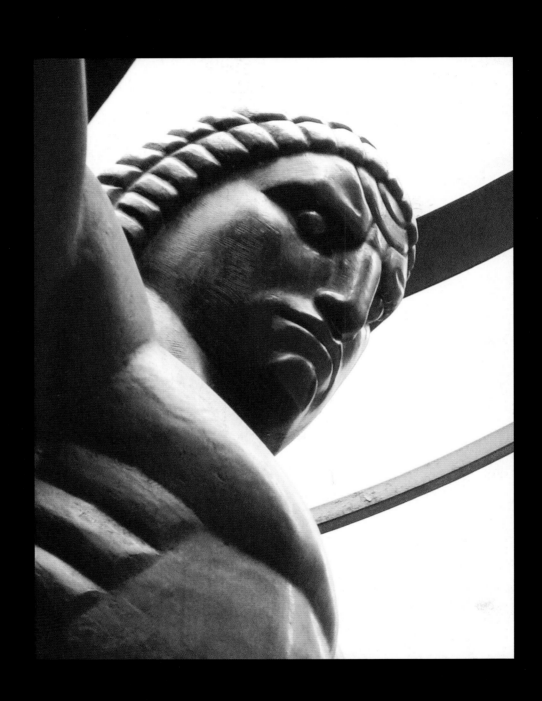